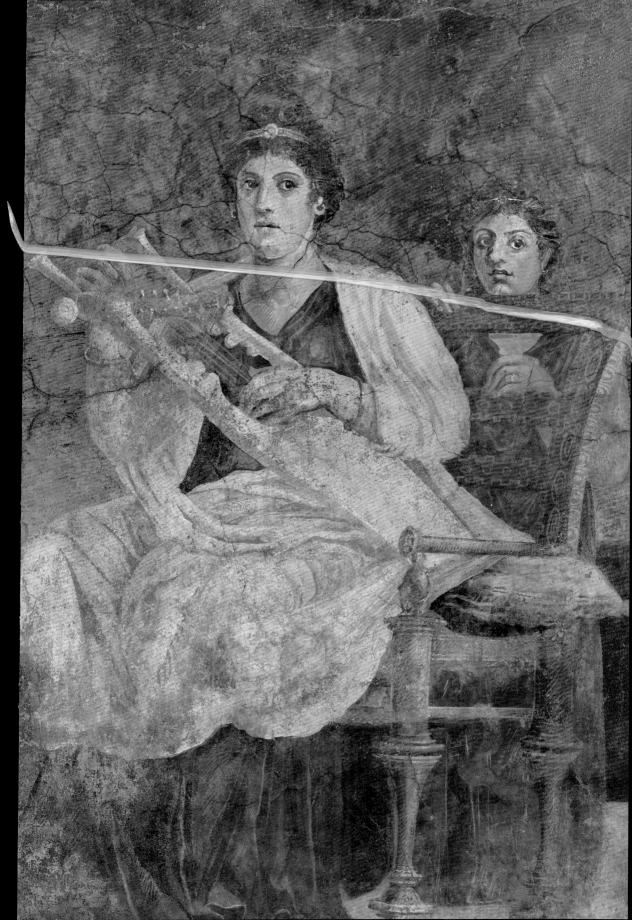

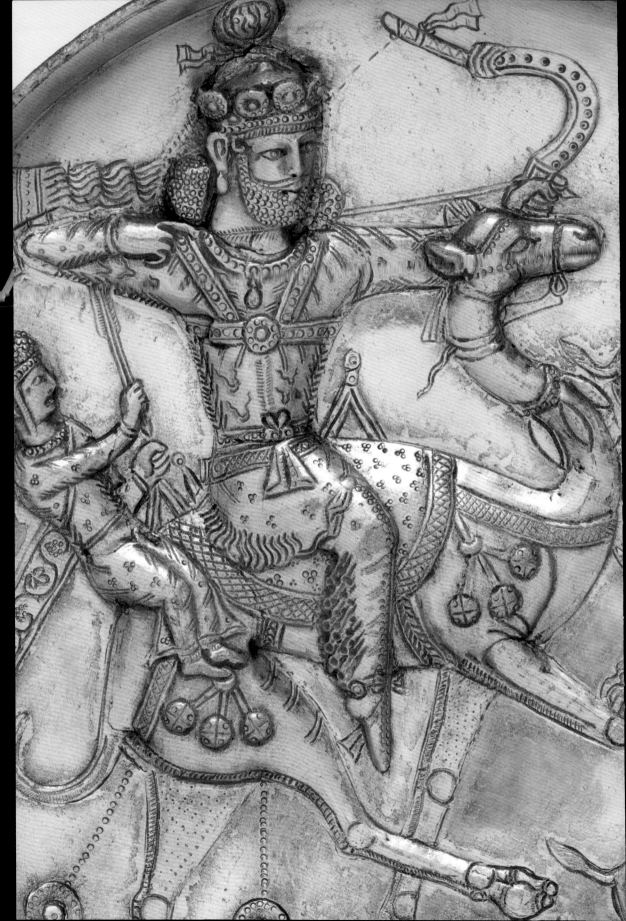

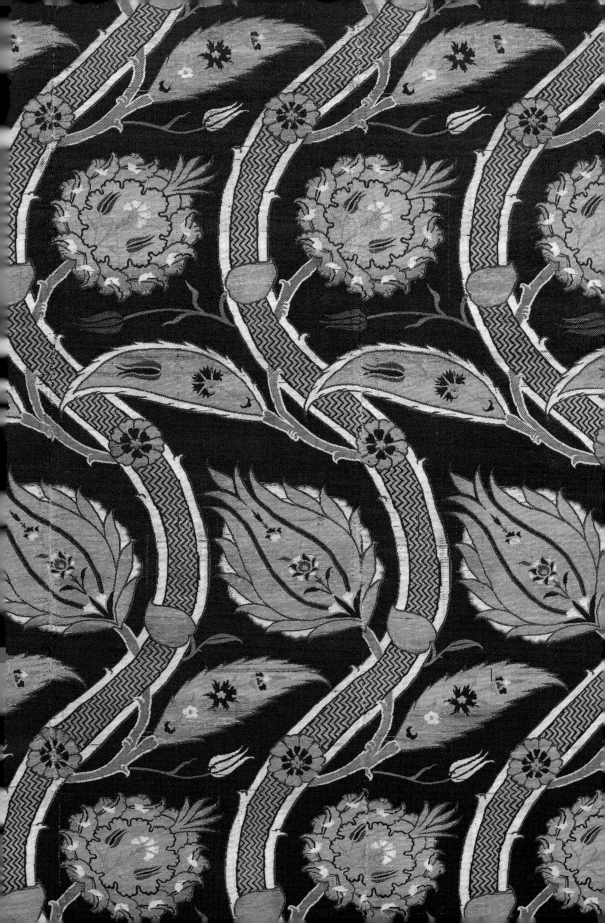

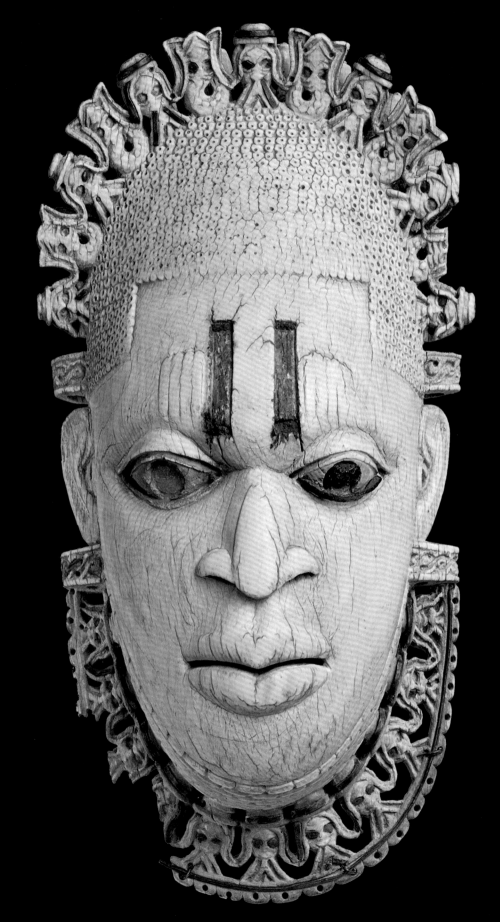

The Metropolitan Museum of Art Guide

The Metropolitan Museum of Art, New York

DISTRIBUTED BY YALE UNIVERSITY PRESS, NEW HAVEN AND LONDON

CONTENTS

DIRECTOR'S FOREWORD

In the past 150 years, The Met has developed into an outstanding, truly global institution by virtue of its extraordinary collection, its multifaceted programming, and its uniquely ambitious exhibition schedule. With more than five thousand years of art from across the globe—1.5 million objects and manifestations of human creativity from the ancient world to the present time—The Met provides a remarkable diversity of artistic expressions, perspectives, viewpoints, and narratives.

For this volume, curators from all seventeen curatorial departments collaborated to identify works that represent the scope of our collection in the most compelling way. The coordination of this effort fell to Gwen Roginsky, Associate Publisher and General Manager of Publications, and Andrea Bayer, Deputy Director for Collections and Administration, who together shaped a mountain of material into a cohesive volume. The result reflects the excellence of our editorial team and the talent of the book's designer, Steven Schoenfelder.

There are so many ways to experience The Met: by visiting our galleries, by connecting with us online, where we have digitized and made available for use more than 400,000 images, and by exploring our world-class publications, which include scholarly titles, exhibition catalogues, and this treasure trove of collection highlights. As an essential resource for experiencing the artistic achievements of humankind, The Met is committed to telling the fascinating and interconnected stories of the cultures of the world.

Max Hollein
Director, The Metropolitan Museum of Art

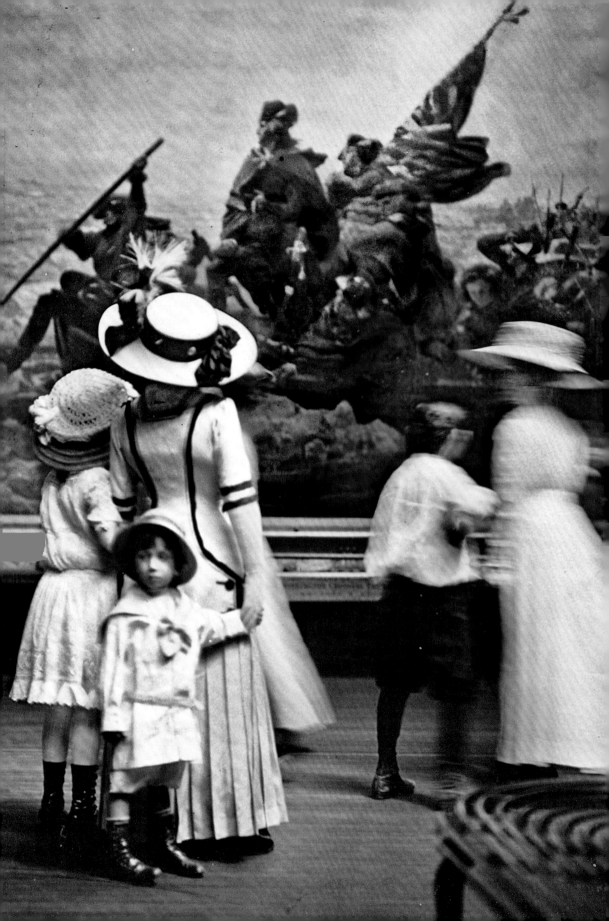

Introduction

Before The Metropolitan Museum of Art owned a single work, it was an idea: a basic social and moral premise that art would fundamentally elevate anyone who had access to it. Individual thought would be heightened, industry and manufacturing would advance, a greater good would be achieved.

It seems important to note these underlying principles at the beginning of a book that celebrates the strength of the Met's collections, as it is astonishing to consider that what literally started as nothing became, over the past century and a half, arguably the greatest encyclopedic art museum in the world.

The concept of the encyclopedic or "universal" museum stems from European models established during the Enlightenment. At the Met our mandate is to collect the greatest artistic achievements of humankind, spanning all cultures and time periods, including objects that date back as far as the eighth millennium B.C. These collections are highlighted in both the permanent installations devoted to each of our seventeen curatorial departments and the temporary exhibitions that focus on specific themes, time periods, or artists. Having this range of material within one museum creates an extraordinary dialogue between seemingly disparate histories and traditions and allows our visitors to literally traverse the globe in a single visit.

In many ways, the Met's story is uniquely American. It is a tale of ambition, civic responsibility, and profound generosity: an idea over lunch—July 4, 1866, in Paris—forged in the shadow of European museums that were defined by centuries of royal patronage. On that day, prominent American lawyer John Jay declared that the United States needed an art museum of its own. A group of fellow Americans in attendance pledged themselves to that goal, and the Metropolitan Museum became a reality four years later.

From the moment of its founding in 1870, the Metropolitan Museum was dedicated to the idea of educating the masses. Its mission statement was unequivocal on this point, stating that the Met was "to be located in the City of New York, for the purpose of establishing and maintaining in said city a Museum and library of art, of encouraging and developing the study of the fine arts, and the application of arts to manufacture and practical life, of advancing the general knowledge of kindred subjects, and, to that end, of furnishing popular instruction."

At the 1880 opening of its building in Central Park, the Met was heralded by Trustee Joseph C. Choate as in "the vital and practical interest of the work-

Visitors to The Metropolitan Museum of Art, 1910, in front of Emanuel Leutze's 1851 painting *Washington Crossing the Delaware*. See also page 364.

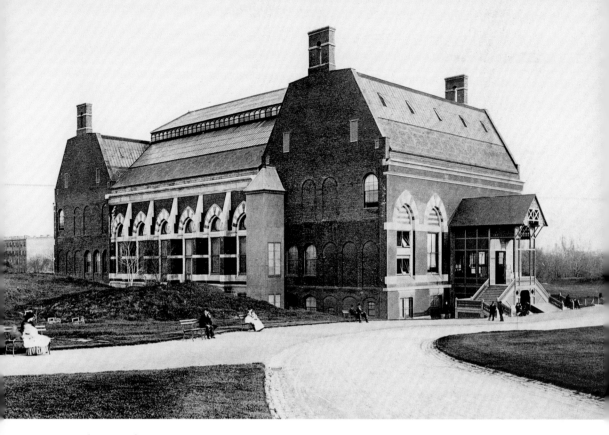

Fig. 1. The Metropolitan Museum of Art, 1880s

ing millions" (fig. 1). However, in the Museum's earliest days it could do little to effect that goal, since it kept genteel opening hours that exactly coincided with the working day (fig. 2). As a result, the Met's early attendance was as narrow in its demographic as the group of wealthy businessmen who were its founders. Edith Wharton's novel *The Age of Innocence* describes the late nineteenth-century Met as "mouldered in unvisited loneliness." Newland Archer sits with Countess Olenska in the Met's vast emptiness and says with resignation, "Ah well—someday, I suppose, it will be a great museum."

And indeed, things were changing. In 1889, after years of discussion, the Met finally started opening for the public on

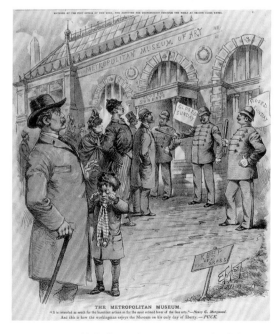

Fig. 2. Cartoon published in *Puck*, January 2, 1889: "And this is how the workingman enjoys the Museum on his only day of liberty."

Sundays, and by 1911 the annual report proudly declared that the Museum "no longer appeals merely to the upper classes." The twentieth century would see the continued growth of both the Museum's audiences and its collections. Students were welcomed, and crowds gathered around pivotal exhibitions like the 1909 "Hudson-Fulton Celebration," the 1942 "Artists for Victory," the 1963 loan of the *Mona Lisa*, and the 1978 "Treasures of Tutankhamun." Visitors steadily increased as the Met's public presence expanded, and today annual attendance is more than five million.

It is interesting to note that the Museum's early mandate to provide art for the people often had only a tangential relationship with original works of art.

In the nascent stages of the Met, when the thinking persisted that masterpieces would never be available for purchase by the Museum, a significant commitment was made to accumulate electrotypes and plaster casts of the world's masterpieces (fig. 3). The plaster casts—totaling more than twenty-six thousand—were installed in what is now the Medieval Sculpture Hall and the two adjacent wings now dedicated primarily to European period rooms.

But in 1902, everything changed. Jacob S. Rogers, an eccentric businessman who made locomotives in Paterson, New Jersey, and by all accounts was more paranoid misanthrope than museum lover, left the Met the extraordinary sum of $5 million to be used solely for the

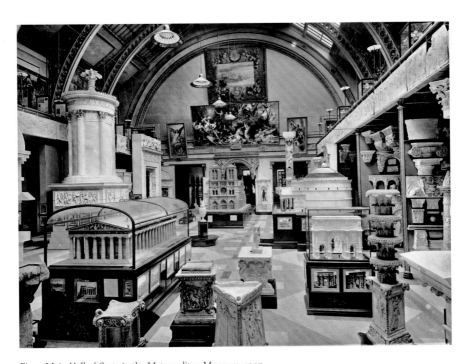

Fig. 3. Main Hall of Casts in the Metropolitan Museum, 1907

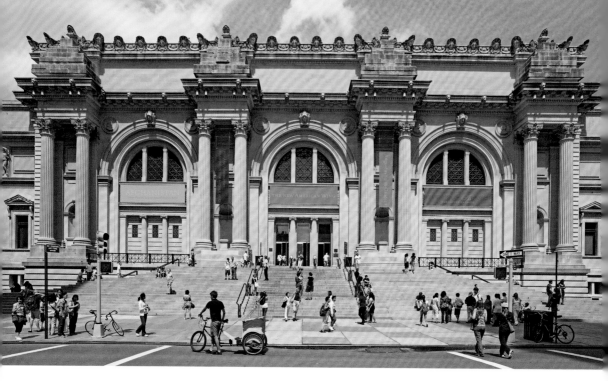

Fig. 4. Facade of the central wing of the Metropolitan Museum

purchase of art. It was a gift that transformed the Met from a struggling institution to a powerful force in the art market, and put the Museum in a position to acquire original works of art. Within the first twenty years following the establishment of the Rogers Fund, the Met bought Bruegel's *The Harvesters*, our remarkable Pompeian wall paintings from Boscoreale, and Gilbert Stuart's *George Washington*, to name just a few of the masterpieces acquired with this transformative contribution.

The Met was not alone in buying masterpieces at the beginning of the twentieth century. Great collectors like J. P. Morgan, Benjamin Altman, and Louisine and H. O. Havemeyer had by then initiated a tradition of extraordinary accumulation and accompanying largesse that has been upheld by generations of

donors to the Museum. As you will see throughout this book, the cornerstones of many of the Met's curatorial departments were gifts from some of the most outstanding private art collections ever built. That legacy continues today, as does the Museum's strong commitment to refining the collections through the purchase of additional works of art.

Like our collections, the Museum's building has also developed over time. The modest 1880 structure that was constructed in the rural confines of Central Park has now expanded to more than two million square feet along a bustling Fifth Avenue (fig. 4). The Neoclassical facade we see today was designed by Richard Morris Hunt and erected in the early years of the twentieth century, and the north and south wings (1911 and 1913) were the work of McKim, Mead & White. The building's

final footprint in Central Park was not established until the Museum's centenary year, 1970, after which the growth of our galleries, by necessity, has occurred from within.

What has not changed throughout the Met's history is our commitment to scholarship. Our scholarly work is the foundation for everything that we do—exhibitions, education programs, publications, the Museum's website. Without the understanding and interpretation of our collections, we would be little more than a warehouse for the treasures we are entrusted to preserve. Our commitment to archaeological work has played a considerable role in the study of the ancient world since the establishment of the Museum's first excavation in 1906, and among the thousands of books we have published, many are the definitive texts in their fields.

The publication of this particular volume comes at a time when access to the Met's collections—and demand for information about them—is greater than ever. Millions of people around the world connect to these works of art via our website, becoming all the more inspired to see the objects themselves here at the Museum. Indeed, there is little that speaks so powerfully to us—both as individuals and as a civilization—as the art within the Met's galleries. Our connection to these collections is fundamentally why the Met was established: a museum created *by* citizens *for* citizens. It was a wildly ambitious concept when the Museum was founded. And remarkably, this idea—art privately amassed, not by the church or royal courts, but by donors determined to share it with the public—has survived without ever losing its relevance.

The Met's original mandate to educate and inspire the public by presenting the greatest artistic achievements of humankind still anchors our thinking about what the Museum should always aspire to be. Our success will help foster an understanding of *all* art and culture and, in turn, encourage a more global perspective on the world in which we now live. I cannot imagine a more important vision for our future.

Note to Reader

Organizing a book about a collection as vast as the Metropolitan Museum's is an exceptional challenge. As you will see, we have divided this volume into five sections to make it easier to navigate the Museum's seventeen curatorial departments. We recognize that this structure, while useful for the reader, has created anomalies such as an American drawing in the "Europe" section and a Renaissance doublet in the "Modern Era" pages. These discrepancies are rare but unavoidable, and we hope that you enjoy the book's larger themes in spite of them.

Ancient World

Ancient Near Eastern Art

The collection of ancient Near Eastern art includes more than seven thousand works ranging in date from the eighth millennium B.C. to just after the Arab conquests in the seventh century A.D. These objects come from a vast region centered in Mesopotamia, between the Tigris and Euphrates Rivers, extending north to the Caucasus and the Eurasian steppes; south to the Arabian Peninsula; west to Anatolia, Syria, and the Levant, bordered by the Mediterranean Sea; and east through Iran and western Central Asia, with connections as far as the Indus River valley. Created in a great variety of forms, styles, and materials, they reflect the many peoples, cities, kingdoms, and empires that flourished in the region over thousands of years. These far-ranging works are presented in contexts that illuminate both their intrinsic significance and their connections to the art of neighboring cultures. At the core of the gallery display is an extraordinary group of Assyrian reliefs from the palace of Ashurnasirpal II (r. ca. 883–859 B.C.) at Nimrud in modern Iraq. The first ancient Near Eastern objects to enter the Museum—Assyrian stone reliefs, cuneiform tablets, and stamp and cylinder seals—were acquired in the late 1800s and have since been supplemented by gifts and purchases, as well as through participation in archaeological excavations in the Near East. The permanent display has also been generously enriched by long-term loans of excavated works from other museum collections.

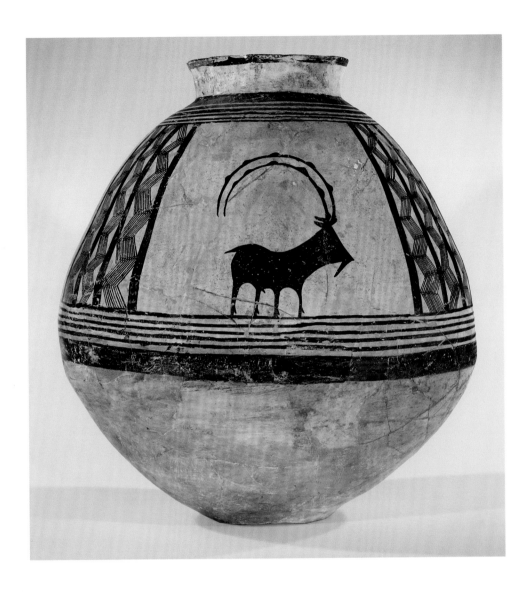

Storage Jar Decorated with
Mountain Goats

Iran, Chalcolithic period, ca. 3800–3700 B.C.
Painted ceramic, H. 20⅞ in. (53 cm)
Purchase, Joseph Pulitzer Bequest, 1959 (59.52)

This ovoid vessel, a masterpiece of early pottery-making, incorporates a design that is stylized but not static. A mountain goat, or ibex, stands in profile on the topmost of six bands, which circle the widest part of this large jar and emphasize its great girth. The curves of the goat's greatly enlarged horns echo the circular form of the jar, as do the curved spaces between the animal's legs. Alternating vertical and zigzag lines frame either side of the animal. The overall artistic effect evokes movement and dynamism in a sophisticated way.

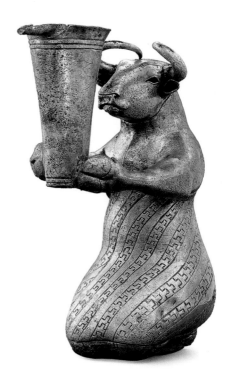

Kneeling Bull Holding a Spouted Vessel

Iran, Proto-Elamite period, ca. 3100–2900 B.C.
Silver, H. 6⅜ in. (16.3 cm)
Purchase, Joseph Pulitzer Bequest, 1966 (66.173)

This small silver bull, clothed in a garment
decorated with a stepped pattern and holding
a spouted vessel, displays a curious blend of
human and animal traits. Representations of
animals in human postures appear in early
Iranian art possibly as symbols of natural forces
or as protagonists in myths or fables. Because it
contains several pebbles inside its hollow body,
the object may have served as a noisemaker in a
ceremonial setting. Traces of cloth found affixed
to the figure suggest that it was intentionally
buried, perhaps as part of a ritual.

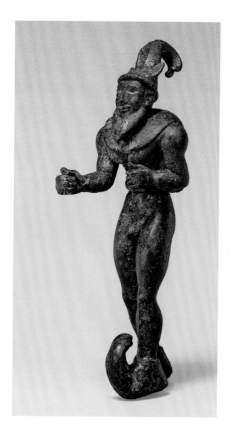

Striding Horned Figure

Iran or Mesopotamia, Proto-Elamite period,
ca. 3100–2900 B.C.
Copper alloy, H. 6⅞ in. (17.5 cm)
Purchase, Lila Acheson Wallace Gift, 2007 (2007.280)

Cast in the lost-wax method at the dawn of
metal sculpture, this dynamic figure conveys
extraordinary power and monumentality on a
small scale. It is one of a pair of nearly identical
images of an energetic male figure wearing the
upturned boots associated with the highland
regions of Iran and Mesopotamia. His power is
further enhanced by the horns of the ibex on
his head and the body and wings of a bird of
prey draped around his shoulders. The blending
of human and animal forms to represent the
supernatural world, and perhaps to express
shamanistic beliefs, is characteristic of the arts
of Proto-Elamite Iran.

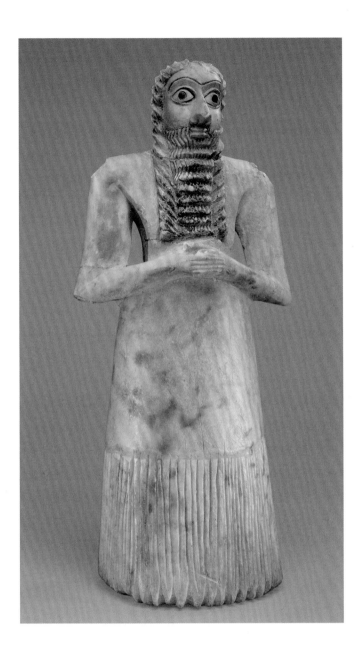

Standing Male Figure

Mesopotamia, excavated at Eshnunna (modern Tell
Asmar), Early Dynastic I–II period, ca. 2900–2600 B.C.
Gypsum, shell, black limestone, bitumen,
H. 11⅝ in. (29.5 cm)
Fletcher Fund, 1940 (40.156)

This figure, with clasped hands and wide-eyed
staring gaze, was found in a temple, ritually
buried along with eleven others. All twelve
are thought originally to have represented
worshippers in perpetual prayer before their
deity. The figure's large head features prominent
eyes inlaid with shell and black limestone.
Stylized tresses fall on either side of a rect-
angular beard, and both hair and beard show
traces of the original bitumen coating. The
statue exemplifies the abstract geometric style
of some Sumerian sculpture, which existed
alongside more realistic works of the Early
Dynastic period.

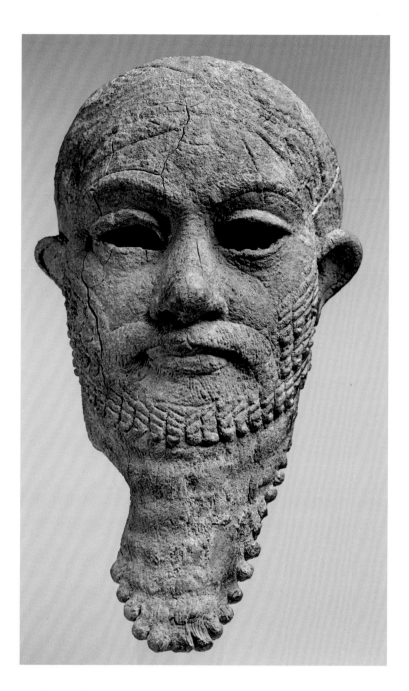

Head of a Ruler

Iran or Mesopotamia, Early Bronze Age,
ca. 2300–2000 B.C.
Copper alloy, H. 13½ in. (34.3 cm)
Rogers Fund, 1947 (47.100.80)

The identity of this lifesize head and where it was created remain a mystery. The expert crafts-manship, innovative technology, and the use of copper alloy, a very costly material, suggest that it represents a king or an elite person. The dark, empty spaces of the eyes were probably once inlaid with contrasting materials, as was characteristic of the arts of the ancient Near East. Patterns in the elegantly coiffed beard and well-trimmed mustache and the curving and diagonal lines of the figure's cloth turban can still be seen beneath the corroded copper surface.

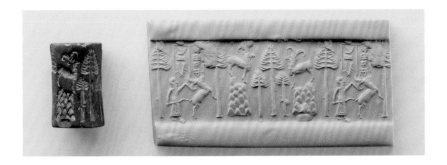

Cylinder Seal and Modern Impression: Hunting Scene

Mesopotamia, Late Akkadian period,
ca. 2200–2100 B.C.
Chert, H. 1⅛ in. (2.8 cm)
Bequest of W. Gedney Beatty, 1941 (41.160.192)

The scene on this cylinder seal is composed of two basic groupings that form an overall continuous design unified by the stylized landscape setting. In one group, two tall trees flank a hunter grasping the horn of an ibex. Above the hunter is a cuneiform inscription identifying the seal owner as Balu-ili, a court official, and his profession as cupbearer. In the other group, ibexes stand on mountains, facing each other and flanking three trees. This seal was made during the Akkadian period, when the iconography used by seal engravers expanded to include a variety of new mythological, thematic, and narrative subjects.

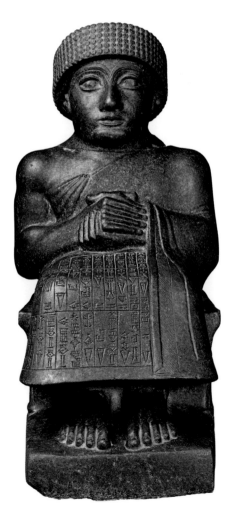

Statue of Gudea

Mesopotamia, probably from Girsu (modern Tello),
Neo-Sumerian period, ca. 2090 B.C.
Diorite, H. 17⅜ in. (44 cm)
Harris Brisbane Dick Fund, 1959 (59.2)

Gudea ruled the Sumerian city-state of Lagash, which encompassed the ancient city of Girsu, where this sculpture was probably found. The vertical columns of cuneiform inscribed on his robe state: LET THE LIFE OF GUDEA, WHO BUILT THE HOUSE, BE LONG. The statue was likely set up in a temple, where it was intended to represent the ruler in perpetuity, and its inscription would have served as a direct plea to the deities of Lagash. The serious expression on the face and the folded hands convey a feeling of piety and calm perfectly suited to the statue's function.

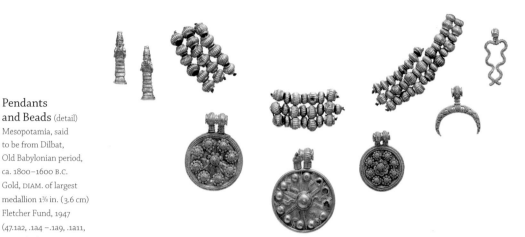

Pendants and Beads (detail)

Mesopotamia, said
to be from Dilbat,
Old Babylonian period,
ca. 1800–1600 B.C.
Gold, DIAM. of largest
medallion 1⅜ in. (3.6 cm)
Fletcher Fund, 1947
(47.1a2, .1a4 –.1a9, .1a11,
.1a12, 1b–i)

These ornaments are among the most important examples of ancient goldwork from Mesopotamia. Based on the range of styles, varied alloys of gold, and differing levels of craftsmanship, the assemblage should probably be seen as a hoard of individual elements rather than as a coherent necklace. Each pendant represents a deity or the symbol of a deity that could have provided protection from evil. It is possible that the gods or goddesses represented by the symbols on the pendants were believed to be present magically in the forms themselves.

Shaft-Hole Axe

Bactria-Margiana (Central Asia),
Bronze Age, ca. 2000 B.C.
Silver, gold foil, L. 5⅞ in. (15 cm)
Purchase, Harris Brisbane Dick Fund, and
James N. Spear and Schimmel Foundation Inc.
Gifts, 1982 (1982.5)

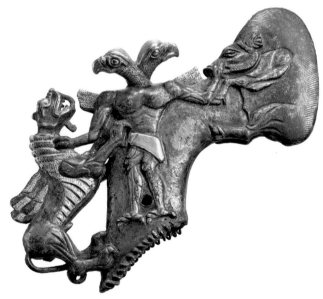

Expertly cast in silver and gilded with gold foil, this axe portrays a bird-headed demon struggling with a boar and a dragon. The boar's form is contorted so that its bristly back defines the blade (upper right); at the bottom a shaft hole held a wooden handle. The precious materials of this weapon indicate that it served a ceremonial rather than a practical function. A prosperous urban culture flourished in Bactria-Margiana during the late third and early second millennia B.C., supported in part by trade in both luxury and utilitarian commodities with civilizations such as Iran, Mesopotamia, and Anatolia.

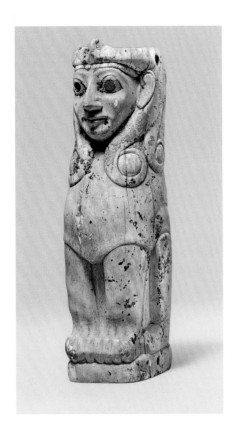

Furniture Support

Anatolia, probably from Acemhöyük,
Old Assyrian Trading Colony period,
ca. 1800–1700 B.C.
Ivory (hippopotamus), gold leaf, H. 5 in. (12.7 cm)
Gift of George D. Pratt, 1932 (32.161.46)

This ivory sphinx is one of four supports
for a small piece of furniture. The body of
the sphinx is leonine in form, and its spiral
locks derive from those of the Egyptian
goddess Hathor. The appearance of Egyptian
features and motifs in the arts of Anatolia is
evidence of cultural interaction in the early
second millennium B.C. These furniture
supports are thought to have come from one
of the merchant colonies in central Anatolia
established during this period by Assyrian
traders from northern Mesopotamia.

Vessel Terminating in the Forepart of a Stag

Central Anatolia, Hittite Empire period,
ca. 1400–1200 B.C.
Silver, gold inlay, H. 7 ⅛ in. (18 cm)
Gift of Norbert Schimmel Trust, 1989 (1989.281.10)

Drinking cups terminating in the forepart of
an animal are a very ancient form of vessel
in the Near East. This fully antlered stag is
beautifully rendered with a naturalism that is
characteristic of Hittite art. The body of the
vessel was hammered into shape from at least a
dozen separate silver sheets. Around the rim, a
band of repoussé work depicts figures in a ritual
or religious ceremony, probably celebrating a
successful hunt. Hittite inventories of objects
used in ritual practice include zoomorphic
vessels such as this one.

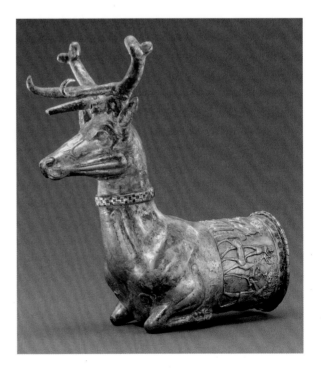

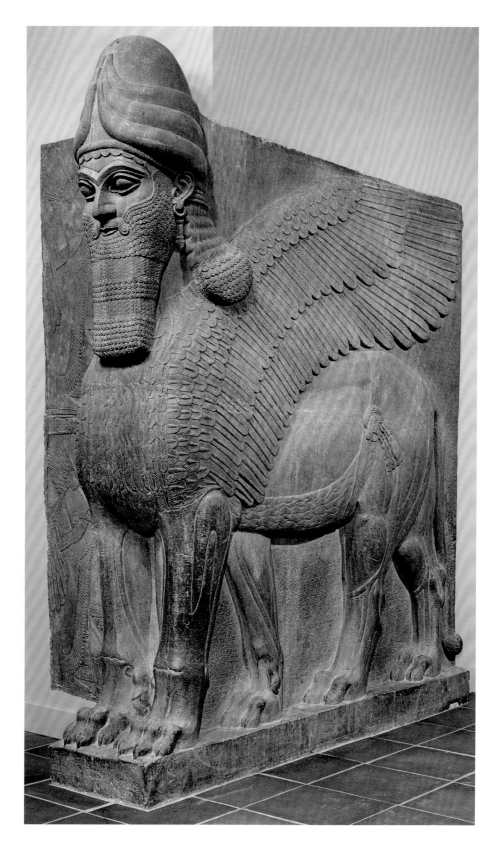

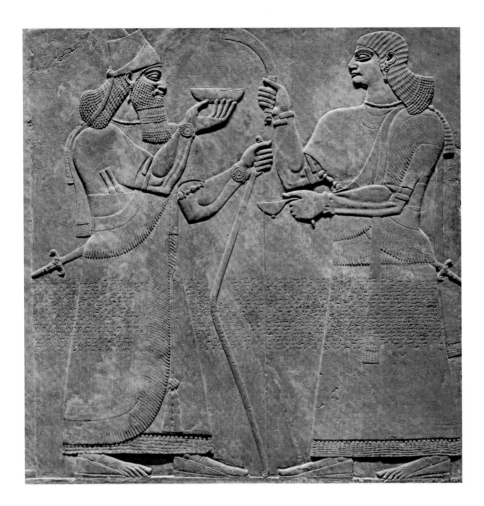

Human-Headed Winged Lion

Mesopotamia, excavated at Kalhu (modern Nimrud), Neo-
Assyrian period, reign of Ashurnasirpal II, ca. 883–859 B.C.
Gypsum alabaster, H. 10 ft. 2½ in. (3.1 m)
Gift of John D. Rockefeller Jr., 1932 (32.143.2)

This winged lion stood in Ashurnasirpal II's
palace at Nimrud, one of the enormous stone
statues of winged beasts set up at entrances and
doorways to protect the king from evil and to
impress all those who entered. Their heads are
crowned with the horned caps typical of deities
throughout the ancient Near East. This lion has
five legs so that from the front it appears to
stand firmly in place, but when viewed from the
side, it is striding forward. The lion thus seems
complete when seen from either angle, thereby
displaying its supernatural and protective
powers from both points of view.

Relief of Ashurnasirpal II

Mesopotamia, excavated at Kalhu (modern Nimrud), Neo-
Assyrian period, reign of Ashurnasirpal II, ca. 883–859 B.C.
Gypsum alabaster, H. 92¼ in. (234.3 cm)
Gift of John D. Rockefeller Jr., 1932 (32.143.4)

The palace rooms at Nimrud were decorated with
large stone slabs carved in low relief as well as
brightly painted walls and ceilings and sculptural
figures guarding the doorways. Here King
Ashurnasirpal II wears a conical cap with a small
peak as an indication of his office. He holds in his
left hand a bow to symbolize his authority and,
in his right hand, a ceremonial offering bowl. The
attendant facing the king clears the air around
him with a flywhisk and holds a ladle containing
replenishment for the royal bowl. The ritual
character of the scene is reflected in the dignified
composure of the figures.

Panel with Striding Lion

Mesopotamia, excavated at Babylon (modern Hillah),
Neo-Babylonian period, reign of Nebuchadnezzar II,
604–562 B.C.
Glazed brick, H. 38¼ in. (97.2 cm)
Fletcher Fund, 1931 (31.13.2)

When Nebuchadnezzar ordered the ancient city
of Babylon to be rebuilt in the middle of the
first millennium B.C., walls of temples, gates,
and palaces were covered with brilliantly colored
glazed-brick images of mythical, protective
beasts and animals sacred to the gods. This lion,
symbolizing the powers of the Mesopotamian
goddess Ishtar, was one of about one hundred
and twenty lions that lined the walls of the Pro-
cessional Way in Babylon. Their function was to
protect this sacred route, particularly during the
New Year's Festival when statues of Babylon's
gods were carried along the street through the
Ishtar Gate to the festival temple.

Figure of a Tribute Bearer

Mesopotamia, excavated at Kalhu (modern Nimrud),
Neo-Assyrian period, ca. 800–700 B.C.
Ivory, H. 5¼ in. (13.5 cm)
Rogers Fund, 1960 (60.145.11)

From the ninth to the seventh century B.C.,
Assyrians ruled Mesopotamia, Syria, the Levant,
and, for a brief period, even Egypt. All types of
tribute as well as skilled artisans were taken to
the Assyrian capitals from many parts of the
empire. This figure is shown bearing gifts from
his native land for the Assyrian king: a monkey,
an oryx (an African antelope), and the skin of
a leopard—all animals found in lands south of
Egypt. This piece, probably designed to decorate
royal furniture, exhibits traits of the Phoenician
style, such as the distinctly Egyptian flavor of
both pose and features.

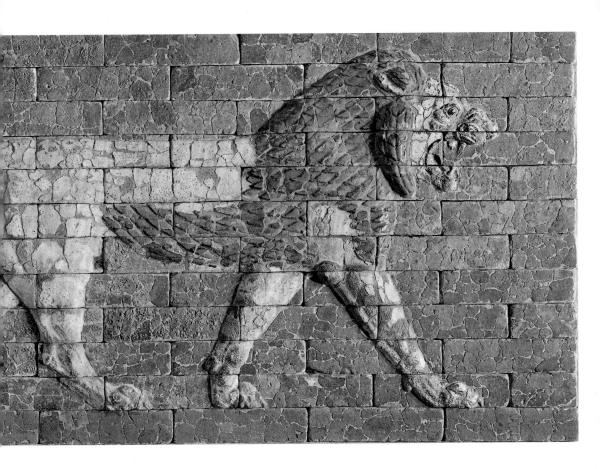

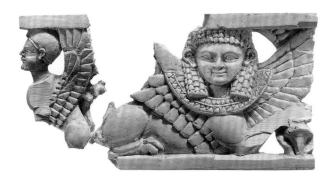

Openwork Plaque with Sphinxes

Syria, probably from Hadatu (modern Arslan Tash),
Neo-Assyrian period, ca. 900–700 B.C.
Ivory, gold foil, H. 2½ in. (6.4 cm)
Fletcher Fund, 1957 (57.80.4a, b)

This ivory plaque may have come from the Neo-
Assyrian building at the imperial outpost of
Arslan Tash in Syria. Although the subject of the
recumbent winged sphinx, here with wig, broad

collar, and lotus flower under the front paw,
is an Egyptian one, the facial type is Syrian in
style. In the Syrian style, single figures are often
shown in profile and juxtaposed in symmetrical
compositions for large pieces of furniture. This
is the case with the two sphinxes here, placed
back to back and forming parts of two separate
scenes. They perhaps flanked trees with coun-
terparts that are now missing.

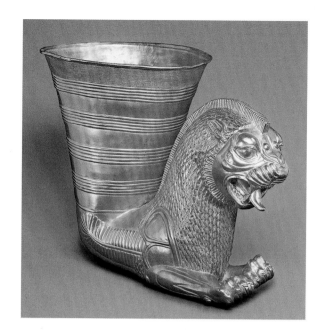

Vessel Terminating in the Forepart of a Leonine Creature

Iran, Achaemenid period,
ca. 600–500 B.C.
Gold, H. 6¾ in. (17 cm)
Fletcher Fund, 1954 (54.3.3)

In this masterpiece of Achaemenid goldwork, the forepart of a lion gracefully turns into a drinking cup. This type of vessel was probably royal and ceremonial in nature and belongs to a long history of drinking vessels made of precious metals. As is typical of Achaemenid style, the ferocity of the snarling lion has been tempered by decorative convention. To make this vessel, several parts were invisibly joined by brazing, demonstrating superb technical skill. One hundred and thirty-six feet of twisted wire decorate the upper band of the vessel in forty-four even rows, and the roof of the lion's mouth is raised in tiny ribs.

Beaker with Birds and Animals

Thrace, ca. 400–300 B.C.
Silver, H. 7⅜ in. (18.7 cm)
Rogers Fund, 1947 (47.100.88)

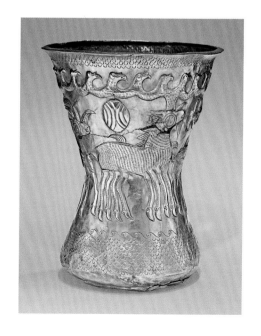

This silver beaker is a fine example of Thracian workmanship and was probably made in the region of present-day Romania or Bulgaria. The fantastic decorative manner in which the animals are represented and the animal horns ending in birds' heads are characteristics of the art of the nomadic peoples who during the first millennium B.C. spread across the steppes of southern Russia into Europe. Although certain contemporary Scythian and Iranian stylistic influences can be noted, the iconography of these scenes is clearly Thracian and probably refers to a native myth or legend.

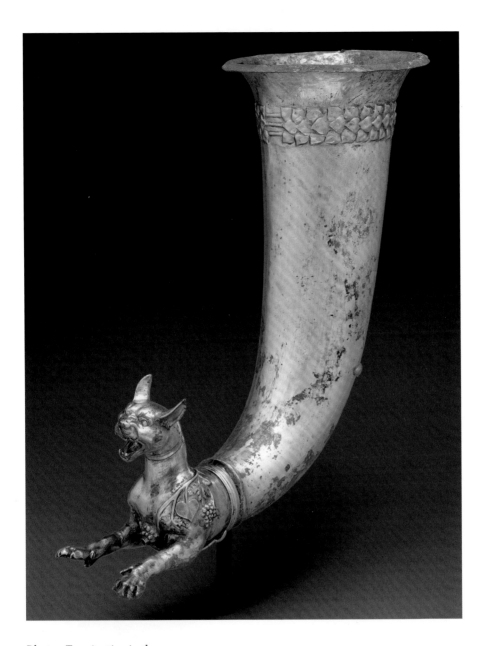

Rhyton Terminating in the Forepart of a Wild Cat

Iran, Parthian period, ca. 100 B.C.–A.D. 100
Silver, mercury gilding, H. 10⅞ in. (27.5 cm)
Purchase, Rogers Fund; Enid A. Haupt, Mrs. Donald
M. Oenslager, Mrs. Muriel Palitz, and Geert C. E. Prins
Gifts; Pauline V. Fullerton Bequest; and Bequests of
Mary Cushing Fosburgh, Edward C. Moore, and Stephen
Whitney Phoenix, by exchange, 1979 (1979.447)

Animal-head drinking vessels and rhytons—
vessels with a hole at the front from which liquid
flows—were highly valued in ancient Near

Eastern society. This rhyton ends in the forepart
of a wild cat, perhaps a panther, with a spout
for pouring in the middle of the chest, around
which is draped a garland of ivy and grapevines.
The panther, ivy, and grapevines with their fruit
are all symbols associated with Dionysus, the
Greek god of fertility and wine. In its imagery
and form, this rhyton brings together Near
Eastern and Greek elements and attests to the
wide range of cultural interaction and influences
during this period.

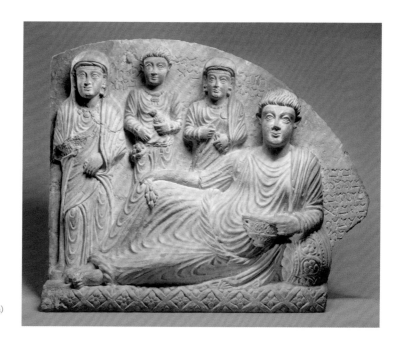

Gravestone

Syria, probably from Palmyra,
ca. A.D. 100–300
Limestone, H. 20¼ in. (51.4 cm)
Purchase, 1902 (02.29.1)

This sculpture in high relief depicting a banquet scene shows full-length figures of a man, his son, and two daughters. The stone probably sealed the opening of a family burial niche in Palmyra. By the mid-first century A.D., Palmyra—or "place of the palms"—was a wealthy and impressive city located along the caravan routes that linked the Parthian Near East with Roman-controlled Mediterranean ports. During the period of great prosperity that followed, the citizens of Palmyra adopted customs and modes of dress from both the Iranian Parthian world and the Graeco-Roman west, a blend that is also present in Palmyrene art.

Incense Burner

Southwestern Arabia, ca. 500 B.C.
Bronze, H. 10⅞ in. (27.6 cm)
Gift of Dr. Sidney A. Charlat, in memory of his parents,
Newman and Adele Charlat, 1949 (49.71.2)

From the middle of the first millennium B.C. until the sixth century A.D., the kingdoms of southwestern Arabia gained considerable wealth and power through their control of the trade in incense between Arabia and the lands of the Mediterranean seacoast. The importance of incense in the religion of the people of southwestern Arabia is reflected in this bronze incense burner. The ibex and snakes decorating it are powerful apotropaic symbols representing virility and fertility, and they were frequently associated with local gods. The disk-and-crescent symbol probably represents the moon god, the chief god of the pantheon.

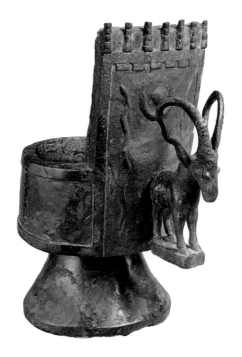

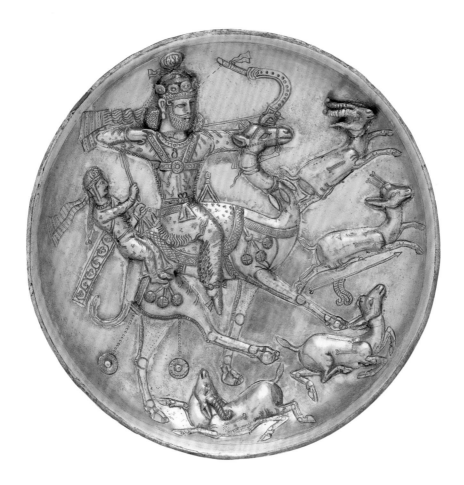

Plate with a Hunting Scene

Iran, Sasanian period, ca. A.D. 400–500
Silver, mercury gilding, DIAM. 7⅞ in. (20.1 cm)
Purchase, Lila Acheson Wallace Gift, 1994 (1994.402)

Beautifully executed in a complex and characteristic Sasanian technique, this plate illustrates a story that was later included in the great Iranian epic the *Shahnama*, or the Book of Kings, written in the eleventh century A.D. In the *Shahnama*, the Sasanian king Bahram Gur or Bahram V (r. 420–38) was challenged to feats of archery by his favorite musician, Azada. Shown here is Bahram Gur shooting an arrow that removed the horns of a male gazelle, transforming it to look like a female, and then shooting two arrows into the head of a female gazelle, making it appear to have horns like those of a male.

Egyptian Art

The core of the Metropolitan's collection of Egyptian art—among a handful of major holdings of its kind worldwide—was essentially formed during the first half of the twentieth century. Its main components are objects excavated by the Metropolitan at sites in Egypt and allocated to the Museum by the Egyptian antiquities authorities during their generous partitioning of finds. Over time, a number of important private collections and single pieces were also bequeathed to or acquired by the Museum. As a result, the collection is particularly rich in works having an archaeological context, such as the monumental statuary representing the female pharaoh Hatshepsut, and in exquisitely crafted objects, such as the unparalleled jewelry of the Middle Kingdom. The works range in date from about three hundred thousand years ago to A.D. 400. The chronological sweep of the collection allows visitors to follow the artistic achievements of one of the world's greatest cultures, from the time humans settled in the Nile Valley to the suspension of the pharaonic hieroglyphic script and the gradual abandonment of the old rites. The Egyptian galleries are beloved by Museum visitors because of the culture's vivid representation of natural forms and striking human figures, conveyed in an artistic language that is as immediate as it is consistent.

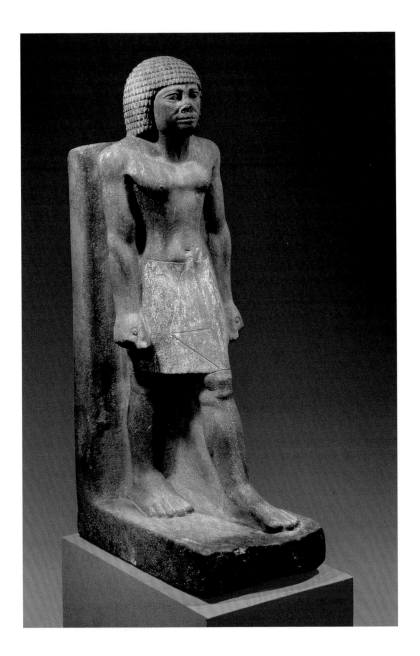

Statue of a Striding Man

El-Kab, Old Kingdom, Dynasty 4, ca. 2575–2465 B.C.
Quartzite, paint, H. 35¼ in. (89.5 cm)
Harris Brisbane Dick Fund, 1962 (62.200)

Created for an elite tomb in the south of Egypt, this vigorous male figure has the broad shoulders, narrow waist, and muscular limbs of a heavyweight athlete. The hands and feet are especially large, and the canonical striding pose is executed in an almost aggressive manner. The broad mouth under the thin moustache is set with determination, and the deep folds beside the nostrils give the face additional character, befitting a man of the pyramid age.

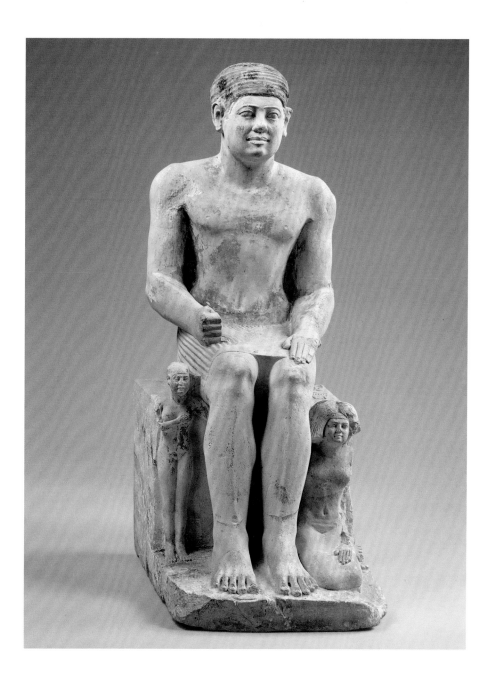

Statue Group of Nikare and
His Wife and Daughter

Probably Saqqara, Old Kingdom, Dynasty 5, probably
reign of Niuserre or after, ca. 2420–2389 B.C. or after
Limestone, paint, 22½ × 8⅞ × 12¾ in.
(57 × 22.5 × 32.5 cm)
Rogers Fund, 1952 (52.19)

The granary official Nikare was involved in a
crucial part of the economy during the reign of
Niuserre or after. Two of four statues preserved
from his tomb are in the Metropolitan Museum.
One (of granite) shows him as a scribe. The one
illustrated here depicts him as the proud head of his
family. His wife, Khuennub, squats beside his left
leg, and his young daughter, Khuennebti, stands
beside the other. The carving is notable for many
sensitively rendered anatomical details, and the
traces of original paint further enliven the image.

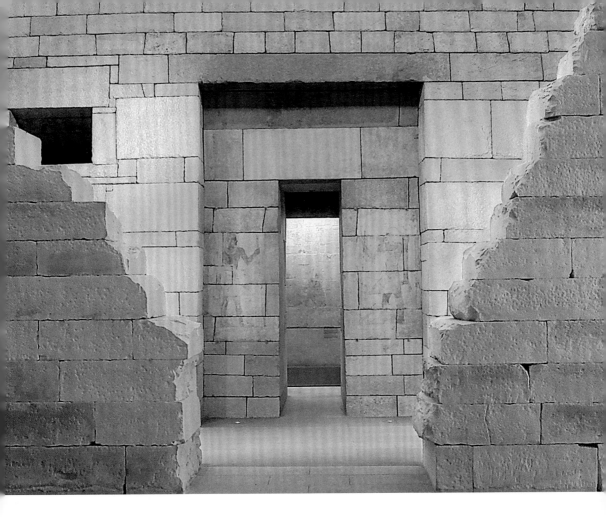

Tomb of Perneb

Saqqara, north of the Step Pyramid,
Old Kingdom, Dynasty 5, reign of Isesi or Unis,
ca. 2381–2323 B.C.
Limestone, paint, H. 15 ft. 9¾ in. (4.82 m)
Gift of Edward S. Harkness, 1913 (13.183.3)

Perneb was a court official who presided at
the robing and crowning of the king. His tomb
superstructure comprised a painted offering
chamber that was reached from a courtyard
through a vestibule. Inside the chamber a
stylized niched doorway (the so-called false
door) provided a place of symbolic contact with
the dead. Not only the decorated offering room
itself but also the courtyard and a secondary
suite of rooms for Perneb's statues are in the
Metropolitan, forming a tomb complex whose
completeness is unique in museum collections.

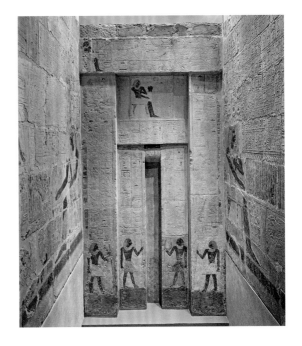

Boat Model

Thebes, Southern Asasif, Tomb of Meketre,
Middle Kingdom, Dynasty 12, early reign of
Amenemhat I, ca. 1981–1975 B.C.
Wood, gesso, paint, linen twine, linen fabric,
H. 14⅝ in. (37 cm), W. with oars 12 in. (30.5 cm),
L. with rudder 68⅞ in. (175 cm)
Rogers Fund and Edward S. Harkness Gift,
1920 (20.3.1)

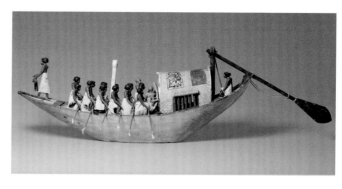

This ancient model, dating to the early reign of Amenemhat I, represents a Nile riverboat under oars on its voyage downstream. Sailing was possible only upstream under the prevailing north wind. Downstream the mast (missing here) would have been removed from its stepping and laid horizontally into the white crotch. The single, long rudder oar is handled by a steersman, and at the prow another man is ready to measure the depth of the ever-shifting river channel. The captain stands before Amenemhat's chief steward, Meketre, who sits in front of his cabin listening to a blind harpist and a singer.

Stela of Mentuwoser

Abydos, Middle Kingdom, Dynasty 12, ca. 1945 B.C.
Limestone, paint, 41⅛ × 18⅞ in. (104.3 × 47.9 cm)
Gift of Edward S. Harkness, 1912 (12.184)

Middle Kingdom Egyptians set up stelae at Abydos so they could participate eternally by proxy in the annual festival celebrating the death and resurrection of Osiris (god of the afterlife). One of the finest extant, this stela was dedicated by the Steward Mentuwoser, who is depicted at an offering table with his father, son, and daughter attending. The text dates the commission to the seventeenth year of the reign of Senwosret I and praises Mentuwoser's administrative services as well as his integrity, success in life, and good deeds to the poor.

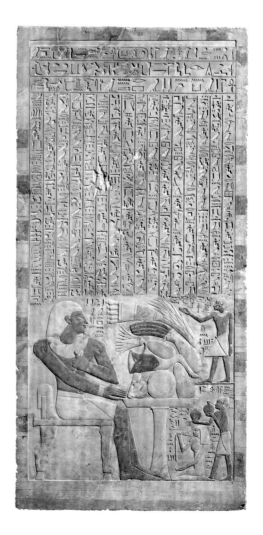

Female Offering Bearer

Thebes, Southern Asasif, Tomb of Meketre,
Middle Kingdom, Dynasty 12, early reign of
Amenemhat I, ca. 1981–1975 B.C.
Wood, gesso, paint, 44⅛ × 6½ × 18¼ in.
(112 × 16.5 cm × 46.5 cm)
Rogers Fund and Edward S. Harkness Gift,
1920 (20.3.7)

In Old Kingdom reliefs, women carrying
food offerings were labeled with the names
of estates destined to provide for the funeral
services in a particular tomb. This unnamed
statue of a richly adorned woman carrying
a basket of food on her head and a duck in
her right hand was created—together with a
companion piece now in Cairo—for the tomb
of the royal chief steward Meketre. Judging
by her jewelry and feather dress, the woman
is not just a servant but also a quasi-divine
female whose role blends with that of the
goddesses Isis and Nephthys, caretakers of
the dead.

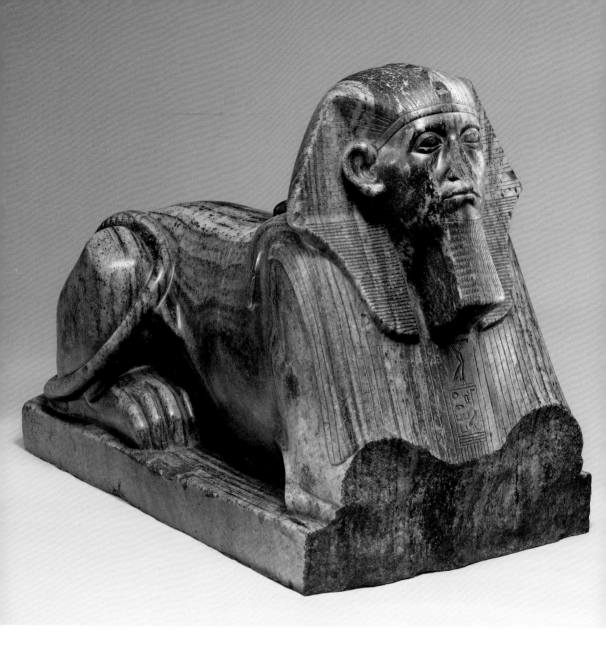

Sphinx of Senwosret III

Thebes, Karnak, Middle Kingdom, Dynasty 12,
ca. 1878–1840 B.C.
Gneiss, 16¾ × 11½ × L. 28¾ in. (42.5 × 29.3 × 73 cm)
Gift of Edward S. Harkness, 1917 (17.9.2)

The Egyptian sphinx combines a lion's body and a human head, often—as here—with a bull's tail. It represented royal power in its most formidable form and was thus frequently employed to protect the entrances to palaces and temples. This sphinx is unique in the use the sculptor made of the stone's veining to emphasize the feline body. The head is a fearsome image of the face of Pharaoh Senwosret III. Below the ceremonial beard, a palace facade (*serekh*) is incised with both the king's so-called Horus name (DIVINE OF FORMS) and throne name (SHINING ARE THE LIFE FORCES [*kas*] OF RE).

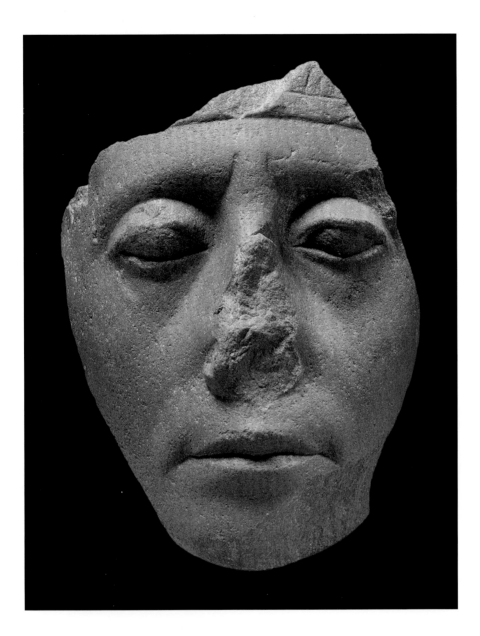

Face of Senwosret III

Middle Kingdom, Dynasty 12, ca. 1878–1840 B.C.
Red quartzite, H. 6½ in. (16.5 cm)
Purchase, Edward S. Harkness Gift, 1926 (26.7.1394)

This face from a statue of Senwosret III presents a strikingly different view of the same ruler depicted in a sphinx bearing his name (facing page). The sphinx's fleshy face looks worn, yet this visage appears fresh and animated. The almond-shaped eyes of the sphinx are small and menacing, whereas those of this face gaze downward, creating an introverted expression that is further enhanced by the deep furrows above the nose. Finally, the drooping corners of the sphinx's mouth convey an embittered outlook, in contrast to the quartzite face's benign receptiveness.

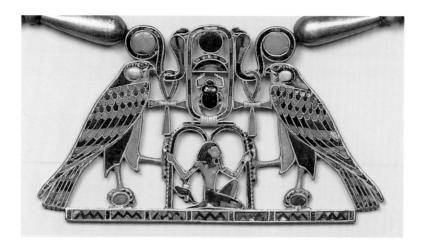

Pectoral of Princess Sithathoryunet
Lahun, Tomb of Sithathoryunet, Middle Kingdom, Dynasty 12, reign of Senwosret II, ca. 1887–1878 B.C.
Gold, carnelian, feldspar, garnet, turquoise, lapis lazuli, L. of necklace 32¼ in. (82 cm), pectoral 1¾ × 3¼ in. (4.5 × 8.2 cm)
Purchase, Rogers Fund and Henry Walters Gift, 1916 (16.1.3)

Egyptian jewelry making reached its peak during the Middle Kingdom, and this pectoral from the reign of Senwosret II is one of the finest achievements of the period. Three hundred seventy-five semiprecious stone inlays in gold cloisonné are combined in a multicolored heraldic composition framed by two solar falcons holding *shen* (dominion) signs. Between the falcons and two *ankh* (life) hieroglyphs, which hang from the tails of the cobras on the falcons' heads, appears the name of Senwosret II. Directly below is the figure of the god of infinity, Heh, who holds palm ribs (hieroglyph for "years") while a tadpole (hieroglyph for "a hundred thousand") hangs from a string over his elbow.

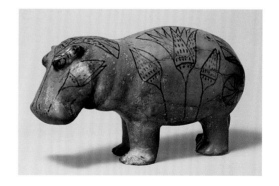

Hippopotamus Figure
Meir, Tomb of Senbi, early Middle Kingdom, early Dynasty 12, ca. 1981–1885 B.C.
Faience, 4⅜ × 7⅞ in. (11.2 × 20 cm)
Gift of Edward S. Harkness, 1917 (17.9.1)

Although a hippopotamus herd could destroy a farmer's fields just by walking through them, the ancient Egyptians revered these animals as beneficial creatures of the muddy water from which all life was derived. The dual qualities of destruction and creation imbued images of hippos with special magical power, and they were often deposited in tombs. The Museum's hippopotamus figure was nicknamed William by a family of visitors who recounted in the humor magazine *Punch* that they kept a reproduction at home, avowing that the animal's facial features indicated approval or rejection of family decisions.

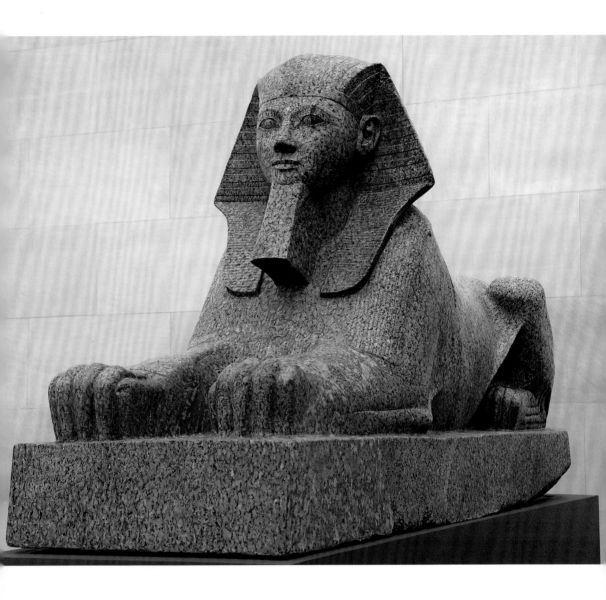

Sphinx of Hatshepsut

Thebes, Deir el-Bahri, Senenmut Quarry,
New Kingdom, Dynasty 18, joint reign of Hatshepsut
and Thutmose III, ca. 1473–1458 B.C.
Granite, paint, H. 64½ in. (164 cm),
L. 11 ft. 3⅛ in. (3.43 m)
Rogers Fund, 1931 (31.3.166)

This majestic sphinx was created during the joint reign of Hatshepsut and her stepson, Thutmose III. After the death of the female pharaoh in 1458 B.C., Thutmose III had the work smashed and dumped in a quarry together with Hatshepsut's other sculptures from the Deir el-Bahri temple. In the 1920s, Metropolitan Museum excavators recovered the fragmented works and reassembled them. Four of the six granite sphinxes in the find are of different sizes and must have stood singly in the temple courtyards. This beast, which weighs 14,900 pounds (6,758.6 kg), appears to have belonged to a pair that presumably flanked an entrance. Remains of its companion piece are in Cairo.

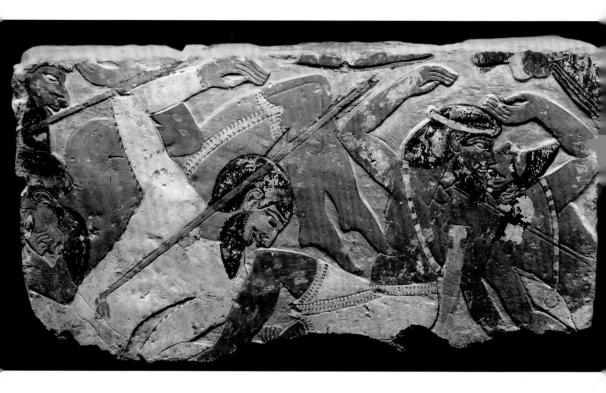

Battle Scene

Thebes, Asasif, Temple of Ramses IV foundation
(reused), New Kingdom, Dynasty 18, possibly reign
of Amenhotep II, ca. 1427–1400 B.C.
Painted sandstone, 10⅝ × 48⅝ × 32¼ in.
(27 × 123.5 × 82 cm)
Rogers Fund and Edward S. Harkness Gift,
1913 (13.180.21)

Reliefs on the walls of New Kingdom temples
often feature large-scale battle scenes. This
block from such a relief was later incorporated
into the foundations of another temple, where
it was discovered, still retaining its original
paint, by Metropolitan Museum excavators.
A number of yellow- and red-skinned western

Asian warriors—wounded by arrows—have
fallen under the horses of the pharaoh's chariot.
The belly of one of the horses is just visible at
the upper edge of the block. After the demise of
Hatshepsut, Thutmose III (r. ca. 1458–1425 B.C.)
conducted numerous military campaigns in the
Levant and western Asia, at some point reaching
even the Euphrates. The wars continued under
his son Amenhotep II (r. ca. 1427–1400 B.C.). It is
possible, however, that the large scene to which
this relief once belonged did not depict a specific
battle but rather represented the pharaoh in
his perennial role as defender of order against
chaos. Stylistically, the relief fits best into the
time of Amenhotep II.

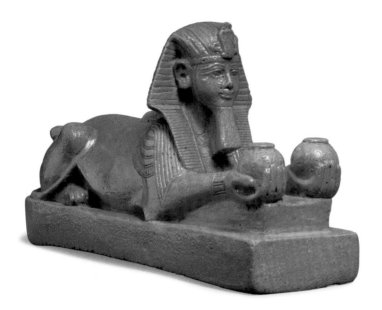

Sphinx of Amenhotep III

New Kingdom, Dynasty 18, ca. 1390–1352 B.C.
Faience, 5¼ × 5¼ × L. 9⅞ in. (13.3 × 13.3 × 25.1 cm)
Purchase, Lila Acheson Wallace Gift, 1972 (1972.125)

This small sphinx of brilliant blue faience is inscribed with the name of King Amenhotep III and shows the characteristic stylized facial features familiar from many images of that ruler. The variant of a sphinx with human hands holding offering vessels existed as early as the Old Kingdom; numerous New Kingdom representations show a king offering some type of small figure that is in turn depicted in an offering pose.

Gazelle

New Kingdom, Dynasty 18, reign of Amenhotep III, ca. 1390–1352 B.C.
Ivory (elephant), wood, blue-pigment inlay, 4½ × 3⅞ in. (11.5 × 10 cm)
Purchase, Edward S. Harkness Gift, 1926 (26.7.1292)

The young gazelle, also from the reign of Amenhotep III, sets its tiny hoofs daintily on the uneven ground of the Egyptian steppe. Spare vegetation is indicated by feathery plant forms incised on the base of the figure and filled in with blue pigment. The gazelle's head sits alertly on a swanlike neck, and the animal's large, velvety brown eyes look with wonder at the world. The ears have broken off and the horns, originally made of another material, are missing.

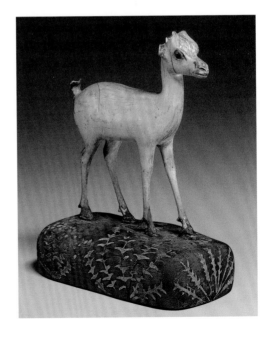

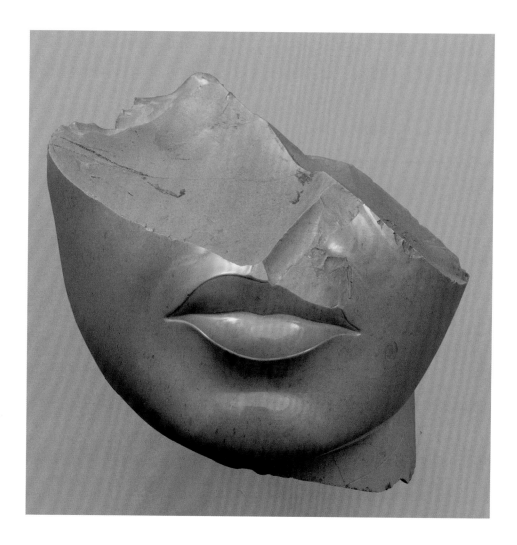

Fragment from the Head of a Queen

Amarna (?), New Kingdom, Dynasty 18, reign of
Akhenaten, ca. 1352–1336 B.C.
Yellow jasper, 5⅛ × 4⅞ × 4⅞ in. (13 × 12.5 cm × 12.5 cm)
Purchase, Edward S. Harkness Gift, 1926 (26.7.1396)

Ever since this sensually alive fragment first
became known through a 1922 exhibition, people
have wondered whom it represents—Queen
Tiye, wife of Amenhotep III; Nefertiti, principal
queen of Akhenaten; or Kiya, his second con-
sort—and the question is still unresolved.
Composite statues proliferated during the reign
of Akhenaten, from which this piece dates. Their
flesh parts were usually made of a reddish or yellow
stone. The garments and accoutrements were made
of other materials, chosen in order to create a stun-
ning visual impact. Occurring naturally in the
mountainous area between the Egyptian Nile Valley
and the Red Sea, red, yellow, or green jasper is as
hard as flint, to which the stone is closely related.
Hand burnishing produced a matte sheen on the
surfaces of pieces sculpted from the red variety, and
on this face of yellow jasper, the tour-de-force
mirrorlike gloss is entirely due to "elbow grease."

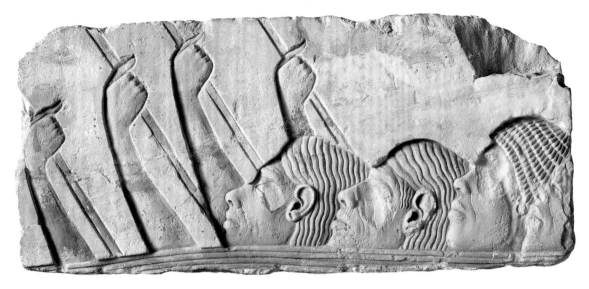

Foreigners

Amarna, later Hermopolis, New Kingdom,
Dynasty 18, ca. reign of Akhenaten, 1352–1336 B.C.
Limestone, paint, 9½ × 21 in. (24.1 × 53.5 cm)
Gift of Norbert Schimmel, 1985 (1985.328.13)

Surviving from Amarna and reused at
Hermopolis is a relief fragment showing the
heads of four foreigners: two Nubians on the
right and possibly two Libyans on the left.

Whether the raised arms and hands holding
poles (perhaps for sunshades) belong to the same
individuals is not clear. Undulating lines at the
bottom of the block may represent the reins of
horses, indicating that the men are accompanying
a king and queen on a chariot ride. During
Akhenaten's reign foreigners served both in the
Egyptian army and as royal bodyguards.

Canopic Jar and Lid

Thebes, Valley of the Kings, Tomb KV 55, New Kingdom,
Dynasty 18, reign of Akhenaten, ca. 1352–1336 B.C.
Egyptian alabaster, blue glass, obsidian, unidentified
stone, H. of lid 7⅛ in. (18.2 cm), DIAM. 6⅜ in. (16.3 cm),
H. of jar 20½ in. (52.1 cm)
Gift of Theodore M. Davis, 1907 (07.226.1); Theodore M.
Davis Collection, Bequest of Theodore M. Davis, 1915
(30.8.54)

This magnificent organ receptacle was
found—together with three companion pieces
now in Cairo—in Tomb 55 in the Valley of
the Kings among a puzzling assemblage of
funerary objects originally made for members
of Akhenaten's family. Scholars have deciphered
the erased name on the four jars as that of
Queen Kiya, Akhenaten's secondary wife. The
lids sit somewhat awkwardly on the four jars,
however, leaving open the possibility that
the combined parts did not originally belong
together.

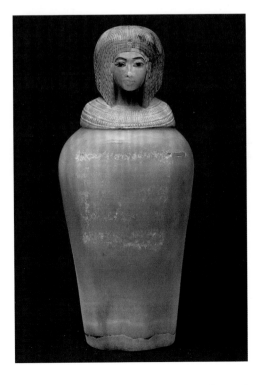

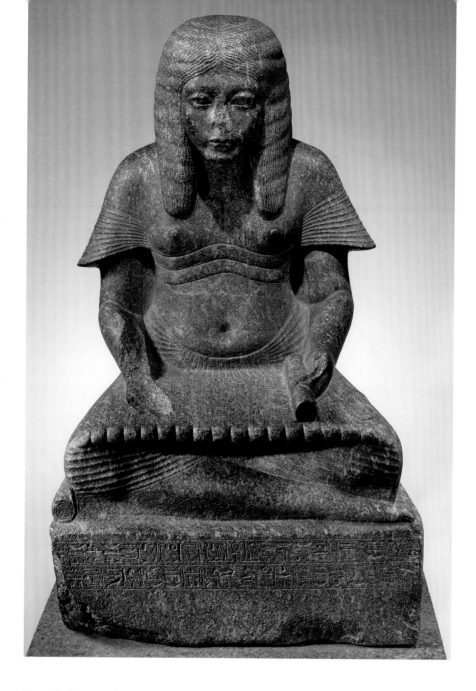

Haremhab as a Scribe

Presumably Memphis, Ptah Temple, Dynasty 18, reign
of Aya or Tutankhamun, ca. 1336–1295 B.C.
Granodiorite, 44½ × 27⅞ × 21⅞ in. (113 × 71 × 55.5 cm)
Gift of Mr. and Mrs. V. Everit Macy, 1923 (23.10.1)

Before he became pharaoh himself, Haremhab
was chief of the army and deputy of the king
under the pharaohs Aya and Tutankhamun.
This statue, commissioned during Haremhab's

generalship, represents him as a scribe and
administrator. Although his right hand is now
missing, it is easy to see that Haremhab is
writing on the papyrus in his lap. The text is a
hymn to Thoth, the god of writing and wisdom.
It praises the god as conscientious vizier under
the sun god Re and implies that Haremhab's
service to the king is like that which Thoth
renders to Re.

Head of Tutankhamun and a Hand of Amun

New Kingdom, Dynasty 18, ca. 1336–1327 B.C.
Limestone (indurated), H. 5⅞ in. (15 cm), D. 9 in. (23 cm)
Rogers Fund, 1950 (50.6)

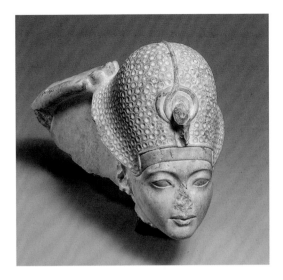

Preserved at the back of this head, representing Tutankhamun, is the hand of the god Amun, indicating that the complete statue group originally depicted the deity seated behind the smaller standing figure of the pharaoh. Prior to the reign of Tutankhamun, Egypt had gone through great religious upheaval under Akhenaten, who promoted a single deity, the light god Aten. Tutankhamun restored the traditional worship of a multitude of gods and the supremacy of the god Amun, as illustrated by this sculpture.

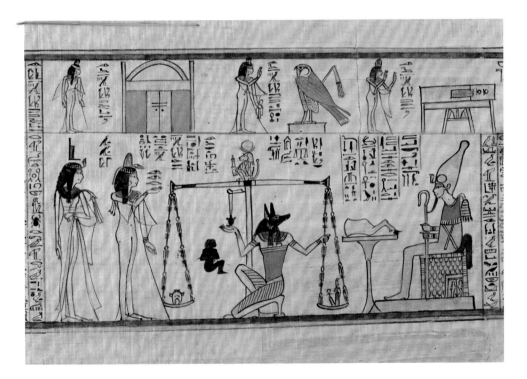

Book of the Dead of Nany (detail)

Thebes, Deir el-Bahri, Tomb of Meritamun, Third Intermediate Period, Dynasty 21, ca. 1050 B.C.
Papyrus, paint, 13¾ in. × 17 ft. 2¼ in. (35 cm × 5.24 m)
Rogers Fund, 1930 (30.3.31)

In this vignette from her Book of the Dead papyrus, Nany, the ritual singer of Amun and daughter of a king—either a self-styled Theban high priest or the king at Tanis in the Nile Delta—stands beside a large scale on which her heart is being weighed against a figure of Maat (goddess of justice and truth). Nany is accompanied by Isis on the left. Anubis, the jackal-headed god of embalming, adjusts the scales and Osiris, the god of the underworld, presides. At issue are Nany's deeds on earth. The outcome is favorable: Anubis announces and Osiris affirms that "her heart is righteous."

Coffin of Henettawy

Thebes, Deir el-Bahri, Tomb of
Henettawy, Third Intermediate Period,
Dynasty 21, ca. 1010–945 B.C.
Wood, gesso, paint, varnish, L. 79⅞ in. (203 cm)
Rogers Fund, 1925 (25.3.182a, b)

A ritual singer of Amun-Re, Henettawy
died in her early twenties and was buried
in a previously used, unadorned crypt. The
brightly colored paintings on her set of
coffins, however, more than compensated for
the absence of wall decorations. The imagery
on this splendid outermost coffin evokes a
mummy wrapped in white linen and adorned
with a funerary mask and amuletic jewelry.
On the sides and lower body, yellow (gold)
bands with hieroglyphs surround miniature
scenes with figures of Henettawy adoring the
god Osiris and protective deities below. On
the foot end, the goddesses Isis and Nephthys
display gestures of mourning. Their figures
are portrayed seemingly upside down so
that they can be viewed from the mask on
Henettawy's head.

Statuette of the God Amun

Possibly Thebes, Karnak, Third Intermediate Period,
Dynasty 22, ca. 945–712 B.C.
Gold, 6⅞ × 1⅞ × 2¼ in. (17.5 × 4.7 × 5.8 cm)
Purchase, Edward S. Harkness Gift, 1926 (26.7.1412)

Amun is represented here carrying a sickle
sword as guarantor of victory in battle. This
solid gold piece, weighing almost two pounds
(.9 kg), was probably used in actual temple
rituals. Fitted at the back of the crown with a
now-broken loop but much too heavy to have
been a piece of jewelry, it may have hung from
a ritual boat-shaped shrine or been worn on a
cord by a priest during processions. The loop
could also be a feature connected with real or
imagined bygone customs. Also on the crown
were two now-broken feathers, which completed
the insignia characteristic of this deity.

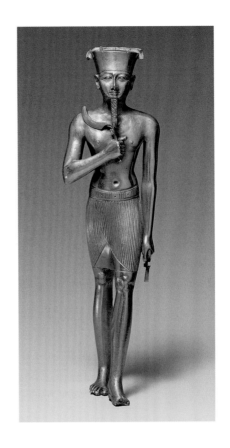

Chalice

Tuna el-Gebel region, Third Intermediate Period,
Dynasty 22, ca. 945–712 B.C
Faience, H. 5¾ in. (14.5 cm)
Purchase, Edward S. Harkness Gift, 1926 (26.7.971)

Stemmed faience cups with bowls in the form of
a blue lotus blossom existed as early as Dynasty
18 (ca. 1550–1295 B.C.). By the beginning of the
first millennium B.C., they had developed into
richly ornamented chalices that were not used
for ordinary drinking but instead served as
votive objects and ritual vessels. The reliefs on
this example evoke myths relating to the birth
of the king as child of the sun god. The watery
marsh environment in the central register
alludes to the renewal of the Egyptian world
after the flooding of the Nile each midsummer.

Torso

Late Period, 4th century B.C.
Meta-graywacke, 24½ × 12⅞ × 10⅝ in.
(62.2 × 32.8 × 27 cm)
Purchase, Lila Acheson Wallace Gift, Gift of Henry Walters,
by exchange, Asher B. Edelman Gift, Judith and Russell
Carson Gift, Ernest L. Folk III Bequest, Ludlow Bull Fund,
and funds from various donors, 1996 (1996.91)

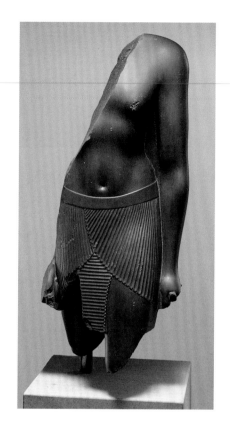

The name of the person this torso represents
has broken off the back pillar of the statue, but
the remaining inscription records his rank as
general and lists the offices he performed at
Busiris, a city in the Nile Delta, and at Abydos,
the southern Egyptian center of the cult of the
god Osiris. The sensitive sculpting of the arm
and chest, with its emphasis on the fleshy parts
of the human body, foreshadows the style of
the Ptolemaic era. Although this masterpiece
is roughly contemporary with late classical
Greek art and Egyptian sculptors conceivably
knew some Greek works, it adheres entirely
to Egyptian traditions that were extensively
revitalized during Dynasty 30 (380–343 B.C.).

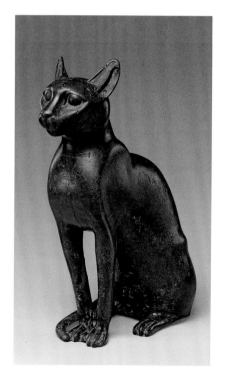

Cat

Macedonian and Ptolemaic periods, 332–30 B.C.
Bronze, leaded, H. 10¾ in. (27.4 cm)
Harris Brisbane Dick Fund, 1956 (56.16.1)

During Egypt's Middle Kingdom, cats were most
often represented as hunters in the wild. They
did not appear as household companions until
the New Kingdom. During the Late Period and
after, it became the custom to bury mummified
cats within temple precincts, especially the ones
dedicated to the goddess Bastet. This container
for a cat mummy demonstrates the luxurious
quality of these gifts to the gods. A master
metalworker created a captivating image of the
feline with sleek muscles, long graceful legs,
and an alert gaze. The now-missing gold ring
in the pierced ear and the incised necklace with
a protective-eye pendant further enhanced the
animal's sacred status.

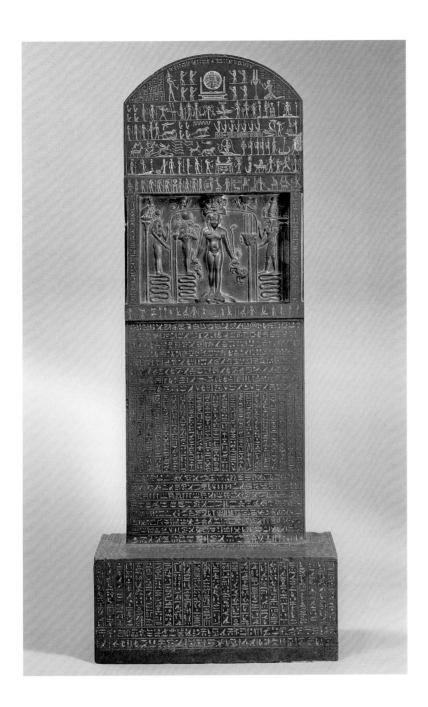

Magical Stela

Alexandria, Late Period, Dynasty 30,
reign of Nectanebo II, 360–343 B.C.
Meta-graywacke, H. overall 32⅞ in. (83.5 cm)
Fletcher Fund, 1950 (50.85)

This stela was originally commissioned during the reign of Nectanebo II by the priest Esatum for the temple of Mnevis (bull deity) at Heliopolis, near present-day Cairo. It is a wonder of delicate carving in hard stone. The deeply incised frontal image shows the young Horus subduing dangerous animals such as crocodiles and scorpions. A text on the base tells the story of how Horus was stung by a scorpion and then healed. The healing spells and protective figures that cover the entire surface held great psychological power for the ancient Egyptians.

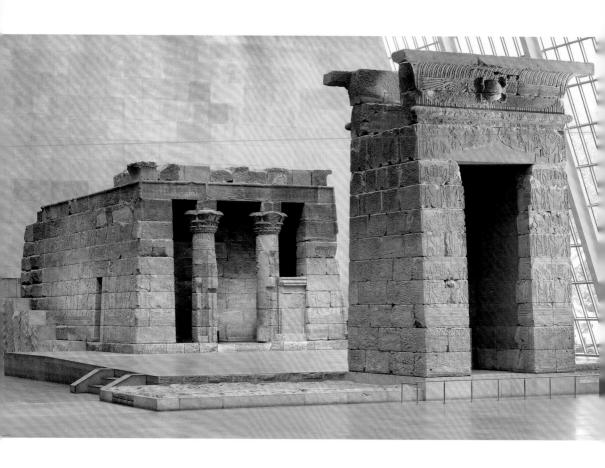

Temple of Dendur in The Sackler Wing

Lower Nubia, Dendur, Roman period, ca. 15 B.C.
Aeolian sandstone, L. 82 ft. (25 m) from gate
to rear of temple
Given to the United States by Egypt in 1965, awarded
to The Metropolitan Museum of Art in 1967, and installed
in The Sackler Wing in 1978 (68.154)

The temple of Dendur was a gift from Egypt to the
United States in recognition of the country's help
in safeguarding the monuments of Nubia. Had
it not been dismantled, the temple would have
been submerged by the Nile behind the Aswan
High Dam. Although small in comparison with its
imposing siblings in Egypt, Dendur possesses all
the essential components of a temple: a gateway,
a pronaos (portico), an offering chamber, and a
sanctuary. The columns feature plant capitals, and
reliefs on the walls show the pharaoh offering gifts
to the gods. At right, the Roman emperor Augustus
presents wine to the god Thoth of Pnubs.

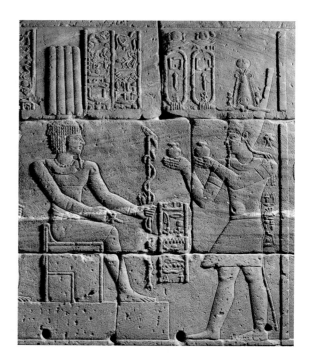

Head of Arsinoe II

Abu Rawash, Wadi Qaren, Ptolemaic period, 278–270 B.C.
Limestone (hardened), 4⅝ × 3½ × 3¼ in.
(11.8 × 8.7 × 8.4 cm)
Gift of Abby Aldrich Rockefeller, 1938 (38.10)

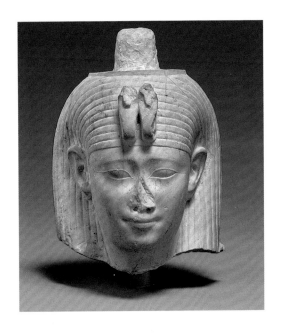

This head from a half-lifesize statue has been
recognized as an image of Arsinoe II, the sister
and wife of King Ptolemy II (284–246 B.C.), based
on close similarities between this work and an
inscribed statue in the Vatican. It may, however,
date to later than the eight-year period when
she held the title of queen of Egypt because the
position and probable form of the crown that
was once attached over the stone protrusion on
top of her head identify the statue as an image
of the deified—and thus deceased—Arsinoe in
the guise of the goddess Isis-Hathor. The purely
Egyptian style testifies to the Macedonian-
Greek Ptolemies' efforts to present themselves
as the true inheritors of the pharaohs.

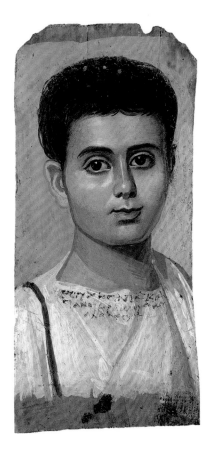

Mummy Portrait of Eutyches

Roman period, A.D. 100–150
Encaustic on wood, paint, 14⅞ × 7½ in. (38 × 19 cm)
Gift of Edward S. Harkness, 1918 (18.9.2)

After centuries of foreign rule and the
widespread settlement of foreigners in the
country, Egyptian society was by the second
century A.D. truly multicultural. This image
of a well-groomed boy with trusting, sad
eyes is inscribed EUTYCHES FREEDMAN OF
KASANIOS; SON OF HERAKLEIDES, EVANDROS (or
HERAKLEIDES, SON OF EVANDROS) I SIGNED. The
boy apparently died young, having been freed
from slavery by Kasanios. One of the two other
persons named may have ordered or paid for the
portrait. Created in the Greek painting tradition,
it was inserted into the wrappings of the boy's
Egyptian-style mummy in order to cover his
head, as masks had done for millennia in Egypt.

Greek and Roman Art

Comprising more than seventeen thousand works dating from about 4500 B.C. to A.D. 330, the Greek and Roman collections present the artistic diversity and achievements of the classical world. The many cultures included extend beyond Greece and Italy: at the height of the Roman Empire, the geographic range stretched from Britain and Spain to Asia Minor, Syria, and northern Africa. The department also exhibits the pre-Greek art of Greece and the pre-Roman art of Italy, notably of the Etruscans, as well as the Cesnola Collection of antiquities from Cyprus, the foundation of our archaeological holdings. The Museum's support of Princeton University's excavation at Sardis in Turkey before 1914 brought further substantial additions. The highlights in this guide are arranged chronologically, tracing the rise and flowering of Greece, the age of Alexander the Great and his successors, and the triumph of imperial Rome. About seventy-five hundred works are on display at any one time, ranging from small, engraved gemstones and coinage (in collaboration with the American Numismatic Society) to monumental statues, and reflecting virtually all of the materials in which ancient artists worked, including marble, terracotta, bronze, ivory, amber, and wood. Areas of particular strength include Cypriot sculpture, painted Greek vases, Roman marble and bronze portraits, and Roman wall paintings. The glass, gold, and silver pieces rank among the world's finest, and the archaic Attic sculpture is second only to that in Athens.

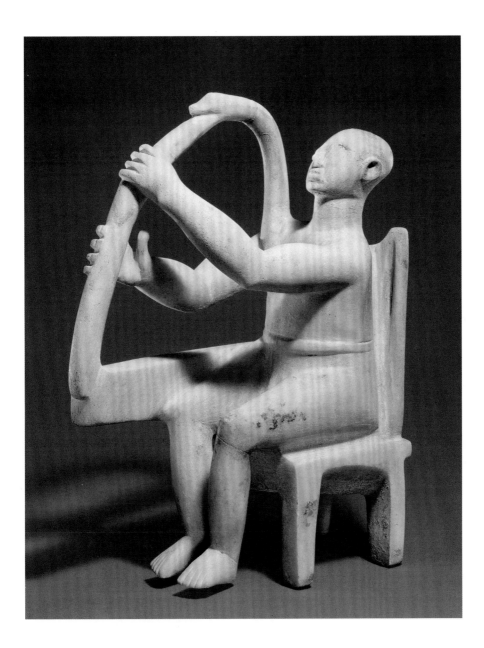

Seated Harp Player

Cycladic, late Early Cycladic I–Early Cycladic II period,
ca. 2800–2700 B.C.
Marble, H. 11½ in. (29.2 cm)
Rogers Fund, 1947 (47.100.1)

This work is one of the earliest of the few known representations of musicians in art of the Early Bronze Age from the Cycladic islands. Such harp players likely represent significant members of their communities, serving as human repositories and communicators of their people's history, mythology, and music in a time before writing. They can be seen as early predecessors to the professional performers of the heroic Mycenaean Age alluded to in Homer's epic poems, such as the *Odyssey*, and in the subsequent rich tradition of oral poetry in ancient Greece.

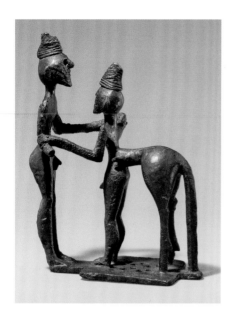

Man and Centaur

Greek, mid-8th century B.C.
Bronze, H. 4⅜ in. (11.1 cm)
Gift of J. Pierpont Morgan, 1917 (17.190.2072)

Half man, half horse, the mythical centaur
was thought to inhabit remote wooded areas.
In much of Greek art, centaurs appear in
combat with humans and, by implication,
were the antithesis of civilized men. The
classic rendering of this subject can be seen in
the metopes of the Parthenon in Athens. It is
also fully represented in this bronze statuette.
The outcome of the conflict is indicated by the
end of the spear visible in the centaur's left
flank and by the greater height of the man.

Kernos

Cycladic, Early Cycladic III–Middle
Cycladic I period, ca. 2300–1900 B.C.
Terracotta, H. 10⅝ in. (27 cm)
Purchase, The Annenberg Foundation Gift,
2004 (2004.363.1)

Made before the introduction of the potter's
wheel, the *kernos* (vase for multiple offerings),
with its twenty-five containers around a central
bowl, exemplifies virtuoso potting and firing.
Although *kernoi* were widely used during the
prehistoric period, particularly impressive
examples have appeared in the Cyclades. This
one, which probably contained offerings of
seeds, grain, flowers, fruit, or liquids, is among
the greatest preserved. It is distinguished also
by its early date of discovery—1829—before
prehistoric Greek art had been systematically
excavated.

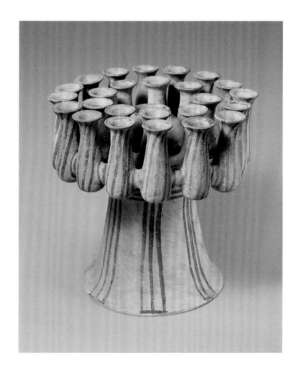

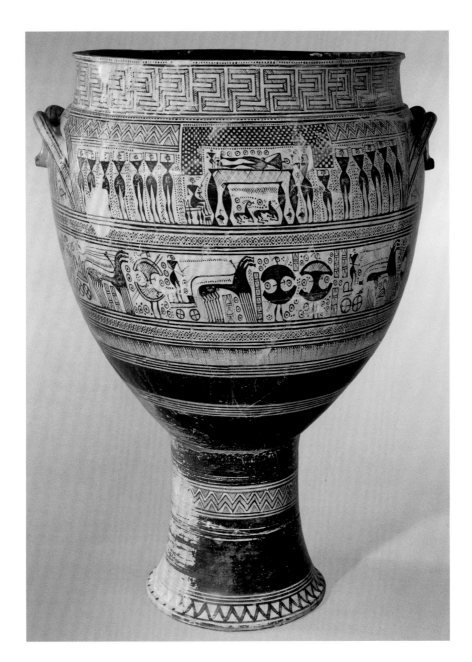

Attributed to the
Hirschfeld Workshop
Krater with Prothesis
Greek, Attic, ca. 750–735 B.C.
Terracotta, H. 42⅝ in. (108.3 cm)
Rogers Fund, 1914 (14.130.14)

In Greek art of the early first millennium B.C., monumental grave markers consisted of large kraters (deep vases) decorated with funerary representations. The principal zone of the vase depicts the *prothesis*, or the laying out of the dead: the deceased is laid upon a bier surrounded by his household and flanked by mourners. The procession of chariots and foot soldiers below may refer to the military exploits of the departed. Because hourglass shields and war chariots were no longer current, the scene also evokes the dead man's glorious ancestry.

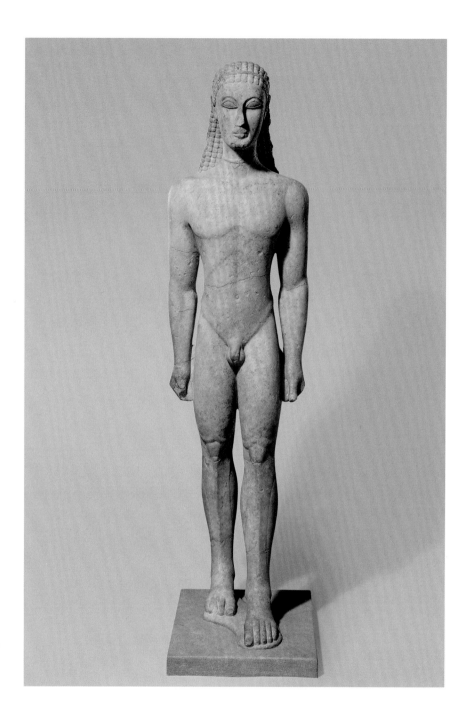

Statue of a Kouros

Greek, Attic, Archaic period, ca. 590–580 B.C.
Marble, H. without plinth 76⅜ in. (194.6 cm)
Fletcher Fund, 1932 (32.11.1)

This kouros (youth) is one of the earliest marble statues of a human figure carved in Attica. Its rigid stance, with the left leg forward and arms at the sides, derived from Egyptian art. This clear, simple pose was used by Greek sculptors throughout the sixth century B.C. Geometric, almost abstract forms predominate in this early figure, and anatomical details are rendered in beautiful analogous patterns. The statue marked the grave of a young Athenian aristocrat.

Grave Stele of a Youth and a Little Girl with Capital and Finial in the Form of a Sphinx

Greek, Attic, Archaic period, ca. 530 B.C.
Marble, H. 13 ft. 10¾ in. (4.24 m)
Frederick C. Hewitt Fund, 1911; Rogers Fund, 1921;
Anonymous Gift, 1951 (11.185a–d, f, g)

Stone funerary monuments, which first appeared during the seventh century B.C., became impressive to the point of ostentation. Said to be from Attica, this is the most complete example preserved from the Archaic period. The base is inscribed TO DEAR ME[GAKLES], ON HIS DEATH, HIS FATHER WITH HIS DEAR MOTHER SET [ME] UP AS A MONUMENT. On the shaft a youth, characterized as an athlete by the *aryballos* (oil flask) suspended from his wrist, stands with a small girl who may be his sister. A sphinx stands guard. The articulation of the athlete's musculature reflects a trend toward the naturalistic rendering of the human body. This development can be traced by comparing the kouros statue opposite, made some fifty years earlier. The sensitivity and precision of carving are complemented by polychromy (varied colors), much of which survives.

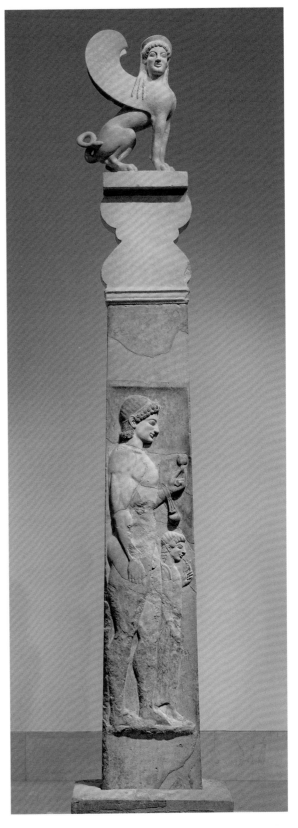

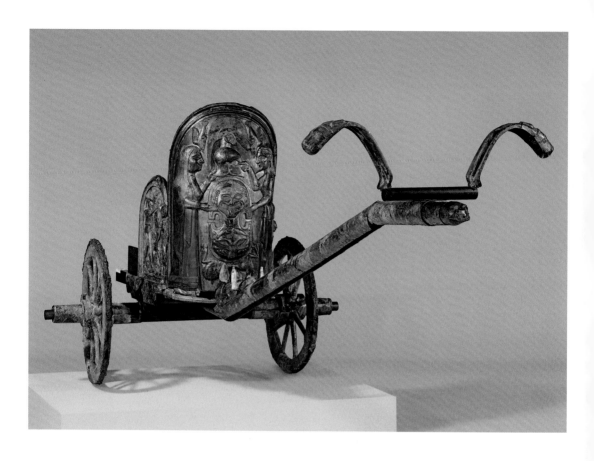

The Monteleone Chariot

Etruscan, 2nd quarter of the 6th century B.C.
Bronze inlaid with ivory, H. 51⅝ in. (131.1 cm),
L. of pole 82¼ in. (208.9 cm)
Rogers Fund, 1903 (03.23.1)

The best-preserved example of its kind from
Italy before the Roman period, the Monteleone
chariot has recently been reconstructed based
on the latest scholarship. Used not in war but
for ceremonial occasions, the vehicle would
have carried the driver and an important
person in a way similar to that represented on
the Amathus sarcophagus (facing page). The
Etruscans were famed for their metalworking
skills. The craftsman of the chariot depicted
scenes from the life of the Greek hero Achilles,
with additional motifs, such as the birds of
prey, testifying further to the owner's prestige
and wealth.

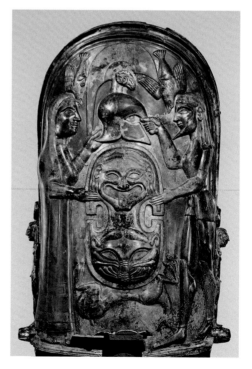

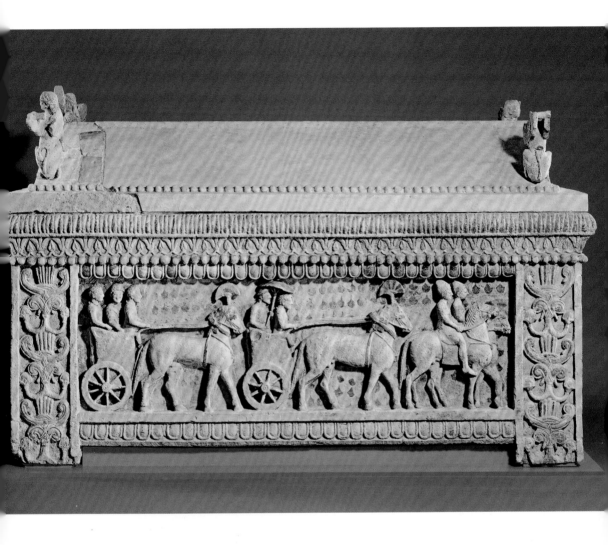

The Amathus Sarcophagus

Cypriot, 2nd quarter of the 5th century B.C.
Limestone, 62 × 93⅛ × 38½ in. (157.5 × 236.5 × 97.8 cm)
The Cesnola Collection, Purchased by subscription,
1874–76 (74.51.2453)

The Amathus sarcophagus, which undoubtedly belonged to a king of Amathus, is arguably the most important object in the Museum's rich collection of Cypriot art. It is remarkable for the color preserved on its surface. The imagery expresses the ruler's power and piety toward the gods in the diverse culture of Cyprus during the fifth century B.C. On the long sides a procession of chariots is escorted by attendants on horseback and followed by foot soldiers. The person of honor is probably the figure under the parasol. The short ends depict Near Eastern Astarte figures and a row of Egyptian Bes figures, both associated with fertility.

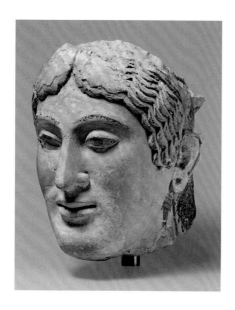

Head of a Woman, Probably a Sphinx

Greek, 1st quarter of the 5th century B.C.
Terracotta, H. 8⅛ in. (20.6 cm)
Rogers Fund, 1947 (47.100.3)

Because limestone and marble were readily available, terracotta (fired clay) was not often used for large-scale sculpture in Greece. The proportions and the break at the neck suggest that this exceptionally fine head belonged to a sphinx and was possibly part of the roof decoration of a small building. Sphinxes traditionally served as guardian figures, notably for funerary monuments, as can be seen on the impressive Attic grave stele illustrated earlier. Of particular note here is the way the application of polychromy renders details such as the earrings and headband.

Attributed to the
Amasis Painter
Lekythos with Women Weaving Wool and Woman among Youths and Maidens

Greek, Attic, ca. 550–530 B.C.
Terracotta, H. 6¾ in. (17.1 cm)
Fletcher Fund, 1931 (31.11.10)

This *lekythos* (oil flask) is said to have been found with another, also in the Museum, depicting a wedding procession, with the bride being brought at night to her husband's house. The two vases may have been wedding gifts that accompanied the recipient to her grave. The weaving of cloth, an important household task, is depicted here in detail, with particular emphasis on the upright loom. On either side of it are women weighing and spinning wool and folding lengths of cloth. The setting would have been the women's quarters of the house.

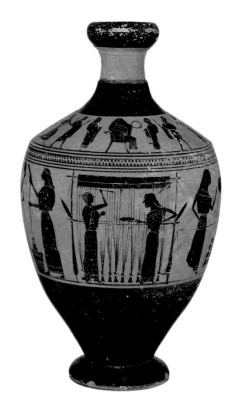

Carved Bow of a Fibula with Reclining Woman and Youth, Attendant, and Bird

Etruscan, ca. 500 B.C.
Amber, L. 5½ in. (14 cm)
Gift of J. Pierpont Morgan, 1917 (17.190.2067)

This work is the most complex carved amber surviving from ancient Italy. At its base, holes containing traces of an iron pin indicate that it was a fibula (safety pin). A woman and man recline on a couch. She holds a small vase with the fingers of her left hand touching its mouth. Her companion is a young, beardless man with a round face. A bird nestles at the shoulders of the couple, and a small attendant stands at their feet. It is unknown whether the figures are mortal or divine.

Attributed to
Epimenes
Scaraboid with Archer Testing an Arrow
Greek, ca. 500 B.C.
Chalcedony, ¾ in. (1.7 cm)
Fletcher Fund, 1931 (31.11.5)

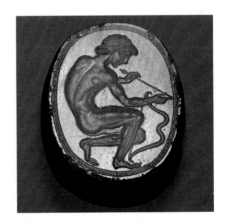

At the end of the sixth century B.C., Greek artists in all media were representing the human body in motion. In sculpture, the mastery of bronze casting allowed the creation of active figures on a larger scale than had been possible in stone. In vase painting, the invention of the red-figure technique allowed painters to draw their decorations freely on the surface of a pot. And on a hard stone less than an inch high, a gem engraver captured the lithe pose, rippling muscles, and beautifully arranged hair of a youth gauging the straightness of his arrow.

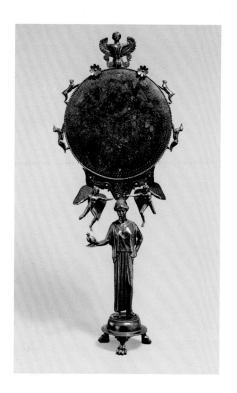

Mirror with Support in the Form of a Draped Woman

Greek, Argive, mid-5th century B.C.
Bronze, H. 16 in. (40.6 cm)
Bequest of Walter C. Baker, 1971 (1972.118.78)

The integration of three-dimensional figures into the design of a functional object is a hallmark of Greek art. A variety of elements—human, animal, and mythological—animate this mirror. A statuette of a woman standing on a base supports the mirror disk. Her simple woolen peplos falls in columnar folds. Two winged Erotes (gods of love) hover about her head. A hound chases a hare up either side of the disk, and a Siren, part bird and part woman, perches on the top.

Attributed to the
Painter of the Woolly Satyrs
Volute-Krater with Battles between Greeks and Amazons and between Centaurs and Lapiths

Greek, Attic, ca. 450 B.C.
Terracotta, H. 25 in. (63.5 cm)
Rogers Fund, 1907 (07.286.84)

Although literary works of the fifth century B.C. document that the Greeks understood the magnitude of their victory in the Persian Wars (490–479 B.C.), Greek artists almost never depicted major historical events or personalities in art. Instead, they represented grand mythological battles between Greeks and eastern adversaries, notably Amazons (mythical warrior women). During the first half of the fifth century B.C., large-scale wall paintings of such encounters decorated the Theseion and the Stoa Poikile (Painted Portico) in Athens. Their influence underlies the scenes on the volute-krater (bowl for mixing wine and water) seen here.

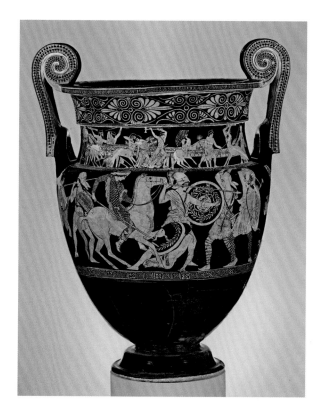

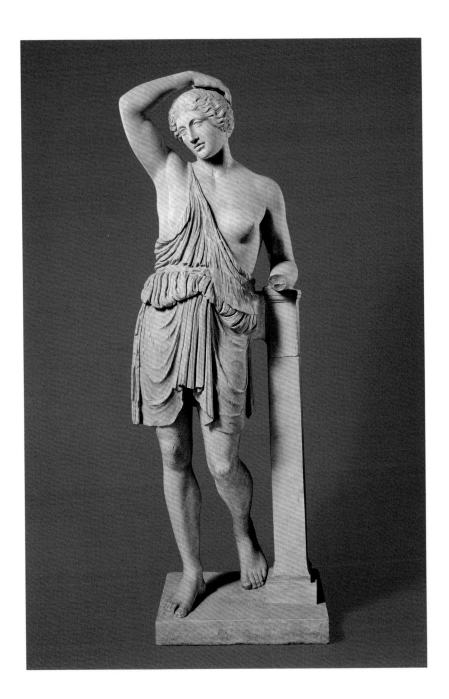

Statue of a Wounded Amazon

Roman, 1st–2nd century A.D.
Copy of a Greek bronze statue of ca. 450–425 B.C.
Marble, H. 80¼ in. (203.8 cm)
Gift of John D. Rockefeller Jr., 1932 (32.11.4)

In Greek art, the Amazons were often depicted battling such mythological heroes as Herakles, Achilles, and Theseus. This statue represents a warrior who has lost her weapons and bleeds from a wound under her right breast. Her chiton is unfastened at one shoulder and belted at the waist with a makeshift bit of bridle from her horse. Despite her plight, her face shows no sign of pain or fatigue. She leans lightly on a pillar and rests her right arm gracefully on her head in a gesture often used to denote sleep or death.

The Ganymede Group

Greek, ca. 330–300 B.C.

Gold, rock crystal, emerald, L. of necklace 13 in.
(33 cm), H. of earrings 2⅜ in. (6 cm), W. of bracelets 3⅛ in. (7.9
cm), W. of fibulae 1⅞ in. (5 cm), H. of ring ¾ in. (2.1 cm)
Harris Brisbane Dick Fund, 1937 (37.11.8–.17)

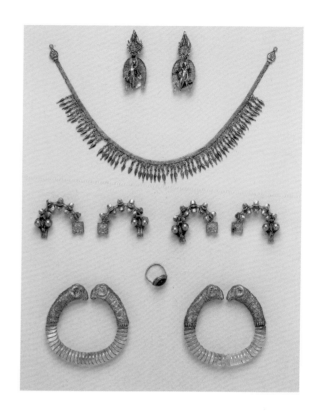

This exquisite assemblage—comprising a pair
of earrings, a necklace, four fibulae, a ring, and
two bracelets—forms a set, although differences
in style suggest that the pieces were not origi-
nally made together. Particularly noteworthy
are the earrings, featuring miniature representa-
tions of the youth Ganymede enfolded by the
wings of an eagle. The god Zeus desired the boy
as a cupbearer and transformed himself into an
eagle to carry him up to Mount Olympos. The
ring is set with an emerald, brought either from
Egypt or the Ural Mountains. The hoops of the
bracelets consist of rock crystal embellished
with gold wire.

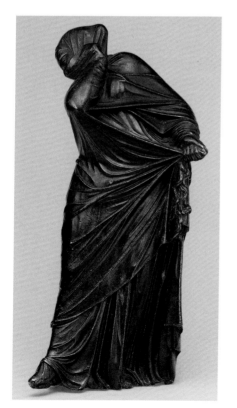

Statuette of a Veiled and Masked Dancer

Greek, 3rd–2nd century B.C.

Bronze, H. 8¼ in. (21 cm)

Bequest of Walter C. Baker, 1971 (1972.118.95)

The complex motion of this dancer is conveyed
exclusively through the interaction of the
body with several layers of dress. The figure
wears a lightweight mantle, drawn taut by the
pressure applied to it by her right arm, left
hand, and right leg, over an undergarment
that falls in deep folds and trails heavily. The
woman's face is covered by the sheerest of veils.
On her extended right foot is a laced slipper.
This dancer has been identified as one of the
professional entertainers, a combination of
mime and dancer, for which the cosmopolitan
city of ancient Alexandria was famous.

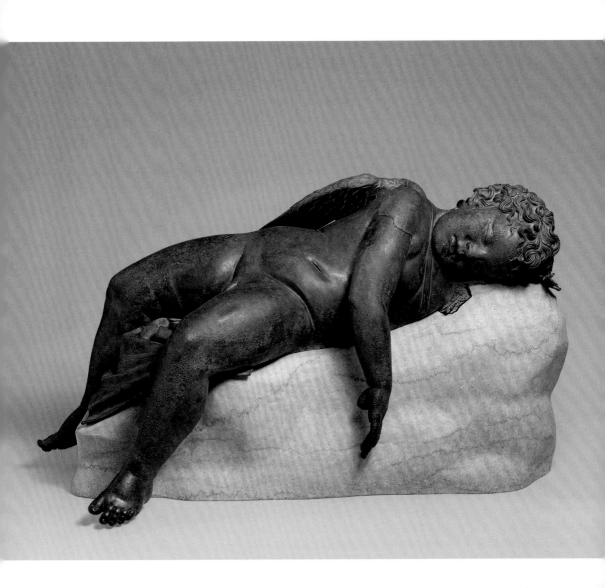

Statue of Eros Sleeping

Greek or Roman, 3rd century B.C.–early 1st century A.D.
Bronze, L. 33⅝ in. (85.4 cm)
Rogers Fund, 1943 (43.11.4)

Hellenistic art is richly diverse in both subject and stylistic development. Hellenistic artists were talented innovators who introduced the accurate characterization of age in visual imagery. Young children enjoyed great favor, whether in mythological form, as baby Herakles or Eros, or in genre scenes, playing with each other or with pets. This Eros, god of love, has been brought down to earth and disarmed, a conception considerably different from that of the powerful, often cruel, and capricious being of Archaic Greek poetry. Among the few bronze statues to have survived from antiquity, this figure, said to be from the island of Rhodes, conveys a sense of the immediacy and naturalistic detail made possible by the medium.

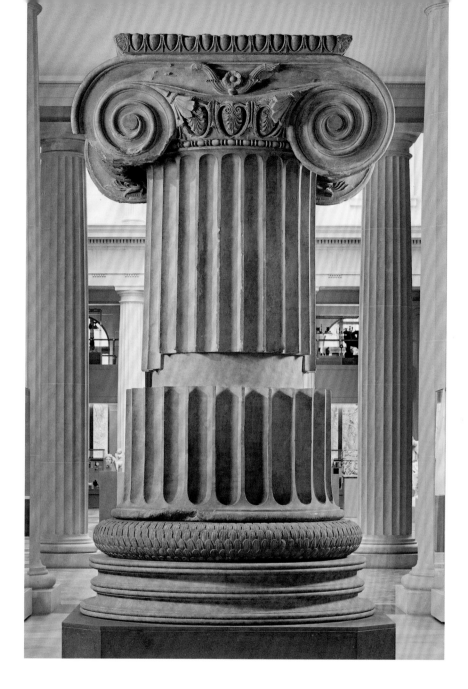

Column from the Temple of Artemis at Sardis

Greek, Hellenistic period, ca. 300 B.C.
Marble, H. 11 ft. 10⅛ in. (3.61 m)
Gift of The American Society for the Excavation
of Sardis, 1926 (26.59.1)

These sections are from a fluted Ionic column that stood more than 58 feet high in its original location at the Temple of Artemis. The delicate foliate carving on the capital is unique among extant capitals from the temple, and the torus (foliated base), with its scalelike vegetal pattern, is also exceptionally elaborate. The capital is slightly smaller than others found at the site, indicating that it does not belong to the outer colonnade. Two similar pairs of columns stood in the East and West Porches, and these sections are probably from one or both of those pairs.

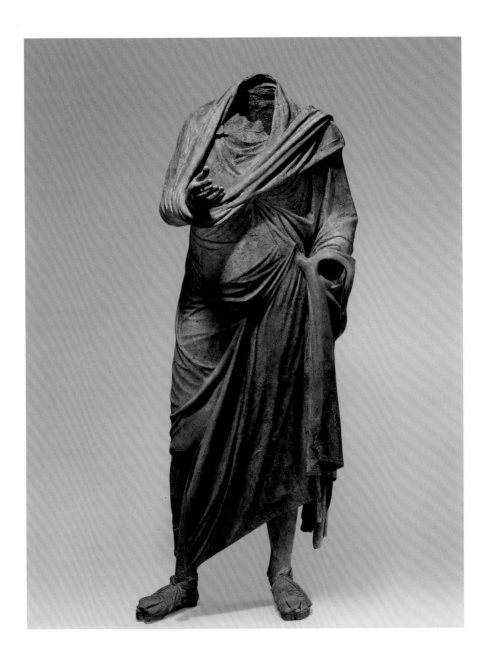

Statue of a Man

Greek, Hellenistic period, mid-2nd–1st century B.C.
Bronze, H. 73 in. (185.4 cm)
Gift of Renée E. and Robert A. Belfer,
2001 (2001.443)

Honorific statues like this one were typically
portraits of prominent individuals awarded by
the city-state or a ruler in gratitude for significant
benefactions. They were the highest honor a city
could offer. This impressive figure stands in
contrapposto: one leg bears his weight, allowing
the free leg to bend. His right hand stretches out
from the folds of his himation (cloak), with open
palm and fingers curled upward in a gesture of
oration, and his left arm lies close to his body.
His cloak is richly appointed with tasseled
weights and decorative horizontal bands, which
may have originally been painted or gilded.

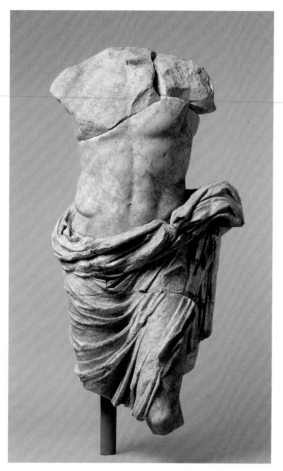
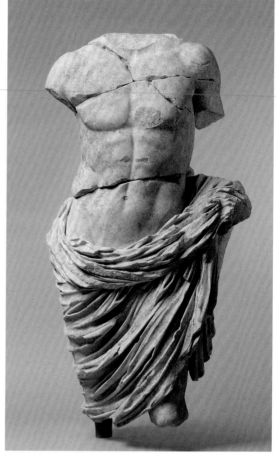

Two Statues of Members
of the Imperial Family

Roman, Augustan or Julio-Claudian
period, 27 B.C.–A.D. 68
Marble, H. 47 in. (119.4 cm); H. 46 in. (116.8 cm)
Bequest of Bill Blass, 2002 (2003.407.8a, b–.9)

From the Classical period onward, standing
half-draped figures like these were used in
representations of the gods as well as in
honorific statues of distinguished mortals.
These works, however, were probably part of a
statuary group glorifying members of the Julio-
Claudian dynasty, which ruled Rome from the
time of Augustus to that of Nero. The stance
of the partially nude figures recalls the canonic
works of Polykleitos, one of the most famous
Greek sculptors of the fifth century B.C., and was
almost certainly intended to impart a heroizing
aura. Statues of members of the imperial family,
both living and deceased, were often displayed
together in public spaces such as a city forum, a
basilica, or a theater.

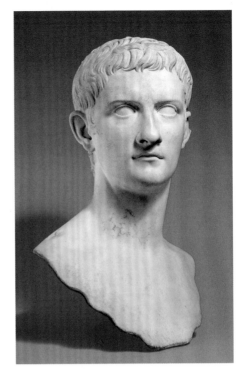

Statue of an Aristocratic Boy

Roman, Augustan period, 27 B.C.–A.D. 14

Bronze, H. 52⅛ in. (132.4 cm)

Rogers Fund, 1914 (14.130.1)

This lifesize statue was found on the Greek
island of Rhodes, a wealthy, flourishing center of
commerce and culture during the Roman period.
With his broad face and short hair, the boy
resembles young princes of the imperial family
of Augustus, but he may have been the son of
a member of the ruling elite or of an important
Roman official stationed on Rhodes. In place
of the traditional Roman toga, the boy wears a
Greek himation (cloak), perhaps indicating his
attendance at one of the celebrated schools of
philosophy and rhetoric on the island.

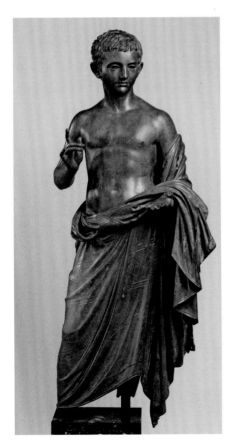

above

**Portrait Bust of the Emperor Gaius,
Known as Caligula**

Roman, Julio-Claudian period, A.D. 37–41

Marble, H. 20 in. (50.8 cm)

Rogers Fund, 1914 (14.37)

This fine bust of Caligula follows the official
portrait style created for Augustus, his great-
grandfather, thereby stressing the unity and
continuity of the Julio-Claudian dynasty. Here,
however, the artist has managed to capture
something of Caligula's own personality. The
proud turn of the head and the thin, pursed
lips may hint at the vanity and cruelty for
which he became infamous. His short reign
ended with his assassination when he was only
twenty-eight years old, after which many of his
portraits were broken up, recarved, or thrown
into the river Tiber.

Wall Painting with Seated Woman Playing a Kithara (detail)
Roman, Late Republican period, ca. 50–40 B.C.
Fresco, 73½ × 73½ in. (186.7 × 186.7 cm)
Rogers Fund, 1903 (03.14.5)

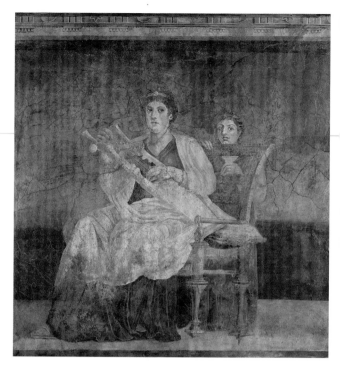

This fresco is one of a series of large panels that decorated the main reception hall of the villa of P. Fannius Synistor at Boscoreale, near Pompeii. Like the Roman city, the villa was buried by the eruption of Mount Vesuvius in A.D. 79. The panels derive from royal paintings created for one of the Macedonian courts of the early Hellenistic period (late fourth and early third centuries B.C.) and probably celebrate a dynastic marriage. The seated woman playing a kithara (lyre) must have been an important person, for she wears a diadem (an embellished headband) and sits on an ornate, thronelike chair.

Garland Bowl
Roman, Augustan period, late 1st century B.C.
Cast glass, DIAM. 7 ⅛ in. (18.1 cm)
Edward C. Moore Collection, Bequest of Edward C. Moore, 1891 (91.1.1402)

A tour de force of ancient glass production, this cast bowl comprises four separate slices, roughly equal in size, of translucent glass—purple, yellow, blue, and colorless—pressed together in an open mold. Each segment was then decorated with an added strip of polychrome mosaic glass (a cross section of bundled glass rods) representing a garland hanging from an opaque white cord. Very few vessels made of large sections or bands of differently colored glass are known from antiquity, and this bowl is the only example that combines the technique with mosaic decoration.

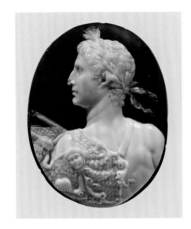

Cameo Portrait of the Emperor Augustus

Roman, Claudian period, A.D. 41–54
Sardonyx, H. 1½ in. (3.8 cm)
Purchase, Joseph Pulitzer Bequest,
1942 (42.11.30)

The cameo depicts Augustus as a triumphant, nude demigod wearing over his left shoulder the *aegis*, a cape usually associated with the Roman gods Jupiter and Minerva. Here it is decorated with the head of a wind god, perhaps intended as a personification of the summer winds that brought the corn fleet to Rome from Egypt and so an oblique reference to Augustus's annexation of Egypt after the defeat of Mark Antony and Cleopatra at Actium in 31 B.C. His pose conveys something of the majesty with which the Principate was imbued by the first emperor. During his long reign (27 B.C.–A.D. 14), Augustus was portrayed in many different guises and media, but in all cases he was consistently shown as a young man with handsome, idealized features.

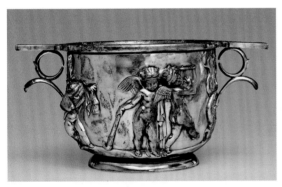 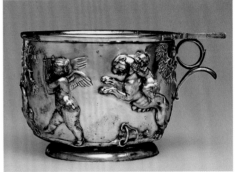

Pair of Skyphoi with Relief Decoration

Roman, Augustan period, late 1st century B.C.–
early 1st century A.D.
Gilt silver, H. 3¾ in. (9.5 cm), DIAM. 8⅛ in. (20.6 cm)
Purchase, Marguerite and Frank A. Cosgrove Jr. Fund
and Lila Acheson Wallace Gift, 1994 (1994.43.1, .2)

These silver skyphoi (cups) represent Roman metalwork of the highest quality. They undoubtedly were produced by one of the leading workshops in Rome that supplied the imperial family as well as the Roman aristocracy. The cups are decorated in high relief with figures of cupids, several of whom are shown dancing and playing instruments. The cupids' association with Dionysiac festivities makes them eminently suitable as subjects on drinking cups meant for an opulent party, but they probably lack any real symbolism. Like many other pieces of ornate silverware, these cups were clearly intended as much for display as for use.

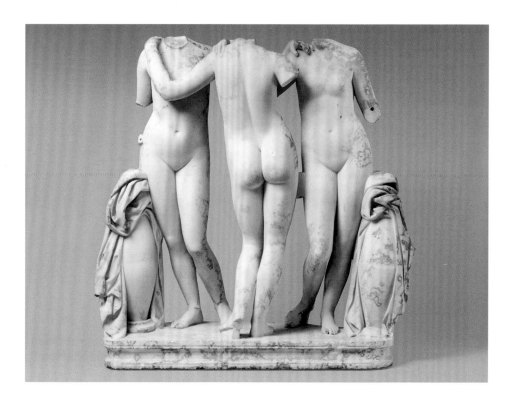

Marble Sarcophagus with the Triumph of Dionysus and the Seasons

Roman, Late Imperial period, ca. A.D. 260–70
Marble, 34 × 85 × 36¼ in. (86.4 × 215.9 × 92.1 cm)
Purchase, Joseph Pulitzer Bequest, 1955 (55.11.5)

This sarcophagus is an exquisite example of funerary art, probably carved in Rome for a wealthy client. The sides and front are decorated with forty human and animal figures sculpted in high relief. At center is the god Dionysus seated on a panther, flanked by four large standing figures that represent the four Seasons (from left to right): Winter, Spring, Summer, and Fall. Around these five central figures are additional Bacchic figures and cult objects, all carved on a smaller scale. On the rounded ends of the sarcophagus are other groups of larger figures, including personifications of earth and water.

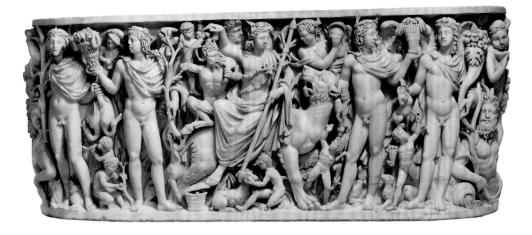

opposite

Statue Group of the Three Graces

Roman, 2nd century A.D.

Marble, 48⅜ × 39⅜ in. (123 × 100 cm)

Purchase, Philodoroi, Lila Acheson Wallace, Mary and
Michael Jaharis, Annette and Oscar de la Renta, Leon Levy
Foundation, The Robert A. and Renée E. Belfer Family
Foundation, Mr. and Mrs. John A. Moran, Jeannette and
Jonathan Rosen, Malcolm Hewitt Wiener Foundation and
Nicholas S. Zoullas Gifts, 2010 (2010.260)

The handmaidens of Aphrodite—Aglaia (Beauty),
Euphrosyne (Mirth), and Thaleia (Abundance)—
are represented as nude young girls in a graceful
friezelike pose. Where and by whom this scheme
of portraying the Three Graces was invented is
not known, but it was most likely developed in the
late Hellenistic period. It became one of the most
famous and widely copied compositions known in
the Roman world, appearing in every medium and
on every kind of object, from coins to sarcophagi
to mosaics. This sculpture may originally have
been placed in a garden or a public bath.

Portrait Head of the
Emperor Constantine I

Roman, Late Imperial period, ca. A.D. 325–70

Marble, H. 37½ in. (95.3 cm)

Bequest of Mary Clark Thompson, 1923 (26.229)

To further his aim of establishing a new
dynasty, Constantine the Great, the first
Christian emperor (r. A.D. 306–37), founded
a new capital of the Roman Empire, naming
it Constantinople after himself. By the time
this head was created, as part of either a
bust or, more probably, an over-lifesize
statue, Constantine had adopted an official
image intended to set him apart from his
immediate pagan predecessors. The long face,
neatly arranged hairstyle, and clean-shaven
appearance of this portrait head reflect a
deliberate attempt to evoke memories of
earlier "good" emperors, such as Augustus
(r. 28 B.C.–A.D. 14) or Trajan (r. A.D. 98–117).

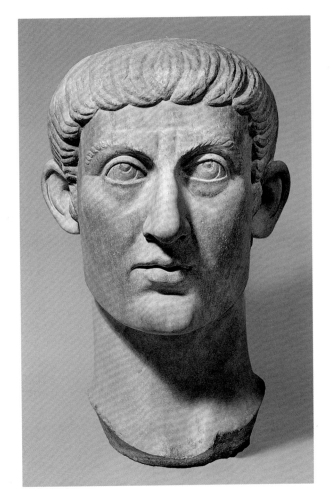

Across Cultures

Asian Art

Dating from the fourth millennium B.C. to the present, the Asian art collection provides an unrivaled experience of the artistic traditions of nearly half the world. The works in the collection represent the cultures of ancient and modern China, Japan, Korea, South Asia, Southeast Asia, and the Himalayan kingdoms. Among the highlights of the Chinese holdings are monumental Buddhist sculptures, archaic jades and bronzes, works of painting and calligraphy, and decorative arts, including ceramics, lacquers, and textiles. Also notable is the tranquil Astor Court, built by traditional Chinese craftsmen and modeled after a famous seventeenth-century garden in Suzhou. Korean holdings are strong in Buddhist sculpture and ceramics. Japanese works include early narrative paintings (handscrolls), folding screens from the fifteenth through the eighteenth century, and Edo-period porcelains. Among the areas of particular strength in South and Southeast Asia are Buddhist stone and bronze sculptures from the Kushan dynasty; Hindu bronzes from the Chola period; early Javanese metalwork; and Khmer sculpture. As distinctive as Asian cultures are from one another, many pieces in the collection reveal similarities in form and iconography occasioned by the sharing of religions, such as Buddhism and Hinduism, or themes and techniques, such as those found in blue-and-white ceramics or ink painting. Viewed together, these works yield both an appreciation of the art of Asia's many cultures and an understanding of the ties among these traditions.

Altar Set

China, Shang and Western Zhou
dynasties, late 11th century B.C.
Bronze; table 7 1/8 × 35 3/8 × 18 1/4 in. (18.1 × 89.9 × 46.4 cm)
Munsey Fund, 1931 (24.72.1–14)

This elaborate set of ritual bronzes, consisting of an altar table and thirteen wine vessels, illustrates the splendor of China's Bronze Age at its peak. The monumental design, intricate surface decoration, and refined casting attest convincingly to artistic sophistication and technical advancement. The set was reportedly found in the early twentieth century at the tomb of a Western Zhou aristocrat in Shaanxi Province. It subsequently entered the collection of Duan Fang, a prominent government official and renowned antiquarian, whose heirs later sold it to the Metropolitan Museum.

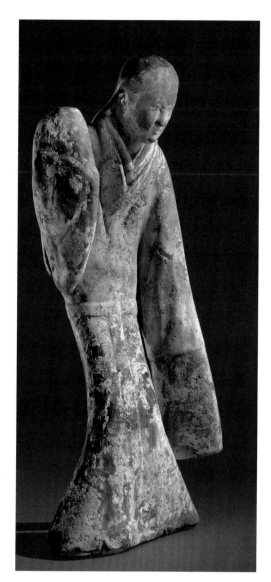

Pendant in the Shape
of a Knotted Dragon

China, Eastern Zhou dynasty, Warring States period,
3rd century B.C.
Jade (nephrite), H. 3⅛ in. (7.9 cm)
Gift of Ernest Erickson Foundation, 1985 (1985.214.99)

A superb example of early Chinese jade carving,
this pendant takes the form of a slender dragon
whose serpentine body makes a graceful loop.
Deep grooves cut into the body give it the
appearance of a twisted rope as well as enhance
the impression of power. The sinuous dragon,
with its curving body and snarling jaws—a
decorative motif prevalent in the late Eastern
Zhou period—was inspired by the art of the
West, which the nomads of the Eurasian steppes
brought to their Chinese neighbors.

Female Dancer

China, Western Han dynasty, 2nd century B.C.
Earthenware with pigment, H. 21 in. (53.3 cm)
Charlotte C. and John C. Weber Collection, Gift of
Charlotte C. and John C. Weber, 1992 (1992.165.19)

A quintessential example of early Chinese
sculpture, this ceramic figure illustrates the
artist's achievement in conveying a sense of
motion in a still object. The sculptor imbued
the dancer with life force by capturing a
tension-filled instant in her movement, when
she throws one sleeve back, gently stoops, and
flexes her knees.

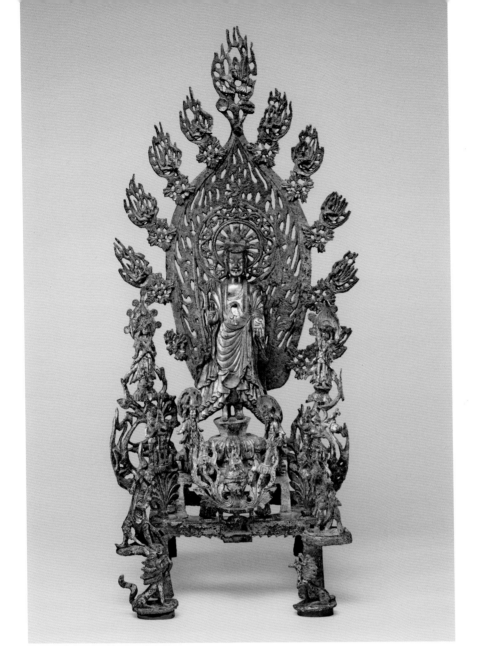

Altarpiece Dedicated to Buddha Maitreya

China, Northern Wei dynasty, A.D. 524
Gilt bronze, H. 30¼ in. (76.8 cm)
Rogers Fund, 1938 (38.158.1a–n)

This altarpiece is a rare, freestanding example
illustrating a style—characterized by attenuated
physiques and thick, concealing drapery—that
developed at the Northern Wei court in the early
sixth century. Maitreya (*Mile fo*), who played
an important role in early Chinese practices,

is understood as the bodhisattva (a spiritually
enlightened savior figure) who will become the
teaching Buddha of the next cosmic era, when
Buddhism, which will have been destroyed, is
reinstated. He is identified on this altarpiece by
an inscription stating that a certain individual
commissioned the sculpture on behalf of his
deceased son and expressing the hope that
the son and other relatives will eventually be
reunited in the presence of a Buddha.

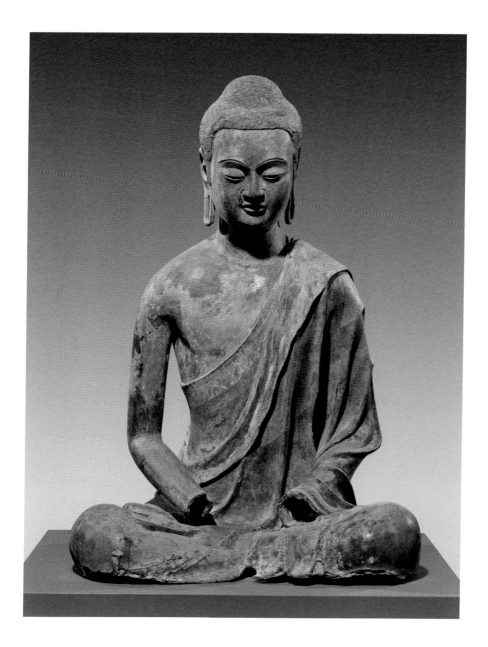

Buddha, Probably Amitabha

China, Tang dynasty, early 7th century
Hollow dry lacquer with traces of gilt and polychrome
pigments, H. 38 in. (96.5 cm)
Rogers Fund, 1919 (19.186)

Devotion to the celestial Buddha Amitabha
(*Amituo fo*) stresses the impossibility of achieving
enlightenment during a life lived under
less-than-ideal circumstances and promotes the
desire for rebirth in Sukhavati, a pure land or
way station in which conditions are conducive

to the quest for advanced understanding. Identi-
fied by the position of the arms, which suggests
that the missing hands were in a gesture of
meditation, this image of Amitabha was made
using the complicated dry-lacquer technique, in
which a core, often wood, is covered with clay
and surrounded by pieces of hemp cloth that
have been saturated with lacquer. Then the core
is removed. In the eighth century this technique
spread from China to Japan.

Dish in the Shape of a Leaf
China, Tang dynasty, late 7th–early 8th century
Silver with parcel gilding, L. 5¾ in. (14.6 cm)
Purchase, Arthur M. Sackler Gift, 1974
(1974.268.11)

The art of the silversmith reached its peak in China during the Tang dynasty (618–906), when close ties with Central and West Asia brought foreign influence in both forms and motifs. The manufacturing techniques also changed from traditional methods of casting to hammering and chasing. This exquisite dish in the shape of a leaf, decorated with flowers and birds in repoussé (hammered from the reverse), exemplifies the marvel of Tang decorative art.

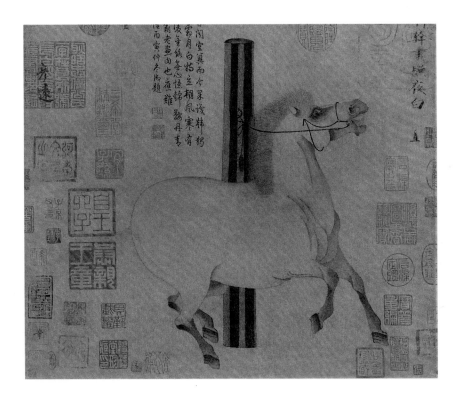

Attributed to
Han Gan
Chinese, active 742–56
Night-Shining White
Tang dynasty, ca. 750
Handscroll; ink on paper, 12⅛ × 13¾ in. (30.8 × 34 cm)
Purchase, The Dillon Fund Gift, 1977 (1977.78)

This portrait of Night-Shining White, a favorite charger of Emperor Xuanzong (r. 712–56), may be the best-known horse painting in Chinese art. The fiery-tempered animal epitomizes Chinese myths about imported "celestial steeds" that "sweated blood" and were really dragons in disguise. The painting has been attributed to Han Gan, who was known for portraying not only the physical likeness of a horse but also its spirit. Although Han is said to have preferred visits to the stables over the study of earlier paintings of horses, the profile image and the abstraction of the animal's anatomy clearly derive from ancient prototypes.

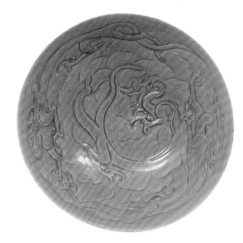

Bowl with Three Dragons

China, Zhejiang Province, Five Dynasties
period, 10th century
Stoneware with carved and incised design
under celadon glaze, DIAM. 10⅝ in. (27 cm)
Rogers Fund, 1918 (18.56.36)

In the West, the term *celadon* is often used to
describe ceramics covered with green glazes. In
China, these wares are generally classified by the
names of the kilns in which they were produced,
both domestically and for trade. In this example,
one of the three lively dragons that fill the
interior has his tail tucked beneath his hind
legs, a design that is characteristic of the Yue
kilns active in Zhejiang Province from as early as
the second century B.C. Yue wares were widely
traded from the eighth to the eleventh century,
when work at the kilns ceased. Examples have
been found as far west as Africa.

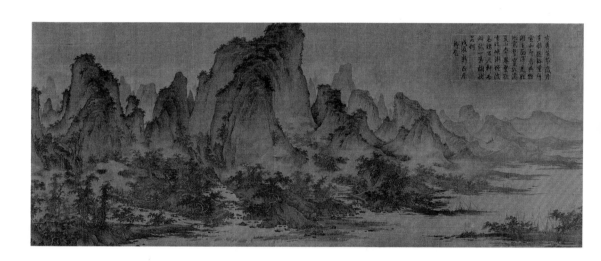

Attributed to
Qu Ding
Chinese, active ca. 1023–ca. 1056
Summer Mountains
Song dynasty, ca. 1050
Handscroll; ink and pale color on silk,
17⅞ × 45⅜ in. (45.3 × 115.2 cm)
Gift of The Dillon Fund, 1973 (1973.120.1)

Between the years 900 and 1100, Chinese paint-
ers created visions of landscape that depict the
sublimity of creation. Viewers are meant to iden-
tify with the human figures in these paintings.

In *Summer Mountains*, travelers make their way
toward a temple retreat. The central mountain sits
in commanding majesty, like an emperor among
his subjects, the culmination of nature's hierarchy.
The advanced use of textural strokes and ink wash
suggests that *Summer Mountains* is by a master
working about 1050, a date corroborated by collec-
tors' seals belonging to the Song emperor Huizong
(r. 1101–25), whose paintings catalogue records
three works entitled *Summer Scenery* by the other-
wise unknown artist Qu Ding.

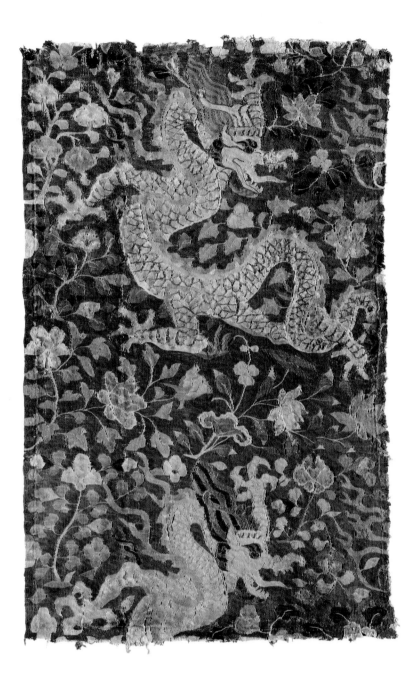

Tapestry with Dragons and Flowers

Eastern Central Asia, 11th–12th century
Silk tapestry, 21⅛ × 13 in. (53.7 × 33 cm)
Fletcher Fund, 1987 (1987.275)

The decorative style of this silk tapestry is typical of Central Asia, where motifs enjoyed great longevity and creative recombination. The form of the dragon, with its long snout and its tail hooked behind its leg, represents a Tang-dynasty convention that survived in Central Asia until at least the Yuan dynasty, founded in 1271 by the Mongol conqueror Khubilai Khan. Placing a dragon on flowers is most likely a Central Asian invention. The brilliant colors and the vitality of the animals are also characteristic features of tapestries of the region, which were probably produced by Uighurs, known for their splendid tapestry-woven clothing.

Guo Xi
Chinese, ca. 1000–ca. 1090
Old Trees, Level Distance (detail)
Song dynasty, late 11th century
Handscroll; ink and color on silk,
13¾ × 41¼ in. (34.9 × 104.8 cm)
John M. Crawford Jr. Collection, Gift of John M.
Crawford Jr., in honor of Douglas Dillon, 1981 (1981.276)

Guo Xi, the preeminent landscape painter of the late eleventh century, sought to give form to poetic images and emotions and was particularly interested in conveying the nuances of seasons and times of day. *Old Trees, Level Distance*, a variation on the classic "level-distance" formula of tall foreground trees set against a wide river valley, is probably a late work done for a fellow government official on the eve of his retirement. In the final section of the handscroll, the leafless trees and deepening mist impart a forlorn, autumnal air to a scene in which two elderly figures approach a pavilion, perhaps to join colleagues in bidding farewell to a friend.

Huang Tingjian

Chinese, 1045–1105

Biographies of Lian Po and
Lin Xiangru (detail)

Song dynasty, ca. 1095
Handscroll; ink on paper, 12¾ in. × 59 ft. 9 in.
(32.5 × 1822.4 cm)
Bequest of John M. Crawford Jr., 1988 (1989.363.4)

Poet, calligrapher, and Chan (Zen) Buddhist
adept, Huang Tingjian believed that calligraphy
should be spontaneous and self-expressive—"a
picture of the mind." Containing nearly twelve
hundred characters, this handscroll is a master-
piece of cursive-script writing. It transcribes an
account of a rivalry between two officials: Lian
Po, a distinguished general; and Lin Xiangru, a
skilled strategist. Huang's transcription ends
abruptly with Lin's words: "When two tigers
fight, one must perish. I behave as I do because
I put our country's fate before private feuds."
Read in the context of Song political infighting,
Huang's transcription becomes a powerful
indictment of the partisanship that led to his
own banishment in 1094.

Emperor Huizong

Chinese, 1082–1135, reigned 1101–25

Finches and Bamboo

Song dynasty, early 12th century

Handscroll; ink, color on silk,

11 × 18 in. (27.9 × 45.7 cm)

John M. Crawford Jr. Collection, Purchase,

Douglas Dillon Gift, 1981 (1981.278)

Huizong was the eighth emperor of the Song dynasty and the most artistically accomplished of his imperial line. *Finches and Bamboo* exemplifies the realistic style of flower-and-bird painting practiced at Huizong's academy. Whether making a study from nature or illustrating a line of poetry, however, the emperor valued capturing the spirit of a subject over literal representation. Here the minutely observed finches are imbued with the vitality of their living counterparts. Drops of lacquer added to the birds' eyes impart a final, lifelike touch.

Emperor Xuanzong's Flight to Shu

China, Song dynasty, mid-12th century
Hanging scroll; ink, color on silk,
32⅝ × 44¾ in. (82.8 × 113.6 cm)
Rogers Fund, 1941 (41.138)

In 745, after thirty-three years of able rule, the
Tang emperor Xuanzong (r. 712–56) fell in love
with the concubine Yang Guifei and became
indifferent to his duties. When Yang's favorite
general, An Lushan, rebelled in 755, Yang Guifei
was blamed. Forced to flee from the capital at

Xi'an to the safety of Shu (Sichuan Province),
the emperor was confronted by mutinous
troops demanding the execution of his lover.
Reluctantly assenting, Xuanzong witnessed
the act in horror and shame and abdicated
soon after. This painting depicts the somber
imperial entourage after the execution. While
the accoutrements of the figures are Tang, the
painting's landscape style of intricately described
volumetric forms and mist-suffused atmosphere
suggests a mid-twelfth-century date.

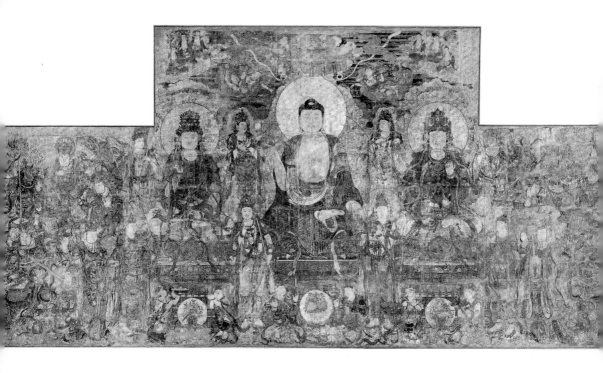

Buddha of Medicine Bhaishajyaguru

China, Shanxi Province, Yuan dynasty, ca. 1319
Water-based pigment over foundation of clay mixed
with straw, H. 24 ft. 8 in. (7.5 m)
Gift of Arthur M. Sackler, in honor of his parents,
Isaac and Sophie Sackler, 1965 (65.29.2)

Healing practices, both physical and spiritual,
played an important role in the transmission
of Buddhism throughout Asia. In this mural,
Bhaishajyaguru (*Yaoshi fo*), the Buddha of
medicine, wears a red robe and is attended by a
large assembly of related deities, including two
seated bodhisattvas who hold symbols for the
sun and the moon. The twelve warriors, six at
each side, symbolize the Buddha's vows to help
others. The robust, full-faced figure and the
shallow spatial construction are characteristic
of the work of Zhu Haogu, who was active in
the early fourteenth century and painted both
Buddhist and Daoist imagery.

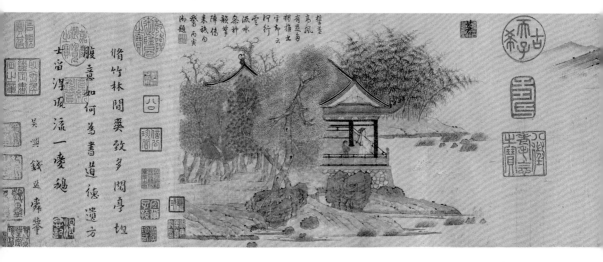

Cosmological Mandala with Mount Meru

China, Yuan dynasty, 14th century
Silk tapestry, 33 × 33 in. (83.8 × 83.8 cm)
Purchase, Fletcher Fund and Joseph E. Hotung
and Danielle Rosenberg Gifts, 1989 (1989.140)

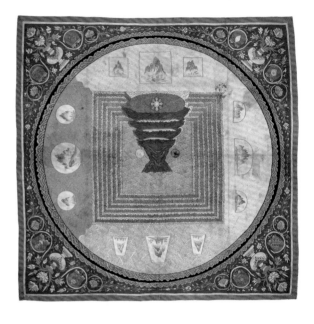

This elaborate tapestry-woven mandala, or cosmic diagram, illustrates Indian imagery introduced into China in conjunction with the advent of Esoteric Buddhism. At the center is the mythological Mount Meru, represented as an inverted pyramid topped by a lotus, a Buddhist symbol of purity. Traditional Chinese symbols for the sun (three-legged bird) and moon (rabbit) appear at the mountain's base. The landscape vignettes at the cardinal directions represent the four continents of Indian mythology but follow the conventions of Chinese-style "blue-and-green" landscapes. The dense floral border derives from imagery of central Tibet, particularly from monasteries with ties to the court of the Yuan dynasty.

Qian Xuan

Chinese, ca. 1235–before 1307
Wang Xizhi Watching Geese (detail)
Yuan dynasty, ca. 1295
Handscroll; ink, color, and gold on paper,
9⅛ × 36½ in. (23.2 × 92.7 cm)
Gift of The Dillon Fund, 1973 (1973.120.6)

After the fall of Hangzhou, the Southern Song capital, in 1276, the artist Qian Xuan chose to live as an *yimin*, a "leftover subject" of the dynasty. Painted in his deliberately primitive "blue-and-green" style, this handscroll illustrates the story of Wang Xizhi (303–361), the calligraphy master of legendary fame and a practitioner of Daoist alchemy, who was said to derive inspiration from natural forms such as the graceful neck movements of geese. In creating a dreamlike evocation of antiquity, the artist prevented a realistic reading of his picture space as a way of asserting the disjuncture he felt after the fall of the Song royal house.

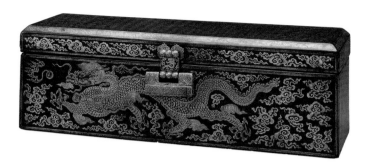

Sutra Box with Dragons among Clouds

China, Ming dynasty, Yongle
period, 1403–24
Lacquer with engraved gold
decoration, L. 16 in. (40. 6 cm)
Purchase, Sir Joseph Hotung and
The Vincent Astor Foundation Gifts,
2001 (2001.584a–c)

Vigorous, sinewy dragons are depicted often on works in porcelain, lacquer, and other materials from the reign of the Yongle emperor. Intended to hold a Buddhist text made in the Chinese handscroll format, elegant boxes like this one were produced both for use at the court and as diplomatic gifts, particularly to Tibet. Although carved lacquers from the period have been preserved in some number, examples decorated in the engraved and gilt technique (*qiangjin*)—in which a pattern carved into a lacquer surface is filled with gold or gold pigment—are rare. It is also unusual for the metalwork lock and key to have survived.

Jar with Dragon

China, Jiangxi Province, Ming dynasty,
Xuande mark and period, 1426–35
Porcelain with underglaze blue,
H. 19 in. (48.3 cm)
Gift of Robert E. Todd, 1937 (37.191.1)

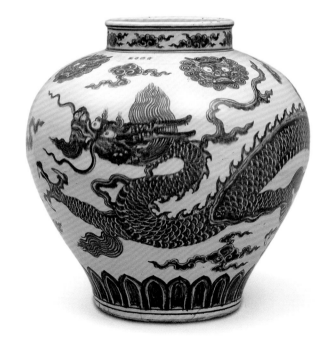

The painting of cobalt blue on a porcelain body, which first flowered in China in the fourteenth century, is arguably the most important development in the global history of ceramics. Produced for the court, this spectacular storage jar, an example of porcelain from Jingdezhen, is dated to the rule of the Xuande emperor by an inscription on the shoulder. The painting depicts a powerful dragon undulating through a sky defined by a few sparse clouds. The unusual monstrous faces on the neck of the jar may derive from the *kirtimukha* (face of glory) that is often found in Indo-Himalayan imagery and was popular in China in the early fifteenth century.

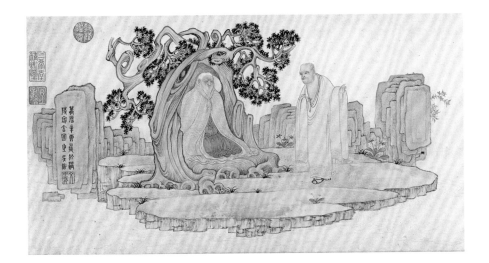

Wu Bin

Chinese, active ca. 1583–1626

The Sixteen Luohans (detail)

Ming dynasty, 1591

Handscroll; ink, color on paper, 12⅝ × 163⅛ in. (32 × 414.3 cm)

The Edward Elliott Family Collection,

Gift of Douglas Dillon, 1986 (1986.266.4)

In the Chinese popular imagination, mendicant monks, conjurers, and mysterious hermits were often thought to be disguised "living luohans," or Buddhist holy men capable of producing miracles.

When government corruption and ineptitude imperiled social order, as it did in late Ming times, such superstitious messianic beliefs became more widespread. Here, in one of his earliest extant works, Wu Bin embraced an archaic figure style and followed the tradition of depicting luohans as fantastic eccentrics whose grotesque features belie their inner spiritual nature. Wu's humorous painting may have had a serious message: holiness can be concealed within an outwardly incongruous form.

Gong Xian

Chinese, 1619–1689

Ink Landscapes with Poems (detail)

Qing dynasty, 1688

Album of sixteen paintings; ink on paper,

10¾ × 16⅛ in. (27.3 × 41 cm)

Gift of Douglas Dillon, 1980, 1981

(1980.516.2; 1981.4.1)

Remaining loyal to the vanquished Ming dynasty, the hermit Gong Xian came to terms with himself as an *yimin*, or "leftover subject," under the Qing dynasty (1644–1911). In this leaf, from an album in which he compared his favorite haunts in and around the former Ming capital of Nanjing with the abodes of the immortals, Gong complemented his image of a reclusive dwelling with a poem that contrasts the ability of orchids, symbols of virtuous men, to endure the cold winter, while brambles—lowly men—are used as firewood. The artist perfected a technique of ink wash and dotting that enabled him to achieve both density and translucency in his paintings.

Wang Hui

Chinese, 1632–1717

The Kangxi Emperor's Southern Inspection Tour, Scroll Three: Jinan to Mount Tai (detail)

Qing dynasty, 1698

Handscroll; ink, color on silk,

26¾ in. × 45 ft. 8¾ in. (67.8 cm × 13.9 m)

Purchase, The Dillon Fund Gift, 1979 (1979.5)

In 1689 the Kangxi emperor (r. 1662–1722), a Manchu whose forebears had conquered China in 1644, made a grand tour to consolidate his authority over southern China. The renowned landscapist Wang Hui was commissioned to record the journey in a series of twelve oversize handscrolls. This scroll, the third in the set, highlights the emperor's visit to Mount Tai, China's "Sacred Peak of the East." Although Wang based his design on maps and woodblock prints—he never visited the mountain—he also connected specific sites with imaginary landscape passages inspired by classical precedents and employed a traditional "blue-and-green" palette to underscore the emperor's beneficent rule.

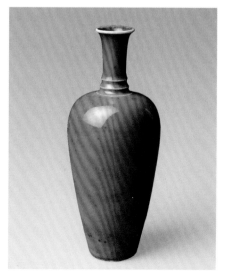

Vase

China, Qing dynasty, Kangxi period, 1662–1722
Porcelain with "peach bloom" glaze, H. 7¾ in. (19.7 cm)
Bequest of Benjamin Altman, 1913 (14.40.377)

Lush pinkish-red glazes, such as the "peach bloom" on this small vase, were first produced in the third quarter of the seventeenth century. Small vases in this shape have long been thought to belong to sets of eight or more accoutrements designed for a writing table. This is one of four vases, each with a subtly different shape, that were found among a set of imple-

ments. It is distinguished from the others by the three thin rings at the base of the neck. These sets, which may or may not actually have been used, were most likely intended for presentation as gifts to officials working at the court. As is often the case with works produced for the court, a six-character inscription on the base indicates that it was made during the reign of the Kangxi emperor (*Da Qing Kangxi nian zhi*). The style of writing of the Chinese characters, however, helps date the piece to the period from 1678 to 1688.

Zaō Gongen

Heian period, 11th century
Gilt bronze with incised decoration,
H. 14¾ in. (37.5 cm)
The Harry G. C. Packard Collection of Asian Art,
Gift of Harry G. C. Packard, and Purchase, Fletcher,
Rogers, Harris Brisbane Dick, and Louis V. Bell Funds,
Joseph Pulitzer Bequest, and The Annenberg Fund Inc.
Gift, 1975 (1975.268.155)

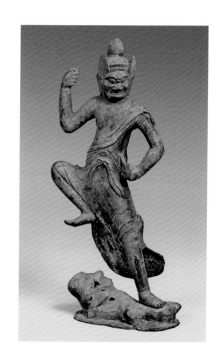

Zaō Gongen is a rare example of a purely
Japanese addition to the Buddhist pantheon.
In the era when this image was created, many
religious practices associated with Zaō took
place in remote temples deep in the mountains.
Through these rites, mountain ascetics
attempted to appropriate for themselves Zaō's
sheer physical power.

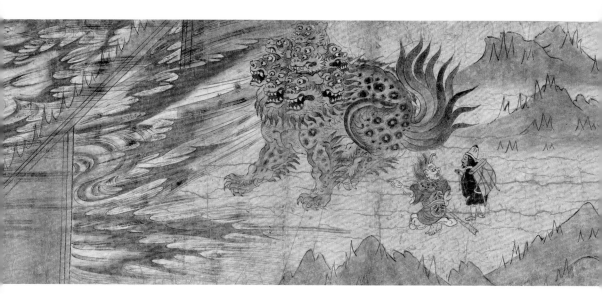

Illustrated Legends of the Kitano Tenjin Shrine (detail)

Japan, Kamakura period, late 13th century
Set of five handscrolls (of varied lengths); ink, color,
cut gold on paper, 11⅜ in. × 18 ft. 9 in.–29 ft. 4¼ in.
(28.8 × 571.4–894.5 cm)
Fletcher Fund, 1925 (25.224a–e)

The Kitano Tenjin Shrine in Kyoto is dedicated
to the ninth-century scholar and statesman
Sugawara Michizane (845–903). Michizane
died in exile, having been slandered by enemies
at court. A series of natural disasters and
plagues then caused the untimely deaths of his
detractors. Michizane's spirit revealed his wish
to be enshrined in the northwestern section of
the capital. He is venerated today as the Shinto
god of learning and calligraphy.

Portrait of Shun'oku Myōha

Nanbokuchō period, ca. 1383
Hanging scroll; ink, color, gold on silk,
45 × 20½ in. (114.3 × 52.1 cm)
Gift of Sylvan Barnet and William Burto,
2007 (2007.329)

This formal portrait depicts Shun'oku
Myōha (1311–1388), a prominent figure
in Zen Buddhism. Made for a temple in
Kyoto, it features an inscription authored
by the sitter. It belongs to a portrait
tradition that originated in China, where
it was associated with funerals and
memorial services. In Japan the genre
came to denote paintings that preserved
the likenesses of Zen masters, not only
for commemorative ceremonies but
also as a way of certifying the successful
transmission of Buddhist teachings
(dharma) from masters to their disciples.
This portrait is bold and compelling,
an effect rendered through expert ink
brushwork combined with intricate color
application defining each detail of the robe
and face.

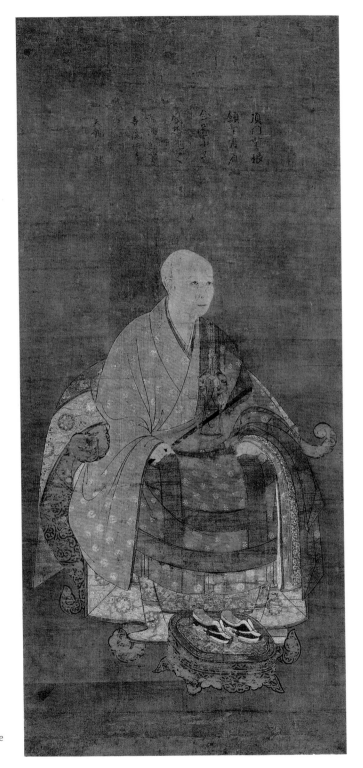

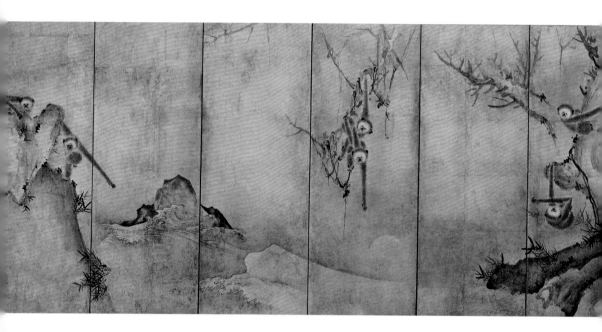

Sesson Shūkei

Japanese, ca. 1504–ca. 1589

Gibbons in a Landscape (detail)

Muromachi period, ca. 1570

Pair of six-panel folding screens; ink on paper,
each 62 in. × 11 ft. 5 in. (157.5 × 348 cm)

Purchase, Rogers Fund and The Vincent Astor
Foundation, Mary Livingston Griggs and Mary Griggs
Burke Foundation, and Florence and Herbert Irving Gifts,
1992 (1992.8.1, .2)

The gibbon, native to the forested mountains
of southern China, is known in Japan through
painting and poetry. Its cry is associated in
poetry with the elevated spirit of solitude and in
Daoist lore with a superior life force. Japanese
Zen monks treasured gibbons painted by the
Chinese monk Muqi (active ca. 1245). By the late
fifteenth century, paintings of gibbons in the
manner of Muqi had become a favored subject
for screen decoration. Here the image of a chain
of gibbons reaching futilely for a reflection of
the moon, a symbol of enlightenment, illus-
trates a fundamental Zen paradox.

Kimono with Design of Shells and Sea Grasses (detail)

Japan, Edo period, early 17th century
Silk embroidery, gold leaf on resist-
dyed warp-float-patterned plain-weave silk,
H. overall 60½ in. (153.7 cm)
Gift of Mr. and Mrs. Paul T. Nomura, in memory of
Mr. and Mrs. S. Morris Nomura, 1992 (1992.253)

The delicate embroidered design of this rare
kimono (*kosode*) was inspired by the natural
scenery of Japan's coast, its beaches strewn with
shells and sea grass. The foundation fabric, wo-
ven with floral motifs on a background of fret-
work, was imported from China. In Japan the
white cloth was then resist-dyed to achieve the
effect of irregular sandbanks, on which marine
motifs were embroidered. Gold-leaf accents on
the alternating light blue bands emphasize the
floral motifs of the woven pattern.

Wine Ewer with Design of Chrysanthemums and Paulownia Crests

Japan, Momoyama period, ca. 1596–1600
Lacquer with sprinkled gold decoration,
H. with handle 10 in. (25.4 cm), W. with spout
10⅛ in. (25.7 cm), DIAM. 7 in. (17.8 cm)
Purchase, Gift of Mrs. Russell Sage, by exchange,
1980 (1980.6)

This vessel may have been used by the powerful
and flamboyant general Toyotomi Hideyoshi
(1536–1598), who unified Japan in the 1590s.
His mausoleum, Kōdaiji, was furnished with
lacquers produced by the Kōami workshop,
featuring close-ups of autumn plants and Toyo-
tomi family crests. Designed in what came to be
known as the Kōdaiji style (referring to black lac-
querware with sumptuous gold ornamentation),
this container features a stunning contrast of
two patterns—totally different in color, rhythm,
and motif. This type of decoration was much
favored at the time by artists working not only
in lacquer but also in ceramics and textiles.

Dish with Design of Three Jars

Japan, Edo period, early 18th century
Porcelain with underglaze blue, overglaze enamels,
H. 1⅝ in. (4.1 cm), DIAM. 6 in. (15.2 cm)
The Harry G. C. Packard Collection of Asian Art,
Gift of Harry G. C. Packard, and Purchase, Fletcher,
Rogers, Harris Brisbane Dick, and Louis V. Bell Funds,
Joseph Pulitzer Bequest, and The Annenberg Fund Inc.
Gift, 1975 (1975.268.563)

The Hizen region of Kyūshū was the center of early porcelain production in Japan. Although many designs and wares made in Kyūshū were intended for export, works of Hizen ware known as the Nabeshima type were commissioned by the Nabeshima clan and produced at an exclusive kiln. A dish like this example would have been part of a dining service. These sets were frequently sent to the shogun in Edo (Tokyo) as an annual tribute. The cheerful design of jars on this dish features the bold, luminous colors and exacting standards characteristic of the high-quality porcelains produced at the Nabeshima kiln.

Kano Sansetsu

Japanese, 1589–1651

The Old Plum

Edo period, ca. 1647
Four sliding door panels; ink, color, and gold on gilt
paper, 68¾ in. × 15 ft. 11⅛ in. (174.6 × 485.5 cm)
The Harry G. C. Packard Collection of Asian Art, Gift of
Harry G. C. Packard, and Purchase, Fletcher, Rogers, Harris
Brisbane Dick, and Louis V. Bell Funds, Joseph Pulitzer
Bequest, and The Annenberg Fund Inc. Gift,
1975 (1975.268.48a–d)

Even the oldest plum puts out green shoots in spring, and thus the tree is a symbol of fortitude and rejuvenation. These sliding doors separated two rooms of an abbot's residence at Tenshō'in, a subtemple of Myōshinji, a famous Zen temple in Kyoto. The exaggerated bend of the tree and the crispness of the geometric rocks are idiosyncrasies associated with signed works by Kano Sansetsu, pupil and son-in-law of the painter Kano Sanraku (1559–1635). Sanraku enjoyed the generous patronage of Myōshinji, and Sansetsu must have received the monks' continued support.

Ogata Kōrin

Japanese, 1658–1716

Rough Waves

Edo period, ca. 1704–9
Two-panel folding screen; ink, color, and gold
on gilt paper, 57⅝ × 65⅛ in. (146.5 × 165.4 cm)
Fletcher Fund, 1926 (26.117)

Many artists and poets have striven to capture
the transitory image of swelling waves. Ogata
Kōrin's rendition has a strangely menacing feel,
no doubt due to the long irregular tentacles of
foam punctured here and there by openings.
Outlined in ink using the ancient Chinese
technique of drawing with two brushes held
together in one hand, the immediate inspiration
for the clawlike waves on this screen may have
been an image by the Muromachi-period artist
Sesson Shūkei (ca. 1504–ca. 1589). The screen
bears a seal reading Dōsū, the name Kōrin
adopted in 1704.

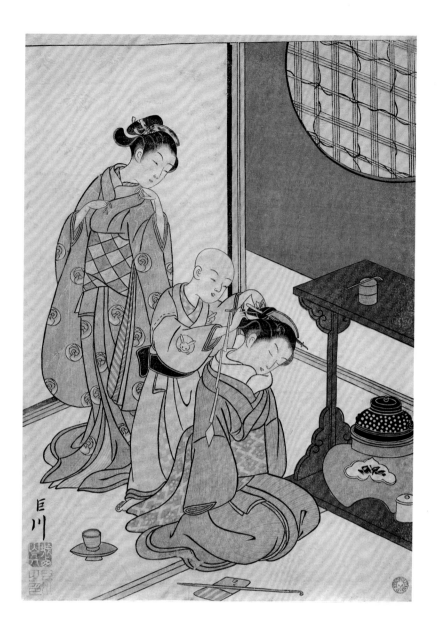

Suzuki Harunobu

Japanese, 1725–1770

Boy Adding a Ribbon to a Young Girl's Hair

Edo period, ca. 1766

Polychrome woodblock print; ink, color on paper,

11¼ × 8 in. (28.6 × 20.3 cm)

The Francis Lathrop Collection, Purchase, Frederick C. Hewitt Fund, 1911 (JP698)

This beguiling scene of a girl lulled by the sound of a softly boiling tea cauldron, set on a portable hearth of the type used during the summer, is one of Harunobu's Eight Parlor Views (*Zashiki hakkei*). It playfully alludes to "Night Rain," one of the Eight Views of the Xiao and Xiang Rivers in China, a venerable theme in both Chinese and Japanese painting. Here the summer mood intrinsic to that landscape is transposed to the interior of an Edo (Tokyo) house of pleasure. Harunobu's work is distinctive for its subtle tonality, achieved by mixing pigments rather than by superimposing two printed colors.

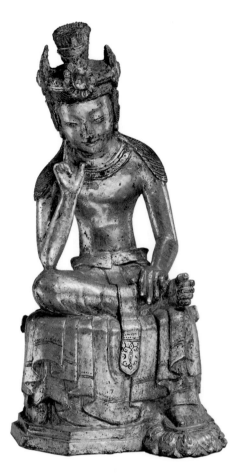

Pensive Bodhisattva
Korea, Three Kingdoms period, mid-7th century
Gilt bronze, 8⅞ × 4 × 4¼ in. (22.5 × 10.2 × 10.8 cm)
Purchase, Walter and Leonore Annenberg and The
Annenberg Foundation Gift, 2003 (2003.222)

Images of the pensive bodhisattva were
produced throughout Asia. In Korea, the type
emerged as an important Buddhist icon during
the sixth and seventh centuries, particularly in
the kingdoms of Baekje and Silla. This seated
figure is among the best preserved and most
spectacular. It is infused with a subtle yet
palpable energy that is articulated in details such
as the pliant and lifelike fingers and toes. The
deity's braided hair has a dramatic linear pattern.
His crown is topped with an orb-and-crescent
motif, indicating Central Asian influence.

Covered Box
Korea, Goryeo dynasty, 12th century
Lacquer inlaid with mother-of-pearl and
tortoiseshell over pigment, brass wire,
H. 1⅝ in. (4.1 cm), L. 4 in. (10.2 cm)
Fletcher Fund, 1925 (25.215.41a, b)

Ensembles containing four trefoil boxes surround-
ing a larger round or flower-shaped box served
as containers for cosmetics or incense. This piece
was originally part of such a set. There are also
similar ceramic and bronze examples, attesting to
a mixing of influences across media. Exquisitely
crafted and intricately ornamented with inlaid
slivers of mother-of-pearl and tortoiseshell, this
jewel of a box represents the height of lacquer
ware made during the Goryeo dynasty (918–1392).

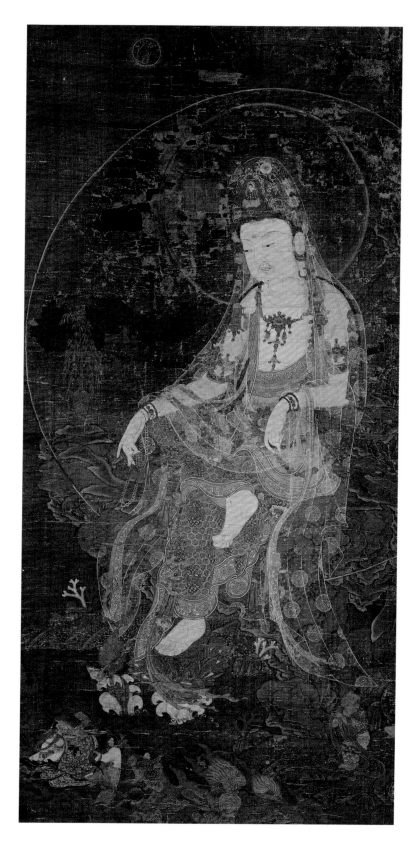

Water-Moon Avalokiteshvara

Korea, Goryeo dynasty, first half of the 14th century
Hanging scroll; ink, color on silk, 45⅛ × 21⅞ in.
(114.5 × 55.6 cm)
Charles Stewart Smith Collection, Gift of Mrs. Charles
Stewart Smith, Charles Stewart Smith Jr., and Howard
Caswell Smith, in memory of Charles Stewart Smith,
1914 (14.76.6)

In this scroll painting, the resplendently attired
bodhisattva known as Water-Moon Avalokitesh-
vara (*Suwol gwaneum*) sits on a rocky outcropping
above the waves. The usual attributes of the
deity—a small image of the Amitabha Buddha on
the crown and a ritual sprinkler holding a willow
branch—are present. At the top of the painting
is a diminutive moon, in which a hare pounds
the elixir of immortality. At the deity's feet stand
elegantly dressed, miniature figures led by the
dragon king. At the lower right is the boy pilgrim
Sudhana (*Seonjae dongja*), whose encounter with
Avalokiteshvara is recounted in the *Avatamsaka
Sutra* (Flower Adornment Scripture).

Moon Jar

Korea, Joseon dynasty, second half of the 18th century
Porcelain, H. 15¼ in. (38.7 cm), DIAM. 13 in. (33 cm), DIAM. of
rim 5½ in. (14 cm), DIAM. of foot 4⅞ in. (12.4 cm)
The Harry G. C. Packard Collection of Asian Art,
Gift of Harry G. C. Packard, and Purchase, Fletcher,
Rogers, Harris Brisbane Dick, and Louis V. Bell Funds,
Joseph Pulitzer Bequest, and The Annenberg Fund Inc.
Gift, 1975 (1979.413.1)

A distinctive type of white porcelain from the
late Joseon era (1392–1910), the moon jar
(*dalhangari*)—so called because of its evocative
form—was usually made by joining two clay
hemispheres. The resulting seam is often visible,
and the overall shape has an organic appearance.
The peach-colored flourishes in the glaze of
this piece, unintentionally acquired during
firing, add to its charm. Though porcelain was
a worldwide phenomenon in the eighteenth
century, vessels of this type are unique to Korea.

Yaksha

India, Madhya Pradesh, Shunga period, ca. 50 B.C.
Sandstone, H. 35 in. (88.9 cm)
Gift of Jeffrey B. Soref, in honor of Martin
Lerner, 1988 (1988.354)

Yakshas (male nature spirits) are personifications
of the natural world. Over time they were wor-
shipped as minor gods in both the Buddhist and
Hindu pantheons, often functioning as protec-
tors of the earth's riches, and they became asso-
ciated with wealth. This potbellied dwarf once
raised his arms to support a bowl on his head,
which identifies him as a "carrier," or *bharava-
haka yaksha*. The closest stylistic parallels to this
form are seen on pillar capitals at the great early
Buddhist stupa (a moundlike structure designed
to hold objects of veneration) of Sanchi, near
Bhopal. In all probability this *yaksha* served as an
attendant at a stupa's entrance, its bowl used to
receive devotees' donations.

Torso of a Bodhisattva

Pakistan, ancient region of Gandhara
(modern Peshawar region), ca. 5th century
Schist, H. 64½ in. (163.8 cm)
Purchase, Lila Acheson Wallace Gift,
1995 (1995.419)

Cult images of bodhisattvas became an
important dimension of Mahayana (the
Great Wheel sect of North Indian Bud-
dhism) Buddhist worship in the fourth
to the fifth century. The monasteries of
the Gandharan region commissioned
large-scale bodhisattvas in recognition of
the growing popularity of these interven-
tionist deities, which embody Buddhist
compassion. The cult of Avalokiteshvara
represents the highest expression of this
sentiment. Probably from the Sahri-Bahlol
monastery, this large stone torso, from
a figure originally about ten feet tall, is a
spectacular survivor from that era. Sen-
sitively modeled and dressed in a draped
monk's robe, it reflects a lingering memory
of contact with the Hellenistic West.

above

Buddha

India, Uttar Pradesh, Mathura, Gupta
dynasty, 5th century

Sandstone, H. 33⅝ in. (85.5 cm)

Purchase, Enid A. Haupt Gift, 1979 (1979.6)

This Buddha image embodies the qualities of
radiant inner calm and stillness, the products
of supreme wisdom. The figure once raised his
right hand (now missing) in the characteristic
abhaya-mudra, a gesture dispelling fear and
imparting reassurance. The Buddha is robed
in the simple, uncut cloth of a monk, and his
religiosity is further conveyed by a large halo
and auspicious markings (*lakshanas*), both
natural and supernatural, denoting Buddha-
hood (the state of perfect enlightenment). As
the summation of stylistic development in a
period of Buddhist expansion, this representa-
tion became the benchmark for the Buddha
image throughout Asia.

below

Seated Buddha Expounding the Dharma

Sri Lanka, Anuradhapura, Late Anuradhapura period,
late 8th century

Copper alloy, H. 10½ in. (26.7 cm)

Purchase, Harris Brisbane Dick Fund, The Vincent Astor
Foundation Gift, Acquisitions and 2008 Benefit Funds,
and John Stewart Kennedy Fund, by exchange, 2009
(2009.60)

The quintessential icon of early Buddhist Sri
Lanka is the Buddha gesturing *vitarka-mudra*,
imparting his dharma to all. Seated in a
meditative yogic posture, he wears the monk's
uttarasanga, an untailored length of cloth
drawn tautly around the body, with his right
shoulder exposed in the southern manner of
Buddhism. His hair is expressed in short, tight
curls to evoke his renunciation of the material
world, when he cut off his hair and gave away
his princely adornments. The eye sockets were
inlaid with precious stones or rock crystal to
add a heightened level of realism. The flame-
shaped head protuberance (*ushniha*) is one of
the principal auspicious markings (*lakshanas*)
of Buddhahood.

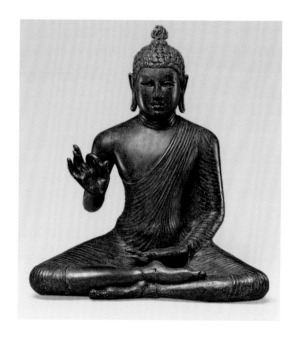

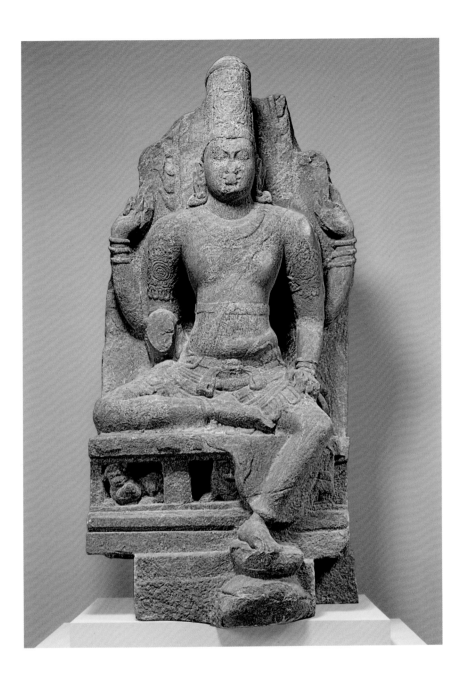

Enthroned Vishnu

India, Tamil Nadu, Pandya dynasty,
second half of the 8th–early 9th century
Granite, H. 9 ft. 9 in. (2.97 m)
Purchase, The Charles Engelhard Foundation Gift,
in memory of Charles Engelhard, 1984 (1984.296)

This monumental sculpture—the largest in the Museum's South Asian collection—is a rare example of the art of the Pandya dynasty, which, along with the Pallava dynasty, initiated the first great phase of temple building in South India. Vishnu sits on a lion throne in the relaxed, regal posture of *lalitasana*. His role in Hinduism is to restore order to the human world and to combat evils that threaten the stability of the universe. He originally held a conch (used as a battle trumpet) in his upper left hand and a war discus in his upper right, and his lower right hand was raised in *abhaya-mudra*.

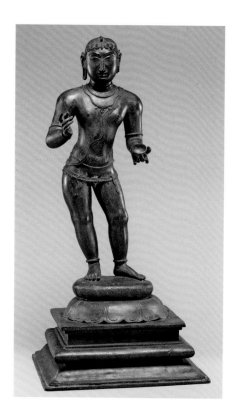

left
Child Saint Sambandar
India, Tamil Nadu, Chola dynasty, late 11th century
Copper alloy, H. 29⅜ in. (74.6 cm)
Purchase, Lila Acheson Wallace and Doris
Wiener Gifts, 2010 (2010.230)

Sambandar, the popular seventh-century child saint, is one of the *muvar*, the three principal saints of South India. Legend recounts that after receiving a gift of milk (represented by the bowl) from the goddess Uma, the infant Sambandar devoted his life to composing hymns in praise of Lord Shiva; his raised hand points to Shiva's heavenly abode at Mount Kailash, in the Himalayas. The sculptor captured the saint's childlike quality while also empowering him with the maturity and authority of a spiritual leader. This icon was intended for processional use during temple festivals celebrating gods and saints.

right
Jain Svetambara Tirthankara in Meditation
India, Gujarat or Rajasthan, Solanki period,
first half of the 11th century
Marble, H. 39 in. (99 cm)
Purchase, Florence and Herbert Irving Gift,
1992 (1992.131)

At the heart of daily Jain religious observance is the veneration of the image of the *jina*, the conceptual basis of which is the pan-Indian ideal of the yogic ascetic. This ancient practice, celebrated in the Vedas (the most ancient Hindu texts), equates the acquisition of spiritual wisdom with the pursuit of advanced forms of meditation and withdrawal from material comforts. In Jainism, the twenty-four liberated souls who are recognized as having attained this elevated state are worshipped as *tirthankaras* (ford crossers). This *jina-tirthankara*, seated on a bejeweled throne cushion, was probably intended to represent Mahavira, the historical founder of Jainism, a near contemporary of the Buddha Shakyamuni in the fifth century B.C.

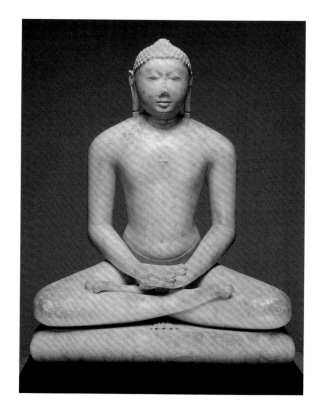

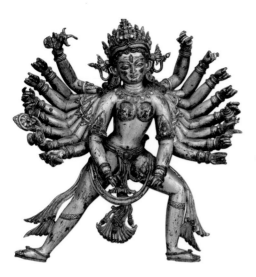

The Goddess Durga as Slayer of the Buffalo-Demon Mahisha

Nepal, 14th–15th century
Gilt copper alloy, inlaid with semiprecious
stones, H. 8¼ in. (21 cm)
Gift of Alice and Nasli M. Heeramaneck, 1986 (1986.498)

This eighteen-armed version of the goddess (*devi*) Durga originally stood on a pedestal upon which she vanquished the buffalo-demon Mahisha, trampling him with one foot while transfixing him with Shiva's trident. This display of the victory of good over evil followed a battle in which Mahisha had defeated the male gods. In despair, they invited Durga to serve as their champion, each lending her a magical weapon. In killing the buffalo-demon, Durga liberated the universe from darkness. Durga is the supreme expression of the power of the *devi*, represented as "the unassailable, the unconquerable."

Portrait of Jnanatapa Attended by Lamas and Mahasiddhas

Tibet, Riwoche Monastery, ca. 1350
Distemper on cloth, 27 × 21½ in. (68.6 × 54.6 cm)
Purchase, Friends of Asian Art Gifts, 1987 (1987.144)

This portrait was created for the Riwoche Monastery in eastern Tibet, a branch of the Taklung Monastery, and is intended to invoke the spiritual lineage of the two monasteries. The central figure is not directly named; however, the name Jnanatapa, denoting a famous Indian *mahasiddha* (a "great perfected one," one of the spiritual fathers of Tantric Buddhism), appears on a veil attached to the painting, and the deity presiding above the central figure is identified as Avagarbha. The official history of the Taklung Monastery records the first abbot of Riwoche Monastery as an incarnation of "the peerless *mahasiddha* Jnanatapa," whose Tantric teacher was Avagarbha, a Bengal *siddha*.

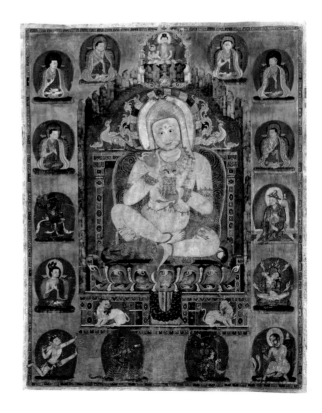

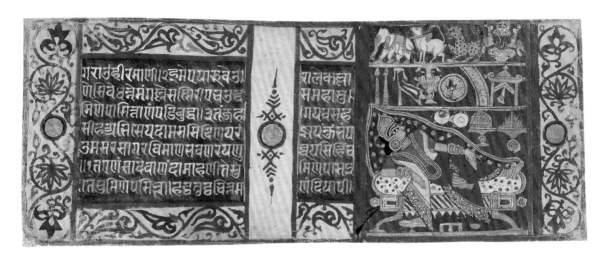

Devananda's Fourteen Auspicious Dreams Foretelling the Birth of Mahavira: Folio from a Kalpasutra Manuscript

India, Uttar Pradesh, Jaunpur, ca. 1465
Opaque watercolor, gold on paper, 4⅝ × 11½ in.
(11.8 × 29.2 cm)
Purchase, Cynthia Hazen Polsky Gift, 1992 (1992.359)

This folio is from an illustrated *Kalpasutra* (Book of Rituals), which contains the biographies of the Jain *tirthankaras* (ford crossers). It depicts the fourteen auspicious dreams of the Brahmani Devananda, who would become the mother of Mahavira. All of the dreams are alluded to by the emblems above the bedchamber scene. The use of gold and an intense ultramarine derived from lapis lazuli demonstrates an awareness of Iranian painting, which had become accessible during the Delhi Sultanate period of the fourteenth and fifteenth centuries. While retaining the broad conventions of the archaic style of western India, the work displays a bold approach to color and ornamentation that connects it to the emerging North Indian schools, which gained their fullest expression in Delhi and the surrounding regions. The horizontal format preserves a memory of the earliest illustrated books in India, printed on trimmed and treated palm-leaf pages.

Devidasa of Nurpur

Indian, active 1680–1720

**Shiva and Parvati Playing
Chaupar: Folio from a
Rasamanjari Series**

India, Himachal Pradesh, Basohli, 1694–95

Opaque watercolor, ink, silver, gold
on paper, image 6½ × 10⅞ in. (16.5 × 27.6 cm)

Gift of Dr. J. C. Burnett, 1957 (57.185.2)

This painting belongs to a series illustrating
the *Rasamanjari* (Essence of the Experience of
Delight), a fifteenth-century Sanskrit love poem
by Bhanudatta devoted to the expression and
classification of the moods and emotions of the
nayaka (hero-lover) and *nayika* (heroine-loved).
It originated in the first treatise on dramatic

arts, Bharata's *Natyashastra*. In this highly
charged scene, enlivened by bold coloring and
spatial ambiguities, Parvati is pleading with her
husband, Shiva, who has just cheated her out of
a necklace in a game of *chaupar*. The symbolic
use of color and gesture is a signature feature of
the Basohli school of this period.

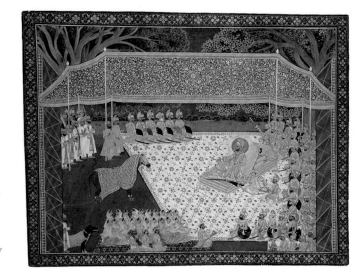

Tara

Indian, active 1836–68

**Maharana Sarup Singh Views
a Prize Stallion,** 1845–46

Opaque watercolor, ink, gold on
paper, 16¾ × 22¾ in. (42.5 × 57.8 cm)

Cynthia Hazen Polsky and Leon B. Polsky
Fund, 2001 (2001.344)

This painting by Tara, the most important
painter in the atelier of Maharana Sarup Singh,
shows the ruler of Mewar viewing a prize
stallion with a large entourage of courtiers. The
richly decorated textile elements—such as the
summer carpet and the canopy—transform
this temporary outdoor installation into an

almost palatial setting. Tara was an accomplished
recorder of major events in the maharana's life
at Udaipur palace and in the countryside of his
realm. An inscription on the reverse identifies the
ruler, the horse, and principal courtiers, suggest-
ing that this painting documents a specific event,
perhaps the maharana's birthday.

Pichwai Depicting the Celebration of the Festival of Cows

India, Deccan, late 18th–early 19th century
Painted and printed gold and silver leaf, opaque
watercolor on indigo-dyed cotton, 97⅝ × 103⅛ in.
(248 × 262 cm)
Purchase, Friends of Asian Art Gifts, 2003 (2003.177)

Pichwais (large paintings on cloth) were hung
behind the main image of a shrine. In the
seventeenth century, the cult image of the
Vallabhacharya sect, which celebrated the
worship of Krishna as Shri Nathji (child king),
was installed in Nathdvara, near Udaipur, in
Rajasthan. About this time, a small number
of wealthy Shri Nathji devotees moved to the
Deccan, where this painting was probably
commissioned. Its indigo ground and extensive
use of gold and silver are typical of Deccan
pichwais of the late eighteenth century. The
unusual iconography of the image indicates
that it was made for the Festival of Cows
(*Gopashtami*), held in the late autumn to
celebrate Krishna's elevation from caretaker
of calves to cowherd.

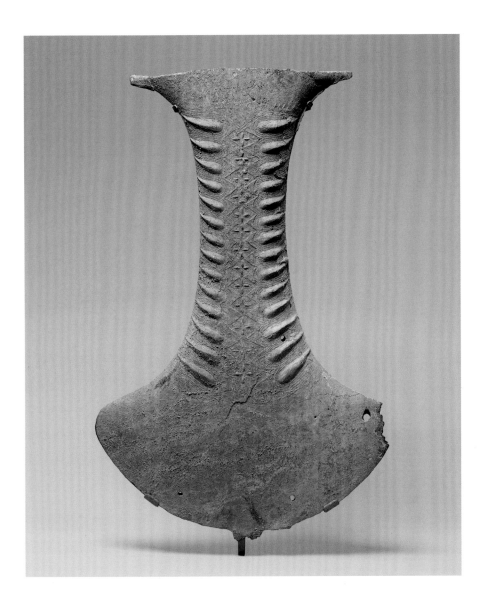

Ceremonial Object in the Shape of an Axe

Indonesia, possibly Sulawesi, Bronze and
Iron Age, ca. 100 B.C.–A.D. 300
Bronze, H. 41¾ in. (105.1 cm)
Purchase, George McFadden Gift and Edith Perry
Chapman Fund, 1993 (1993.525)

This remarkable ceremonial object, a concep-
tual as well as technical tour de force, almost
certainly functioned as a percussive instrument
to be suspended and struck. Striations on the
flanged neck, resembling the raised markings
of crocodile skin, are combined with lozenge
patterning and may have helped secure the
rope from which the instrument was hung.
An anthropomorphic face with spiral banding
and a sawtooth pattern appear on the reverse.
The object bears comparison with the so-called
Makassar Axe in the National Museum of Indo-
nesia, found in southern Sulawesi a century ago.

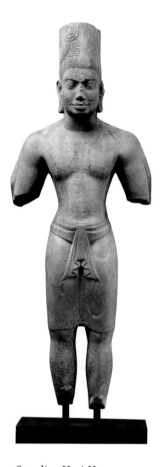

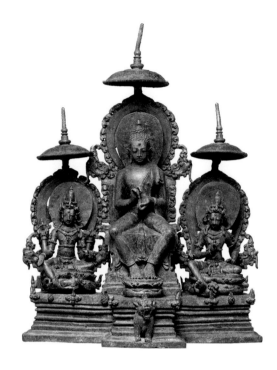

Standing Hari-Hara

Cambodia or Vietnam, pre-Angkor period,
late 7th–early 8th century
Stone, H. 35½ in. (90.2 cm)
Purchase, Laurance S. Rockefeller Gift and
Anonymous Gift, 1977 (1977.241)

Enthroned Buddha Attended by the Bodhisattvas Avalokiteshvara and Vajrapani

Indonesia, Java, Early Eastern Javanese period,
second half of the 10th century
Bronze, 11½ × 8⅝ × 5 in. (29.2 × 21.9 × 12.7 cm)
Purchase, Rogers Fund and Gift of Dr. Mortimer D.
Sackler, Theresa Sackler and Family, 2004 (2004.259)

Sculptural evidence makes clear that a cult devoted to Hari-Hara, a syncretic deity uniting Vishnu (Hari) and Shiva (Hara) in one form, was popular in the Mekong Delta area of mainland Southeast Asia in the seventh and eighth centuries. The accommodation of both principal Hindu male deities in a single cult had obvious advantages for local rulers who had recently adopted Hindu culture. An example of the pre-Angkorian Prasat Andet style, this royal cult icon once had a highly polished surface. Shiva is identified by the vertical third eye on his forehead and by his piled, matted hair, while Vishnu's conical, undecorated miter (headdress) is one of his distinguishing features in the pre-Angkor period.

This ensemble, consisting of seven separately cast pieces, is one of the most elaborate of known surviving Javanese bronzes. The central figure, his hands raised in teaching the dharma, can be identified either as Shakyamuni, the historical Buddha, or as Vairocana, his transcendent manifestation. The lion emerging from the center of the main base refers to the Buddha's clan name. Seated on the left is Avalokiteshvara, supported by his vehicle the calf-bull Nandin, and on the right is Vajrapani, accompanied by his mount, a *makara* (mythical crocodile-elephant hybrid). The figures' slender proportions and angular features mark this triad as a product of the Early Eastern Javanese period.

Standing Divinity, Possibly Shiva

Cambodia, Siem Reap Province, Angkor,
Angkor period, 11th century
Gilt copper alloy, silver inlay,
H. 51½ in. (130.8 cm)
From the Collection of Walter H. and
Leonore Annenberg, 1988 (1988.355)

This figure is the most intact metal image
surviving from Angkor. It belongs to a
small group of metal sculptures of Hindu
deities associated with royal cult practices
that was discovered in Khmer territories
in Cambodia and northeastern Thailand.
Although it defies ready identification—the
gesturing hands neither conform to a
standard iconographic *mudra* nor hold key
attributes—the figure may portray Shiva
in anthropomorphic form, an unusual
representation in Khmer art. It is possible
that the sculpture served a dual purpose,
representing primarily a cult icon for worship
in a royal sanctuary and also acting as an
ancestor image of a deceased ruler.

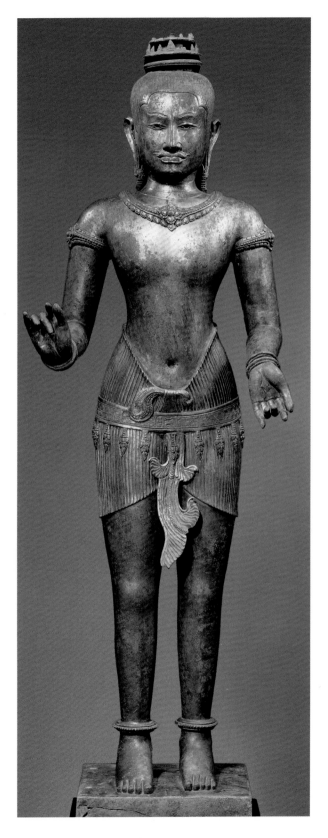

Islamic Art

Islam, the religion founded by Muhammad in A.D. 622, spread in succeeding generations from Mecca in Arabia to Spain in the West and to India and Central Asia in the East. The Museum's collection of Islamic art, which dates primarily from the seventh to the nineteenth century, reflects the diversity and range of Islamic culture. In 1891 the Museum received its first major group of Islamic objects, a bequest of Edward C. Moore. Since then the collection has grown through gifts, bequests, and purchases; it has also received important artifacts from the Museum-sponsored excavations at Nishapur, Iran, in 1935–39 and 1947. The Museum now offers perhaps the most comprehensive exhibition of Islamic art on permanent view anywhere in the world in its new galleries of the Art of the Arab Lands, Turkey, Iran, Central Asia, and Later South Asia. The emphasis on the regional context of the objects underscores the understanding that Islam did not produce a single, monolithic artistic expression, but instead connected a vast geographic expanse through centuries of change and cultural influence. Outstanding holdings include ceramics and textiles from all parts of the classical Islamic world, as well as glass and metalwork from Egypt, Syria, Mesopotamia, and Persia; royal miniatures from the courts of Persia and Mughal India; and classical carpets from the sixteenth and seventeenth centuries. An early eighteenth-century room from Syria and a fifteenth-century-style Moroccan court built by craftsmen from Fez complement the complex of galleries and study areas.

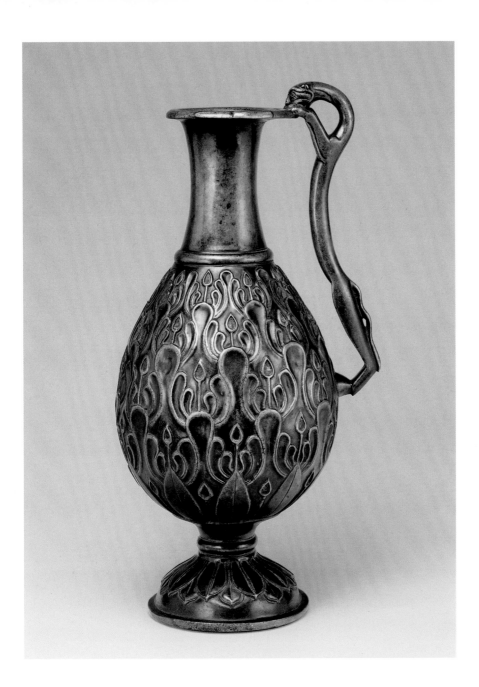

Ewer with a Feline-Shaped Handle

Iran, 7th century

Bronze; cast, chased, and inlaid with copper,

H. 19⅛ in. (48.5 cm), DIAM. 8¼ in. (21.1 cm)

Fletcher Fund, 1947 (47.100.90)

This ewer exemplifies how early Islamic art produced in Iran was influenced by earlier cultures. The shape of the ewer is reminiscent of metalwork during both the Parthian (247 B.C.–A.D. 224) and Sasanian (A.D. 224–651) empires. The duck heads on the rim and the abstract vegetal design covering the body are motifs of purely Sasanian derivation. The overall composition and forms demonstrate the transition from a figural style to a growing taste for rhythmic repeating patterns in the early Islamic period. The handle is shaped like an elongated cat, which peers at the ducks on the rim as if about to pounce on them.

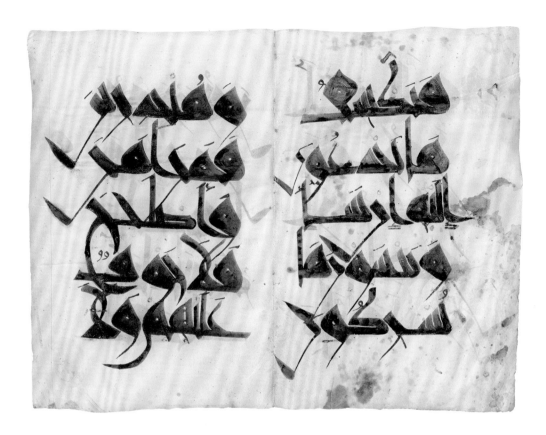

Bifolio from the Mushaf al-hadina

Probably Tunisia, Qairawan, ca. A.H. 410/A.D. 1019–20
Ink, opaque watercolor, gold on parchment,
17½ × 23⅜ in. (44.5 × 60 cm)
Purchase, James and Diane Burke Gift, in honor
of Dr. Marilyn Jenkins-Madina, 2007 (2007.191)

The *Mushaf al-hadina* (known as the Nurse's
Qur'an) was commissioned for donation to the
Great Mosque of Qairawan by the nursemaid of
Abu-Manad Badis ibn al-Mansur (r. A.D. 996–
1016), the Zirid ruler. Written in a form of
Kufic script that was unique to North Africa,

it is remarkable not only for its calligraphy but
especially for its two inscriptions providing doc-
umentary evidence that the work was commis-
sioned by a female servant of a royal medieval
household. Female patrons associated with the
Zirid court, whether princesses or in royal ser-
vice, were not uncommon. They commissioned
Qur'ans to exemplify their wealth and piety. The
manuscript was copied on animal-derived parch-
ment, which remained in use in this region long
after paper was commonly used for Qur'ans in
Egypt, Iraq, and Iran.

Bowl with Arabic Inscription

Iran, Nishapur, 10th century
Earthenware; white slip with black slip
decoration under transparent glaze,
H. 7 in. (17.8 cm), DIAM. 18 in. (45.7 cm)
Rogers Fund, 1965 (65.106.2)

Inscriptions figure prominently in the decoration of objects and buildings throughout the history of Islamic art. Yet it is on bowls such as this one, which were made in the eastern Islamic world, that they were used with an unequaled purity and power, both as calligraphy and to enhance the objects they decorated. This bowl is an unusually large, particularly fine example of its kind. The inscription, in elegant Kufic script, reads: PLANNING BEFORE WORK PROTECTS YOU FROM REGRET; PROSPERITY AND PEACE.

Panel

Spain, probably Córdoba, 10th–early 11th century
Ivory; carved and inlaid with stone with traces
of pigment, 4¼ × 8 in. (10.8 × 20.3 cm)
John Stewart Kennedy Fund, 1913 (13.141)

This panel, carved from a single piece of elephant ivory, once adorned one side of a rectangular box. It belongs to a group of tenth- and eleventh-century ivories made in Spain during the reign of the Umayyad caliphs (711–1031). They were created mainly for the royal family and were made in the capital, Córdoba, or in Madinat al-Zahra, the royal residence. Because of the Umayyads' Syrian roots, it is not surprising that many of the motifs found on these ivories can be traced to that area. The leaf arabesques on this plaque are a stylized version of the vine-and-acanthus scroll popular in late antiquity.

Crescent-Shaped Pendant with Confronted Birds

Egypt, 11th century

Gold, cloisonné enamel, turquoise; filigree,
1¾ × 1⅜ in. (4.5 × 3.5 cm)

Theodore M. Davis Collection, Bequest of
Theodore M. Davis, 1915 (30.95.37)

Art produced in Cairo during the reign of the Fatimids (969–1171) is characterized by a notable increase in the use of human and animal motifs and by a high level of craftsmanship. This pendant, with its elaborate designs constructed in filigree on a gold grid, is an especially fine example of goldwork. The Fatimids borrowed from Byzantine art the use of crescent-shaped ornaments as well as the technique of cloisonné enamel, which was employed here for the birds in the center. The goldsmith may have bought the inserts ready-made and then placed them in the gold setting, fixing them with adhesive.

Luster Bowl with Winged Horse

Iran, late 12th century

Stonepaste; luster-painted on opaque monochrome glaze, H. 3¼ in. (8.3 cm), DIAM. 8 in. (20.3 cm)

Rogers Fund, 1916 (16.87)

In the twelfth century, potters emigrating from Egypt or Syria introduced luster-painted ceramics to Iran. Consequently, early luster production in Iran shares characteristics with lusterwares made in Fatimid Egypt, including the monumental quality of this bowl's design, featuring a large-scale, winged horse in white against a clearly distinguished luster ground, and the festooned border. Formerly, this bowl was attributed to Rayy (near Tehran), but it is now believed that Kashan to the south was the only luster-producing center at the time.

Ja'far ibn Muhammad ibn 'Ali,
active late 12th century
Incense Burner of Amir Saif al-Dunya wa'l-Din Muhammad al-Mawardi
Iran, dated A.H. 577/A.D. 1181–82
Bronze; cast, engraved, chased, pierced,
33½ × 32½ × 9 in. (85.1 × 82.6 × 22.9 cm)
Rogers Fund, 1951 (51.56)

Zoomorphic incense burners were popular during the Seljuq period (ca. 1040–1157). This example in the shape of a lion is exceptional for its monumental scale, the refinement of its engraved ornament, and the wealth of information provided by the Arabic calligraphic bands inscribed on its body. These include the names of the patron and the artist, as well as the date of manufacture. The head is removable for coal and incense to be placed inside, and the body and neck are pierced so that the scented smoke could escape. The incense burner's large size suggests that it was made for a palatial setting.

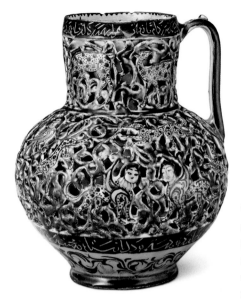

Pierced Jug with Harpies and Sphinxes
Iran, probably Kashan, dated A.H. 612/A.D. 1215–16
Stonepaste; openwork decoration, polychrome
painted under turquoise glaze, H. 8¼ in. (20.8 cm),
DIAM. 6⅝ in. (16.8 cm)
Fletcher Fund, 1932 (32.52.1)

With a carved and pierced outer shell that
surrounds a solid inner container, this intricate
feat of pottery emulates a metal object. The
openwork—featuring Harpies (mythical bird-
women), Sphinxes, quadrupeds (four-footed
mammals), and scrolls—was first painted with
touches of black and cobalt blue. The entire jug
was then covered in a transparent turquoise
glaze. The Persian verses around the rim were
written by the poet Rukn al-Din Qummi, and an
anonymous love poem near the base includes
the date of production.

Mosque Lamp for the
Mausoleum of Amir Aydakin
al-'Ala'i al-Bunduqdar
Egypt, probably Cairo, shortly after 1285
Brownish glass; blown, folded foot, applied
handles; enameled and gilded, H. 10⅜ in.
(26.4 cm), DIAM. 8¼ in. (21 cm)
Gift of J. Pierpont Morgan, 1917 (17.190.985)

Mamluk amirs adopted emblems, often
connected to their ceremonial roles at court,
which decorated the objects and buildings they
commissioned. Here the two gold crossbows
against a red shield indicate that the patron
of this lamp held the high-ranking office of

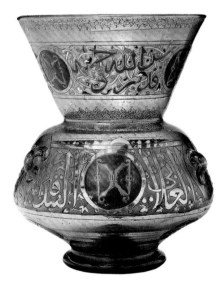

bunduqdar (keeper of the bow) at the Mamluk
court. The inscription states that the lamp was
ordered for the mausoleum of Aydakin al-'Ala'i,
who died in Cairo in 1285.

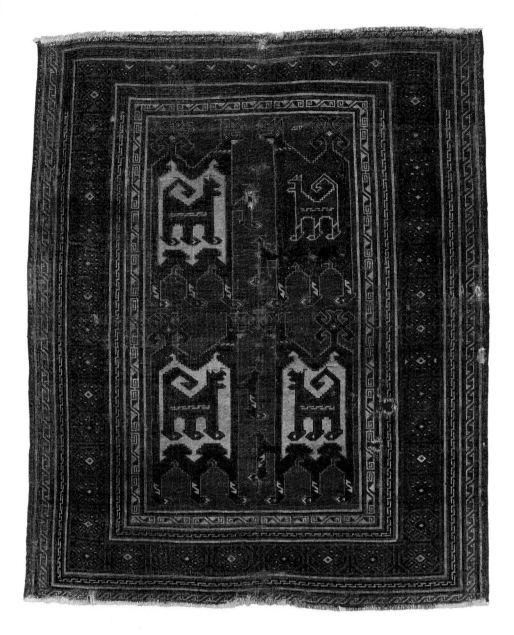

Confronted Animal Rug

Turkey, 14th century
Wool (warp, weft, and pile); symmetrically
knotted pile, 65 × 54½ in. (165.1 × 138.4 cm)
Purchase, Harris Brisbane Dick Fund, Joseph Pulitzer
Bequest, Louis V. Bell Fund and Fletcher, Pfeiffer and
Rogers Funds, 1990 (1990.61)

With its highly geometric design, this wool
rug represents an early tradition of weaving
popular in Europe, where similar rugs are found
in fourteenth- and fifteenth-century churches
and depicted in paintings of that period. In fact,
the depiction of a rug with the same design
in an early fifteenth-century Sienese painting
allowed for the dating of this example. It is
one of only three complete rugs in the world
from such an early date, and its design of
large, confronted (facing) animals, each with
a smaller animal inside, probably derives from
contemporary textiles. Later Turkish carpets
of the sixteenth century incorporated floral
and vegetal motifs as well as distinctive styl-
ized stars and medallions.

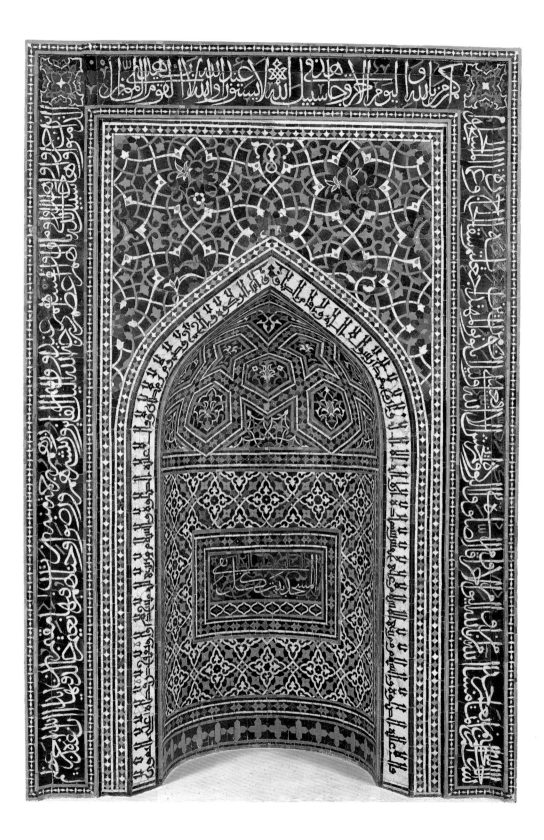

The Elephant Clock: Folio from a Book of the Knowledge of Ingenious Mechanical Devices

Syria, dated A.H. 715/A.D. 1315
Ink, opaque watercolor, gold on
paper, 11⅞ × 7¾ in. (30 × 19.7 cm)
Bequest of Cora Timken Burnett, 1956 (57.51.23)

This page comes from a 1315 treatise on
inventions of the author Isma'il al-Jazari. His
Elephant Clock was especially intricate: every
half hour, the bird on the dome whistled, the
man below dropped a ball into the dragon's
mouth, and the driver hit the elephant with
his goad. This automaton is reminiscent of the
elaborate clocks found on medieval town halls
in Europe, which made the passage of time
more entertaining through the performance of
the moving figures. The folio is a rare survival
from Syria, where few such manuscripts from
this date are known.

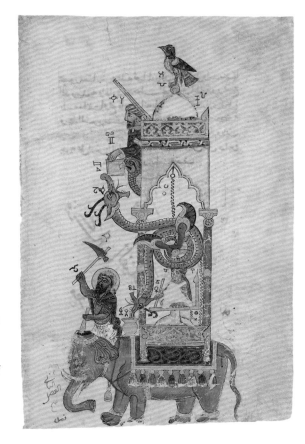

opposite

Mihrab

Iran, Isfahan, A.H. 755/A.D. 1354–55
Mosaic of polychrome-glazed cut tiles on stonepaste body,
set in mortar, H. 11 ft. 3 in. × 9 ft. 5⅝ in.
(3.43 × 2.89 m)
Harris Brisbane Dick Fund, 1939 (39.20)

The most important element in any mosque is
the *mihrab*, the niche that indicates the direction
of Mecca, the Muslim holy pilgrimage site in
Arabia, which Muslims face when praying. This
example from the Madrasa Imami in Isfahan is
composed of a mosaic of small glazed tiles fitted
together to form various patterns and inscriptions.
Qur'anic verses run from the bottom right
to the bottom left of the outer frame; a second
inscription with sayings of the Prophet, in Kufic
script, borders the pointed arch of the niche; and a
third inscription, in cursive, is set in a frame at the
center of the niche. The result is one of the earliest
and finest surviving examples of mosaic tile work.

Pair of Minbar Doors

Egypt, Cairo, ca. 1325–30
Rosewood, mulberry wood; carved, inlaid
with carved ivory, ebony, other woods,
77 ¼ × 35 × 1¾ in. (196.2 × 88.9 × 4.4 cm)
Edward C. Moore Collection, Bequest of
Edward C. Moore, 1891 (91.1.2064)

A *minbar*, or pulpit, consists of a podium
that has doors at its base and is reached by
stairs. This pair of doors probably comes
from the *minbar* of the mosque of the amir
Saif al-Din Qawsun in Cairo. Furnishings
in Cairo's mosques, especially during the
Mamluk period (1250–1517), were deco-
rated with intricately constructed poly-
gons. This pair of doors exhibits a great
variety of patterns, most of which are also
found in other media, such as stone carv-
ings, marble mosaics, and stucco window
grilles. The accurate cutting required to
make these patterned objects is remark-
able, as every piece affects the whole.

Jonah and the Whale: Folio from a Jami' al-tawarikh

Iran, ca. 1400
Ink, opaque watercolor,
gold, silver on paper,
13¼ × 19½ in. (33.7 × 49.5 cm)
Purchase, Joseph Pulitzer
Bequest, 1933 (33.113)

The story of Jonah and the Whale, which is mentioned in the Qur'an, was popular in the Muslim world and frequently illustrated in manuscripts of world histories such as this one, which translates as Compendium of Chronicles. Here, however, no text accompanies the image. It may have been held up during an oral recitation, or it may have been intended for display on its own. Its monumentality, direct presentation, and strong coloring suggest the influence of wall painting. In this image, the whale delivers Jonah to shore, where a gourd vine, often depicted in Western medieval illustrations of the subject as well, curves out and over his head.

Sword Guard in the Form of Confronting Dragons

Central Asia, 14th–early 15th century
Nephrite (jade); carved, 2 × 4 × 1⅛ in.
(5.1 × 10.2 × 3 cm)
Gift of Heber R. Bishop, 1902 (02.18.765)

Several jade objects of the Timurid period (ca. 1370–1507) have terminals or handles decorated with dragon heads. However, the prototype for this object is found in Timurid metalwork. The deep green of this cross guard, a color favored by the Timurids, accentuates the stylized ferocity of the mythical beasts. The Timurids' partiality to jade is most likely rooted in their belief in its protective qualities, an attribute also associated with dragons. Considering that jade is known for its hardness and thus is extremely difficult to carve, the workmanship of this highly detailed object is extraordinary. Without a blade, we cannot tell how often this sword was used in battle, but we should assume it was used, as the Timurid period was marked by regional conflict.

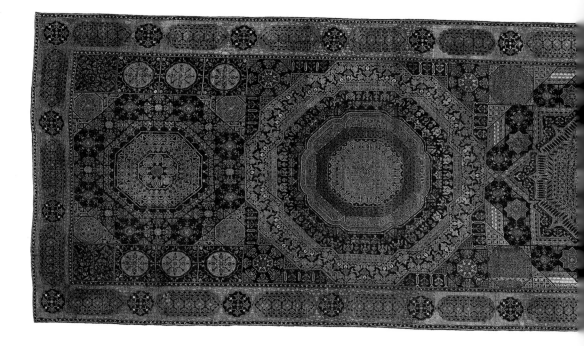

The "Simonetti" Carpet
Egypt, probably Cairo, ca. 1500
Wool warp, weft, pile; asymmetrically
knotted pile, 29 ft. 5 in. × 7 ft. 10 in. (8.97 × 2.39 m)
Fletcher Fund, 1970 (1970.105)

Named the "Simonetti" carpet after a former
owner, this majestic weaving is among the
most famous of all Mamluk carpets. One
of the larger floor coverings of its type, this
example has five medallions instead of the
more customary one or three, and it displays a
slightly brighter and more varied palette. Likely
produced in Egypt under the Mamluk dynasty,
such carpets are surprisingly rich in appearance
considering their relatively coarse weave and
limited color range. The overall effect is that
of a luminous mosaic.

Attributed to
Sultan Muhammad
Iranian, active first half of the 16th century
Tahmuras Defeats the Divs:
Folio from the Shahnama of Shah
Tahmasp, Iran, ca. 1525
Opaque watercolor, ink, silver, gold on paper,
11⅛ × 7⅜ in. (28.3 × 18.6 cm)
Gift of Arthur A. Houghton Jr., 1970 (1970.301.3)

The heroic ruler Tahmuras, shown here galloping
across a meadow, defeated the *divs* (demons),
who, in exchange for their lives, taught him the
art of writing. This folio from a *Shahnama* (Book
of Kings) is attributed to Sultan Muhammad, of
the first generation of artists of this illustrated
narrative of the ancient kings of Iran from their
mythical beginnings to the Arab conquest in 651.
The humor of the *divs*' ghastly faces and gestures
and the painterly treatment of their spotty skin
are typical of Sultan Muhammad's style. Details
such as kite-shaped clouds and extreme fore-
shortening reveal the artist's Turkmen roots.
Animal forms hidden in the rocks, another char-
acteristic of paintings by this artist, remind us of
the spirit world.

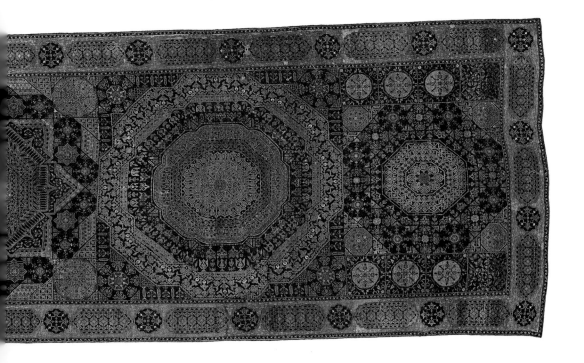

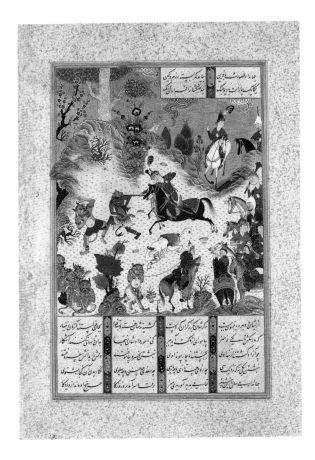

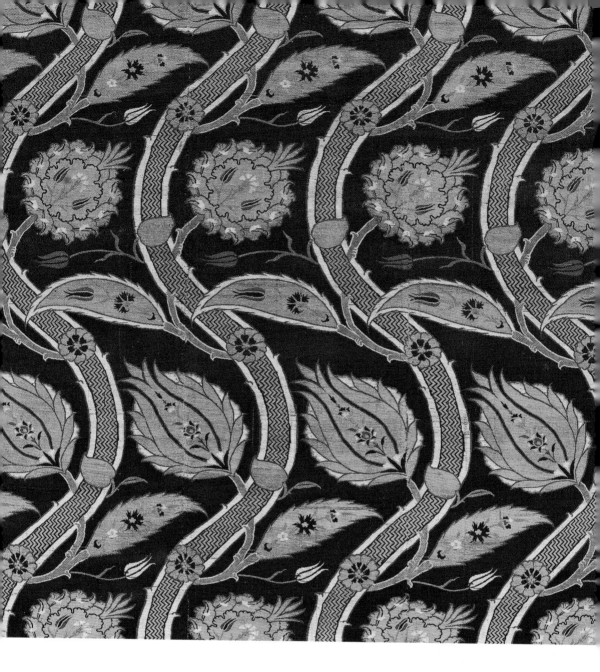

Length of Fabric

Turkey, probably Istanbul, ca. 1565–80
Silk, metal-wrapped thread; lampas,
48 × 26½ in. (121.9 × 67.3 cm)
Purchase, Joseph Pulitzer Bequest, 1952 (52.20.21)

Spectacular silks with large patterns were favored materials for luxury garments among the courtly elite of sixteenth-century Istanbul and were often used for the bold, richly colored caftans of the Ottoman sultans. In this example, the vertical pattern of foliage is stylistically comparable to that of the ceramic wall tiles in buildings of the period. The weave, referred to in Turkish as *kemha*, incorporates metal-wrapped thread into a lampas, or multiweave fabric. Ottoman *kemha* fabrics typically combine a satin ground with a woven twill design highlighted with gold. Catching the light, their glittering patterns appear to float above a shimmering background.

Habiballah of Sava
Iranian, active ca. 1590–1610
The Concourse of the Birds:
Folio from the Mantiq al-tair of
Farid al-Din 'Attar, Iran, Isfahan, ca. 1600
Ink, opaque watercolor, silver, gold
on paper, 13 × 8¼ in. (33 × 20.8 cm)
Fletcher Fund, 1963 (63.210.11)

The illustration on this folio depicts a scene
from a mystical poem, *Mantiq al-tair* (Language
of the Birds), written by a twelfth-century
Iranian, Farid al-Din 'Attar. The birds, which
symbolize individual souls in search of the
simurgh (a mystical bird representing ultimate
spiritual unity), are assembled in an idyllic
landscape to begin their pilgrimage under
the leadership of a hoopoe (perched on a rock
at center right). The careful, harmonious
composition is consistent with that of the late
fifteenth-century Timurid miniatures also in
the manuscript, but three factors indicate that
this image is later: the presence of the hunter,
who has no place in the narrative; his firearm,
a weapon that gained currency in Iran after the
mid-sixteenth century; and the signature of the
late sixteenth- to early seventeenth-century
artist Habiballah.

Tughra of Sultan Süleyman
the Magnificent
Turkey, Istanbul, ca. 1555–60
Ink, opaque watercolor, gold on
paper, 20½ × 25⅜ in. (52.1 × 64.5 cm)
Rogers Fund, 1938 (38.149.1)

Raised to a high art form in the Ottoman
court, the *tughra* (official signature) served as
the seal of Sultan Süleyman the Magnificent
(r. 1520–66). Affixed to every royal edict, this
stylized signature is an intricate calligraphic
composition comprising the name and titles of
the sultan, his father's name, and the phrase
THE ETERNALLY VICTORIOUS. Its bold, gestural
line contrasts with the delicate, swirling vine-
scroll illumination used to ornament the seal.

This signature served as the heading for a long,
narrow document in scroll form, the first line of
which is preserved in golden script.

Tile with Floral and Cloud-Band Design
Turkey, Iznik, ca. 1578
Stonepaste; polychrome painted under transparent
glaze, 9¾ × 9⅞ × ¾ in. (24.9 × 25.1 × 1.7 cm)
Gift of William B. Osgood Field, 1902 (02.5.91)

Restorations to Istanbul's Topkapi Palace
after 1574 resulted in major commissions for
ceramic tiles. Designed in the imperial workshop
in Istanbul, these tiles were executed at the
famous kilns of Iznik. This example, when
aligned with others of its type, forms a pattern
of four floral palmettes interspersed with red,
ribbonlike cloud bands. Many of these tiles
remain in place, having adorned the walls of the
Ottoman palace for more than four centuries.

Manohar
Indian, active 1582–1624
Bahram Gur and the Princess of the Blue Pavilion: Folio from a Khamsa of Amir Khusrau Dihlavi, India, 1597–98
Ink, opaque watercolor, gold on paper,
9¾ × 6¼ in. (24.8 × 15.9 cm)
Gift of Alexander Smith Cochran, 1913 (13.228.33)

Approximately one century after the Persian
poet Nizami wrote his *Khamsa* (Quintet), the
Indian poet Amir Khusrau Dihlavi composed
a response that slightly varies the stories. This
folio comes from an illustrated version of Dih-
lavi's verses made for the Mughal emperor Akbar
(r. 1550–1605). The manuscript's deluxe quali-
ties are expressed in the precise calligraphy by
Muhammad Husain Zarrin Qalam, as well as in
the gold border decorations, illuminations, and
fine paintings that incorporate Safavid Persian
and Europeanizing stylistic influences. Painted
by Manohar, this page depicts a story, told by a
princess to King Bahram Gur, about a youth and
the fairy queen he imagines meeting nightly in
a lush garden.

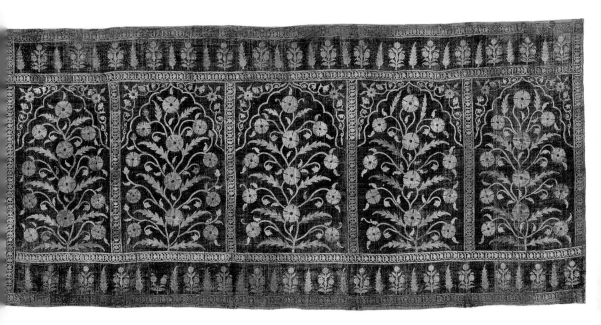

Tent Lining

India, ca. 1635
Silk, gold; cut velvet, painted, 8 ft. 9¾ in. × 18 ft. 5¼ in. (2.69 × 5.62 m)
Purchase, Bequest of Helen W. D. Mileham, by exchange, Wendy Findlay Gift, and funds from various donors, 1981 (1981.321)

In the lavish temporary encampments used by Mughal emperors when traveling for reasons of state or pleasure, the tents were lined with beautiful textiles. This panel, from the interior of a tent complex, indicates the colorful ambience of such tent cities. A gold-painted floral-and-leaf motif fills the narrow borders, and the large main border shows poppy plants alternating with miniature trees or stylized leaves. The velvet ground is intensified by glittering gold leaf, which was applied by covering parts of the design with an adhesive substance, placing the leaf on top, and rubbing it into the surface. During the reign of Shah Jahan (1627–58), when this was made, the "flower style" found favor in all media, from architecture to textiles.

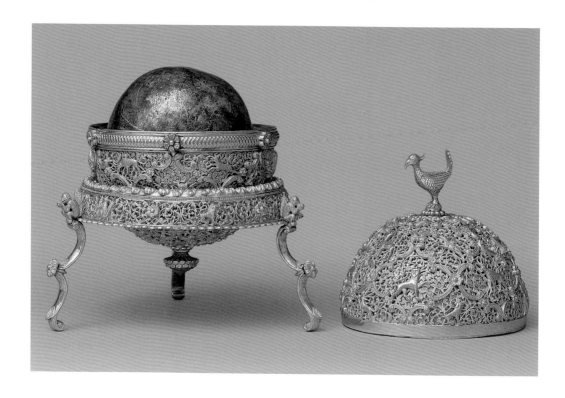

Goa Stone and Gold Case

India, Goa, late 17th–early 18th century
Container: gold; pierced, repoussé, with cast legs and
finials; Goa stone: compound of organic and inorganic
materials, H. 2⅝ in. (6.7 cm), DIAM. 5⅝ in. (14.4 cm)
Rogers Fund, 2004 (2004.244a–d)

So-called Goa stones were manufactured by
Jesuit priests living in Goa, a small province
on India's western coast. They are man-made
versions of bezoars (mixtures of gallstones and
hairs found in the stomachs of deer, sheep, and
antelopes), which, when scraped and ingested
with tea or water, were thought to have medici-
nal properties. Elaborate containers of gold
or silver were made for them and exported to
Europe. The egg-shaped gold container enclos-
ing this stone consists of rounded halves, each
covered with a layer of pierced, chased, and chis-
eled gold foliate openwork. The surface pattern
is overlaid with a variety of beasts, including
unicorns and griffins.

Damascus Room

Syria, Damascus, dated A.H. 1119/A.D. 1707
Wood, marble, stucco, glass, mother-of-pearl,
ceramic tiles, stone, iron, brass, glazes and paints, gold,
22 ft. ½ in. × 16 ft. 8 in. × 26 ft. 2 in. (6.71 × 5.1 × 8 m)
Gift of The Hagop Kevorkian Fund, 1970 (1970.170)

The Damascus room is from an upper-class
Syrian home of the Ottoman period (1516–1918).
As was customary in Islamic lands, these rooms
were reserved for the master of the house and
his guests. The antechamber contains a fountain
set in a floor of richly colored marble. The lav-
ishly painted wood panels, including window
shutters and closet doors, feature raised designs,
poetic Arabic inscriptions, and architectural
vignettes. The open niches were used for books
and other objects. The high stained-glass win-
dows set in stucco permitted tinted light to
enter, while the lower grilled windows allowed
in fresh air.

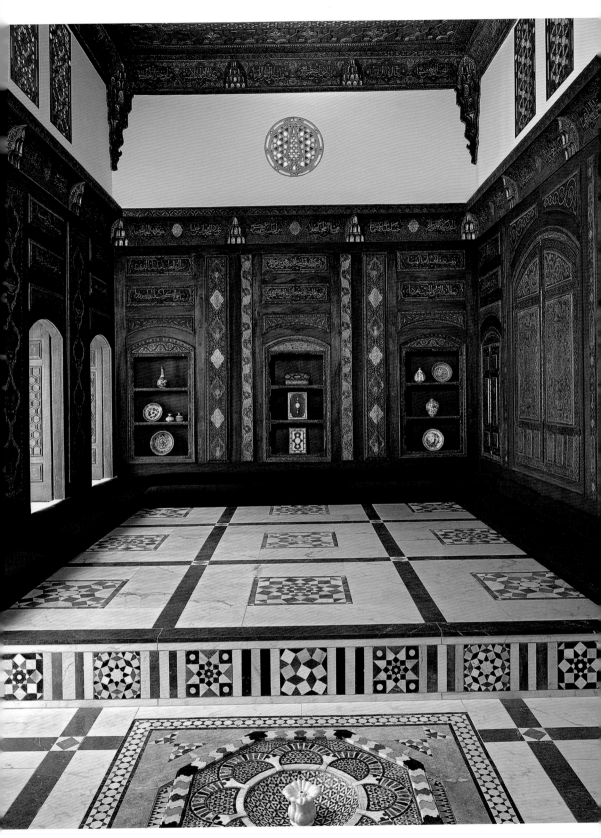

Africa, Oceania, the Americas

Drawn from a vast diversity of cultural traditions, the nearly twelve thousand works in the Department of the Arts of Africa, Oceania, and the Americas span forty centuries, four continents, and thousands of islands. The Museum's first acquisitions in these areas occurred in 1882 and were greatly expanded over the course of the twentieth century—most notably by the gift and bequest of works from the collection of Nelson A. Rockefeller. On view are figurative sculpture and masks, gold and silver ornaments, vessels, textiles, and monumental images in wood and stone. Among the grand themes that often unite these disparate artistic traditions are the roles that many works played in religion—the veneration of ancestors, deities, and other supernatural beings—and as attributes of authority—objects made for use by members of the social, political, and religious elite. Highlights include creations by artists from the Court of Benin in Nigeria; major sculptural genres from West and Central Africa; devotional works from the Ethiopian Orthodox Church; images of gods, ancestors, and spirits from New Guinea, Island Melanesia, Polynesia, and Island Southeast Asia; Precolumbian objects in gold, ceramics, and stone from Mexico and Central and South America; and Native North American works.

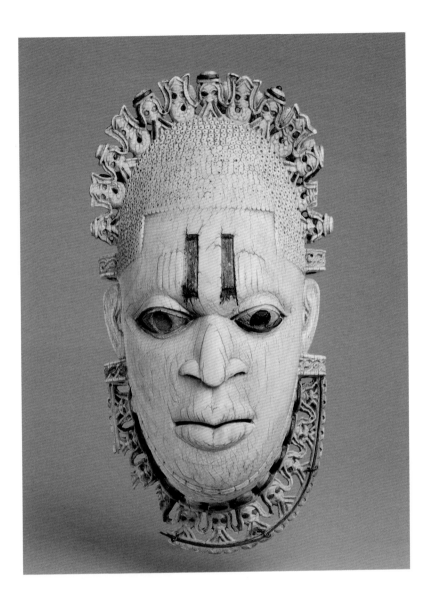

Queen Mother Pendant Mask

Nigeria, Kingdom of Benin, Edo peoples, 16th century
Ivory, iron, copper (?), 9⅜ × 5 × 3¼ in. (23.8 × 12.7 × 8.3 cm)
The Michael C. Rockefeller Memorial Collection,
Gift of Nelson A. Rockefeller, 1972 (1978.412.323)

This icon of African art was once worn as a
pectoral by the king of Benin on ceremonial
occasions. Its subject is Idia, the *iyoba* (queen
mother) and counselor to the *oba* (king) Esigie,
one of Benin's great leaders of the sixteenth
century, who commemorated her in a series
of exceptionally refined depictions. Her strong
features are framed by the elegant openwork
carving of an elaborate collar and coiffure, which
feature miniature motifs that were attributes of
power: Portuguese traders, who brought great
wealth to the kingdom; and the mudfish, a
creature whose existence in two distinct realms
is a metaphor for the semidivine identity of
Benin's leadership.

below

Seated Couple

Mali, Dogon peoples, 18th–early 19th century
Wood, metal, H. 28¾ in. (73 cm)
Gift of Lester Wunderman, 1977 (1977.394.15)

This work's impressive scale and formal
complexity have led scholars to suggest that
it may have been created for display at the
funerals of influential members of a Dogon
extended family. The graphic composition
constitutes an eloquent statement about
human duality and the distinct yet comple-
mentary partnership of man and woman.
The figures' elongated bodies are depicted as
a series of parallel vertical lines traversed by
horizontals that draw them together. With
understated elegance and an economy of
detail, the artist distilled man and woman to
a perfectly integrated and harmonious union.

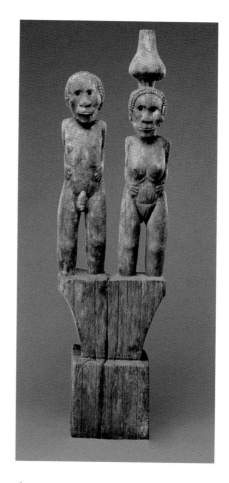

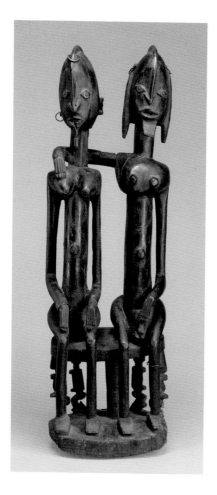

above

Couple

Madagascar, Menabe region, Sakalava peoples,
17th–late 18th century
Wood, pigment, H. 39 in. (99.1 cm)
Purchase, Lila Acheson Wallace, Daniel and Marian
Malcolm, and James J. Ross Gifts, 2001 (2001.408)

Created as the finial of a freestanding exterior
monument, this couple ranks as the foremost
artistic achievement of a region where African
and Indian Ocean aesthetic traditions converge.
The idea of the fundamental complementary
relationship of man and woman, so eloquently
depicted here, is an important theme in Mala-
gasy spiritual life. The work's quiet power and
lyrically balanced symmetry have made it one of
the rare examples of southeast African sculpture
to have influenced Western art. It was known in
Paris by the early twentieth century and entered
the collection of the British sculptor Sir Jacob
Epstein about 1922–23.

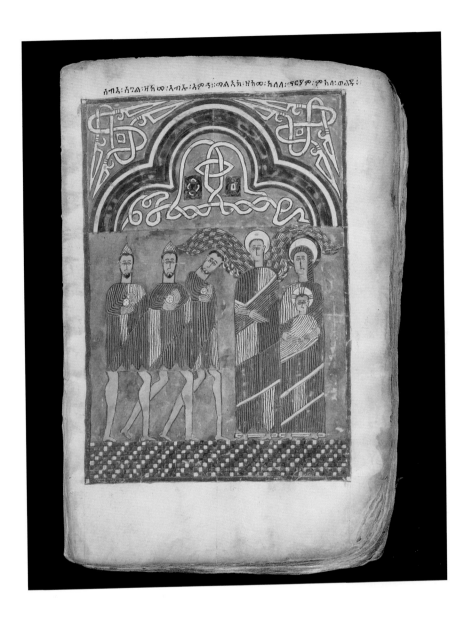

Illuminated Gospel

Folio 8r, The Adoration of the Magi
Ethiopia, Amhara region, late 14th–early 15th century
Wood, vellum, pigment, 16½ × 11¼ × 4 in.
(41.9 × 28.6 × 10.2 cm)
Rogers Fund, 1998 (1998.66)

This illuminated Gospel, created at a monastic center in the Lake Tana region of Ethiopia, is a rare surviving example of a devotional work predating the sixteenth century from this outpost of Christianity. Its text and imagery draw upon Byzantine and Coptic prototypes that were first translated into Classical Ethiopic as well as a local pictorial idiom in the sixth century. Lavish Gospel texts, the holiest of an ecclesiastic center's possessions, were received as gifts from royal patrons. In this example, illustrating the Adoration of the Magi, the stylized painting combines bold figurative imagery with an emphasis on rich, abstract patterns that define the textiles worn at that time and the settings in which the narrative unfolds.

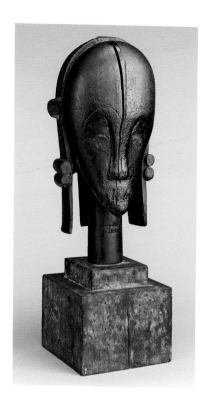

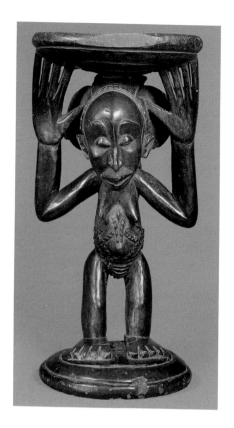

Sculptural Element from a Reliquary Ensemble

Gabon, Fang peoples, Betsi group,
19th–early 20th century
Wood, metal, palm oil, 18¼ × 9¾ × 6⅝ in.
(46.5 × 24.8 × 16.8 cm)
The Michael C. Rockefeller Memorial Collection,
Bequest of Nelson A. Rockefeller, 1979 (1979.206.229)

The most monumental of the known free-standing heads created by Fang masters from equatorial Africa during the nineteenth century, this work relates to a tradition in which figurative sculptures of the founding ancestors of an extended lineage are positioned on top of portable family altars containing precious relics. Once divorced from that context in the early twentieth century, the sculpture became a source of inspiration to artists in the West. Acquired by the Chilean poet Vicente Huidobro shortly after his arrival in Paris in 1918, it may have moved him to write the poem "Ecuatorial," which he dedicated to Picasso.

The Buli Master

possibly Ngongo ya Chintu
Hemba, Democratic Republic of the Congo, ca. 1810–1870
Prestige Stool with Female Caryatid,
19th century
Wood, metal studs, H. 24 in. (61 cm)
Purchase, Buckeye Trust and Charles B. Benenson Gifts,
Rogers Fund and funds from various donors, 1979 (1979.290)

Among the most significant possessions of Luba chiefs are elaborately carved seats of office supported by caryatid figures considered integral to the investiture ceremony that establishes their right to rule. The Luba trace succession and inheritance through the female line; thus, the caryatid imagery found on royal seats represents female ancestors who provide the chiefs with symbolic support. This ceremonial seat of office has been attributed to the Buli Master, one of the best-known African artists active before Europe's colonization of the region. This sculptor's highly expressive style is evident in the figure's elongated features, prominent cheekbones, and emotional intensity.

Mangaaka Power Figure

Democratic Republic of the Congo, Chiloango River
region, Kongo peoples, mid–late 19th century
Wood, paint, metal, resin, ceramic, H. 46½ in. (118 cm)
Purchase, Lila Acheson Wallace, Drs. Daniel
and Marian Malcolm, Laura G. and James J. Ross,
Jeffrey B. Soref, The Robert T. Wall Family, Dr. and
Mrs. Sidney G. Clyman, and Steven Kossak Gifts,
2008 (2008.30)

The Central African *nkisi n'kondi* is a ubiquitous
genre in African art. Conceived to house
specific mystical forces, these power figures
were collaborative creations of Kongo sculptors
and ritual specialists. They document vows
sealed and treaties signed and symbolize the
eradication of evil. Identified with *mangaaka*,
the preeminent force of jurisprudence, this
example is attributed to the atelier of a master
active along the coast of Congo and Angola at
the end of the nineteenth century. The various
metals embedded in the expansive torso attest
to the figure's central role as witness to and
guardian of affairs critical to its community.

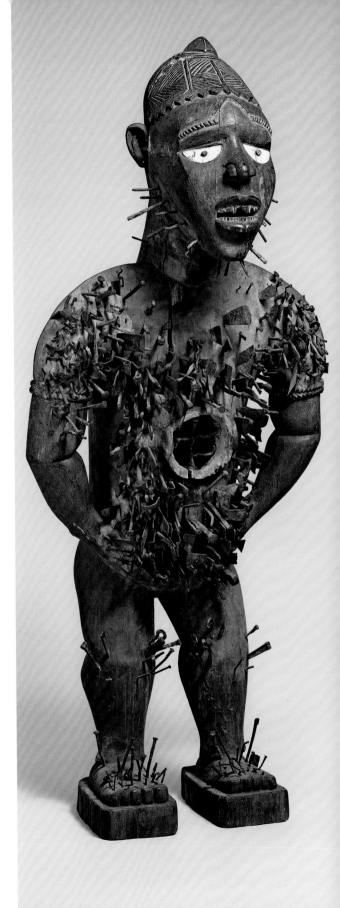

Male Figure

French Polynesia, Gambier Islands, Mangareva,
18th–early 19th century
Wood, H. 38¾ in. (98.4 cm)
The Michael C. Rockefeller Memorial Collection,
Bequest of Nelson A. Rockefeller, 1979 (1979.206.1466)

The people of Mangareva in the Gambier Islands
southeast of Tahiti once venerated a diversity
of supernatural beings, including major deities,
ancestors, and other entities. Some were rep-
resented as *tiki* (human images), a term that
originated in Polynesia. Nearly all Mangarevan
sculpture was destroyed when the islanders con-
verted to Christianity in 1835–36, and roughly a
dozen works are all that survive today. The iden-
tity of this *tiki* is unknown; however, it is similar
to examples identified historically as Rogo, an
agricultural deity who brought the rains that
sustained the growth of crops and whose pres-
ence was indicated by rainbows and mist.

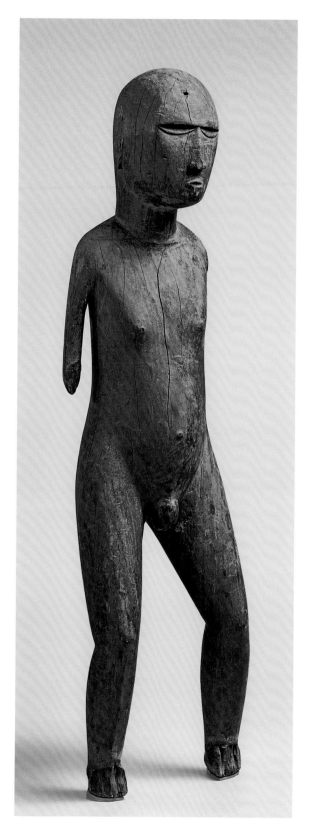

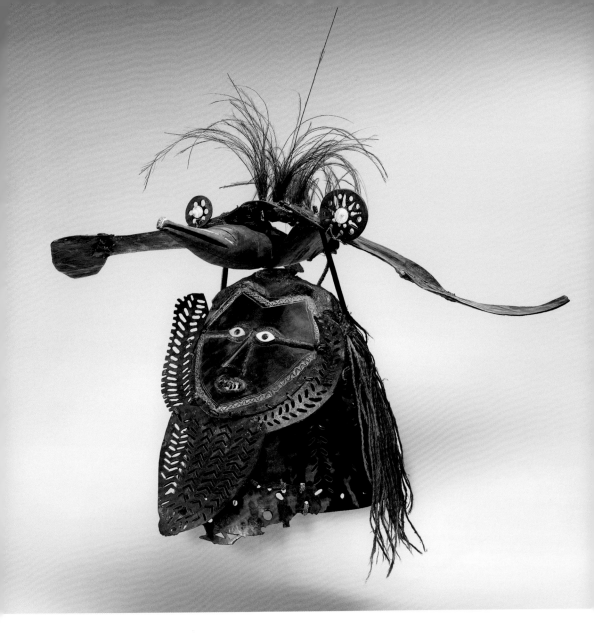

Mask

Australia, Torres Strait, probably Mabuiag Island,
mid–late 19th century
Turtle shell, wood, cassowary feathers, fiber,
resin, shell, paint, H. 21½ in.(54.6 cm)
The Michael C. Rockefeller Memorial Collection,
Purchase, Nelson A. Rockefeller Gift, 1967 (1978.412.1510)

Unique to the Torres Strait Islands between
Australia and New Guinea, turtle-shell masks
were constructed by heating individual pieces
of turtle shell, bending them into the desired
shape, piercing the edges, and joining them

together with fiber to create three-dimensional
forms. Probably from Mabuiag Island, this mask
was likely used during funerary ceremonies
and increase rites (rituals designed to ensure
bountiful harvests and abundant fish and
game). During these rites, men wore the masks,
known as *buk*, *krar*, or *kara*, with rustling dance
costumes of grass and reenacted events from
the lives of primordial culture heroes. This
mask, which may depict one such culture hero,
is surmounted by a frigate bird, perhaps his
personal totem.

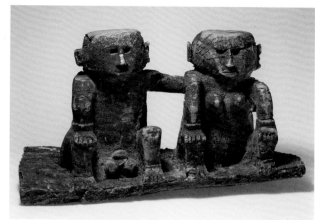

Ancestral Couple
Indonesia, Nusa Tenggara, Flores Island,
Nage people, late 19th–early 20th century
Wood, H. 11¾ in. (29.8 cm)
Gift of Fred and Rita Richman, 2006 (2006.510)

This remarkable ancestral couple from
the Nage people of Flores Island in
Indonesia probably represents the
founders of one of the village clans.
Human images (*ana deo*) depicting ancestor
spirits and other supernatural beings were
frequently associated with ancestral shrines.
Possibly an independent sculpture, the pair may
alternatively have been riders who sat atop a
ceremonial horse figure in a shrine, from which
they were later removed and preserved as a sacred
object. Whatever their original context, the fig-
ures—the man tenderly embracing his consort—
present a quiet dignity that is compelling.

Skull Hook
Papua New Guinea, Papuan Gulf region,
Omati River, Pai'ia'a village, Kerewa people,
19th–early 20th century
Wood, paint, H. 55⅞ in. (141.9 cm)
The Michael C. Rockefeller Memorial Collection,
Gift of Nelson A. Rockefeller, 1969 (1978.412.796)

Among the Kerewa people of southeast New
Guinea, who formerly practiced headhunting,
the most important sacred object was the *agiba*
(skull hook), a flat, openwork carving used to
display human skulls, which were hung from
the projections at the base. Each *agiba* report-
edly represented a spirit that revealed itself to
the carver in a dream. Kerewa men once lived
in vast communal houses in which each clan
or subclan had a separate cubicle with a shrine
containing one or more *agiba* and other sacred
objects. Presiding over the accumulated skulls
taken by clan members, the *agiba* symbolized
the clan's vitality and power.

Shield

Solomon Islands, probably New Georgia or
Guadalcanal Island (shield), possibly Santa
Isabel Island (inlay), early–mid-19th century
Fiber, Parinarium-nut paste, chambered-nautilus
shell, pigment, H. 33¼ in. (84.5 cm)
The Michael C. Rockefeller Memorial Collection,
Gift of Nelson A. Rockefeller, 1972 (1978.412.730)

Shimmering and enigmatic, the inlaid shields
of the Solomon Islands are made predomi-
nantly of ordinary basketry shields overlaid
with Parinarium-nut paste and then painted
and inset with mother-of-pearl. Only about
twenty-five survive today. The shields consis-
tently depict a central human figure, possibly a
warrior or protective spirit, above a transverse
band, which is often adorned, as here, with
human faces. Extremely fragile, the shields
probably served as ceremonial objects carried
as marks of social status and prowess in war.

Bis Pole

New Guinea, Indonesia, Papua (Irian Jaya) province,
Omadesep village, Asmat people, late 1950s
Wood, paint, fiber, H. 18 ft. (5.5 m)
The Michael C. Rockefeller Memorial Collection,
Bequest of Nelson A. Rockefeller, 1979 (1979.206.1611)

The towering *bis* poles of the Asmat people of
southwest New Guinea are created for a feast
that honors the recently dead and assists their
spirits in reaching the world of the ancestors.
Each pole is carved from a single inverted tree
with one root forming a winglike projection. The
large human figures in the shaft represent the
deceased individuals honored by the feast. The
lower portion, as here, occasionally depicts a
canoe transporting the dead to the afterworld.

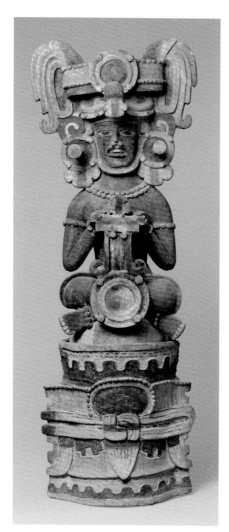

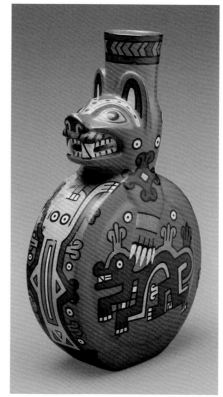

below
Feline Bottle
Peru, Wari, 6th–9th century
Ceramic, H. 8 in. (20.3 cm)
Purchase, Arthur M. Bullowa Bequest
and Rogers Fund, 1996 (1996.290)

During the second half of the first millennium A.D., the Wari peoples, centered in Peru's Ayacucho region, dominated the south-central Andes. The Wari cultural influence was particularly strong in the southern valleys of the Pacific coast, where many fine, well-preserved, and colorful textiles and ceramics are thought to have come from. This handsome bottle features a modeled feline head at the neck. It combines Wari imagery with elements of the ceramic tradition—such as the rich colors and the well-burnished surface—that flourished in the Nasca and neighboring valleys for centuries.

above
Censer with Seated King
Guatemala, Maya, 4th century
Ceramic, H. 31½ in. (80 cm)
Gift of Charles and Valerie Diker, 1999 (1999.484.1a, b)

Large ceramic censers—containers for copal and incense—are among the most complex sculptures in fired clay created by the ancient Maya peoples of southern Mexico and adjacent Guatemala. This censer, made in two parts, is thought to bear the image of a Maya king seated in a royal pose. He wears a grand headdress and ear ornaments and holds an offering tray. Smoke, thought to carry offerings to the spirits and deities in the supernatural realm, was an integral element of all sacred Maya ceremonies.

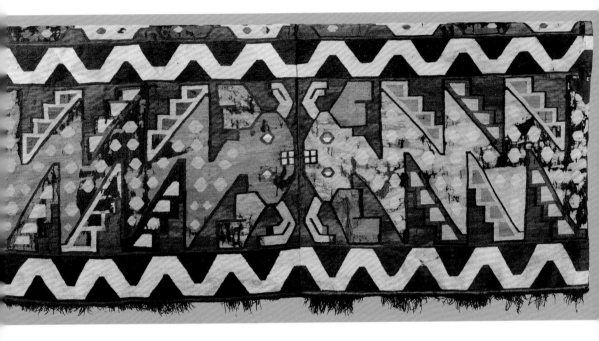

Tunic with Mythical Serpents

Peru, Nasca-Wari, 9th century
Camelid hair, H. 21½ in. (54.6 cm)
Gift of George D. Pratt, 1929 (29.146.23)

The primary item of clothing for men in ancient Peru was the tunic, an untailored shirt, with or without sleeves, with vertical armholes at the shoulder and a slit opening at the top for the neck. These tunics display a great deal of variety in weaving techniques and patterning as well as a wide range of colors. In addition to being practical, they were expressions of ethnic affiliation, social status, and religious beliefs. This example is made using a tapestry weave, a technique in which the wefts (horizontal yarns) are pushed down tightly to conceal the warps (vertical yarns) completely. It features a bold design showing two mythical serpents with spotted, zigzag bodies facing each other at the center seam of the tunic. They have large heads with bicolored eyes, bared teeth, whiskers or barbels, and ears or fins. The tunic is currently considered a hybrid style. Nasca characteristics include its shape and weaving technique, whereas the rendering of the creatures' eyes and teeth is typical of the Wari style.

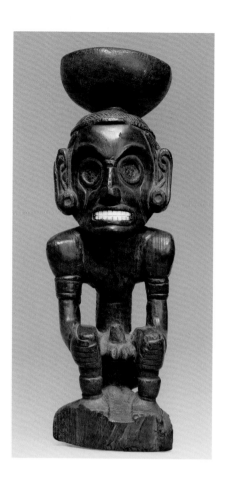

Deity Figure

Dominican Republic (?), Taino,
10th–early 11th century
Ironwood, shell, H. 27 in. (68.5 cm)
The Michael C. Rockefeller Memorial Collection,
Bequest of Nelson A. Rockefeller, 1979 (1979.206.380)

Several centuries prior to the arrival of the
Spanish in the Caribbean islands in the
late fifteenth century, the Taino peoples,
who inhabited the Greater Antilles, created
distinctive art forms for ritual use. Produced
in different sizes and materials—wood, clay,
stone, shell, and bone—the works display a
strong, compelling imagery, often emphasizing
the eyes and mouths. This striking figure
of a crouched, emaciated male clutching his
knees was called a *zemí* (idol). *Zemís*, the most
important cult objects in Taino society, were
used in ceremonies that included inhaling
cohoba, a hallucinogenic snuff.

Figure Pendant

Colombia, Tairona, 10th–16th century
Gold, H. 5½ in. (14 cm)
Gift of H. L. Bache Foundation, 1969 (69.7.10)

The Tairona people of the Sierra Nevada de
Santa Marta in northern Colombia produced
some of the grandest and most complex
gold castings ever made in the Americas.
Emphasizing volume and three-dimensional
form, this pendant depicts a broad-shouldered
male figure, perhaps a nobleman or chief,
wearing an enormous headdress with elaborate
spiral and braided elements in the sidepieces;
on his cap are two birds with oversize beaks.
The meticulously accurate miniature nose and
ear ornaments and the labret in the lower lip
are comparable to full-size examples found in
Tairona tombs.

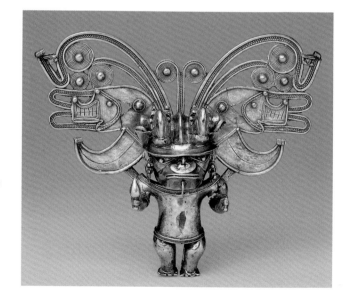

Kneeling Female Figure

Mexico, Aztec, 15th–early 16th century
Stone, H. 21½ in. (54.6 cm)
Museum Purchase, 1900 (00.5.16)

At the time of the Spanish conquest in the six-
teenth century, the Aztecs controlled most of
central Mexico from their capital city of Tenoch-
titlán, which had many impressive temples, royal
residences, colorful markets, and busy canals.

Exceptionally skilled on the battlefield and at
empire building, the Aztecs also created some
of the finest stone sculptures produced in
ancient Mexico. Lacking the attributes of Aztec
female deities, such as characteristic hairstyles
and headdresses, this kneeling figure wears a
traditional skirt held with a double-knotted belt
above the waist, ear ornaments, and a headband.
She probably represents a noble Aztec woman.

Arms and Armor

For thousands of years, arms and armor have played a vital role in virtually all cultures. The best examples often represent the highest artistic and technical capabilities of the societies and periods in which they were made, forming a unique aspect of both art history and material culture. The Museum received its first pieces of arms and armor in the 1890s. In 1904 substantial acquisitions of Japanese and European examples brought international recognition to the collection, leading in 1912 to the establishment of a separate Department of Arms and Armor, which remains the only one of its kind in the United States today. The department—one of the most comprehensive and encyclopedic in the world—endeavors to collect, preserve, research, publish, and exhibit the most distinguished examples of the art of the armorer, sword maker, and gunsmith, focusing on works that are notable for their outstanding design and decoration rather than for their purely military or technical interest. The holdings comprise approximately fourteen thousand objects, primarily from European, Near Eastern, and Far Eastern lands. Roughly one thousand pieces, from about the fifth century A.D. to the late nineteenth century, remain on permanent display, offering a broad range of objects from Europe, the United States, Japan, India, and a number of Islamic cultures.

Armor

Japan, early 14th century
Iron, leather, lacquer, silk, copper, gold,
pigments, H. (as mounted) 37½ in. (95.3 cm)
Gift of Bashford Dean, 1914 (14.100.121a–e)

This armor, called *yoroi*, is an example of a type
of cavalry armor in use from about the tenth
to the fourteenth century in Japan. Very few
yoroi survive today, and this is the only one in
an American collection. Weighing 38 pounds,

it is made up of hundreds of small iron and
leather plates coated with lacquer and joined by
silk laces. The chest area is covered in leather
stenciled with the image of the Buddhist deity
Fudo Myo-o, whose characteristics of fierceness
and immovability were well suited to samurai
ethics. This *yoroi* was preserved for centuries in
a shrine near Kyoto, where Ashikaga Takauji,
the military ruler of Japan and founder of the
Ashikaga shogunate, had reputedly donated it.

Horseman's Shield

Germany, ca. 1450
Wood, leather, linen, gesso, pigments, silver leaf,
22 × 16 in. (55.9 × 40.6 cm)
Gift of Mrs. Florence Blumenthal, 1925 (25.26.1)

Elegantly shaped cavalry shields of this type, called *targes*, were used either in tournaments or by lightly armored cavalry in Germany in the Late Gothic period. This example is painted with an elaborately rendered coat of arms, probably that of the Gottsmann family of Franconia. The female figure at the side holds a banderole inscribed with the motto HAB MYCH ALS ICH BIN (Take me as I am). The decoration, with its brilliant colors on a silver-leaf ground, is remarkably well preserved because it was hidden for centuries beneath layers of later paint. The leather-lined back of the shield is painted with a small figure of Saint Christopher to offer spiritual protection to the carrier of the shield.

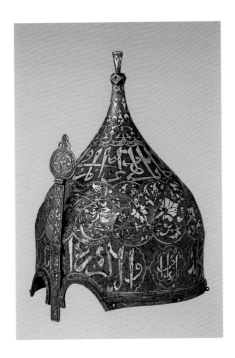

Turban Helmet

Anatolia or Iran, late 15th century
Steel and silver, H. 13⅝ in. (34.6 cm)
Rogers Fund, 1950 (50.87)

Among the rarest and most visually impressive helmets worn in the Islamic world was the so-called turban helmet, a modern term alluding to the bulbous, swirling form that evokes the shape and wrappings of a turban. While the type seems to have originated as early as the fourteenth century, most surviving examples, like this one, date from the late fifteenth to the early sixteenth century. Turban helmets were used by the Aq Quyunlu (White Sheep Turkmen) and Shirvan dynasties in Azerbaijan and Iran, and by the Ottomans as well. The surface of the helmet is densely covered with engraved and silver-damascened decoration prominently featuring Arabic inscriptions.

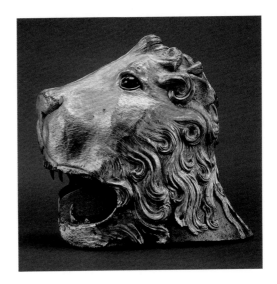

Helmet in the Form of a Lion's Head

Italy, ca. 1460–80
Steel, copper, gold, glass, pigments, textile,
H. 11⅜ in. (29.8 cm)
Harris Brisbane Dick Fund, 1923 (23.141)

This helmet is the earliest surviving example of Renaissance armor *all'antica* (in the antique style). It represents the head of the Nemean lion, whose pelt was worn as a headdress and cloak by the mythological hero Hercules, who was frequently portrayed in Renaissance art wearing the pelt as a symbol of indomitable strength,

courage, and perseverance. The helmet, weighing more than eight pounds, consists of a gilt-copper outer shell skillfully embossed to form the lion's head, which is mounted over a type of plain steel helmet known as a sallet. Beautifully sculptural, this helmet is also a masterpiece of the early Renaissance goldsmith's work.

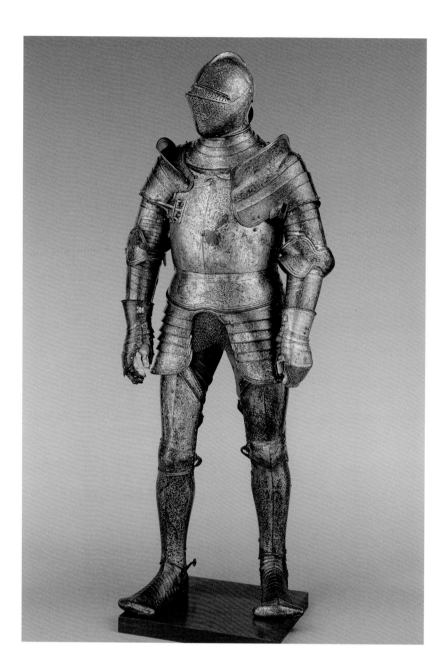

Armor Garniture

England, Greenwich, 1527
Steel, gold, leather, copper alloys, H. 6 ft. 1 in. (1.85 m)
Purchase, William H. Riggs Gift and Rogers Fund,
1919 (19.131.1, .2)

This armor, which weighs 65 pounds, is the earliest dated example from the Royal Workshops at Greenwich, established in 1514 by Henry VIII to produce armors for himself and his court. It is also the earliest surviving Greenwich garniture, an armor made with a series of exchange and reinforcing pieces by which it could be adapted for use in battle and in tournaments. In addition, the overall etching and gilding distinguish it as the most richly decorated of all Greenwich armors. The design of this ornament is attributed to the German artist Hans Holbein the Younger, who worked at the English court from 1526 to 1528.

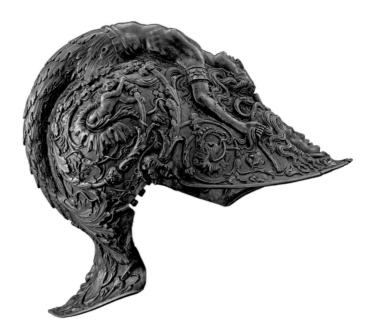

Filippo Negroli
Italian, ca. 1510–1579
**Burgonet in the
all'Antica Style,** 1543
Steel, gold, H. 9½ in. (24.1 cm)
Gift of J. Pierpont Morgan,
1917 (17.190.1720)

This burgonet (helmet), a masterpiece of
Renaissance metalwork, is signed by Filippo
Negroli of Milan, whose embossed armor was
praised by sixteenth-century chroniclers as
"miraculous" and deserving of "immortal merit."
The bowl of the helmet is made from a single
sheet of steel that is embossed in high relief
in the *all'antica* style—with motifs inspired

by classical art—and patinated to look like
bronze. The sides of the helmet are covered
with acanthus scrolls encircling putti, a
motif probably derived from the Roman wall
frescoes in the Golden House of Nero, which
was rediscovered in the late fifteenth century
and greatly influenced Renaissance design.

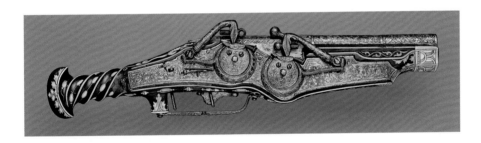

Peter Peck
German, 1503–1596, and
Ambrosius Gemlich
German, active ca. 1520–50
**Double-Barreled Wheel-Lock Pistol
of Emperor Charles V,** ca. 1540–45
Steel, gold, wood, horn, L. 19⅜ in. (49.2 cm),
CALIBER .46 in. (12 mm)
Gift of William H. Riggs, 1913 (14.25.1425)

This wheel-lock pistol, a masterpiece by the
Munich clockmaker and gunsmith Peter Peck,
combines mechanical ingenuity with sophisti-

cated design. Its etched and gilded barrels and
other metal parts were decorated by the artist
Ambrosius Gemlich with the emblems of Holy
Roman Emperor Charles V. The wheel-lock
mechanism, invented in Italy or Germany in the
late fifteenth or early sixteenth century, was the
first truly automatic ignition system, allowing a
gun to be primed and loaded in advance and
ready for immediate use. Charles V was one of the
first high-ranking patrons to commission elabo-
rately decorated firearms such as this.

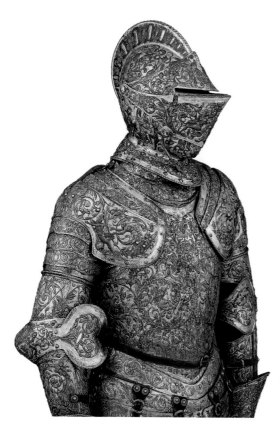

Armor of Henry II, King of France (detail)
French, ca. 1550
Steel, gold, silver, leather, textile, H. 6 ft. 2 in. (1.9 m)
Harris Brisbane Dick Fund, 1939 (39.121a–n)

This is one of the most elaborate and complete French parade armors in existence. Its surface is delicately embossed with a dense pattern of foliate scrolls inhabited by classical figures and fabulous creatures that derive from Italian late Renaissance and Mannerist ornament. The crescent moon, a symbol favored by Henry II, is also worked into the decoration. Twenty original design drawings for this armor survive. One is by Jean Cousin the Elder, and the rest are by either Étienne Delaunne or Baptiste Pellerin, all distinguished Parisian artists of the mid-sixteenth century.

Israel Schuech
German, active 1590–1610, and
Juan Martinez
Spanish, active 16th to 17th century
Rapier of Christian II, Elector of Saxony (detail), 1606
Steel, bronze, gold, jewels, glass, seed pearls, enamel, L. 48 in. (121.9 cm)
Fletcher Fund, 1970 (1970.77)

The intricately cast and chiseled gilt-bronze hilt of this sword is the only recorded work of the Dresden sword cutler Israel Schuech. The decoration of strapwork and allegorical figures, set with paste jewels and formerly enameled, rivals the opulent goldsmiths' work then in vogue at the Saxon court. The hilt is fitted with a blade from Toledo, a city famous for the quality of its sword blades, which were exported all over Europe. This example was made by Juan Martinez, who signed his work Espadero del Rey (royal sword maker).

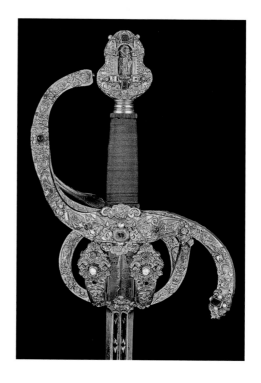

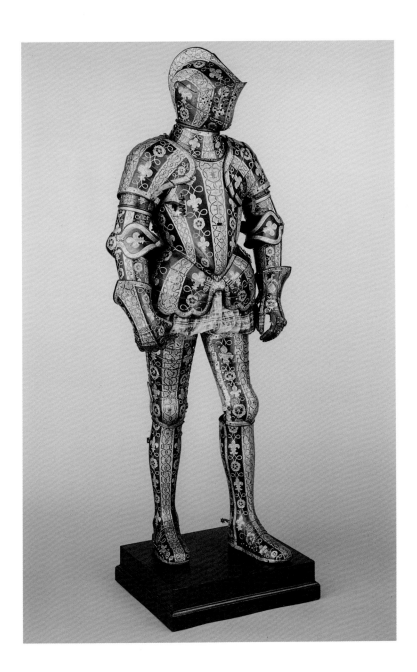

Armor Garniture of George Clifford, Third Earl of Cumberland

England, Greenwich, ca. 1585
Steel, gold, leather, textile, H. 5 ft. 9½ in. (1.8 m)
Rogers Fund, 1932 (32.130.6a–y)

The Cumberland armor, the best preserved and most extensive armor garniture from the Royal Workshops at Greenwich, represents the technical and decorative peak of that school. Designed for field and tournament use, it was made under the direction of the master armorer Jacob Halder. It comprises the man's armor (weighing 60 pounds), with several exchange or reinforcing elements, and the horse's armor, consisting of a shaffron (head defense) and saddle plates. George Clifford was a favorite of Queen Elizabeth I and was appointed Queen's Champion in 1590. The decoration of his armor includes the Tudor rose, the fleur-de-lis, and the cipher of Elizabeth—two Es back to back.

Pierre Le Bourgeois

French, d. 1627

Flintlock Gun of Louis XIII, King of France

(detail), ca. 1620

Steel, brass, silver, gold, wood, mother-of-pearl,

L. 55 in. (139.7 cm), CALIBER .59 in. (15 mm)

Rogers and Harris Brisbane Dick Funds, 1972 (1972.223)

This is one of the earliest guns equipped with
a flintlock, a firing mechanism that would
dominate firearms technology for the next
two hundred years. It was made for Louis XIII
by Pierre and Marin Le Bourgeois of Lisieux,
to whom the invention of the flintlock is
traditionally ascribed. Bearing the crowned
monogram of the king, the gun is lavishly
embellished with delicate wire and mother-of-
pearl inlays, a finely carved wood stock, and
gilt-brass fittings. Louis XIII was an avid gun
collector and an amateur gunsmith. This gun
is engraved with the inventory number 134,
indicating that it was part of the royal collection,
or *cabinet d'armes*.

opposite

Samuel Colt

American, 1814–1862

**Colt Third Model Dragoon Percussion
Revolver,** serial no. 12406, ca. 1853

Steel, gold, wood (walnut), L. 14 in. (35.6 cm),

CALIBER .44 in. (11 mm)

Gift of George and Butonne Repaire, 1995 (1995.336)

Colt revolvers were highly valued by soldiers and
frontiersmen. Deluxe Colt firearms such as this
one were standard factory models transformed
into showpieces through the addition of lavish
engraved decoration. Custom engravers at the
Colt factory in Hartford, Connecticut, many of
them recent immigrants from Germany, set the
standard for American firearms decoration in
the 1850s and 1860s. The Museum's revolver
is one of only a handful of examples with
sumptuous gold inlay, placing it among the
finest Colts in existence. One of a pair, this
pistol's mate was presented by Colt to Czar
Nicholas I of Russia in 1854, and it is now in the
State Hermitage Museum, Saint Petersburg.

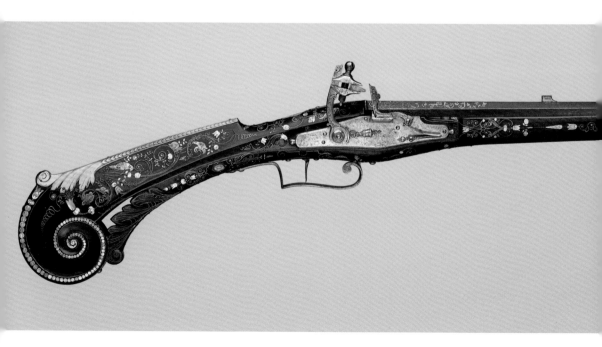

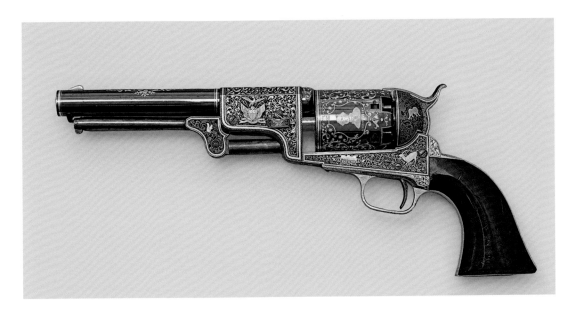

Congressional Presentation Sword
of Major-General John E. Wool (detail)
United States of America, probably Baltimore, 1854
Steel, gold, brass, diamonds, rubies, L. 39¼ in. (99.6 cm)
Purchase, Arthur Ochs Sulzberger and Mr. and
Mrs. Robert A. Goelet Gifts, 2009 (2009.8a–c)

Preserved in almost pristine condition, this
is one of the most original and finely crafted
American swords ever made. It was awarded
to General Wool by the U.S. Congress on
January 23, 1854, in recognition of his gallantry
at the battle of Buena Vista during the Mexican
War of 1846–48. Unlike most American presen-
tation swords, which were directly modeled on
European or classical examples, the Wool sword
is decidedly American in concept and iconogra-
phy. The custom of presenting swords to mili-
tary officers for distinguished service dates back
to the American Revolution.

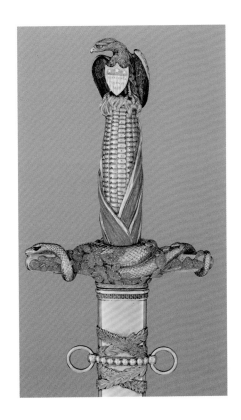

Musical Instruments

The only department at the Metropolitan Museum to exhibit objects originally meant to appeal to the ear as much as to the eye, the Department of Musical Instruments holds approximately five thousand examples from six continents and the Pacific Islands, dating from about 300 B.C. to the present. The collection, which was begun in 1889, is unsurpassed in its comprehensive scope and illustrates the development of musical instruments from all cultures and eras. Selected for their technical and social importance as well as for their tonal and visual beauty, the instruments may be interpreted as art objects, as ethnographic record, and as documents of the history of music and performance. The basic instrument types are aerophone (wind), which generates sound through the vibration of air; chordophone (stringed), through the vibration of strings; membranophone (percussion), through the vibration of a stretched membrane; and idiophone, made of naturally sonorous material(s) that require no additional tension to produce sound. A fifth type, electrophone, generates sound electronically or through amplified means. Although the greatest strength of the department lies in its encyclopedic nature, instruments of particular interest include Ming-dynasty lutes, Renaissance and Baroque instruments, Stradivarius violins, the earliest piano (1720) by Bartolomeo Cristofori, King George III's silver kettledrums, African harps and drums, and guitars owned by the Spanish virtuoso Andrés Segovia.

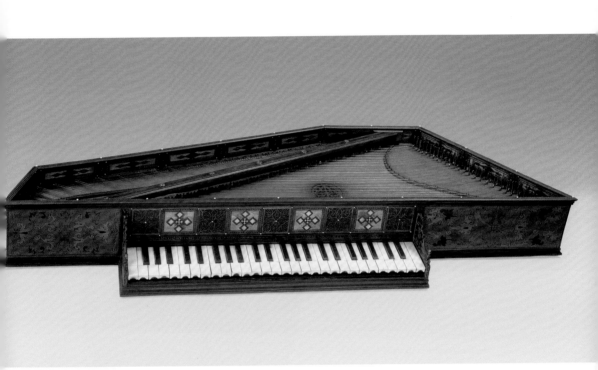

Pentagonal Spinet

Italy, Venice, 1540
Wood, various other materials, L. 57¼ in. (145.4 cm)
Purchase, Joseph Pulitzer Bequest, 1953 (53.6a, b)

Made for Elena della Rovere, duchess of Urbino, this spinet bears an elaborate decoration of certosina, painting, carving, and intarsia. Mythological figures embellish the carved keyboard brackets, and inlaid dolphins, possibly by a German craftsman, flank the keyboard itself. Symmetrical traceries over the keyboard and the sound hole have a delicate Gothic design. The motto inscribed above the keys translates as "I am rich in gold and rich in tone; if you lack goodness leave me alone." As one of the oldest playable keyboard instruments, this spinet uses crow quills to pluck its brass strings, creating a lutelike tone.

Andrea Amati
Italian, ca. 1505–ca. 1578
Violin, ca. 1560
Maple, spruce, various other
materials, L. 22⅝ in. (57.4 cm)
Purchase, Robert Alonzo Lehman
Bequest, 1999 (1999.26)

Andrea Amati, earliest of the Cremonese
luthiers (makers of stringed instruments),
is credited with defining the violin's elegant
form and setting a standard that characterizes
the work of his followers, including his two
sons, his grandson Nicolò Amati, and Antonio
Stradivari. This violin, one of the earliest
surviving, is embellished with the lily of the
House of Valois, a Latin motto translating
as "that religion is and always shall be the
only fortress," and a coat of arms, ostensibly
belonging to Philip II of Spain. Likely part of
a gift from Catherine de' Medici and Henri
II of France upon the 1559 marriage of their
daughter Elisabeth of Valois to Philip II,
the violin celebrates a union designed to
consolidate peace between France and Spain.

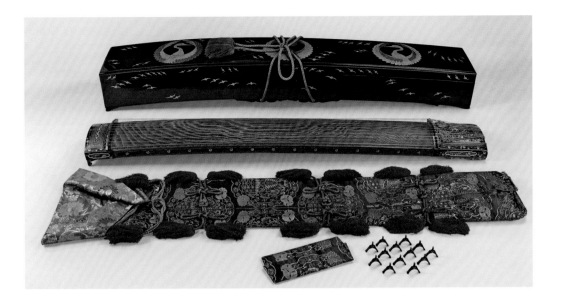

Workshop of
Goto Yujo
Japan, 1440–1512
Metalwork by
Goto Teijo
Japan, 1603–1673

Koto, early 17th century
Various woods, ivory and tortoiseshell inlays,
gold and silver inlays, metalwork, 5⅛ × 9½ × 74⅝ in.
(13 × 24.2 × 189.5 cm)
Purchase, Amati Gifts, 2007 (2007.194a–f)

This rare koto (a type of zither) is a tour de force
of Japanese decorative and musical arts. The
foundation for modern Japanese koto music

was formed during the seventeenth century,
although a strong tradition existed previously.
This koto, with its copious inlay and remarkable
decoration by Teijo, ninth-generation master and
perhaps the most skilled member of the famous
Goto family of metalwork artists, documents
this important musical development. It also
reflects the status of its owner (the powerful
Karasumaru clan) and the koto's role as a symbol
of Japan. The elaborate lacquered case, dating
from the early nineteenth century, is decorated
with gold cranes (an emblem of the Karasumaru
family) and geese.

I. B. Gahn
German, active 1698–1711
Alto Recorder in F, ca. 1700
Ivory, L. 19⅛ in. (48.6 cm)
The Crosby Brown Collection of Musical Instruments,
1889 (89.4.909)

Johann Benedikt Gahn was admitted as a
master in the Nuremberg woodturners guild
in 1698. Specializing in musical instruments,
he maintained a workshop until his death in
1711. About sixteen recorders and a few oboes

of ivory or boxwood have survived. Some of
his recorders, like this one, feature carved
decoration with acanthus leaves and a mask, a
motif linked to Nuremberg that also appears
on instruments by others, such as those of the
famous woodwind maker Johann Wilhelm
Oberlender the Elder. The alto recorder became
the favorite size among recorders after 1700.
Elephant-tusk ivory, a particularly adaptable
but exotic material, has long been employed
for valuable instruments.

Flute

Germany, Saxony, 1760–90
Porcelain and metal, L. 24⅝ in. (62.6 cm)
Gift of R. Thornton Wilson, in memory
of Florence Ellsworth Wilson, 1943 (43.34a–g)

In 1708 Johann Friedrich Böttger rediscovered
a process, already known in China, of making
hard-paste porcelain, which generated a new
luxury industry. Porcelain musical instruments
posed enormous problems because substantial
shrinkage occurred during drying and firing.

Large molds had to be made to guarantee
the precise final dimensions. Wood flutes
are easily fine-tuned and voiced by drilling;
porcelain, however, makes later manipulations
problematic. After the porcelain sections of
this flute were fired, a goldsmith completed the
metalwork, making joints, sockets, the cap, and
the key. Porcelain flutes and carillons were rare,
but ocarinas were more common. Flutes like this
one were known among the high nobility.

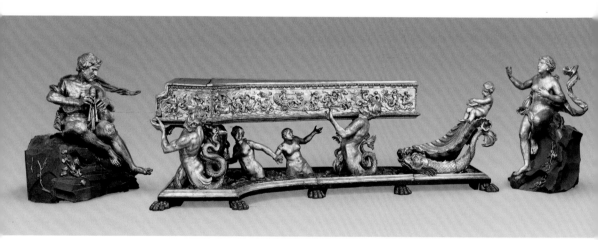

Michele Todini

Italian, baptized 1616–1689
Harpsichord and Figures, ca. 1670
Wood, various materials; harpsichord case:
118 × 38 × 14¾ in. (299.7 × 96.5 × 37.5 cm)
The Crosby Brown Collection of Musical Instruments,
1889 (89.4.2929a–e)

This gilded case, which ranks among the finest
examples of Roman Baroque decorative art,
encloses an Italian harpsichord with an unusually
large five-octave range. The instrument originally

formed part of Todini's Galleria Armonica (a
museum for musical instruments) in Rome and
is described in his catalogue of 1676. The flanking
figures of Polyphemus playing a bagpipe and the
startled Galatea would have been displayed with
the harpsichord in front of a scenic backdrop.
Polyphemus was positioned on a "mountain"
concealing organ pipes that simulated the sound
of his bagpipe. Todini's ingenuity grew out of the
same musical climate that led to the invention of
the piano by 1700.

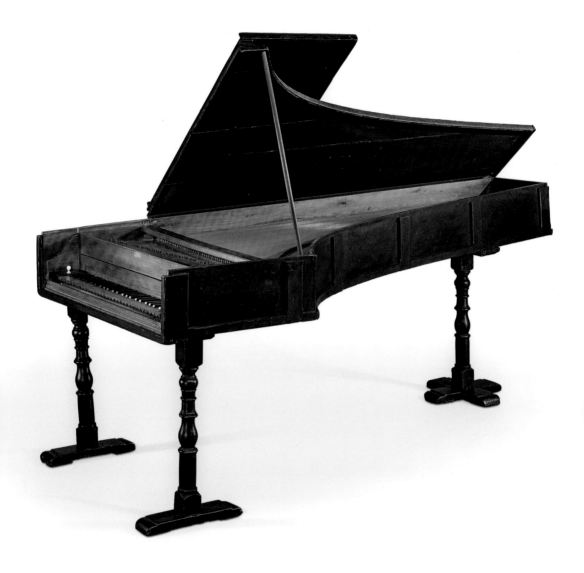

Bartolomeo Cristofori
Italian, 1655–1731
Piano, 1720
Cypress, boxwood, brass, various other
materials, L. 90 in. (228.6 cm)
The Crosby Brown Collection of Musical
Instruments, 1889 (89.4.1219)

This piano, the oldest in existence, is one of
three that survive from the workshop of Bar-
tolomeo Cristofori, who invented the piano
at the Medici court in Florence about 1700.

The Museum's example is dated 1720 and remains
in playable condition. Its complex mechanism pre-
figures that of the modern piano, but its keyboard
is shorter and no pedals exist to provide tonal
contrast. Instead, the compass comprises three
distinct registers: a warm, rich bass; more asser-
tive middle octaves; and a bright, short-sustaining
treble. Intended chiefly for accompaniment,
Cristofori's invention was called a *gravicembalo
col piano e forte* (harpsichord with soft and loud),
referring to its novel dynamic flexibility.

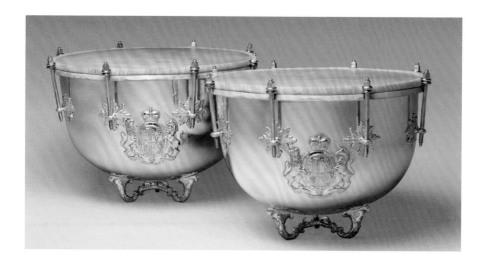

Franz Peter Bunsen
German, master 1754–1795
Kettledrums, 1779
Silver, iron, calfskin, textiles. H. 16⅛ in. (41 cm),
DIAM. 20⅞ in. (53 cm), WT. 52.9 lb. (24 kg)
Purchase, Robert Alonzo Lehman Bequest, Acquisitions
Fund, and Frederick M. Lehman Bequest, 2010
(2010.138.1–.4)

This magnificent pair of silver kettledrums was
made in Hanover for the Royal Life Guards of
George III, king of Great Britain and Ireland and
elector of Hanover, whose coat of arms they bear.
From the seventeenth through the nineteenth
century, such ceremonial drums were played on
horseback, accompanied by trumpeters lead-
ing the royal procession. Only a handful of sets
survive today, as many were melted down for
their precious materials. This is the oldest of four
pairs built for British monarchs of the House of
Hanover (1714–1901). The original crimson ban-
ners that were draped around the lower portion
of the drums during use also survive.

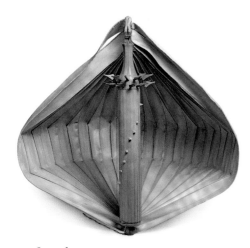

Sesando
Indonesia, Timor, late 19th century
Palm leaf, bamboo, wire, H. 22½ in. (57 cm)
The Crosby Brown Collection of
Musical Instruments, 1889 (89.4.1489)

Among the most remarkable string instruments
in Oceania is the *sesando*, a tubular bamboo
zither made from the frond of a lontar palm.
Collected on the island of Timor, this *sesando* was
likely made by a member of the local Rotinese
community, whose residents originated on the
neighboring island of Roti. *Sesando* music is be-
lieved to have supernatural powers. The musician
uses the right hand to pluck the bass strings
while the left hand plays the treble. The pitch is
adjusted with movable bridges and tuning pegs.
The *sesando* is most often used to accompany
songs portraying the world as dominated by
inescapable fate and life as ultimately fleeting.

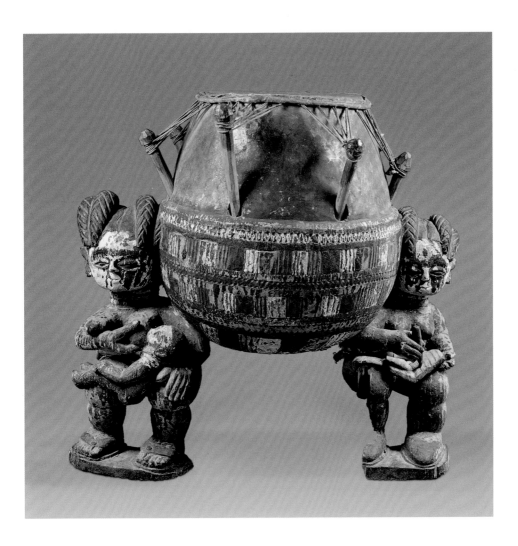

Kettledrum with Female Caryatids

Ghana, Asante traditional area, Akan peoples,
early 20th century
Wood, pigment, w. 21 in. (53.4 cm)
Gift of Raymond E. Britt Sr., 1977 (1977.454.17)

Master or lead drums such as this kettle-shaped one were the musical and visual focal point of secular bands that performed a traditional form of entertainment popular in the Akan communities of southern Ghana. Drums in these ensembles were thought of in terms of a family, with the master drum being the mother, emphasizing the importance of the traditional matrilineal kinship system. The two female caryatids holding the drum represent the instrument's perceived femininity. The mother nurturing her child alludes to female fecundity and to the importance of the matrilineal line in Akan culture. The woman writing in a book reflects the Akan preoccupation with education. These motifs exemplify the common familial, social, and political iconography of master drums.

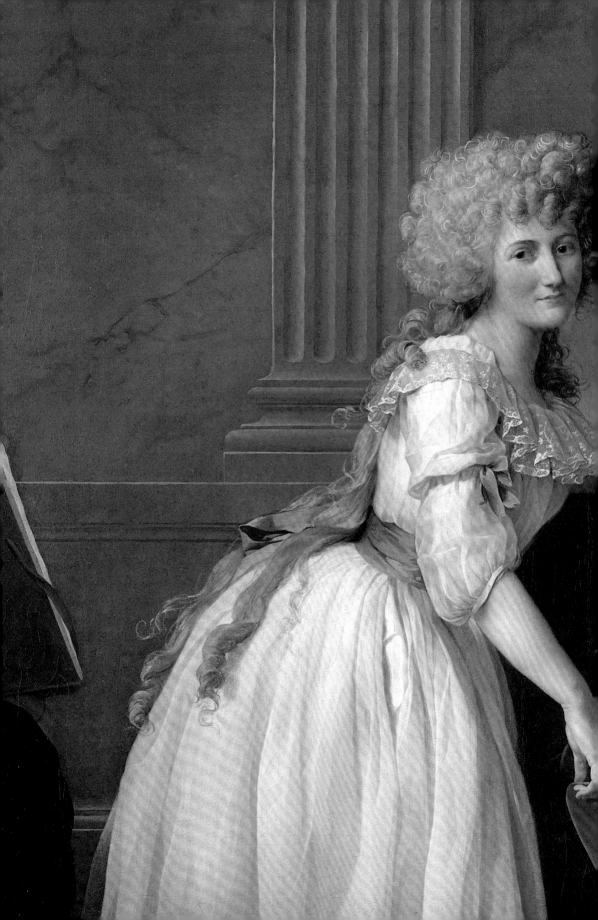

Medieval Art

The Museum acquired its first medieval object in 1873, but the core of the collection in the main building was not formed until 1917, when the son of the financier and collector J. Pierpont Morgan donated some two thousand objects owned by his father. Today the collection is among the most comprehensive in the world, encompassing the art of the Mediterranean and Europe from the establishment of New Rome (Constantinople) in the fourth century to the beginning of the Renaissance in the early sixteenth century. Represented are an abundance of works from the late antique and early Byzantine worlds. An extensive assemblage of early medieval art, which includes the jewelry of Anglo-Saxons, Franks, and Visigoths, among other peoples, highlights the artistic achievements of Western Europe at the same moment. A display of icons and other church furnishings, including a lectionary from the church of Hagia Sophia in modern Istanbul, makes plain the Museum's rich holdings in art of the Greek East from 800 to 1500. The same period in the West saw the emergence of the Latin Church as the most important patron of the arts, and several galleries testify to the splendid possessions of Western monasteries and churches. Stained glass from key monuments like the royal abbey of Saint-Denis outside Paris, Notre-Dame in Paris, and the cathedral of Amiens evoke the great age of church building. Additional works from the Gothic period include luxury tableware and a rotating display of tapestries that recall the court society of late medieval nobility.

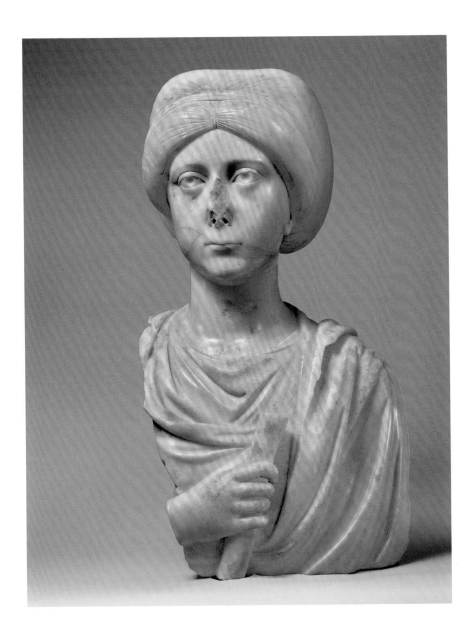

Portrait Bust of a Woman with a Scroll

Byzantine, probably Constantinople,
late 4th–early 5th century
Marble, 20⅞ × 10⅞ × 8¾ in. (53 × 27.5 × 22.2 cm)
The Cloisters Collection, 1966 (66.25)

This sensitively carved portrait bust presents a mature woman with a thoughtful expression and piercing gaze; the scroll held in her right hand signals an appreciation for classical learning and marks her as a member of the elite. She wears a mantle, tunic, and head covering, typical dress for an aristocratic woman. Such head coverings came into fashion in the fourth century. The bust possibly formed part of a commemorative display, perhaps documenting a public donation, or may have been used in a domestic setting.

Medallion with a Portrait of Gennadios

Roman, probably Alexandria, ca. 250–300
Gold glass, 1⅝ × ¼ in. (4.1 × .6 cm)
Fletcher Fund, 1926 (26.258)

This exquisitely vivid image of an educated youth of the powerful port city of Alexandria was worked in gold on dark blue glass. The medallion, made to be mounted and worn as a pendant, probably celebrates his success in a musical contest, as it is inscribed in Greek: GENNADIOS MOST ACCOMPLISHED IN THE MUSICAL ARTS.

The Antioch "Chalice"

Byzantine, ca. 500–550
Silver, gilt silver, 7¾ × 7⅛ × 6 in.
(19.6 × 18 × 15.2 cm)
The Cloisters Collection, 1950 (50.4)

When this work was discovered in the early 1900s, its plain silver inner cup was considered by many to be the Holy Grail, the cup used by Christ at the Last Supper. Subsequent scholarship has shown that the object is a standing lamp. The elaborately inhabited vine-scroll shell encasing the cup contains two images of the youthful enthroned Christ. On one side, he holds a scroll, his "word"; on the other side, he sits beside a lamb and above an eagle with outspread wings—symbols of his role as the savior of humankind.

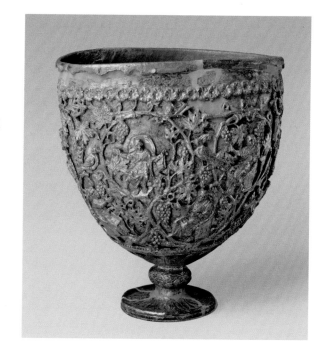

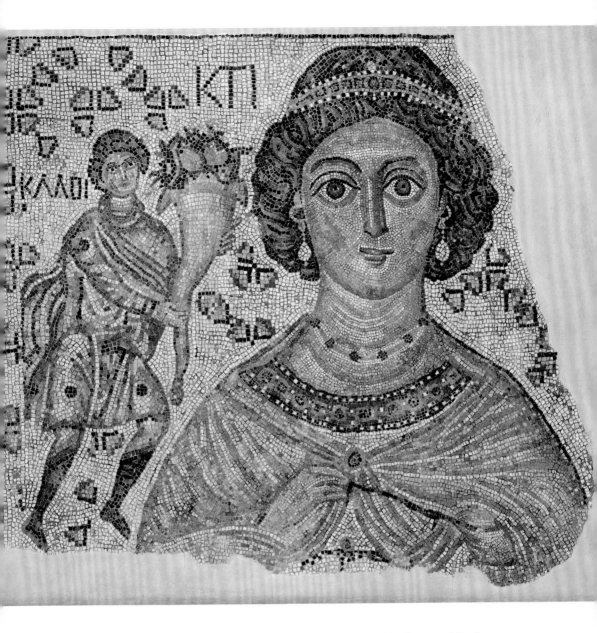

Fragment of a Floor Mosaic with a Personification of Ktisis

Byzantine, ca. 500–550; modern restoration
Marble, glass, 59½ × 78⅝ × 1 in.
(151.1 × 199.7 × 2.5 cm)
Harris Brisbane Dick Fund and Fletcher Fund, 1998
(1998.69); Purchase, Lila Acheson Wallace Gift,
Dodge Fund, and Rogers Fund, 1999 (1999.99)

Abstract concepts were often personified in Late Roman and Byzantine art. Here a bejeweled woman, holding the measuring tool for the Roman foot, is identified by the restored Greek inscription as Ktisis, the personification of the act of generous donation or foundation. Beside the head of a man with a cornucopia, originally one of a pair flanking Ktisis, is the inscription GOOD in Greek, half of a text that probably read GOOD WISHES. The fragment, made of marble and glass tesserae (small pieces of colored material), is typical of the exceptional mosaics created throughout the Byzantine world in the sixth century.

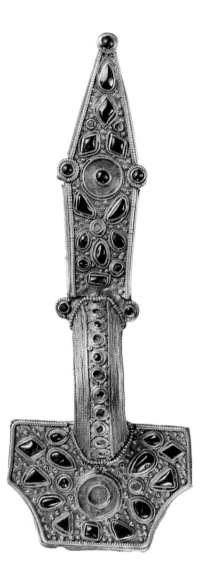

Glass Claw Beaker
Frankish, found in Bellenberg-Voehringen,
southern Germany, 5th–6th century
Glass, 7⅜ × 4¼ in. (18.7 × 10.8 cm)
Gift of Henry G. Marquand, 1881 (81.10.189)

Most Frankish glass vessels display simple
shapes and minimal color, with decoration
generally limited to trails applied to the glass.
Among a number of innovative designs, the
most elaborate was the claw beaker, decorated
with protruding clawlike forms. Few survive,
and those that do were generally found in the
richly furnished graves of aristocrats.

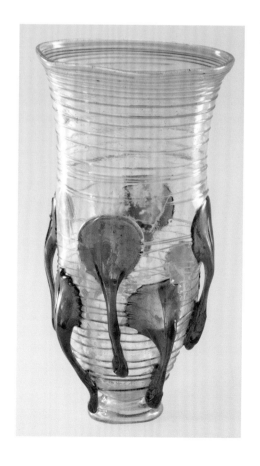

Bow Brooch
Late Roman, ca. 400–450
Silver with gold-sheet overlay and garnets,
6⅝ × 2½ × 1⅜ in. (16.7 × 6.2 × 3.5 cm)
Fletcher Fund, 1947 (47.100.19)

This brooch is a luxury version of the kind
worn by eastern Germanic women living
along the Danube River in the 300s and 400s.
It undoubtedly belonged to a woman of high
social standing as part of a rich ensemble of
gold jewelry—armlets, rings, and collars with
pendants—that she would have worn as burial
costume.

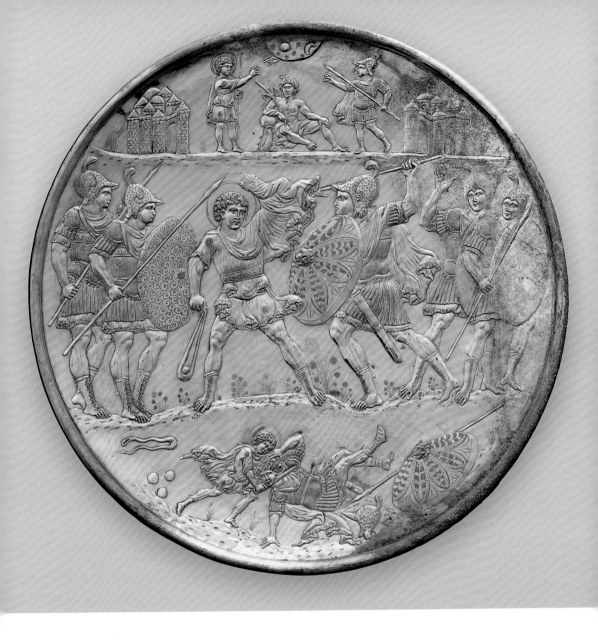

Plate with the Battle of David and Goliath

Byzantine, Constantinople, ca. 629–30
Silver, DIAM. 19½ in. (49.4 cm), D. 2⅝ in. (6.6 cm)
Gift of J. Pierpont Morgan, 1917 (17.190.396)

In the scene on the upper part of the plate, David challenges Goliath. As they battle, David appears to be on the defensive, but the advance of his men and the retreat of Goliath's soldiers foretell his victory. Below, a triumphant David beheads the giant (1 Samuel 17:41–51). This is one of nine plates from the so-called Cyprus Treasure showing classicizing scenes from the life of David. Made in Constantinople during the reign of Heraclius (610–41), six of the plates are in the Metropolitan and three in the Cyprus Museum. Their theme may relate to the identification of the emperor as a new David after his decisive defeat of the Persians in 628–29, which resulted in the recapture of Jerusalem.

True Cross Reliquary (The Fieschi Morgan Staurotheke)

Byzantine, possibly Constantinople, ca. 800
Cloisonné enamel, gilt silver, gold, niello,
1⅛ × 4⅛ × 2⅞ in. (2.7 × 10.3 × 7.1 cm)
Gift of J. Pierpont Morgan, 1917 (17.190.715a, b)

The lid of this box made to contain a relic of the True Cross displays the Crucifixion of Christ. Christ's garment, a purple colobium (sleeveless tunic), follows an Early Christian tradition. His erect posture and open eyes express his triumph over death as the Virgin and John the Theologian grieve on either side of him. Surrounding the Crucifixion scene and appearing on the sides are the busts of twenty-seven saints. On the underside of the lid are four scenes announcing Christ's role as savior: the Annunciation, the Nativity, the Crucifixion, and the Anastasis (Descent into Hell). The engraved underside of the box resembles a book cover, perhaps a reference to the Gospels, which contain the story of the Crucifixion.

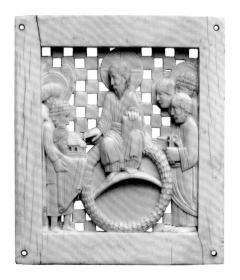

Plaque with Christ Receiving Magdeburg Cathedral from Emperor Otto I

Ottonian, probably Milan, ca. 962–68
Ivory (elephant), 5⅛ × 4½ × ⅜ in. (13 × 11.3 × .8 cm)
Gift of George Blumenthal, 1941 (41.100.157)

Magdeburg Cathedral in Saxony (Germany) was dedicated in 968. Emperor Otto I (r. 962–73), shown smaller than the company of saints, offers a model of the cathedral to Christ for his blessing. Saint Mauritius, patron saint of the Ottonian emperors and of the city of Magdeburg, is shown behind Otto. This panel and sixteen others illustrating the life of Jesus, thought to have been carved in Italy, were once part of a furnishing—such as a pulpit, doors to the choir, or an altar—made for the cathedral. Following fires in 1008 and 1049, the set was dismantled, and individual panels were used on reliquaries and book covers.

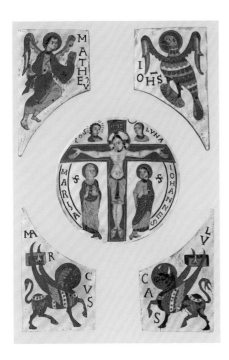

Enamels with the Crucifixion and Symbols of the Evangelists

French, Conques, ca. 1100
Champlevé and cloisonné enamel on gilt copper,
Evangelist symbols each approx. 4 × 2⅜ × ⅛ in.
(10.1 × 6.1 × .3 cm), Crucifixion DIAM. 4⅛ in. (10.3 cm), TH.
⅛ in. (.3 cm)
Gift of J. Pierpont Morgan, 1917 (17.190.426–.429);
Purchase, Michel David-Weill Gift and 2006 Benefit Fund,
2007 (2007.189)

Abbot Bégon III (r. 1087–1107) commissioned precious works of art for his monastery at Conques. Distinguished by its unusual technique, style, and palette, this ensemble, probably from a book cover, was almost certainly among them. For each piece, the goldsmith superimposed copper plaques, the lower one set with cloisons (wires) that define features and drapery, and the upper one cut to define the silhouettes of the figures and the cross.

Jaharis Byzantine Lectionary

Constantinople, ca. 1100
Tempera, gold, ink on parchment, folio 43r:
14⅛ × 21¼ in. (36 × 54 cm)
Purchase, Mary and Michael Jaharis Gift and Lila Acheson
Wallace Gift, 2007 (2007.286)

The four delicately detailed Evangelist portraits in this manuscript, framed by elaborate borders reminiscent of cloisonné enamel, represent the apogee of late eleventh- to early twelfth-century Byzantine art. Depicted here is the white-haired Evangelist Matthew sitting before a city wall with his name inscribed in Greek above. Shown to have been made for use in Hagia Sophia, the patriarchal church of the Byzantine Empire, this manuscript exemplifies the Byzantine interest in the art of the book. Colophons (inscriptions in the text) indicate that in the first years of the eighteenth century the work was still in Constantinople as the property of Chrysanthos Notaras, patriarch of Jerusalem and one of the important early members of the so-called Greek Enlightenment.

Plaque with the Journey to Emmaus and Jesus Appearing to Mary Magdalen

Spanish, possibly León, ca. 1115–20
Ivory (elephant), 10⅝ × 5¼ × ¾ in. (27 × 13.4 × 1.9 cm)
Gift of J. Pierpont Morgan, 1917 (17.190.47)

The plaque illustrates two Gospel accounts of Jesus' appearance to his followers after the Resurrection. In the top scene, Jesus, unrecognized, joins two apostles traveling from Jerusalem to Emmaus. They lament the Crucifixion, and Jesus explains its importance. Below, Jesus appears to Mary Magdalen, who mistakes him for a gardener. When she recognizes him, he tells her not to touch him since he has not yet ascended to heaven. With swirling drapery, elongated bodies, and powerful, dramatic gestures, the plaque, part of a larger ensemble, perhaps a reliquary, relates to works created in León, a royal city on the pilgrimage road to the shrine of Saint James.

Virgin and Child Enthroned

French, Auvergne, ca. 1150–1200
Walnut, paint, gesso, linen, 31⅜ × 12½ × 11½ in.
(79.5 × 31.7 × 29.2 cm)
Gift of J. Pierpont Morgan, 1916 (16.32.194)

More than an image of mother and child, this composition, with Jesus held rigidly on the Virgin's lap, emphasizes the role of the Christ Child as the embodiment of divine Wisdom. To reinforce the message, Jesus would have held a book. The sculpture exhibits an austere beauty, seen in the rhythmic pattern of the Virgin's robe, the delicate veil framing her face, and the surviving traces of paint, notably on the green pillow. Such statues were used as devotional objects and were carried in church processions. This image probably functioned as a container for holy relics. It has two cavities—one behind the Virgin's shoulder, the other at her chest.

Column Statue of a King

French, from the royal abbey of Saint-Denis, ca. 1150–60
Limestone, 45½ × 9 × 9½ in. (115.6 × 22.9 × 24.1 cm)
Purchase, Joseph Pulitzer Bequest, 1920 (20.157)

This figure of an unidentified king is the only complete statue to survive from the now-destroyed cloister of the royal abbey at Saint-Denis. The halo distinguishes this king as a saint. Under the energetic Abbot Suger, the abbey, the burial site of French kings, was rebuilt (1122–51) in what was hailed in the Middle Ages as the French style and subsequently called Gothic. Integrating a standing figure with a cylindrical column is one of the distinguishing characteristics of the new Gothic style.

Head of King David

French, from the cathedral of Notre-Dame, Paris, south portal of the west facade (Saint Anne Portal), ca. 1145
Limestone, 11¾ × 8⅜ × 8⅜ in. (29.7 × 21.1 × 21.3 cm)
Harris Brisbane Dick Fund, 1938 (38.180)

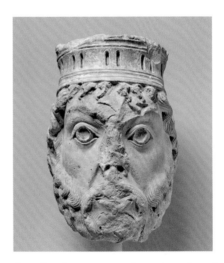

Once thought to represent the ancient rulers of France, the monumental sculptures of kings on the cathedral of Notre-Dame were ordered to be destroyed during the French Revolution. Carved of a fine-grained limestone, the expressive face originally had inlaid lead eyes. The head comes from the west facade, dedicated to the life of Saint Anne, mother of the Virgin Mary, and to the genealogy and early life of Jesus, considered a descendant of the biblical king David.

Leaf from a Commentary on the Apocalypse of Saint John

Spanish, Castilla y León, from the Benedictine monastery of San Pedro de Cardeña, ca. 1180
Tempera, gold, ink on parchment,
17½ × 11⅞ in. (44.5 × 30 cm)
Purchase, The Cloisters Collection, Rogers and Harris Brisbane Dick Funds, and Joseph Pulitzer Bequest, 1991 (1991.232.10)

Illustrated Beatus manuscripts, unique to medieval Spain, are a testament to the artistry and intellectual milieu of monastic culture there. They bring to life a vision of the end of the world as recorded by Saint John in the Apocalypse (Revelation) and filtered through the lens of Beatus of Liébana, an eighth-century Asturian monk. In the illustration on this leaf, the events heralded by the fifth angel's trumpet are as terrifying as they are otherworldly: the smoke from the pit darkens the sun, menacing striped locusts sting their victims with scorpion-like tails, and the undead plead for mercy. The leaf comes from a manuscript disassembled in the 1870s.

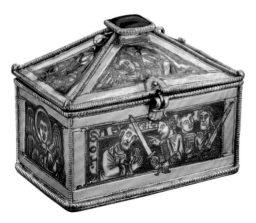

Reliquary Casket of Saint Thomas Becket

English, ca. 1173–80
Gilt silver with niello and glass,
2¼ × 2¾ × 1⅞ in. (5.5 × 7 × 4.7 cm)
Gift of J. Pierpont Morgan, 1917 (17.190.520)

One of the earliest reliquaries associated with Thomas Becket, the archbishop of Canterbury murdered in 1170 by knights of the court of Henry II, this example is also one of the finest. Its dramatic use of black niello against silver lends a graphic immediacy to the scene of Becket's death. A partially preserved inscription on the back seems to indicate that a relic of Becket's blood was once inside; the red glass gem on top reinforces that possibility.

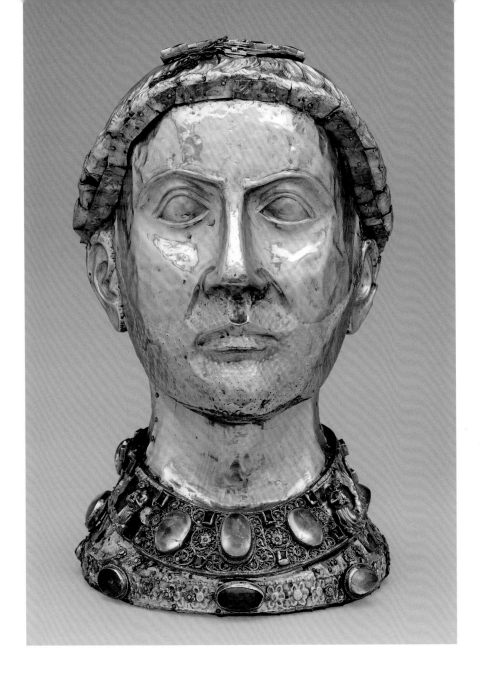

Reliquary Bust of Saint Yrieix

French, from the church of Saint-Yrieix-la-Perche, near
Limoges, ca. 1220–40

Silver, gilt silver, rock crystal, gems, glass,
15 × 9¼ × 10¼ in. (38.1 × 23.4 × 26.1 cm)

Gift of J. Pierpont Morgan, 1917 (17.190.352a, b)

Saint Yrieix, whose skull was once contained in
this reliquary, was the sixth-century founder
of a monastery in the town south of Limoges
that now bears his name. A special veneration
of reliquaries in the form of the heads of local
saints developed in the Limoges region during
the Middle Ages, a devotion that continues
to the present day. On feast days the image
would have been carried in procession through
the streets and then placed on the altar for
adoration by the faithful. The reliquary's
precious material evoked the saint's heavenly
countenance, and the skull imparted a sense of
his abiding authority.

Scenes from the Legend of Saint Vincent of Saragossa and the History of His Relics

French, from the Lady Chapel (now destroyed) of the Abbey of Saint-Germain-des-Prés, Paris, ca. 1245–47

Pot-metal glass, vitreous paint, lead, 147 × 43½ in. (373.4 × 110.5 cm)

Gift of George D. Pratt, 1924 (24.167a–k)

The monks of Saint-Germain-des-Prés had a special devotion for Saint Vincent (d. 304), as their abbey had been founded to receive a relic of the saint's tunic, which had been transported from Spain by the Merovingian king Childebert (d. 558), shown here on horseback at left, accompanied by his brother Lothar on a white horse. The remaining scenes of this window, a composite from a larger ensemble, illustrate Saint Vincent's confrontations with the Roman proconsul Dacian. Like the famous contemporary windows of Louis IX's royal chapel, the Sainte-Chapelle, these panels make it clear that by the middle of the thirteenth century, Paris was the leading center for a new, expressive style of glass painting.

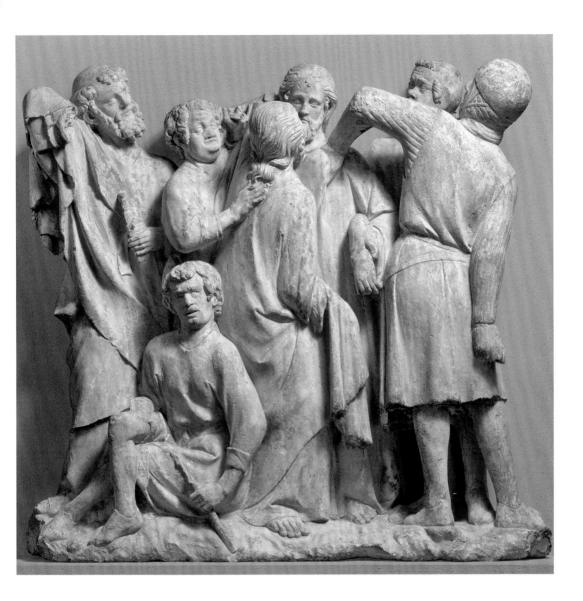

Relief with the Betrayal and Arrest of Jesus

French, Picardy, from the cathedral of Amiens, ca. 1264–88
Limestone with traces of paint, 39¼ × 43 × 9 in.
(99.7 × 109.2 × 22.9 cm)
Mr. and Mrs. Isaac D. Fletcher Collection,
Bequest of Isaac D. Fletcher, 1917 (17.120.5)

In medieval churches, choir screens separated the nave from the choir. By the thirteenth century these barriers often were decorated with extensive narratives, especially of Jesus' Passion, the final events in his earthly life. Four key events are dramatically compressed here: Peter sheathing his sword after severing the ear of Malchus, the high priest's servant; Jesus miraculously restoring the ear; Judas betraying Jesus with a kiss; and Roman soldiers arresting Jesus. Because they hindered worshippers' ability to participate in church ritual, most European churches eventually eliminated choir screens; the one at the cathedral in Amiens was destroyed in 1755. This relief is one of the largest and best-preserved narrative sculptures to survive.

Aquamanile in the Form
of a Knight on Horseback

German, Lower Saxony, probably Hildesheim, ca. 1250
Copper alloy, 14¾ × 12⅝ × 5⅝ in. (37.5 × 32 × 14.2 cm)
Gift of Irwin Untermyer, 1964 (64.101.1492)

Aquamanilia, from the Latin words for "water" and "hands," were used to pour water for diners at table or by priests preparing Mass. This example represents the courtly ideals of knighthood that pervaded Western medieval culture and influenced the production of objects intended for daily use. The knight wears a type of armor that disappeared toward the third quarter of the thirteenth century. Unfortunately, his shield—which probably displayed the arms of the owner—and his lance are lost. The crosshatched circles on the horse's body suggest that he is a dappled-gray warhorse, highly prized in the Middle Ages.

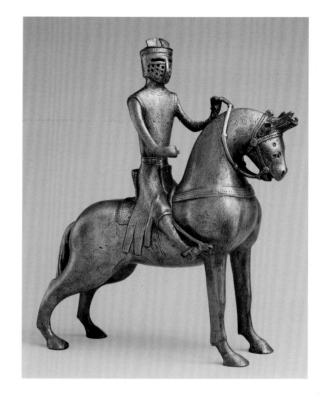

Box with Scenes
from Romances

French, Paris, ca. 1310–30
Ivory (elephant), 4¼ × 10 × 6¼ in.
(10.9 × 25.3 × 15.9 cm)
Casket: Gift of J. Pierpont Morgan,
1917 (17.190.173a, b); front panel:
The Cloisters Collection, 1988 (1988.16)

The lid of this box with scenes from Arthurian and other courtly tales presents an assault on the metaphorical Castle of Love with a tournament and knights catapulting roses. The front panel presents two poignant scenes from the tragedy of Pyramus and Thisbe (at right) as well as one of Aristotle teaching Alexander the Great and two of Phyllis riding on Aristotle's back (at left). The ends depict Tristan and Isolde; a hunter killing a unicorn; a knight rescuing a lady; and Galahad receiving the key to the castle. On the back are scenes with Lancelot as well as Gawain and the maidens welcoming their deliverer.

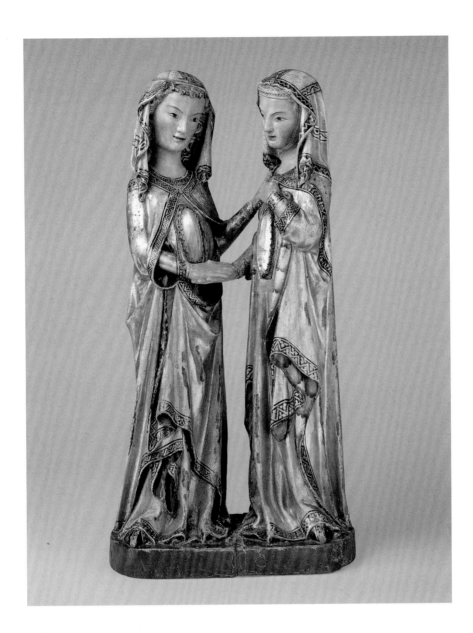

Attributed to

Master Heinrich of Constance

German, active ca. 1310–20

The Visitation

German, from the Dominican convent of
Katharinenthal, Switzerland, ca. 1310–20
Walnut with paint, gilding, rock-crystal cabochons,
23¼ × 11⅞ × 7¼ in. (59.1 × 30.2 × 18.4 cm)
Gift of J. Pierpont Morgan, 1917 (17.190.724)

Soon after the Virgin Mary learned that she
would be the mother of Jesus, she visited
her cousin Elizabeth, who was also expecting
a child; he would become John the Baptist.

With the original paint and gilding almost
completely intact, the figures of Mary and
Elizabeth have crystal-covered cavities
through which images of their infants may
originally have been seen. Here Mary tenderly
places her hand on Elizabeth's shoulder as
Elizabeth raises her arm to her breast in
reference to her declaration, "Who am I, that
the mother of the Lord should visit me?"
(Luke 1:43). Scenes of the Visitation similar to
this one occur in other, contemporary works
from German-speaking lands.

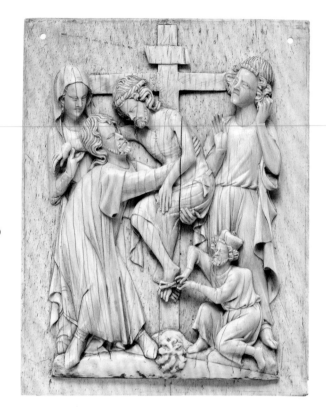

Relief with the Descent from the Cross

French, probably Paris, ca. 1320–40
Ivory (elephant) glued to whalebone with traces of
paint and gilding, 9⅛ × 7¼ × ⅞ in. (23.2 × 18.3 × 2.1 cm)
Gift of J. Pierpont Morgan, 1917 (17.190.199)

This ivory relief of the Deposition is one of
five extant appliqué plaques with scenes of
the Passion of Christ, now separated among
museums in Antwerp, London, Oslo, and
Paris. These plaques were intended to form
a continuous frieze across the back of an
altar—a retable—though it is unlikely that
all five pieces come from the same retable.
Like stone and wood examples from the
same period, the plaques were probably
mounted on an architectural support. The
sensitive carving of the Deposition plaque—
mounted later on the large flat sheet of
whalebone—with elegant and emphatic ges-
tures, domed heads, and flowing drapery,
points to Parisian ivory carving during the
first half of the fourteenth century.

opposite

Tapestry with the Annunciation

South Netherlandish, ca. 1410–30
Wool warp, wool weft, gilt-metal-wrapped thread,
11 ft. 6 in. × 9 ft. 9 in. (3.5 × 2.97 m)
Gift of Harriet Barnes Pratt, in memory of her husband,
Harold Irving Pratt (February 1, 1877–May 21, 1939),
1949 (45.76)

Seated within an elaborate room, the Virgin
Mary looks away from her book on the lectern,
startled by the sudden entrance of the archangel
Gabriel. He holds a scroll with the words AVE
GRATIA PLENA (Hail [Mary] full of grace). In the
sky, God the Father sends toward the Virgin
the infant Jesus bearing a cross, preceded
by the dove of the Holy Spirit. They descend
toward the Virgin's ear, through which she was
believed to have conceived. The enclosed garden
emphasizes Mary's virginity, and the single
white lily placed in an elaborate pottery jar
symbolizes her purity.

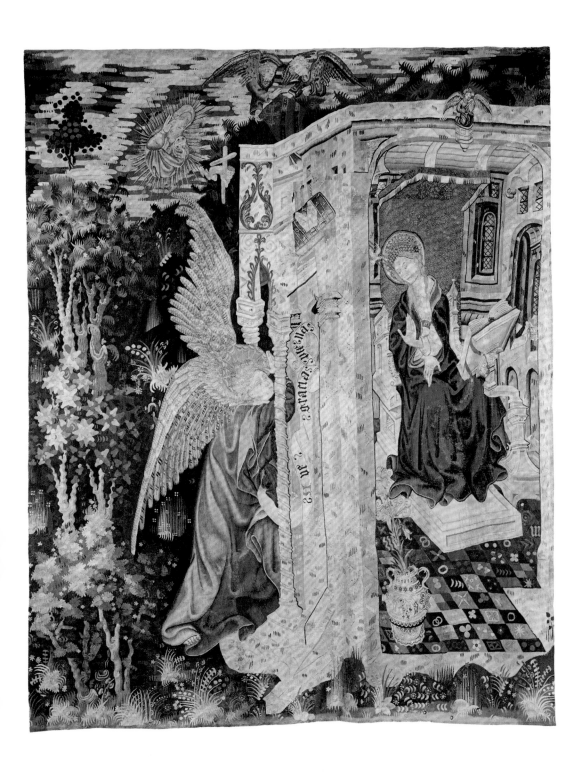

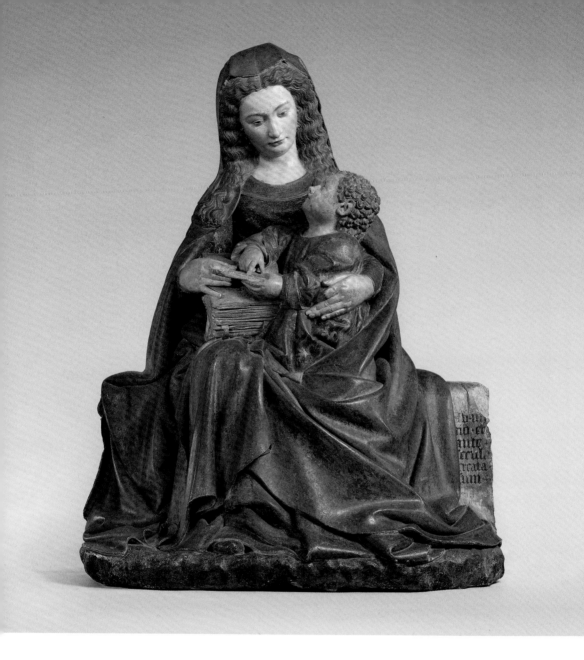

Claus de Werve

French, active 1396–1439

Virgin and Child

French, from the Franciscan convent of the
Poor Clares, Poligny, Burgundy, ca. 1415–17
Limestone with original paint and gilding,
53 ⅜ × 41⅛ × 27 in. (135.5 × 104.5 × 68.6 cm)
Rogers Fund, 1933 (33.23)

It was probably either John the Fearless, Duke
of Burgundy (d. 1419), or his wife, Margaret
of Bavaria (d. 1424), who commissioned this

masterpiece for the convent of Poor Clares,
which they founded at Poligny. The curly-haired
Jesus looks up at his mother as she holds him
and a book on her lap. This tender scene also
represents a sophisticated theological theme,
heralded by the Latin inscription on the bench
from the biblical book of Ecclesiasticus, extolling
wisdom: FROM THE BEGINNING, AND BEFORE
THE WORLD, WAS I CREATED . . . (24:14). By the
thirteenth century, the Catholic Church had
come to consider this a reference to Mary.

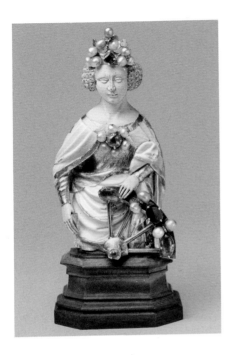

Saint Catherine of Alexandria

French, early 15th century
Gold, ronde-bosse enamel, jewels,
3⅞ × 2⅛ × 1⅛ in. (9.8 × 5.4 × 2.8 cm)
Gift of J. Pierpont Morgan, 1917 (17.190.905)

Saint Catherine, shown here holding the wheel
on which legend says she was tortured, was
a widely venerated virgin martyr. Beautiful,
erudite, and aristocratic, she came to hold a
special place in the devotions of the French
court. Although this statuette is reputed to
have come from a convent in Clermont-Ferrand,
the refined enamel on gold, the saint's coiffure,
and the precious gem-studded decoration are
hallmarks of the work of Parisian goldsmiths.
The figure may have come from a shrine, where
it and those of other saints would have been
integrated into an architectural ensemble.

Crib of the Infant Jesus

South Netherlandish, Brabant, ca. 1400–1500
Wood, paint, lead, gilt silver, painted parchment, silk
embroidery with seed pearls, gold thread, and translucent
enamels, 14 × 11⅜ × 7¼ in. (35.4 × 28.9 × 18.4 cm)
Gift of Ruth Blumka, in memory of Leopold Blumka,
1974 (1974.121a–d)

Miniature cradles for the Christ Child were
popular devotional objects in the fifteenth and
sixteenth centuries, especially in convents,
where they were often presented to women
taking their vows. This splendid cradle comes
from the Grand Béguinage of Louvain, Bel-
gium, established in the twelfth century for
lay women. It is decorated on either end with
carved representations of the Nativity and the
Adoration of the Magi. The biblical family tree of
Christ is illustrated on the embroidered coverlet.

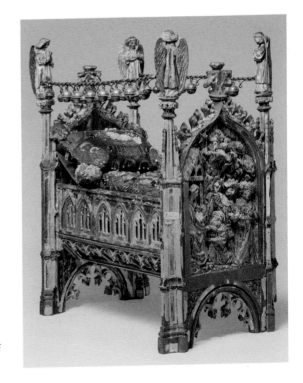

The Cloisters

The Metropolitan's branch museum dedicated to the art and architecture of medieval Europe is located on four acres overlooking the Hudson River in northern Manhattan's Fort Tryon Park. Its name derives from its incorporation of architectural sculpture from medieval cloisters from present-day France—principally Saint-Michel-de-Cuxa, Saint-Guilhem-le-Désert, Trie-sur-Baïse, and elements once thought to have come from Bonnefont-en-Comminges. These form the nucleus of the museum, which was designed by Charles Collens, architect of New York City's Riverside Church, in a simplified medieval style. It opened in 1938 as a result of the generosity of American philanthropist and collector John D. Rockefeller Jr., who financed the conversion of land into a public park to house the new museum. Three of the cloisters feature gardens planted according to horticultural information found in medieval treatises and poetry, garden documents, and herbals. The overall effect is not a copy of any specific medieval structure but rather a harmonious and evocative setting for more than two thousand artworks, objects, and architectural elements from the medieval West, dating largely from the twelfth through the fifteenth century and including exceptional examples of stained-glass windows. Small-scale objects of extraordinary splendor, including carved ivories, goldsmiths' creations, enamels, and illuminated manuscripts, are displayed in the Treasury. Medieval works of private devotion are shown alongside the celebrated Annunciation Triptych (called the Merode Altarpiece) from the workshop of the Netherlandish master Robert Campin. Particularly beloved are the seven tapestries illustrating the Hunt of the Unicorn.

Cloister

Catalan, from the Benedictine monastery of Saint-
Michel-de-Cuxa, near Perpignan, France, ca. 1130–40
Marble, 90 × 78 ft. (27.4 × 23.8 m)
The Cloisters Collection, 1925 (25.120.398–.954)

A cloister plays a vital role in monastic life.
Essentially a covered walkway framing an open
courtyard, it serves as a place for meditation,
for reading aloud, and for daily washing.
It also links the church to other buildings
used by the monks. The warm beauty of the
local pink marble harmonizes this cloister's
varied carvings, from simple block forms to
intricately worked capitals with lions, beasts,
mermaids, and scrolling leaves. Some reflect
fables or symbolize the struggle between
good and evil. Regardless, the Cuxa artists
delighted in conveying the tense energy of
the forms. After nine centuries, much of the
sculpture from Saint-Michel-de-Cuxa was
dispersed during the French Revolution. The
original cloister, probably built during the rule
of Abbot Gregory (1130–46), was almost twice
the size of the present reconstruction.

Plaque with the Pentecost

South Netherlandish, Meuse Valley, ca. 1150–60
Champlevé and translucent enamel on
gilt copper, 4⅛ × 4⅛ in. (10.3 × 10.3 cm)
The Cloisters Collection, 1965 (65.105)

More than twelve jewel-like hues enliven this
tiny masterpiece illustrating the moment when,
according to the New Testament Acts of the
Apostles, the Holy Spirit empowered Jesus'
apostles for ministry. Fifty days after Easter, a
sound like a mighty wind came from heaven,
tongues of fire hovered over the apostles, and
they were able to speak other languages. Here
the hand of God appears over Saint Peter, seated
in the middle of the apostles, holding the keys
to heaven. This plaque is part of a series made in
the Meuse region (modern France and Belgium),
probably as part of an altar or pulpit.

Enthroned Virgin and Child

French, Burgundy, 1130–40
Birch with paint and glass, H. 40½ in. (102.9 cm)
The Cloisters Collection, 1947 (47.101.15)

This carving has enormous sculptural power,
despite the loss of Jesus' head and much of the
throne. Originally the piece was richly colored;
traces of paint indicate that the Virgin wore a
forest-green tunic with vermilion cuffs and a
lapis-lazuli veil. The child wore a yellow tunic
over a red undergarment. His book was blue on
the front and white and black on the sides. The
Virgin's elongated face and the drapery compare
closely to sculpture from the cathedral of Saint-
Lazare in Autun.

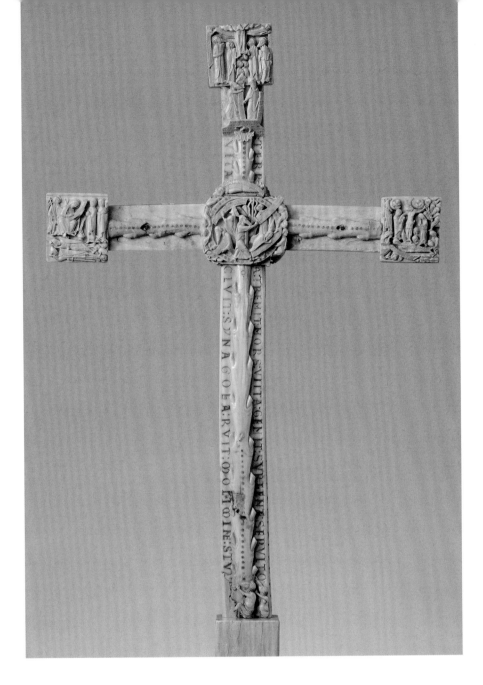

Cross

English, ca. 1150–60
Ivory (walrus), 22⅝ × 14¼ in. (57.5 × 36.2 cm)
The Cloisters Collection, 1963 (63.12)

The cross is intricately carved on both sides with nearly a hundred figures and as many inscriptions. The complex program, its specific texts, and the attire of some figures indicate that the cross was created for a monastery. Scenes on the square plaques on the front culminate in the Ascension of Christ. On the back, prophets hold scrolls inscribed with their own words, understood as foretelling the Crucifixion. Other inscriptions reflect theological disputes between Christians and Jews. Whether meant for debate or intended as invective, the cross reflects the anti-Jewish sentiment that was on the rise in the twelfth century.

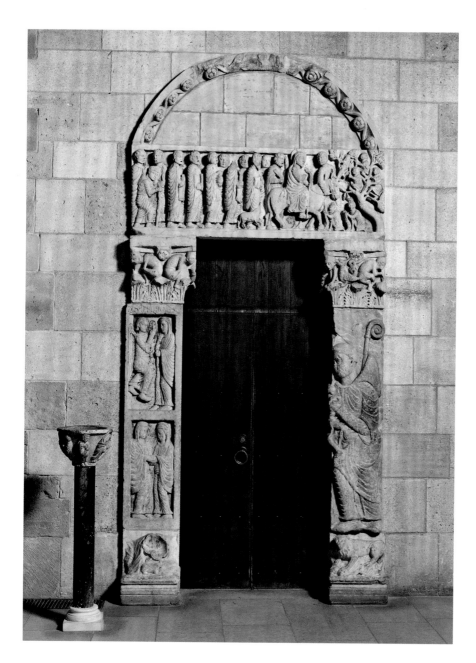

Workshop of
Biduinus
active late 12th century

Portal

Italian, Tuscany, from the church of San Leonardo
al Frigido, near Massa, ca. 1175
Carrara marble, 13 ft. 2 in. × 6 ft. 3 in. (4 × 1.9 m)
The Cloisters Collection, 1962 (62.189)

Dedicated to Saint Leonard, the patron saint
of prisoners, this portal served as the main

entrance of the small church of San Leonardo
al Frigido in Tuscany. An antique sarcophagus
was reused for the supporting jambs on the
sides of the door; it was carved to show the
Annunciation and the Visitation on the left and
Saint Leonard holding an emblematic prisoner
on the right. The Entry into Jerusalem on the
lintel is modeled after an Early Christian tomb
relief, reflecting twelfth-century Italy's revival
of interest in that earlier period.

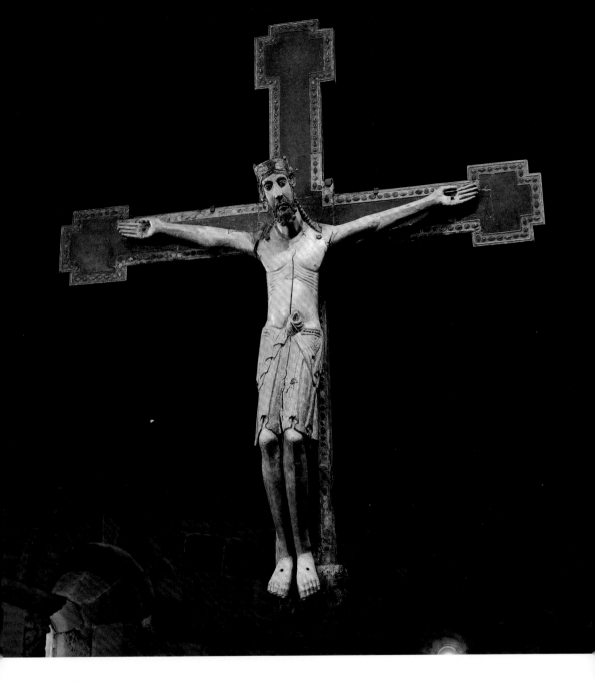

Crucifix

Spanish, Castilla y León, ca. 1150–1200
Body: white oak, paint, gilding, applied stones;
cross: red pine, paint; 8 ft. 6½ in. × 6 ft. 9¾ in. × 1 ft. 3¾ in.
(2.6 × 2.1 × .4 m)
Samuel D. Lee Fund, 1935 (35.36a, b)

Christ appears here in a manner typical of the
twelfth century: triumphant over death, with his
eyes open, and crowned. The patterns of his beard
and rib cage are boldly carved, as is the drapery of
the loincloth, and much of the painted and gilded
decoration is original. The reverse is embellished
with a painted image of the Lamb of God (Agnus
Dei) at the center and symbols of the Four Evange-
lists at the terminals, suggesting that the cross was
intended to be seen from both sides. There are con-
flicting accounts about the original location of the
Crucifix; it has been said to be from the convent
of Santa Clara at Astudillo, near Palencia, but the
source of the information is not reliable.

Cloister

French, from the Benedictine monastery of Saint-Guilhem-le-Désert, near Montpellier, late 12th–early 13th century
Limestone, 30 ft. 3 in. × 23 ft. 10 in. (9.2 × 7.3 m)
The Cloisters Collection, 1925 (25.120.1–.134)

In 804, Guilhem, duke of Aquitaine, count of Toulouse, and a member of Charlemagne's court, renounced his worldly privilege and founded a Benedictine monastery in the rugged hills outside Montpellier. Situated in a region of France with abundant remains of classical monuments, these cloister elements reveal considerable classical influence—evident, for example, in the use of carved acanthus leaves and meander patterns—and their style is typical of sculptures created about the turn of the thirteenth century. The abbey, a regular stop on the pilgrimage route to Santiago de Compostela in northwestern Spain, suffered severe damage during the Wars of Religion and the French Revolution. Approximately 140 elements were used to reconstruct this cloister, including columns, pilasters, and capitals.

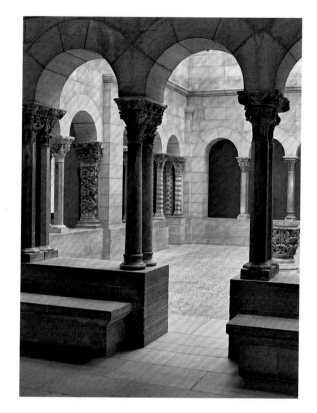

Apse

Spanish, Castilla y León, from the church of San Martín in Fuentidueña, near Segovia, ca. 1175–1200
Limestone, H. (to top of barrel vault) 29 ft. 8½ in. (9.1 m), w. (max. interior) 22 ft. ½ in. (6.7 m)
Exchange Loan from the Government of Spain (L.58.86)

Little is known about the church of San Martín in Fuentidueña. By the nineteenth century, only the apse—the semicircular east end, beyond the altar—had survived in fair condition. The reconstructed apse simulates a typical twelfth-century Segovian church. Covered by a barrel vault and a half-dome, it has three small windows in the wall. Flanking these are columns with Saint Martin of Tours and the Angel Annunciate with Mary. Below a triumphal arch are capitals featuring the Adoration of the Magi and Daniel in the Lions' Den.

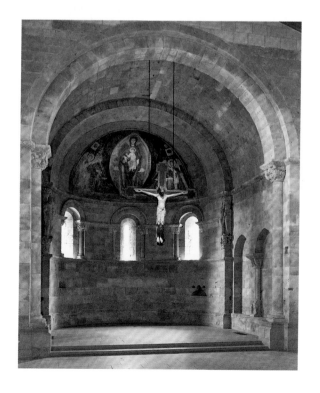

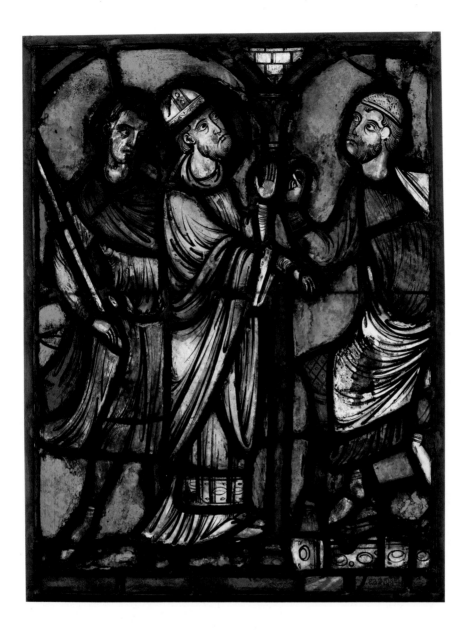

Saint Nicholas Accuses the Consul

French, Picardy, from the cathedral of Saint-Gervais-
et-Saint-Protais at Soissons, ca. 1200–1210
Pot-metal glass, vitreous paint, 21½ × 16¼ in. (54.6 × 41.3 cm)
The Cloisters Collection, Gift of the Glencairn
Foundation, 1980 (1980.263.3)

This panel is one of two based on the legend
of Saint Nicholas. Wearing rose-colored robes
and a miter on his head, Nicholas appears before
the local consul seeking the release of knights
falsely accused of treason. A palace guard
looks on. The panel probably came from an
ambulatory chapel of Saint Nicholas at Soissons
Cathedral, whose choir was under construction
in the 1190s. The composition, with each
narrative element framed by an arcade, is among
the earliest examples of a type strongly linked
with Soissons. The classicizing, elegant figures
and flowing drapery are typical of northern
France at this time.

Lion

Spanish, Castilla y León, from the chapter house of the
monastery of San Pedro de Arlanza, near Burgos, after 1200
Fresco transferred to canvas, 10 ft. 11 in. × 11 ft.
(3.3 × 3.4 m)
The Cloisters Collection, 1931 (31.38.1a, b)

The explosive power of this lion is suggested by
the taut sinews of his muscles, his intent stare,
and his bristling mane. He is one of a pair that
originally framed a doorway on the upper level
of the chapter house, a meeting place for the
monks of San Pedro de Arlanza. Created in the
thirteenth century, this fresco was hidden by
eighteenth-century renovations, rediscovered
after a fire in 1894, then sold first to a private
citizen and finally to the Museum. Also on view
at The Cloisters is a fresco of a dragon from the
same chapter house.

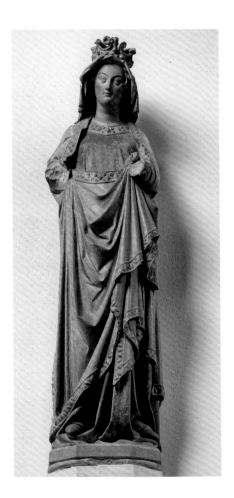

Virgin
Alsace, Strasbourg (modern France), ca. 1250
Sandstone with original paint and gilding,
H. 58½ in. (148.6 cm)
The Cloisters Collection, 1947 (47.101.11)

Among the great examples of Gothic sculpture, this regal image of the Virgin once stood on the monumental choir screen of Strasbourg Cathedral. Its place of honor near the center was marked by a canopy with angels holding a crown over the Virgin's head. The now-missing infant Jesus stood next to Mary on a rosebush, which may allude to the Virgin as a "rose without thorns," or, because of its red color, to the blood of Christ poured out at his Crucifixion. In 1680, the screen was removed as a result of changes in church ritual.

Chalice, Paten, and Straw
German, from the Benedictine monastery
of Saint Trudpert at Münstertal, near Freiburg
im Breisgau, ca. 1230–50
Silver, gilt silver, niello, jewels, H. of chalice
8 in. (20.3 cm), DIAM. of paten 8¾ in. (22.2 cm),
L. of straw 8½ in. (21.6 cm)
The Cloisters Collection, 1947 (47.101.26–.29)

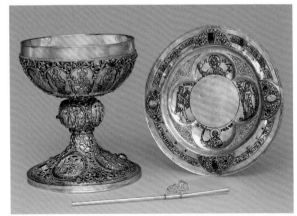

Richly patterned with delicate twisting wire and repoussé and niello images, this ensemble was created for use at Mass: a paten for bread and a chalice and straw for wine. Straws, often in pairs, were sometimes used to prevent spilling the wine, consecrated as the blood of Christ. On the chalice and paten, scenes from the life of Christ are paired with Old Testament events thought to prefigure them. The Twelve Apostles encircle the bowl of the chalice, and Saint Trudpert, patron of the monastery near Freiburg im Breisgau from which these pieces come, is given greater prominence on the paten, opposite Christ in the top medallion.

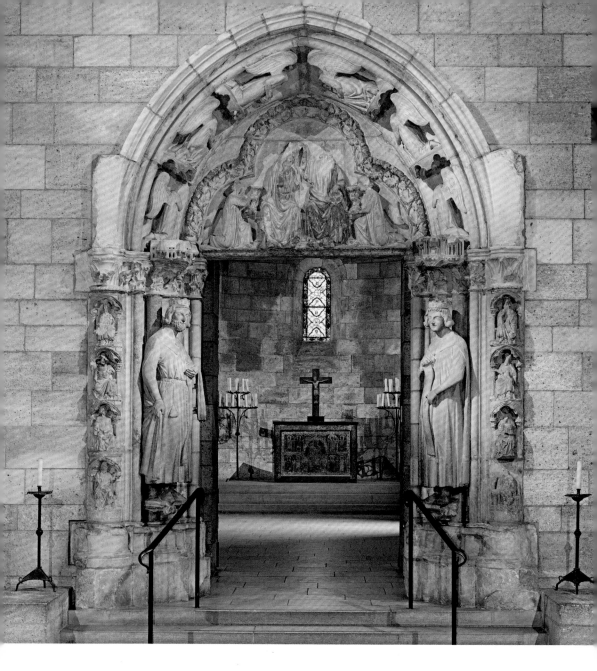

Doorway

French, Burgundy, from the abbey of
Moutiers-Saint-Jean, near Dijon, ca. 1250
Limestone with traces of paint,
15 ft. 5 in. × 12 ft. 7 in. (4.7 × 3.8 m)
The Cloisters Collection, 1932 (32.147);
The Cloisters Collection, 1940 (40.51.1, .2)

The first Christian kings of France, Clovis I and
his son Clothar I, legendary founders of the
abbey of Moutiers-Saint-Jean, stand on either
side of the portal, holding their foundation
charters. In flanking niches are biblical figures
believed to foretell the crucifixion of Jesus. In
the tympanum above, Christ crowns the Virgin
as Queen of Heaven. This portal, probably from
the north aisle of the cloister, would have led
into the abbey church. It was severely damaged
during the Wars of Religion in the sixteenth
century; the heads of the two kings may have
been repaired in the seventeenth century.

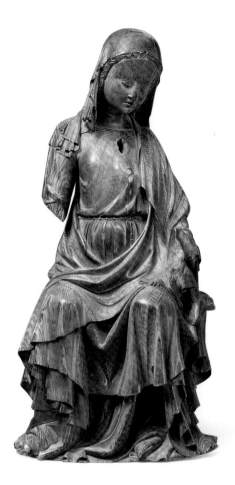

Enthroned Virgin and Child

English, probably London, ca. 1300
Ivory (elephant), 10¾ × 5⅜ × 3¾ in. (27.3 × 13.5 × 9.6 cm)
The Cloisters Collection, 1979 (1979.402)

Representing a high point in English ivory
carving, this sculpture rivals in importance the
twelfth-century Cloisters cross shown earlier.
Although related in style to cathedral sculpture,
this small-scale figure exemplifies the intimate
type of image that emerged when the cult of
the Virgin was at its height, about this time.
Paris was renowned for such ivory carvings;
only a few can be considered English. Walnut oil
may have been used to darken the surface—as
recommended in the twelfth-century treatise
On Divers Arts—or the color of the ivory may be
the result of exposure to extreme heat. Only part
of the figure of the infant Jesus survives, by his
mother's left knee.

Diptych with the Coronation of the Virgin and the Last Judgment

French, probably Paris, ca. 1260–70
Ivory (elephant), 5 × 5⅛ in. (12.7 × 13 cm)
The Cloisters Collection, 1970 (1970.324.7a, b)

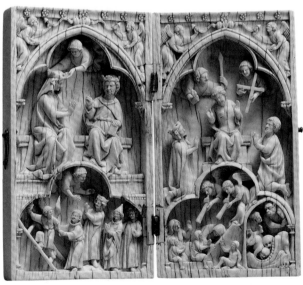

The exceptionally high relief of this
diptych brings the drama of these scenes,
commonly paired in cathedral sculpture, to
a miniature stage on which the tiny figures
appear to move and gesture freely. Under
the Coronation of the Virgin, a friar is first
among those led by an angel toward the ladder
to Heaven, followed by a king and a pope. At
right the Virgin and Saint John the Baptist
kneel before Christ, who sits in judgment; below,
angels awaken the dead by sounding horns, and
demons lower the sinful into the mouth of Hell.

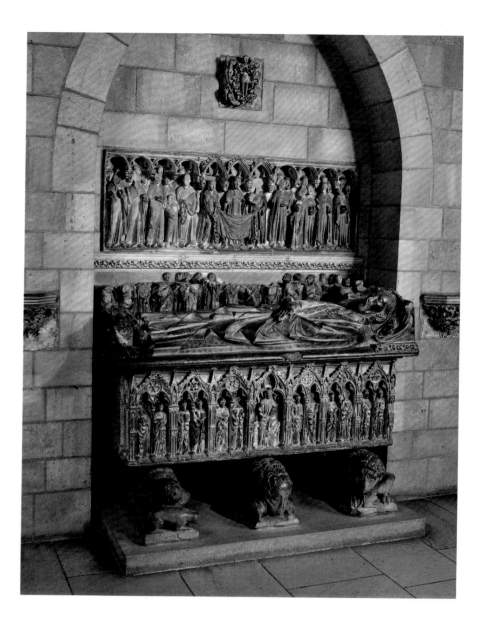

Tomb Effigy of Ermengol VII, Count of Urgell

Catalan, Lleida, from the Premonstratensian
monastery of Santa María de Bellpuig de les Avellanes,
Spain, ca. 1300–1350
Limestone with traces of paint,
89 × 79½ × 35 in. (226.1 × 201.9 × 88.9 cm)
The Cloisters Collection, 1928 (28.95a–i)

The various styles and disparate dimensions of
this elaborate monument suggest that it was
assembled from elements originally intended
for several different tombs. The count (d. 1184)
is depicted with his head on tasseled cushions,
his eyes closed, and his hands crossed above a
sheathed sword. Just behind, a group of mourn-
ers, now damaged, is carved into the same slab.
Below, under arches, Christ in Majesty is flanked
by the Twelve Apostles. A separate relief above
the effigy depicts a funeral with three celebrants.
At the top, angels carry a soul to heaven.

Adoration of the Magi

Austrian, from the choir of the castle chapel at
Ebreichsdorf, south of Vienna, ca. 1390
Pot-metal and colorless glass with silver stain and
vitreous paint; details 27¼ × 13 in. (69.2 × 33 cm),
27⅜ × 12⅞ in. (69.4 × 32.8 cm); each lancet
11 ft. 8¾ in. × 12⅛ in. (357.2 × 30.8 cm)
The Cloisters Collection, 1986 (1986.285.1, .2)

Narrative detail, rich color, and graphic
patterning distinguish the royal workshop that
created this glass. The Virgin, in purple, sits
with her child on a straw mattress, with animals
feeding at her side. Regally attired kings offer
golden gifts; one humbles himself by kneeling
and removing his crown. Ebreichsdorf castle,
south of Vienna, was built as a defense against
the Mongols; in more peaceful times, Rudolf
von Tirna (d. 1406) added a chapel with a cycle
of stained glass. Plundered by the Turks in
1683, the castle never returned to its medieval
splendor. Apart from a panel in Vienna,
only The Cloisters windows, including seven
scenes from the life of Christ and architectural
canopies, survive.

Julius Caesar and Attendants

South Netherlandish, 1400–1410
Wool warp and wefts, 13 ft. 9½ in. × 7 ft. 9 in. (4.2 × 2.4 m)
Gift of John D. Rockefeller Jr., 1947 (47.101.3)

Among the earliest and finest of medieval tapestries, this hanging was part of an ensemble commemorating nine heroes: three from Hebrew tradition, three from pagan antiquity, and three from the Christian world. Here Julius Caesar wears an emperor's open crown, and the double-headed imperial eagle hangs on his throne. Musicians and court figures surround him; the dark-skinned man at the top left may symbolize Caesar's African lands. Representative of both wisdom and valor, the Nine Heroes were first named in an early fourteenth-century French poem, "The Vows of the Peacock." The Cloisters' Nine Heroes are thought to have belonged to Jean de France, duc de Berry, a renowned patron of the arts.

Workshop of
Robert Campin
South Netherlandish, Tournai (modern Belgium),
ca. 1375–1444
**Annunciation Triptych (Merode
Altarpiece),** ca. 1427–32
Oil on oak; central panel 25¼ × 24⅞ in. (64.1 × 63.2 cm),
each wing 25⅜ × 10¾ in. (64.5 × 27.3 cm)
The Cloisters Collection, 1956 (56.70a–c)

The Archangel Gabriel appears in the Virgin's
home, along with a tiny Christ Child transported
through the window on rays of light. Their
entrance has extinguished the candle on the
table, but the Virgin, reading, seems unaware of
them. In the right wing of the altarpiece, Saint
Joseph is busy in his carpenter's shop. In the left
wing, the donor, Peter Engelbrecht (identified
by the heraldic emblems in the stained glass in
the windows in the center panel), and his wife
witness the Annunciation. An early masterpiece
of oil painting, the triptych presents a common
subject with an engagingly fresh approach and
exquisite detail, as seen in the cityscape outside
Joseph's window.

above
Jean Pucelle
French, active 1319–34
**The Hours of Jeanne d'Evreux,
Queen of France**
French, Paris, ca. 1324–28
Grisaille, tempera, ink on vellum,
folio 154v: 3⅝ × 2½ in. (9.2 × 6.2 cm)
The Cloisters Collection, 1954 (54.1.2)

Delicate shades of gray (grisaille) impart a
surprisingly sculptural quality to this tiny
book's scenes of the life of Christ and of Saint
Louis, seen here as he miraculously receives
his prayer book while in prison. Some seven
hundred marginal images depict the bishops,
beggars, dancers, and musicians of medieval
Paris, as well as apes, rabbits, dogs, and
imaginary creatures. All are brought to life
by the keen observation, fine draftsmanship,
and imagination of the artist. This book of
hours was intended for the queen's private
use as she prayed throughout the day. Jeanne
d'Evreux bequeathed it to King Charles V in
1371. Upon the king's death, the prayer book
entered the collection of his brother Jean de
France, duc de Berry.

below
Herman, Paul, and Jean de Limbourg
Franco-Netherlandish, active in France, by 1399–1416
**The Belles Heures of Jean de France,
Duc de Berry**
French, Paris, 1405–1408/1409
Tempera, gold leaf, ink on vellum, folio 168r:
9⅜ × 6¾ in. (23.8 × 17 cm)
The Cloisters Collection, 1954 (54.1.1)

The *Belles Heures* (Beautiful Hours), a private
devotional book, was the first of several sump-
tuous manuscripts commissioned from the
Limbourg brothers by Jean de Berry. Perhaps
the only virtually complete and stylistically con-
sistent prayer book to survive from the duke's
extraordinary library, its ninety-four full-page
and fifty-four column illuminations include
unusual cycles reflecting his personal interests.
Depicted here is the miracle of Saint Nicholas
saving travelers at sea. Using a luminous palette,
the artists blended rounded Italianate figures
with a detailed northern vision of nature.

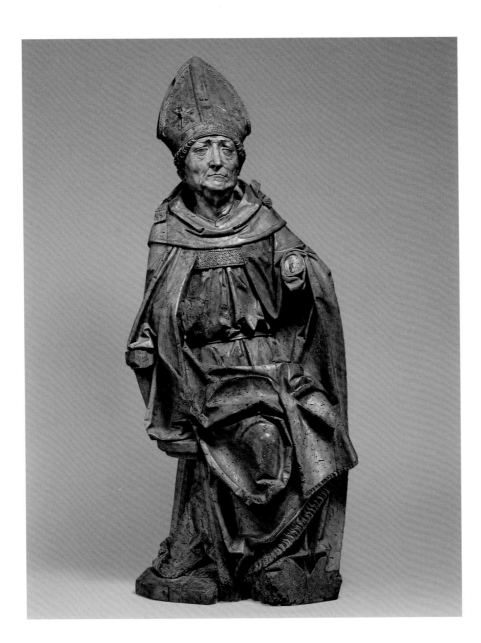

Tilman Riemenschneider

German, 1460–1531

Seated Bishop

German, Lower Franconia, Würzburg, ca. 1495–1500
Lindenwood with gray-black stain, 35½ × 14 × 5⅞ in.
(90.2 × 35.6 × 14.9 cm)
The Cloisters Collection, 1970 (1970.137.1)

Riemenschneider was one of the most gifted
late medieval lindenwood sculptors in southern
Germany. He sometimes chose not to paint the
sculptures intended for large altarpieces but

rather to stain a few details in black, as he did
with the eyes of this figure, and then to finish
the surface with a clear glaze. The identification
of the bishop is uncertain, but his seated
position suggests that he may represent Saint
Augustine or Saint Ambrose, and is perhaps
from an altarpiece of the four early "fathers
of the church." The sensitive and descriptive
rendering of the elderly face suggests both
psychological depth and spiritual fervor, traits
common in German art at the time.

below

Beaker with Apes

South Netherlandish, probably the
Burgundian territories, ca. 1430–40
Silver, gilt silver, painted enamel,
H. 7⅞ in. (20 cm), DIAM. 4⅝ in. (11.7 cm)
The Cloisters Collection, 1952 (52.50)

One of the finest surviving examples of
medieval enamel created for a princely table,
this beaker illustrates a popular legend about
the folly of man. A sleeping peddler is robbed
by a band of apes. Lying just above the base,
he fails to stir as the apes strip away his
clothes. Other apes, having taken his goods,
cavort in the branches overhead. The unusual
grisaille enamel technique is found on several
other surviving objects, all associated with the
courts of the dukes of Burgundy.

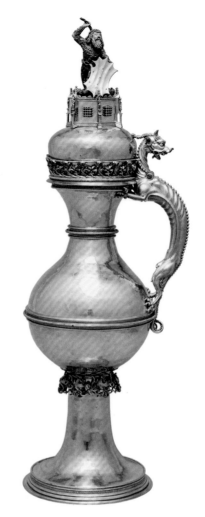

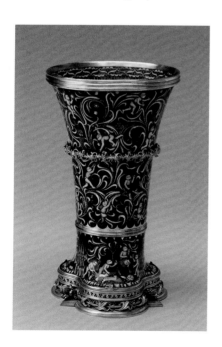

above

Ewer with Wild Man Finial

German, probably Nuremberg, late 15th century
Gilt silver, enamel, paint, H. 25 in. (63.5 cm)
The Cloisters Collection, 1953 (53.20.2)

Atop this ewer is a bearded man wielding a club.
Legendary figures in the art and literature of
the late Middle Ages, such "wild men," believed
to possess great virility, were thought to live in
forests and to follow primitive instincts. One of
a pair, this ewer and its mate have long been
identified with a pair mentioned in the 1526 and
1585 inventories of the Teutonic Knights, a
military and religious society founded during
the Crusades. Neither bears a hallmark, but
they can be attributed to the prosperous city of
Nuremberg by stylistic comparison to the work
of the Nuremberg goldsmith Sebastian
Lindenast the Elder.

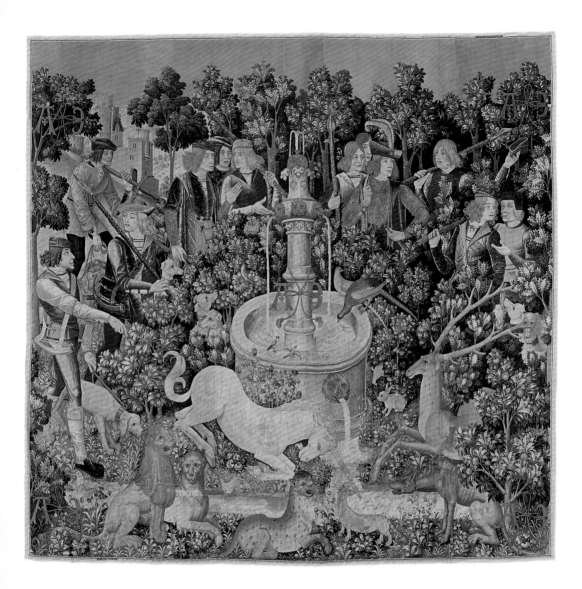

The Unicorn Is Found

South Netherlandish, 1495–1505
Wool warp with wool, silk, silver, gilt wefts,
12 ft. 1 in. × 12 ft. 5 in. (3.7 × 3.8 m)
Gift of John D. Rockefeller Jr., 1937 (37.80.2)

In this tapestry, one of seven at The Cloisters devoted to the legendary Unicorn, the mythical horselike animal kneels before a fountain, dipping its long, twisting horn into the stream flowing below. Pairs of pheasants and goldfinches perch at the fountain's edge. Deer and rabbits rest in the vegetation alongside wild animals, notably a lion. Twelve hunters and their dogs surround the animals, planning an attack. Plants believed to be antidotes to poisoning, such as sage and orange, flourish near the stream, which is being purified by the unicorn's magic horn. Each of the seven tapestries at The Cloisters contains the letters A and E knotted together, likely the initials of the unknown couple who first owned the tapestries.

Drawings and Prints

The Metropolitan Museum of Art houses one of this country's largest collections of Western drawings, prints, and illustrated books, spanning from the fifteenth century to the present day. The drawings collection began in 1880, when Cornelius Vanderbilt presented the Metropolitan with six hundred seventy European old master works, which were eventually supplemented by major drawings by Leonardo, Michelangelo, Rembrandt, and Goya. Over the decades, the collection has become comprehensive in scope, containing creations by the greatest European artists of the fifteenth through the nineteenth century. The Department of Drawings and Prints also includes prints by Dürer, Rembrandt, Van Dyck, Degas, and Cassatt and has now expanded into one of the world's most encyclopedic repositories of printed images. Ornament and architectural drawings, prints, and books and a large collection of ephemera constitute further components of the department's holdings, as does an important group of printing plates and woodblocks from all periods. In total, the department houses more than 1.2 million prints, sixteen thousand drawings, and twelve thousand illustrated books, and maintains study rooms for use by scholars.

Andrea Mantegna

Italian, ca. 1430/31–1506

Bacchanal with a Wine Vat, ca. 1475

Engraving, 11¾ × 17¼ in. (29.8 × 43.8 cm)
Purchase, Rogers Fund, The Charles Engelhard Foundation
Gift, and The Elisha Whittelsey Collection, The Elisha
Whittelsey Fund, 1986 (1986.1159)

The renowned Renaissance artist Andrea
Mantegna produced some of his most celebrated
compositions in the medium of engraving.
Dating to the 1470s, Mantegna's friezelike

Bacchanal with a Wine Vat, along with its
companion, *Bacchanal with Silenus*, was inspired
by the designs of Roman sarcophagi. In the
Bacchanal with a Wine Vat, Mantegna used
layers of diagonal and zigzag hatching—and
touches of cross-hatching—to achieve rich tonal
effects hitherto unseen in Italian printmaking.
This shading technique and the deftly drawn
contours, which vary endlessly in their width
and depth, skillfully emulate pen-and-ink
drawings of the time.

Leonardo da Vinci

Italian, 1452–1519

The Head of the Virgin in Three-Quarter View Facing Right, 1508–12

Black chalk, charcoal, red chalk, with some traces of white chalk (?), 8 × 6⅛ in. (20.3 × 15.6 cm)

Harris Brisbane Dick Fund, 1951 (51.90)

This poetically beautiful drawing is probably a study for the head of the Virgin Mary in Leonardo's painting of the *Virgin and Child with Saint Anne* in the Louvre in Paris, to which it corresponds closely in both scale and appearance. The artist employed a rich combination of media, softly smudging the strokes of black chalk, red chalk, and charcoal to achieve a delicately shadowed modeling "in the manner of smoke" (*sfumato*), as he described the technique in his notes. The extraordinary atmospheric softness, subtle modulation of form, and nuanced gradation of light and shadow reflect Leonardo's profound and scientifically grounded understanding of optical phenomena.

Michelangelo Buonarroti

Italian, 1475–1564

Studies for the Libyan Sibyl, ca. 1511

Red chalk, with small accents of white chalk on
the left shoulder of the figure in the main study,
11⅜ × 8⅜ in. (28.9 × 21.4 cm)

Purchase, Joseph Pulitzer Bequest, 1924 (24.197.2)

Based on a posed male studio assistant or model,
this masterful drawing by Michelangelo of the
head, torso, and upraised arms of a muscular,

gracefully twisting figure is a preparatory study
for the Libyan Sibyl, one of the female seers of the
pagan world who appears on the frescoed ceiling
of the Sistine Chapel in the Vatican palace. In a
series of subsidiary sketches, the artist restudied
details such as the figure's refined profile, pirouet-
ting toe, and upraised hand, which in the fresco
holds the sibyl's prophetic book. Owned by the
artist's heirs after his death, this is one of Michel-
angelo's most important and celebrated drawings.

Albrecht Dürer

German, 1471–1528

Melencolia I, 1514

Engraving, 9½ × 7½ in. (24.1 × 19.1 cm)

Harris Brisbane Dick Fund, 1943 (43.106.1)

The Metropolitan holds more than five hundred impressions of prints by the supreme printmaker Albrecht Dürer. One of his most puzzling prints, *Melencolia I* is a depiction of the intellectual situation of the artist and, by extension, a spiritual self-portrait of Dürer himself. In medieval philosophy, each individual was thought to be dominated by one of the four humors; melancholy was the least desirable, and melancholics were considered the most likely to succumb to insanity. Renaissance thought, however, also linked melancholy to creative genius. Here the winged personification of Melancholy holds a caliper and is surrounded by other tools associated with geometry, the one of the seven liberal arts that underlies artistic creation.

Lucas van Leyden

Netherlandish, ca. 1494–1533

The Archangel Gabriel Announcing the Birth of Christ

Pen and brown ink, traces of squaring in black chalk,
8¼ × 6½ in. (21.1 × 16.5 cm)
Promised Gift of Leon D. and Debra R. Black,
and Purchase, Lila Acheson Wallace Gift and
2007 Benefit Fund, 2008 (2008.253)

Lucas van Leyden, considered by many to be
the first major Dutch artist, built his interna-
tional fame almost exclusively upon his work as
a printmaker. This drawing, one of fewer than
thirty accepted as by him, is the latest addition
to Lucas's small drawn oeuvre. The sheet com-
plements one of comparable size and technique
in the Kupferstichkabinett, Berlin, which depicts
the Virgin looking up in surprise at hearing the
archangel's message, and in which Lucas simi-
larly married the figure's monumentality with
a rich and subtle pattern of lines, hatchings, and
cross-hatchings.

Urs Graf

Swiss, ca. 1485–1529/30

A Mercenary Holding the Banner of the Canton Glarus

Pen and brown ink, 11⅜ × 7½ in. (28.8 × 19 cm)
Promised Gift of Leon D. and Debra R. Black, and
Purchase, Harris Brisbane Dick Fund, 2003 (2003.323)

Conceived as one of a series of standard-bearers
of the thirteen cantons of the Swiss Confederacy,
this drawing depicts a mercenary holding the
banner of Glarus, featuring the sixth-century
Irish monk Saint Fridolin, who converted the
region to Christianity. The importance given to
the saint makes him appear almost alive, but
his meek expression contrasts with the vigorous
stance of the standard-bearer and the latter's
fashionable clothes. The often unorthodox sub-
jects depicted by Urs Graf, who for a time served
as a mercenary himself, are matched by his
exuberant, calligraphic manner of drawing.

Albrecht Altdorfer
German, 1480–1538
Landscape with a Double Spruce
Etching, 4⅜ × 6⅜ in. (11.1 × 16.2 cm)
Purchase, Gift of Halston, by exchange,
The Elisha Whittelsey Collection, The Elisha
Whittelsey Fund, and Pfeiffer Fund, 1993
(1993.1097)

Within the confines of a small etching plate, Altdorfer created an expansive Danube valley vista with large mountains, nestled villages, and a river that winds its way beyond the two pines that command the foreground. Such vibrant images, lacking any traditional historical or religious references, were the first western European prints to give landscape pride of place as subject rather than background. Altdorfer appears to have produced these now-rare scenes for a limited audience of connoisseurs with a taste for intimate and unusual subjects. The remarkable spontaneity and freedom of draftsmanship in this etching echo those of the artist's numerous landscape drawings.

Peter Paul Rubens
Flemish, 1577–1640
**The Jesuit Nicolas Trigault in
Chinese Costume,** 1617
Black, red, and white chalk, blue pastel, pen and brown ink,
on light brown laid paper, 17½ × 9¾ in. (44.6 × 24.8 cm)
Purchase, Carl Selden Trust, several members of
The Chairman's Council, Gail and Parker Gilbert,
and Lila Acheson Wallace Gifts, 1999 (1999.222)

This magnificent costume study is also an affecting portrait of Nicolas Trigault, a Flemish Jesuit missionary to China. Rubens, who had close ties to the Jesuit college of Antwerp, made the drawing when Trigault visited the city to raise funds and recruit new missionaries. The costume combines a Korean cap and the robe of a Chinese scholar, conveying the Jesuits' desire to assimilate into Chinese culture while at the same time acknowledging and keeping a certain distance from it. Rubens beautifully captured the cut, texture, and weight of the robe but also elaborated on its colors in the Latin inscription.

Perino del Vaga

Italian, 1501–1547

Jupiter and Juno: Study for the "Furti di Giove" Tapestries, ca. 1532–35

Pen and ink with brown wash, heightened with white, on gray paper, 17 × 15¾ in. (43.1 × 40 cm)

Purchase, Acquisitions Fund and Annette and Oscar de la Renta Gift, 2011 (2011.36)

A gifted pupil of Raphael, Perino del Vaga ranks among the most important and influential artists of the sixteenth century. This polished study showing Jupiter and Juno reclining in bed is a design for a lost tapestry, part of a series called the *Furti di Giove*, depicting the clandestine romantic assignations of Jupiter. They were commissioned by the naval hero and ruler of Genoa Andrea Doria, for whom Perino worked in the late 1520s and 1530s. Striking for its monumental scale, high degree of finish, and rich combination of ink, wash, and white highlighting, the drawing is a masterful demonstration of the artist's gifts as a draftsman.

Claude Lorrain (Claude Gellée)
French, active Italy, 1604/5?–1682
Queen Esther Approaching the Palace
of Ahasuerus, 1658
Pen and brown ink, brown wash, over black chalk,
heightened with white, 11⅞ × 17½ in. (30 × 44.4 cm)
Purchase, The Annenberg Foundation Gift, 1997 (1997.156)

This magnificent compositional study depicts
the Old Testament story of Esther, queen to the
Persian king Ahasuerus. Unaware of her Jewish
ancestry, the king had demanded that all Jews
be put to death. Esther went to the king's palace
and implored him to show mercy. The scene was
presumably made as a presentation drawing for
François Bosquet, bishop of Montpellier, who
had commissioned from the artist a companion
piece to his *Sermon on the Mount*, now in the
Frick Collection in New York. Although many
of his canvases depict biblical and mythologi-
cal subjects, Claude was primarily a landscape
painter and therefore set the subject of Esther
seeking mercy, which is typically shown indoors,
in an invented landscape animated by fantastic
architecture and a diffuse naturalistic light.

Rembrandt (Rembrandt van Rijn)

Dutch, 1606–1669

Christ Crucified between the Two Thieves: The Three Crosses, 1653

Drypoint and burin, first state of five, printed on
vellum, 15 × 17¼ in. (38.1 × 43.8 cm)
Gift of Felix M. Warburg and his family, 1941 (41.1.31)

The Three Crosses, one of Rembrandt's finest works
in any medium, represents the culmination of his
virtuosity as a printmaker. He drew on the cop-
perplate entirely in drypoint, which allowed him
to exploit the velvety areas of burr raised by the

tool (drypoint needle) scratching the surface of
the metal plate. By creatively inking his plates
and printing them on different supports, Rem-
brandt produced a unique work each time he
printed. Here ink deliberately left on the plate
lightly veils the figures at the foot of the cross on
the right, and a thicker layer obscures the bushes
along the right edge. This impression is printed
on vellum (animal skin), which infuses the com-
position with a warm light. Less absorbent than
paper, vellum holds ink on the surface, softening
lines and enhancing the richness of the image.

Jean-Honoré Fragonard
French, 1732–1806
A Gathering at Woods' Edge
Red chalk, 14¾ × 19⅜ in. (37.5 × 49.2 cm)
Purchase, Lila Acheson Wallace Gift, 1995 (1995.101)

opposite, above
Joseph Mallord William Turner
British, 1775–1851
The Lake of Zug
Watercolor over graphite, 11¾ × 18⅜ in. (29.8 × 46.6 cm)
Marquand Fund, 1959 (59.120)

The pictorial qualities of this sheet and the virtuoso handling of the red chalk suggest an independent work, probably created in the studio from a plein-air study. A stand of mature trees, bursting with profuse sunlit foliage, guards the shady entrance to the woods. In a characteristic manipulation of scale, Fragonard presented small groupings of elegant figures, half lost in shadow, as restrained echoes of the vigor and fecundity of the overgrown landscape. The dramatic naturalism associated with Dutch landscape artists, especially Jacob van Ruisdael, is here merged with a vision of nature as a welcoming milieu for aristocratic dalliance, a legacy of Jean-Antoine Watteau's *fêtes galantes*.

Commissioned in 1843 by Hugh Munro of Novar (1797–1864), and based on sketches Turner had made during an extended sojourn in the Swiss Alps, this drawing was later owned by the admiring critic John Ruskin (1819–1900). Female figures resembling nymphs bathe in the foreground while the sun rises over the mountains behind the distant lakeside town of Zug. The accomplished rendering of light and atmosphere, created through successive applications of delicate layers of wet and dry color followed by touches of scraping, is characteristic of Turner's finest work and served his determination to imbue landscape with mythic resonance.

Caspar David Friedrich
German, 1774–1840
**View of the Eastern Coast
of Rügen Island with
a Shepherd**, 1805–6
Sepia-colored ink, sepia-colored
wash, white gouache, graphite on
off-white wove paper, 24¼ × 39 in.
(61.6 × 99 cm)
Purchase, several members of
The Chairman's Council Gifts and
Fletcher Fund, and Promised Gift
of Leon D. and Debra R. Black,
2002 (2002.260)

Before he took up painting in 1807, Caspar David Friedrich had already created some of the most fascinating landscape drawings of his time. This exceptionally large sheet from about 1805–6 is based on sketches made on the island of Rügen, in the Baltic Sea, not far from the artist's birth-place. The austere island inspired some of Friedrich's greatest works, in which he combined a close observation of nature with a pervasive romanticism. A solitary human figure contemplating the expanse of nature would be a recurring theme in his oeuvre.

Jean-Auguste-Dominique Ingres
French, 1780–1867
**Virgil Reading the Aeneid to Augustus,
Livia, and Octavia,** 1809/19 (?)
Pen and black ink, graphite, gray watercolor washes,
white gouache heightening, Conté crayon on blue paper,
15 × 12¾ in. (38.1 × 32.3 cm)
Purchase, Rogers Fund and Promised Gift of Leon D.
and Debra R. Black, 2009 (2009.423)

Ingres was the greatest Neoclassical artist of his generation. His unique interpretation of antique subjects combined archaeological exactitude and carefully calibrated emotional drama. Here the poet Virgil reads the *Aeneid* to the Roman emperor Augustus, his wife, Livia, and his sister Octavia. As the poet recites the words "Tu Marcellus eris" (Marcellus you shall be), Octavia faints into the emperor's lap. Marcellus is the name of her dead son, whose nude statue presides over the nocturnal scene, projecting a ghostly shadow onto the wall. The drawing relates to a painting commissioned of Ingres in 1811 by General Miollis (1759–1828), who served under Napoléon I in Italy.

Goya (Francisco de Goya y Lucientes)
Spanish, 1746–1828
The Giant, by 1818
Aquatint, first state of two, 11¼ × 8¼ in. (28.5 × 21 cm)
Harris Brisbane Dick Fund, 1935 (35.42)

This rare print of a mysterious gargantuan creature sitting on the edge of the earth is one of Goya's most disturbing and haunting images. The forlorn monster, who looks over his shoulder into a night sky lit only by the barest sliver of a moon, inspires both our pity and our dread. In a process similar to mezzotint engraving, Goya scraped highlights into metal previously roughened with grainy tint. The result is an ominously dark image, akin to the so-called Black Paintings that the aging artist painted on the walls of his house near Madrid.

James McNeill Whistler
American, 1834–1903
The Doorway, from Venice, a Series of Twelve Etchings
Etching and drypoint, sixth state of seven,
11½ × 7⅞ in. (29.2 × 20 cm)
Harris Brisbane Dick Fund, 1917 (17.3.90)

Whistler created the plate for this image, one of twelve views commissioned by the Fine Art Society in London, while visiting Venice during 1879 and 1880. He began by etching the lines with great care, strengthened them with drypoint, and then applied two colors of ink during printing. Black ink was used for the lines that describe the richly decorated doorway of the Palazzo Gussoni on the canal called Rio de la Fava. Brown ink was expressively wiped over portions of the plate containing few lines, in a manner approaching monotype, to create the evanescent passage of water in the foreground and the evocative reflections within the dusky workshop behind the steps.

Vincent van Gogh

Dutch, 1853–1890

Corridor in the Asylum,

September 1889

Oil color and essence over black chalk on pink laid ("Ingres") paper, 25⅝ × 19⅜ in. (65.1 × 49.1 cm)

Bequest of Abby Aldrich Rockefeller, 1948 (48.190.2)

This haunting view of a sharply receding corridor in the asylum at Saint-Rémy, France, with a small male figure in the middle distance turning toward a door, is Van Gogh's most powerful description of the institution where he spent a year, from May 1889 to May 1890, shortly before the end of his life. The artist sent this unusually large and colorful drawing to his brother Theo, to give a picture of his surroundings. The bright, acid colors applied in bold hatching create an echoing vibration, and the strongly diminishing perspective suggests a vise closing in on the figure.

Georges Seurat
French, 1859–1891
Portrait of Aman-Jean, 1882–83
Conté crayon on Michallet paper, 24½ × 18¾ in.
(62.2 × 47.5 cm)
Bequest of Stephen C. Clark, 1960 (61.101.16)

Seurat's study of his friend the artist Edmond
François Aman-Jean (1860–1936) ranks as one
of the great portrait drawings of the nineteenth
century. Aman-Jean and Seurat were art
students together in Paris, where they shared a
studio in 1879. The drawing was shown in the
Paris Salon of 1883 and was the first work by
the twenty-three-year-old artist to be exhibited
publicly. Seurat's signature technique of using
Conté crayon on textured paper gives the work
its luminosity and tonal harmony, and the
classically balanced pose of the artist in profile
imparts an enduring, timeless quality.

Andy Warhol
American, 1928–1987
Marilyn, 1967
Screenprint, 6 × 6 in. (15.2 × 15.2 cm)
Printed by Aetna Silkscreen Products, Inc., New York,
and published by Factory Additions, New York
Gift of Factory Additions, 1967 (67.855)

This small but striking image of Marilyn Mon-
roe was mailed out as a flyer to announce the
publication of Warhol's *Marilyn*, a portfolio of
ten large screenprints. In it, Warhol altered
Marilyn's publicity photograph for the 1953 film
Niagara by adding Day-Glo colors to the actress's
face. Each work in the portfolio features a differ-
ent scheme of colors, layered on using the com-
mercial technique of screenprinting, which the
artist further exploited by printing his images
off-register and in large editions. Warhol's
embrace of commercial methods transformed
Marilyn's image from that of an inaccessible sex
goddess into a consumer product, available to
anyone for the right price.

European Paintings

The Metropolitan Museum's world-famed collection of European paintings encompasses works of art from the thirteenth through the nineteenth century—from Giotto to Gauguin. Apart from its many individual masterpieces by artists as diverse as Jan van Eyck, Caravaggio, and Degas, the Museum possesses the most extensive collection of seventeenth-century Dutch art in the Western Hemisphere, including outstanding works by Frans Hals, Rembrandt, and Vermeer. Its holdings of El Greco and Goya are the finest outside of Spain, while the survey it offers of French painting between Neoclassicism and Post-Impressionism is second only to that found in Paris. The collection traces its origins back to the establishment of the Museum in 1870, when 174 paintings were acquired from three private sources. Since then, it has been enriched by numerous donations and bequests from civic-minded collectors. In recent years, curatorial purchases and gifts have enabled the department to build up a notable collection of seventeenth-century Italian paintings and to augment its great holdings of Impressionist works with a rich group of plein-air oil sketches. These additions to the collection reflect our constantly evolving ideas about the legacy of the past.

Duccio di Buoninsegna
Italian, active 1278–1318
Madonna and Child, ca. 1300

Tempera and gold on wood; overall 11 × 8¼ in. (27.9 × 21 cm), painted surface 9⅜ × 6½ in. (23.8 × 16.5 cm)
Purchase, Rogers Fund, Walter and Leonore Annenberg and The Annenberg Foundation Gift, Lila Acheson Wallace Gift, Annette de la Renta Gift, Harris Brisbane Dick, Fletcher, Louis V. Bell, and Dodge Funds, Joseph Pulitzer Bequest, several members of The Chairman's Council Gifts, Elaine L. Rosenberg and Stephenson Family Foundation Gifts, 2003 Benefit Fund, and other gifts and funds from various donors, 2004 (2004.442)

This exquisite work by the Sienese master Duccio defines a transforming moment in Western art by representing the sacred figures of the Madonna and Child in terms appropriated from real life. Departing from the Byzantine notion of a painting as a symbolic image of a divine being, Duccio endowed his figures with a new humanity, exploring the psychological relationship between mother and child. The parapet—among the earliest examples of this pictorial device—connects the fictive world of the painting with the real world of the viewer. The original frame shows burns from devotional candles that were lit in front of the work.

Giotto di Bondone
Italian, 1266/76–1337
The Epiphany, possibly ca. 1320
Tempera on wood, gold ground,
17¾ × 17¼ in. (45.1 × 43.8 cm)
John Stewart Kennedy Fund, 1911 (11.126.1)

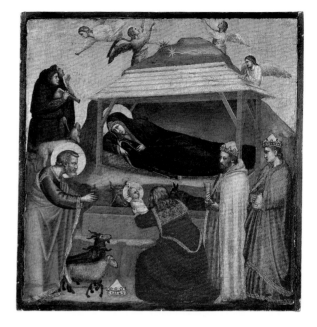

Giotto's status as a seminal figure in the visual arts in Italy has remained virtually unchallenged since his lifetime. His art exhibits qualities of intellectual distinction hitherto not associated with the art of painting. This panel, showing the manifestation of the infant Christ to the Magi, belongs to a series of scenes from the life of Christ, of which six others are known, and is notable for the way the figures move freely within a carefully described space. No less notable are the action of the king reaching to take the child from the manger and the concerned look on the Virgin's face.

Pietro Lorenzetti
Italian, active 1320–44
The Crucifixion, 1340s
Tempera and gold leaf on wood; overall
16½ × 12½ in. (41.9 × 31.8 cm), painted
surface 14⅛ × 10⅛ in. (35.9 × 25.7 cm)
Purchase, Lila Acheson Wallace Gift and Gwynne
Andrews Fund, 2002 (2002.436)

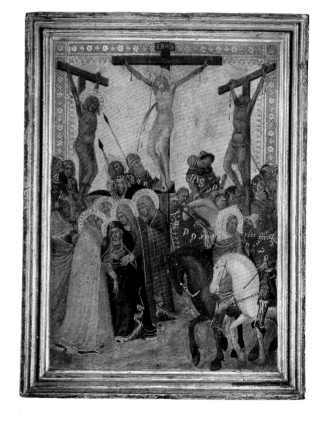

This panel, of unusual dramatic intensity and characterization, belonged to a portable altarpiece, of which one other panel is known. Trained in Siena under Duccio, Pietro Lorenzetti, like his brother Ambrogio, is one of the true innovators of Italian art. With its emphasis on dramatic narration, this panel fully testifies to the scope of the artist's imagination. It was painted as a devotional aid, but every detail, such as the swooning Virgin or the energetic figure about to break the legs of one of the thieves, demonstrates Pietro's ability to imbue the biblical subject with a human dimension.

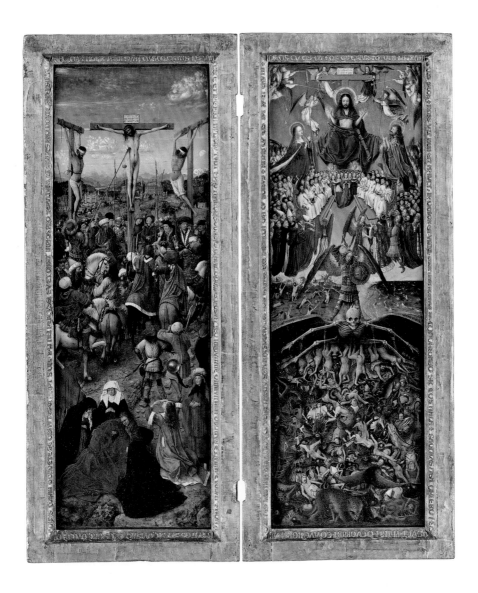

Jan van Eyck

and workshop assistant
Netherlandish, ca. 1390–1441
The Crucifixion and **The Last Judgment,** ca. 1440
Oil on canvas, transferred from wood,
each 22¼ × 7¾ in. (56.5 × 19.7 cm)
Fletcher Fund, 1933 (33.92ab)

These pictures, juxtaposing Christ's sacrifice for the salvation of humankind with the Last Judgment, are late works by the Bruges artist Jan van Eyck, the most celebrated painter of fifteenth-century Europe. *The Crucifixion* presents the scene as an eyewitness account set against a distant landscape. In contrast, *The Last Judgment* is organized hieratically in three tiers, with the scale of the figures manipulated to indicate their relative importance. The texts on the original frames are given form in the pictures with remarkable literalness, establishing a play between word and image. The upper half of *The Last Judgment* was painted in part by an assistant.

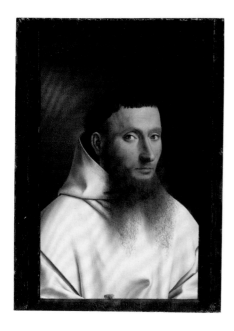

Petrus Christus
Netherlandish, active 1444–75/76
Portrait of a Carthusian, 1446
Oil on wood; overall 11½ × 8½ in. (29.2 × 21.6 cm),
painted surface 11½ × 7⅜ in. (29.2 × 18.7 cm)
The Jules Bache Collection, 1949 (49.7.19)

Petrus Christus was a leading Bruges painter
in the years following the death of Jan van
Eyck in 1441. In this portrait, arguably one of
his finest and the earliest of his dated works,
Christus moved beyond the flat, neutral
backgrounds of portraits then current and
posed his subject in the corner of an implied
room. Enhancing the effect of verisimilitude is
a trompe l'oeil frame with an inscribed sill, upon
which a fly rests momentarily.

Fra Filippo Lippi
Italian, ca. 1406–1469
**Portrait of a Woman with a Man at
a Casement,** ca. 1440
Tempera on wood, 25¼ × 16½ in. (64.1 × 41.9 cm)
Marquand Collection, Gift of Henry G. Marquand,
1889 (89.15.19)

One of the great Florentine portraits of its time,
this work is also the earliest surviving Italian
double portrait and the earliest instance of such
a portrait in a domestic setting. It may have
commemorated the betrothal or wedding of
the two figures. The word *lealt[a]* (loyalty) is
depicted as though embroidered on the cuff of
the red gown at the woman's left wrist. She is
wearing the sumptuous clothing and jewelry of
a newlywed. The carefully rendered dress and
jewels, as well as the buildings and gardens
depicted in the background, may document
family possessions.

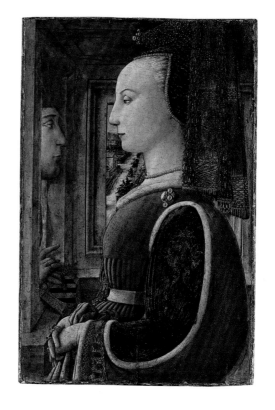

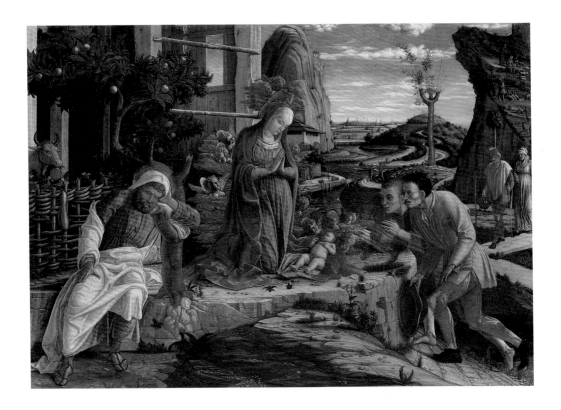

Andrea Mantegna
Italian, 1430/31–1506
The Adoration of the Shepherds,
shortly after 1450
Tempera on canvas, transferred from wood;
overall 15¾ × 21⅞ in. (40 × 55.6 cm), painted surface
14⅞ × 21 in. (37.8 × 53.3 cm)
Purchase, Anonymous Gift, 1932 (32.130.2)

Mantegna, one of the prodigies of Italian paint-
ing, created this work when he was in his early
twenties, and it reveals the full development of
his astonishing gift for descriptive detail. Plants
spring from crevices in the rocky foreground,
and the surface of a river ripples against its
banks. Although the subject of the picture is
traditional, the way Mantegna incorporated
these details gives prominence to his artistic
achievement. The expressive treatment of the
figures seems to be a response to the ideas of
contemporary court humanists. The meticu-
lous description of the landscape is thought to
reflect Mantegna's admiration for Netherland-
ish painting.

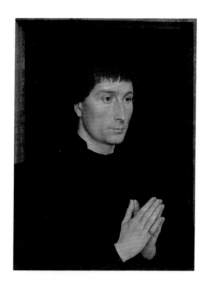

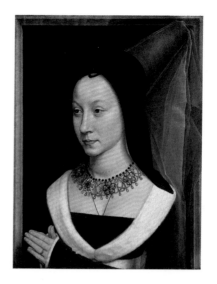

Hans Memling
Netherlandish, active 1465–94
Tommaso di Folco Portinari (1428–1501)
and **Maria Portinari (Maria Maddalena
Baroncelli, born 1456),** probably 1470
Oil on wood; Tommaso, overall 17⅜ × 13¼ in. (44.1 ×
33.7 cm), painted surface 16⅝ × 12½ in. (42.2 × 31.8 cm);
Maria, overall 17⅜ × 13⅜ in. (44.1 × 34 cm), painted
surface 16⅝ × 12⅝ in. (42.2 × 32.1 cm)
Bequest of Benjamin Altman, 1913 (14.40.626–27)

Hans Memling was the leading painter in
Bruges from 1465 until his death in 1494.
These portraits depict Tommaso and Maria

Portinari, members of the large Italian mercan-
tile community in Bruges, where Tommaso
managed a branch of the Medici bank from
1465 to 1478. Among the masterpieces of
Northern Renaissance art, these portraits
were probably commissioned upon the cou-
ple's marriage in 1470, when Maria was about
fourteen and Tommaso about forty-two. The
paintings originally formed the wings of a por-
table triptych, flanking a devotional image of
the Virgin and Child.

Rogier van der Weyden
Netherlandish, ca. 1399–1464
**Francesco d'Este (born about 1430,
died after 1475),** ca. 1460
Oil on wood; overall 12½ × 8¾ in. (31.8 × 22.2 cm),
painted surface, each side 11¾ × 8 in. (29.8 × 20.3 cm)
The Friedsam Collection, Bequest of Michael Friedsam,
1931 (32.100.43)

Rogier van der Weyden was much sought after
as a portraitist. The subject of this portrait,
Francesco d'Este, was the illegitimate son of
the ruler of Ferrara, and he was sent to the
Netherlands for education and military train-
ing. He was painted by Rogier in Brussels
about 1460. The hammer and ring he holds
may be either jousting prizes or symbols of
authority.

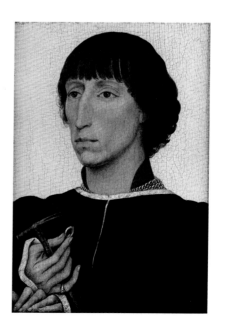

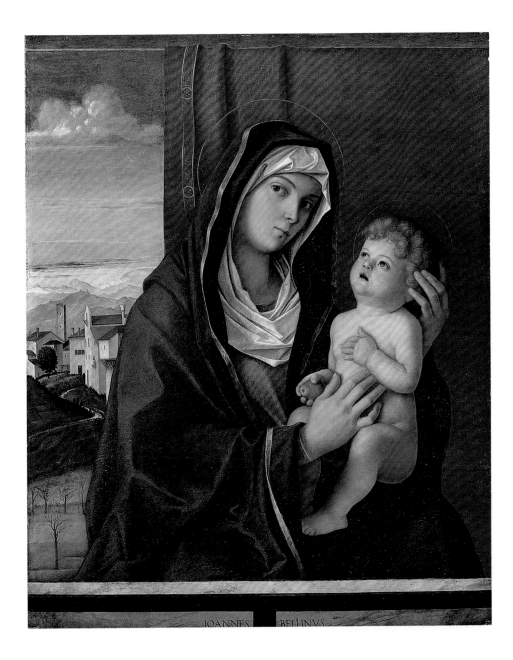

IOANNES BELLINVS

Giovanni Bellini
Italian (Venetian), active 1459–1516
Madonna and Child, late 1480s
Oil on wood, 35 × 28 in. (88.9 × 71.1 cm)
Rogers Fund, 1908 (08.183.1)

Giovanni Bellini, who came from a family of well-known artists that included his father Jacopo and his brother Gentile, held a pre-eminent position among Venetian artists throughout his life. His small-scale devotional panels demonstrate his ability to combine religious piety with the naturalism and aesthetic of the early Renaissance. Atypically, the cloth behind the figures is here pulled aside, revealing a distant landscape that in its light and atmosphere anticipates the works of Giorgione and Titian. The landscape is allegorical, moving the viewer from a barren foreground into a flourishing background—from death to rebirth.

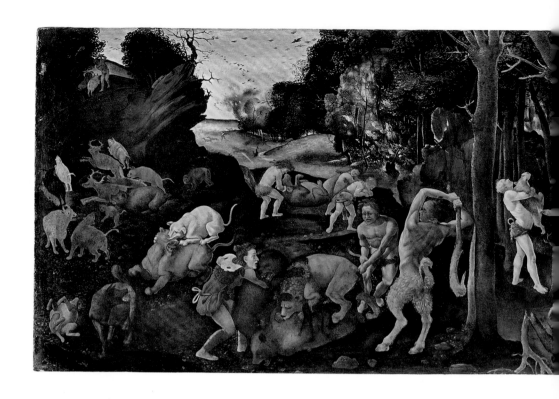

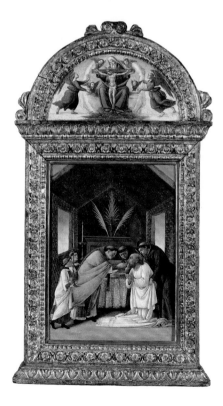

Botticelli (Alessandro di Mariano Filipepi)

Italian, 1444/45–1510

The Last Communion of Saint Jerome,

early 1490s

Tempera and gold on wood, 13½ × 10 in. (34.3 × 25.4 cm)

Bequest of Benjamin Altman, 1913 (14.40.642)

Botticelli, who trained with Filippo Lippi, is perhaps the best-known painter of the early Renaissance. This work depicts the death of Saint Jerome, who is shown in his bedroom cell near Bethlehem, supported by his brethren. It was painted for the Florentine wool merchant Francesco del Pugliese, who was a supporter of the radical preacher Savonarola, and he may have been attracted to the subject for its deeply devotional content. The exceptionally fine frame was carved in the workshop of Giuliano da Maiano, and its painted lunette is by Bartolomeo di Giovanni, who sometimes worked with Botticelli.

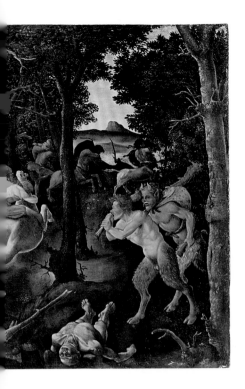

Piero di Cosimo (Piero di Lorenzo
di Piero d'Antonio)
Italian, 1462–1522
A Hunting Scene, ca. 1485–1500
Tempera and oil transferred to Masonite,
27¾ × 66¾ in. (70.5 × 169.5 cm)
Gift of Robert Gordon, 1875 (75.7.2)

This remarkable painting, showing a hunt of
lions, bears, and other creatures by men and
satyrs, is among the most singular works of
the Renaissance. It is thought to belong to a
series inspired by works of the Roman writers
Lucretius and Vitruvius, and it is among the
most imaginative evocations of the life of primi-
tive man. Lucretius noted how the primitives
lived like wild beasts. In this painting, figures
brandish crude clubs, and animals in the dis-
tance flee a forest fire.

Filippino Lippi
Italian, ca. 1457–1504
Madonna and Child, ca. 1485
Tempera, oil, and gold on wood,
32 × 23½ in. (81.3 × 59.7 cm)
The Jules Bache Collection, 1949 (49.7.10)

Filippino Lippi, among the most gifted and
accomplished Florentine painters, was trained
first by his father, Fra Filippo Lippi, and he
later entered the workshop of Botticelli. His
style was inspired by these two masters.
The picture reveals the influence of Flemish
painting in the view through the loggia on the
left and in the still life with the candlestick
casting a shadow. Its brilliant colors—
especially the blue of the Madonna's mantle,
painted in expensive ultramarine—were
probably requested by the patron, Filippo
Strozzi.

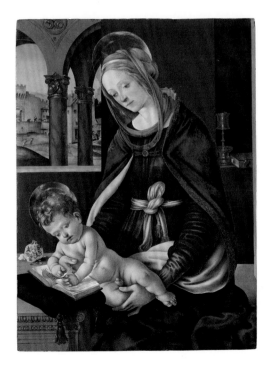

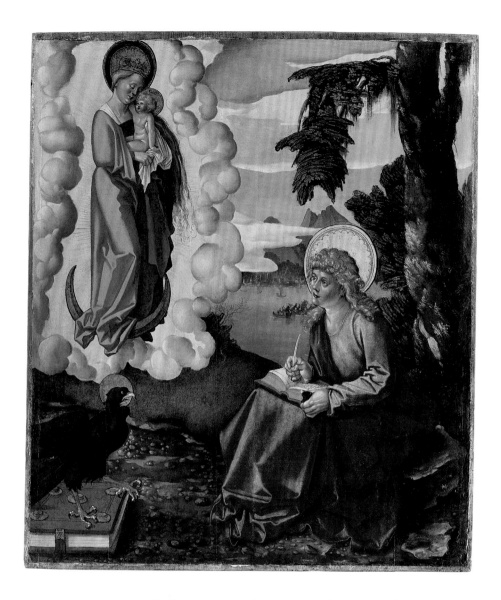

Hans Baldung Grien (Hans Baldung)

German, 1484/85–1545

Saint John on Patmos, ca. 1511

Oil on wood; overall 35¼ × 30¼ in. (89.5 × 76.8 cm),
painted surface 34⅜ × 29¾ in. (87.3 × 75.6 cm)
Purchase, Rogers and Fletcher Funds; The Vincent Astor
Foundation, The Dillon Fund, The Charles Engelhard
Foundation, Lawrence A. Fleischman, Mrs. Henry J.
Heinz II, The Willard T. C. Johnson Foundation Inc.,
Reliance Group Holdings Inc., Baron H. H. Thyssen-
Bornemisza, and Mr. and Mrs. Charles Wrightsman
Gifts; Joseph Pulitzer Bequest; special funds; and other
gifts and bequests, by exchange, 1983 (1983.451)

A painter, printmaker, and stained-glass
designer of great originality, Baldung came
from a family of lawyers and doctors. At
eighteen he entered Dürer's workshop in
Nuremberg. This panel, originally part of a
triptych, shows the apostle John on the island
of Patmos composing the book of Revelation;
the eagle is his emblem. The altarpiece was
commissioned by the Order of Saint John of
Jerusalem at Grünen Wörth, near Strasbourg,
and is mentioned in a record from about
1510–11, approximately five years after
Baldung left Dürer's workshop.

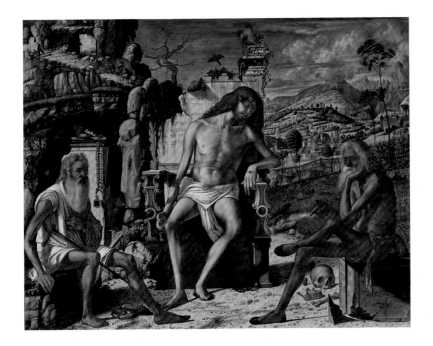

Vittore Carpaccio
Italian, ca. 1455–1523/26
The Meditation on the Passion, ca. 1480–1510
Oil and tempera on wood, 27¾ × 34⅛ in. (70.5 × 86.7 cm)
John Stewart Kennedy Fund, 1911 (11.118)

In addition to his well-known narrative cycles in Venice, Carpaccio painted a number of devotional images employing elaborate symbols. This one is among the most memorable. At the right Job sits on a block inscribed in Hebrew with the passage, "I know that my redeemer liveth." Saint Jerome, portrayed as a hermit on the left, interpreted this biblical passage to refer to the Resurrection of Christ, whose dead body is displayed on a broken throne with the crown of thorns at its base. The landscape, barren on the left and pastoral on the right, also alludes to the contrasting themes of life and death.

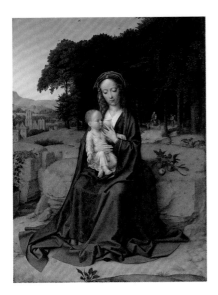

Gerard David
Netherlandish, ca. 1455–1523
The Rest on the Flight into Egypt, ca. 1512–15
Oil on wood, 20 × 17 in. (50.8 × 43.2 cm)
The Jules Bache Collection, 1949 (49.7.21)

Representing one of the most popular themes in Netherlandish painting, this composition suggests a continuous narrative in which the viewer is meant to participate vicariously. In the background is a vignette of the Holy Family emerging from the forest en route to a contemporary town nestled in the valley at the left. David's new awareness of Italian Renaissance conventions is evident in the pyramidal composition of the Virgin and Child and in the use of chiaroscuro to convey the volume of forms.

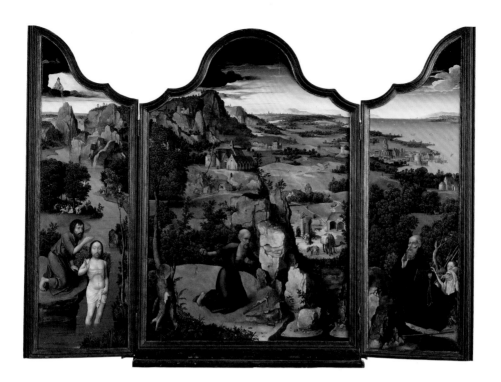

Joachim Patinir

Netherlandish, active 1515–24

The Penitence of Saint Jerome, ca. 1518

Oil on wood; central panel, overall, with engaged frame, 46¼ × 32 in. (117.5 × 81.3 cm); each wing, overall, with engaged frame, 47½ × 14 in. (120.7 × 35.6 cm)

Fletcher Fund, 1936 (36.14a–c)

A milestone in the history of European landscape painting, this triptych may have been made for a church in southern Germany. Patinir reversed the normal scale of figure to background. From left to right, Saint John the Baptist baptizing Christ in the Jordan River, Saint Jerome, and Saint Anthony the Hermit, with the monsters that assailed him, are situated in front of a vast and splendid panoramic landscape, which the viewer is encouraged to travel through visually in the manner of a pilgrimage.

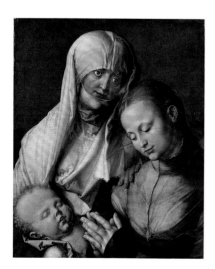

Albrecht Dürer

German, 1471–1528

Virgin and Child with Saint Anne,

probably 1519

Oil on wood, 23⅝ × 19⅝ in. (60 × 49.8 cm)

Bequest of Benjamin Altman, 1913 (14.40.633)

The Venetian painter Giovanni Bellini, whose art Dürer admired during his sojourn in Venice, probably inspired the motif of the Virgin adoring the sleeping Christ Child. Looking on is the Virgin's mother, Saint Anne, who was particularly venerated in Germany. The model for Saint Anne was Dürer's wife, Agnes. The picture was intended for private devotion.

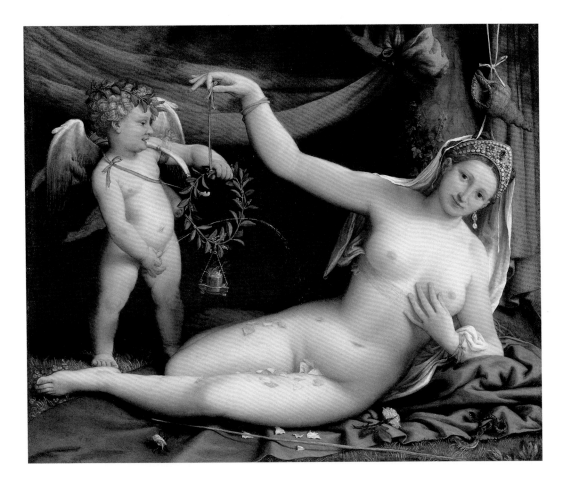

Lorenzo Lotto

Italian, ca. 1480–1556

Venus and Cupid, mid-1520s

Oil on canvas, 36⅜ × 43⅞ in. (92.4 × 111.4 cm)

Purchase, Mrs. Charles Wrightsman Gift, in honor of Marietta Tree, 1986 (1986.138)

The theme of this picture, by the most unconventional genius of the Venetian Renaissance, was inspired by classical marriage poems and was almost certainly painted to celebrate a wedding. Indeed, Venus may be a portrait of the bride. The shell above Venus's head and the rose petals on her lap are conventional attributes of the goddess. The ivy is symbolic of conjugal fidelity, while the myrtle wreath and brazier suspended from it are accoutrements of the marriage chamber. Venus wears the earring and diadem of a sixteenth-century bride. Cupid's action of urinating through a myrtle wreath is an augury of fertility and confers a mood of lighthearted wit on this very private image.

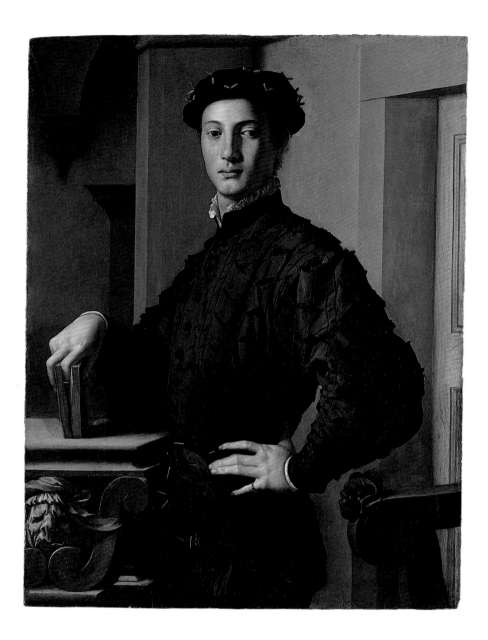

Bronzino (Agnolo di Cosimo di Mariano)
Italian, 1503–1572
Portrait of a Young Man, 1530s
Oil on wood, 37⅝ × 29½ in. (95.6 × 74.9 cm)
H. O. Havemeyer Collection, Bequest of
Mrs. H. O. Havemeyer, 1929 (29.100.16)

Painted in Florence, this portrait is among
Bronzino's most arresting. The sitter is not
known, but he must have belonged to Bronzino's
close circle of literary friends, which included the
historian Benedetto Varchi and the poet Laura
Battiferri, both of whom sat for the artist.
Bronzino himself composed verses both serious
and ribald. Some of the fanciful and witty con-
ceits in this picture—for example, the grotesque
heads carved on the table and chair and the
masklike face formed by the folds of the youth's
breeches—would have been much appreciated
in literary circles as ironic comments on portrai-
ture and self-presentation.

Andrea del Sarto (Andrea d'Agnolo)
Italian, 1486–1530
The Holy Family with the Young Saint John the Baptist, ca. 1530
Oil on wood, 53½ × 39⅝ in. (135.9 × 100.6 cm)
Maria DeWitt Jesup Fund, 1922 (22.75)

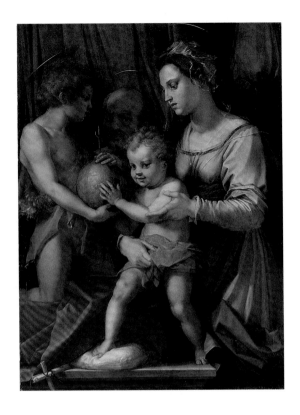

Although Sarto's style was rooted in the artistic ideals of the Renaissance, including the integration of naturally proportioned figures in a clearly defined space, his expressive use of color and varied, complex poses inspired the first generation of Mannerist painters. This grand and much-copied work has been interpreted as signifying the transfer of Florence's allegiance from Saint John the Baptist—its patron saint—to Christ. Sarto was known as "the painter without defects," and this reputation is fully evident in the masterful rendering of the figures, the nobility and complexity of their gestures, and the use of sumptuous color.

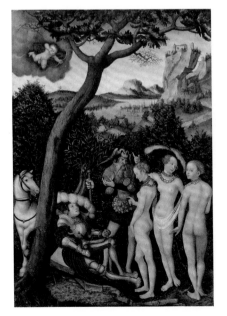

Lucas Cranach the Elder
German, 1472–1553
The Judgment of Paris, possibly ca. 1528
Oil on wood, 40⅛ × 28 in. (101.9 × 71.1 cm)
Rogers Fund, 1928 (28.221)

Born into a family of artists, Lucas Cranach became a celebrated court painter for the electors of Saxony in Wittenberg. This picture depicts Paris as he deliberates who is the fairest of three goddesses: Minerva, Venus, and Juno. Mercury, standing nearby, holds the coveted prize—a golden apple (here represented by a glass orb)—while above Cupid aims his arrow at Venus. This myth was a favorite subject of the mature Cranach and his courtly patrons. A closely similar picture, also by the artist and now in the Öffentliche Kunstsammlungen Basel, is usually dated about 1528, as is this painting.

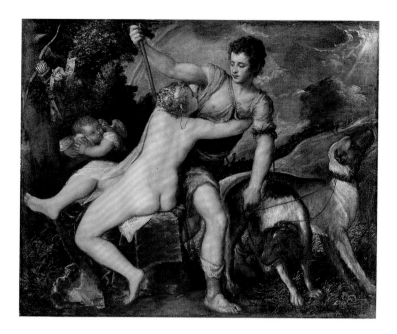

Titian (Tiziano Vecellio)
Italian, 1485/90–1576
Venus and Adonis, 1560s
Oil on canvas, 42 × 52½ in. (106.7 × 133.4 cm)
The Jules Bache Collection, 1949 (49.7.16)

Titian, the greatest painter of the Venetian Renaissance, produced two versions of this scene from Ovid's *Metamorphoses*, one for Philip II of Spain and the other for the Farnese family in Rome; the Farnese version is now lost. The goddess Venus vainly tries to restrain her mortal lover Adonis from departing for a hunt. The mood of playful sensuality conceals the tragic irony that Adonis is destined to be killed during the hunt by a wild boar. Some of the artist's most powerful works from later in his career contrasted the sensuality and cruelty of classical mythology.

Hans Holbein the Younger
German, 1497/98–1543
Portrait of a Member of the Wedigh Family, Probably Hermann Wedigh (died 1560), 1532
Oil on wood, 16⅜ × 12¾ in. (42.2 × 32.4 cm),
with added strip of ½ in. (1.3 cm) at bottom
Bequest of Edward S. Harkness, 1940 (50.135.4)

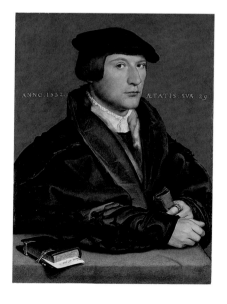

This sitter, whose ring displays the arms of the Wedigh family of Cologne, is probably Hermann von Wedigh III, a member of the London Steelyard trading company. The piece of paper inserted into the small devotional book is inscribed with a quotation from the Roman comedy *Andria* by Terence: "Truth breeds hatred." These words serve both as a reference to the content of the book and, perhaps, as the sitter's personal motto.

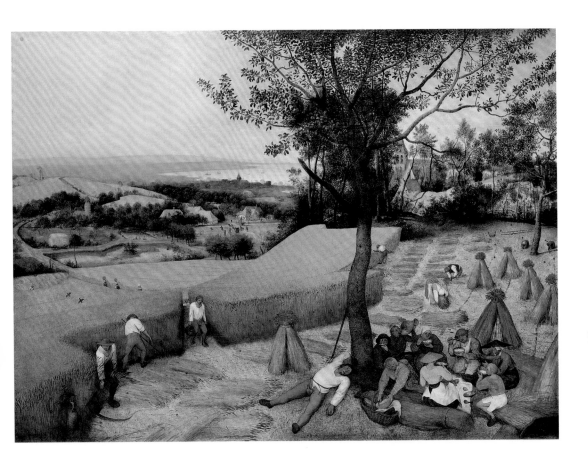

Pieter Bruegel the Elder
Netherlandish, ca. 1525–1569
The Harvesters, 1565
Oil on wood; overall, including added strips at top, bottom, and right, 46⅞ × 63¾ in. (119 × 162 cm); original painted surface 45⅞ × 62⅞ in. (116.5 × 159.5 cm)
Rogers Fund, 1919 (19.164)

This painting illustrates harvesting in August and September, with laborers taking a lunch break in the shade of a tree while in the distance figures amuse themselves and ships set sail from a port. Through his remarkable sensitivity to nature's workings, Bruegel created a watershed in the history of Western art, in which the religious pretext for landscape painting was suppressed in favor of a new humanism. Bruegel's depiction of the local scene is not idealized but rather based on observation of nature and human activities. The vastness of the panorama across the rest of the composition reveals that Bruegel's emphasis is not on the labors that mark the seasons of the year, but on the atmosphere and the transformation of the landscape itself. The work, part of a series of six showing the times of the year, was commissioned from Bruegel by the Antwerp merchant Niclaes Jongelinck.

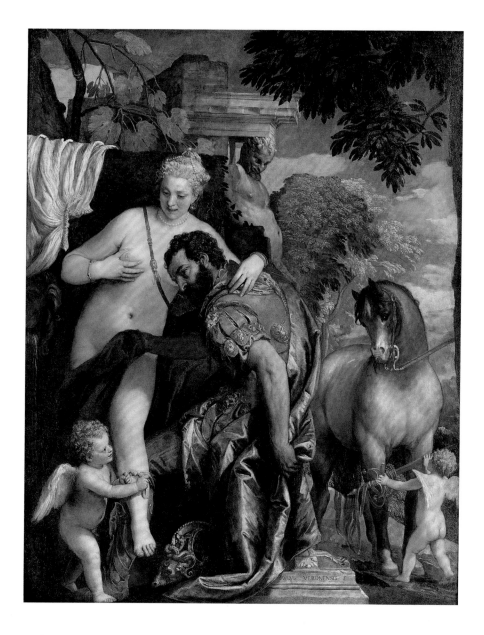

Paolo Veronese (Paolo Caliari)

Italian, 1528–1588

Mars and Venus United by Love, 1570s

Oil on canvas, 81 × 63⅜ in. (205.7 × 161 cm)

John Stewart Kennedy Fund, 1910 (10.189)

This picture, in which Cupid binds Mars (the god of war) to Venus with a love knot, celebrates the nurturing and civilizing effects of love, as conveyed by the milk flowing from Venus's breast and the tethering of Mars's horse. In the early seventeenth century, it hung near other mythological and allegorical scenes by the artist in the collection of Holy Roman Emperor Rudolf II in Prague. This is one of Veronese's most renowned paintings, created at the height of his powers. The Venetian painter was among the greatest masters of light and color, and his work had an enduring impact on later artists, from Annibale Carracci and Velázquez to Tiepolo.

Annibale Carracci
Italian, 1560–1609
The Coronation of the Virgin, after 1595
Oil on canvas, 46⅜ × 55⅝ in. (117.8 × 141.3 cm)
Purchase, Bequest of Miss Adelaide Milton de Groot
(1876–1967), by exchange, and Dr. and Mrs. Manuel
Porter and sons Gift, in honor of Mrs. Sarah Porter,
1971 (1971.155)

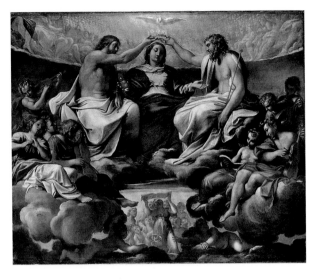

Together with Caravaggio, Annibale Carracci
was one of the two most influential painters
in Italy during the seventeenth century. This
pivotal work was painted for Cardinal Pietro
Aldobrandini shortly after Annibale's arrival in
Rome in 1595; it remained in the Aldobrandini
collection until 1800. In it Annibale brought
together two currents of Italian painting, the
northern Italian sensitivity to the effects of
light and color and the careful spatial organiza-
tion and idealized figure types associated with
the High Renaissance. In this work Annibale
began to redefine classicism for the seventeenth
century.

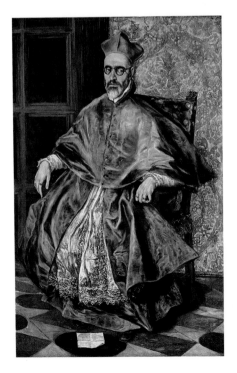

El Greco (Domenikos Theotokopoulos)
Greek, active Italy and Spain, 1540/41–1614
Portrait of a Cardinal, Probably Cardinal Don Fernando Niño de Guevara (1541–1609), ca. 1600
Oil on canvas, 67¼ × 42½ in. (170.8 × 108 cm)
H. O. Havemeyer Collection, Bequest of Mrs. H. O.
Havemeyer, 1929 (29.100.5)

This celebrated portrait—a landmark in the his-
tory of European portraiture—has become syn-
onymous not only with El Greco but with Spain
and the Inquisition. The sitter, Niño de Guevara,
became cardinal in 1596 and rose to prominence
as Inquisitor General. Guevara was in Toledo in
February and March of 1600, and he visited the
city again in 1601 and 1604; his portrait must
have been painted on one of these occasions by
El Greco, who lived there at this time.

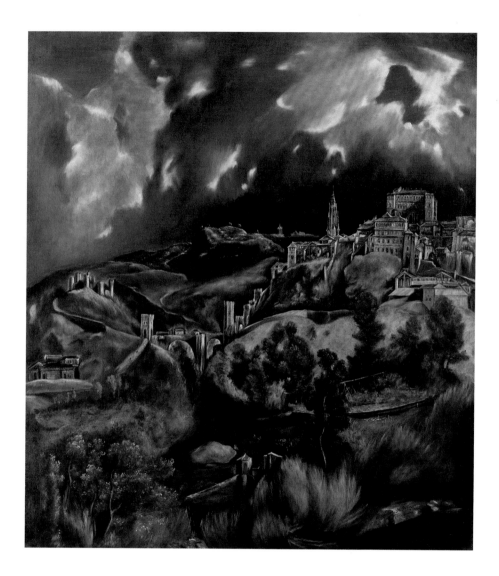

El Greco (Domenikos Theotokopoulos)

Greek, active Italy and Spain, 1540/41–1614

View of Toledo, ca. 1597–99

Oil on canvas, 47¾ × 42¾ in. (121.3 × 108.6 cm)

H. O. Havemeyer Collection, Bequest of

Mrs. H. O. Havemeyer, 1929 (29.100.6)

This painting, El Greco's greatest landscape, belongs to an artistic tradition of emblematic city views. As with El Greco's finest portraits, its approach is interpretive rather than literal. It seeks to capture the essence of the city rather than to document its actual appearance. This partial view of Toledo, showing the eastern part of the city from the north, would have excluded the cathedral, which the artist imaginatively moved to the left of the dominant Alcázar. A string of buildings descends a steep hill to the Roman Alcántara Bridge, and on the other side of the Tagus sits the Castle of San Servando. The picture was in El Greco's studio in Toledo at his death and was later purchased by the conde de Arcos, a major collector who owned at least seven paintings by the artist.

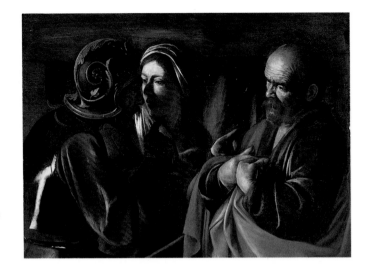

Caravaggio
(Michelangelo Merisi)
Italian, 1571–1610
The Denial of Saint Peter, 1610
Oil on canvas, 37 × 49⅜ in. (94 × 125.4 cm)
Gift of Herman and Lila Shickman, and
Purchase, Lila Acheson Wallace Gift, 1997
(1997.167)

A marvel of narrative as well as pictorial concision, this picture was painted by Caravaggio in the last months of his tempestuous life and marks an extreme stage in his revolutionary style. In it he eschews delicacy and beauty of color and concentrates exclusively on the human drama. Peter is shown in the courtyard of the high priest, where a woman accuses him of being a follower of Christ. The pointing finger of the soldier and two pointing fingers of the woman allude to the three accusations and to Peter's three denials. Caravaggio's late works depend for their dramatic effect on brightly lit areas standing in stark contrast to a dark background.

Frans Hals
Dutch, 1582/83–1666
Merrymakers at Shrovetide, ca. 1616–17
Oil on canvas, 51¾ × 39¼ in. (131.4 × 99.7 cm)
Bequest of Benjamin Altman, 1913 (14.40.605)

In its coloring, brushwork, and crowded composition, this important early painting by Hals recalls contemporary works by the Flemish artist Jacob Jordaens. The subject is Vastenavond (Shrovetide or Mardi Gras), a pre-Lenten feast famous for foolish behavior. Two figures from the comic stage, Peeckelhaering (Pickled Herring) and Hans Wurst (John Sausage), wear appropriate food and make inappropriate advances toward a young "lady" (actually a man in costume) with a bull neck and a laurel wreath on "her" head.

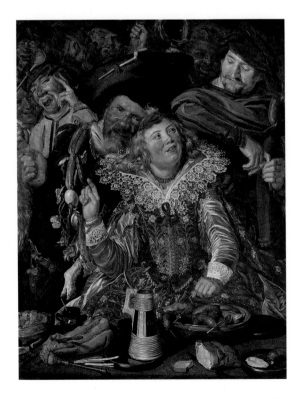

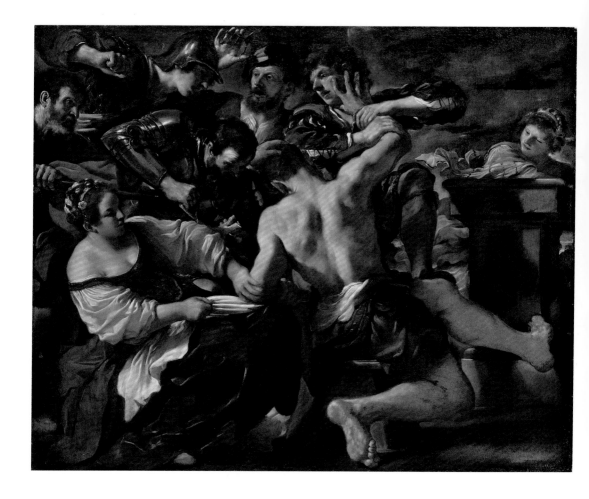

Guercino (Giovanni Francesco Barbieri)
Italian, 1591–1666
Samson Captured by the Philistines, 1619
Oil on canvas, 75¼ × 93¼ in. (191.1 × 236.9 cm)
Gift of Mr. and Mrs. Charles Wrightsman, 1984 (1984.459.2)

With massive, lifelike figures, Guercino's painting illustrates the climactic moment in the Old Testament story of Samson and Delilah—the moment when Samson is set upon by Philistines, who bind and blind him, aided by his deceitful lover, Delilah. The focus of this powerful and immensely inventive composition is the vigorously modeled back of Samson, but Guercino conjured a scene of striking intensity, filling the canvas with figures. The dramatic lighting is typical of Guercino's early naturalistic chiaroscuro style. This is one of several commissions that Guercino, then at the height of his powers, received from Cardinal Giacomo Serra, the papal legate to Ferrara and a noted collector.

Hendrick ter Brugghen
Dutch, 1588–1629
The Crucifixion with the Virgin and Saint John, ca. 1624–25
Oil on canvas, 61 × 40¼ in. (154.9 × 102.2 cm)
Funds from various donors, 1956 (56.228)

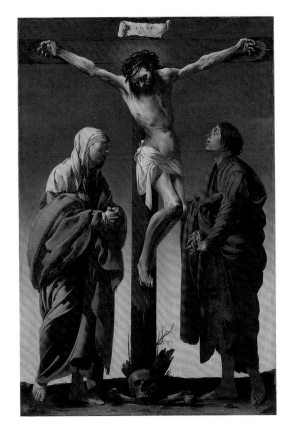

This canvas of about 1624–25 was painted as an altarpiece, probably for a Catholic church in Utrecht, where Catholicism was tolerated but not encouraged. The strikingly archaic qualities of the picture, such as the angular figure of Christ, the shallow space, and the starry sky, have reminded many viewers of late medieval woodcuts, prints by Dürer, and Matthias Grünewald's Isenheim Altarpiece in Colmar, France. It appears likely that the Museum's painting was made to replace an earlier altarpiece that had been damaged or destroyed. Painted in a fugitive pigment (smalt), the sky once had a bluer cast.

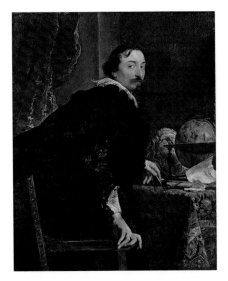

Anthony van Dyck
Flemish, 1599–1641
Lucas van Uffel (died 1637), ca. 1622
Oil on canvas, 49 × 39⅝ in. (124.5 × 100.6 cm)
Bequest of Benjamin Altman, 1913 (14.40.619)

Van Uffel was a wealthy Flemish merchant and shipowner who lived in Venice, where he met Van Dyck during the early years of the painter's Italian period (1621–27). The sitter is presented as a learned gentleman, with divider calipers, a recorder, the bow of a viola da gamba, an antique head, a drawing, and a celestial globe suggesting his various interests. The canvas was first recorded in the collection of the landgraves of Hesse-Kassel in the 1730s.

Valentin de Boulogne
French, 1591–1632
The Lute Player, ca. 1626
Oil on canvas, 50½ × 39 in. (128.3 × 99.1 cm)
Purchase, Walter and Leonore Annenberg Acquisitions
Endowment Fund; funds from various donors;
Acquisitions Fund; James and Diane Burke and Mr. and
Mrs. Mark Fisch Gifts; Louis V. Bell, Harris Brisbane Dick,
Fletcher, and Rogers Funds and Joseph Pulitzer Bequest,
2008 (2008.459)

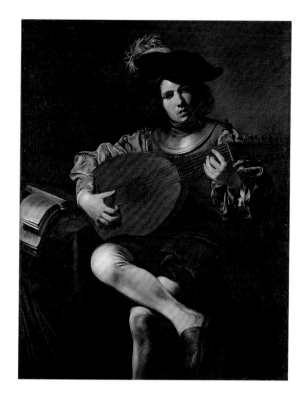

Valentin was the greatest French follower of
Caravaggio and one of the outstanding artists in
seventeenth-century Rome, where he spent his
entire career. His most frequent subjects were
scenes of merriment—music-making, drinking,
and fortune-telling—painted with a directness
and vividness for which the only parallel is
found in the early work of Velázquez. This pic-
ture, showing a soldier of fortune singing a love
madrigal, is unique in Valentin's oeuvre. It is
perhaps emblematic of the sobriquet Amador,
Spanish for "lover boy," which he took when, in 1624 in Rome, he joined the society of foreign
artists known as the Bentveughels (birds of a
feather). Valentin died relatively young, at the
peak of his fame, leaving few works.

Georges de La Tour
French, 1593–1653
The Fortune-Teller, probably 1630s
Oil on canvas, 40⅛ × 48⅝ in. (101.9 × 123.5 cm)
Rogers Fund, 1960 (60.30)

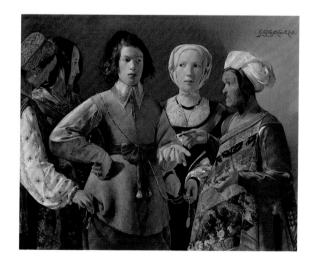

While an old Gypsy crone tells his fortune, a
naive youth is robbed by her accomplices. This
subject was popular among Caravaggesque
painters throughout Europe in the seventeenth
century. La Tour's painting may have been con-
ceived in theatrical terms as an allusion to the
parable of the prodigal son. The inscription
includes the name of the town Lunéville, in
Lorraine, where La Tour lived.

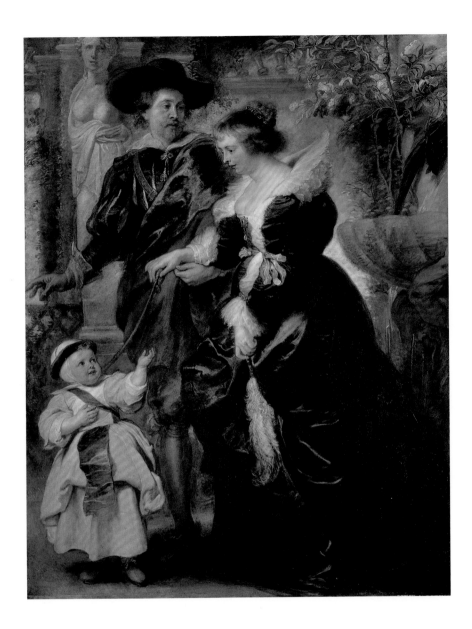

Peter Paul Rubens
Flemish, 1577–1640
Rubens, His Wife Helena Fourment (1614–1673), and One of Their Children,
mid–late 1630s
Oil on wood, 80¼ × 62¼ in. (203.8 × 158.1 cm)
Gift of Mr. and Mrs. Charles Wrightsman, in honor of Sir John Pope-Hennessy, 1981 (1981.238)

Set in a "garden of love" similar to the garden behind Rubens's town house in Antwerp, this magnificent self-portrait of the artist, his second wife, Helena Fourment, and one of their children celebrates Helena as wife and mother. Married in 1630, the couple had five children; the one shown here must be Frans, born July 12, 1633. His older sister, Clara Joanna, is probably not included because the picture lauds Helena for giving the wealthy painter a male heir (who would inherit all of his property). The parrot is an emblem of the Virgin and therefore symbolizes ideal motherhood.

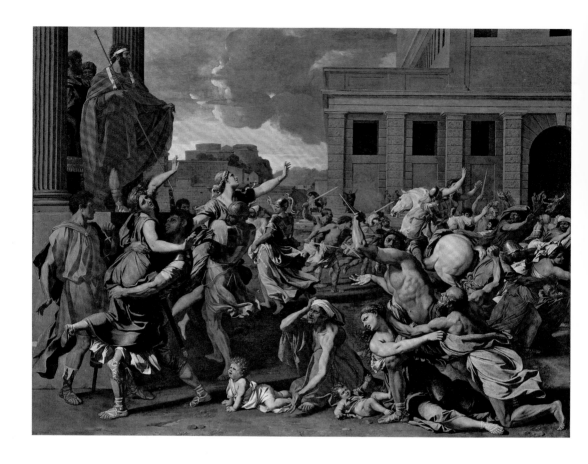

Nicolas Poussin

French, active Italy, 1594–1665

The Abduction of the Sabine Women,

probably 1633–34

Oil on canvas, 60⅞ × 82⅝ in. (154.6 × 209.9 cm)

Harris Brisbane Dick Fund, 1946 (46.160)

According to legend, the earliest Romans invited the neighboring Sabines to Rome with the intention of forcibly retaining their young women as wives. Here Romulus raises his cloak as the prearranged signal for the warriors to seize the women. Poussin's study of antiquity is demonstrated by the yellow armor worn by the man at the right, which is modeled after a Roman *lorica*, which was made of leather and reproduced the anatomy of the male torso. Long considered a defining masterpiece of French classical painting, this work belonged to the maréchal de Créquy, French ambassador to Rome. Créquy would thus have had an opportunity to meet Poussin, who spent his adult life in that city.

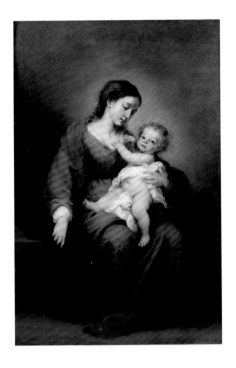

Bartolomé Esteban Murillo
Spanish, 1617–1682
Virgin and Child, ca. 1670–72
Oil on canvas, 65¼ × 43 in. (165.7 × 109.2 cm)
Rogers Fund, 1943 (43.13)

This picture, one of Murillo's loveliest, formed
part of the collection of the marqués de
Santiago, who owned a number of outstanding
works by the artist. In 1728 it was inventoried as
"Our Lady of the Milk with the Child." Indeed,
the infant's attention has been momentarily
diverted from nursing by the presence of the
viewer. The popularity of Murillo's paintings of
the Madonna and Child derives from his ability
to endow a timeworn theme with qualities of
intimacy and sweetness. The picture dates from
the early 1670s, when Murillo was the most
famous artist in Spain.

Jusepe de Ribera
Spanish, active Italy, 1591–1652
**The Holy Family with Saints Anne
and Catherine of Alexandria,** 1648
Oil on canvas, 82½ × 60¾ in. (209.6 × 154.3 cm)
Samuel D. Lee Fund, 1934 (34.73)

Though Spanish by birth, hence his nickname
Lo Spagnoletto, Ribera lived most of his adult life
in Naples, which was ruled by a Spanish viceroy.
During his early years in Rome, he adopted
Caravaggio's practice of working directly from
posed models. In Ribera's art, figures drawn
from everyday life are translated into compel-
ling images of saints, prophets, and classical
philosophers. Key to the impact of his paintings
is the use of formal compositions derived from
his study of Raphael. This late work—one of
Ribera's finest—epitomizes his achievement.
Especially notable are the beautiful still-life pas-
sages, the brilliant rendition of fabrics, and the
tender expressions of the subjects.

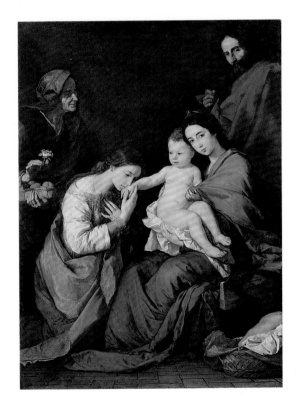

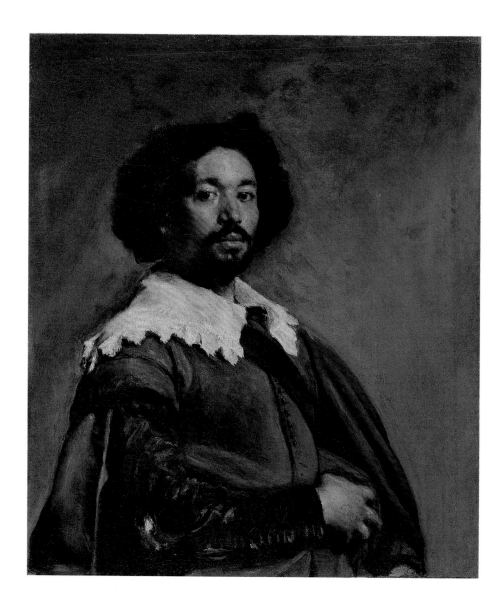

Velázquez (Diego Rodríguez
de Silva y Velázquez)
Spanish, 1599–1660
**Juan de Pareja (born about 1610,
died 1670)**, 1650
Oil on canvas, 32 × 27½ in. (81.3 × 69.9 cm)
Purchase, Fletcher and Rogers Funds, and Bequest
of Miss Adelaide Milton de Groot (1876–1967), by
exchange, supplemented by gifts from friends of the
Museum, 1971 (1971.86)

This extraordinary portrait depicts Velázquez's
Moorish slave and workshop assistant. Painted
in Rome, it was displayed publicly at the Pan-
theon in March 1650. Velázquez clearly intended
to impress his Italian colleagues with his artistry.
Indeed, as we are told by the artist's biographer
Antonio Palomino, the picture "gained such
universal applause that in the opinion of all the
painters of the different nations everything else
seemed like painting but this alone like truth."
Velázquez conveyed not only the physical pres-
ence but also the proud character of the sitter,
who became a painter in his own right and was
freed by Velázquez in 1654.

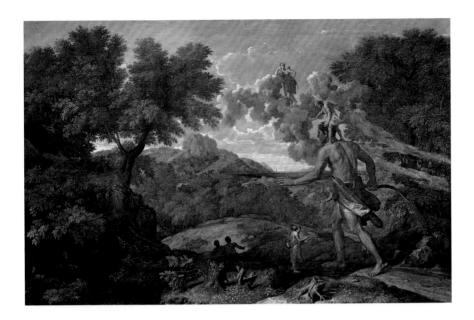

Nicolas Poussin

French, active Italy, 1594–1665

Blind Orion Searching for the Rising Sun, 1658

Oil on canvas, 46⅞ × 72 in. (119.1 × 182.9 cm)

Fletcher Fund, 1924 (24.45.1)

For his depiction of the gigantic hunter, Poussin drew on the Greek writer Lucian (*De domo* 27–29): "Orion, who is blind, is carrying Cedalion, and the latter, riding on his back, is showing him the way to the sunlight. The rising sun is healing [his] blindness." The artist also studied a sixteenth-century commentary that gave the myth a meteorological interpretation. Accordingly, he added Diana in the clouds, a symbol of the power of the moon to gather the earth's vapors and turn them into rain. This remarkable painting brings together Poussin's fascination with both classical mythology and the immense power of nature.

Rembrandt (Rembrandt van Rijn)

Dutch, 1606–1669

Self-Portrait, 1660

Oil on canvas, 31⅝ × 26½ in. (80.3 × 67.3 cm)

Bequest of Benjamin Altman, 1913 (14.40.618)

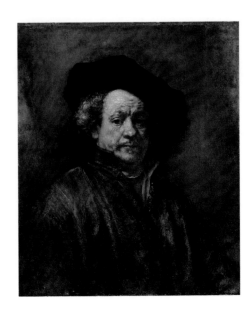

The dozen or more self-portraits that date from each decade of Rembrandt's career vary considerably in composition, expression, and technique. In the late examples, the broad applications of paint convey a candid record of the artist's aging features. Self-portraits by the famous master were especially prized by collectors in Rembrandt's own time.

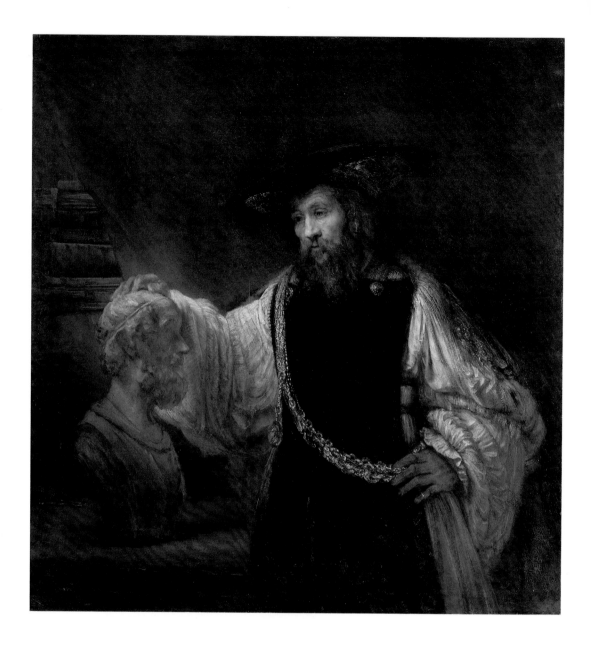

Rembrandt (Rembrandt van Rijn)
Dutch, 1606–1669
Aristotle with a Bust of Homer, 1653
Oil on canvas, 56½ × 53¾ in. (143.5 × 136.5 cm)
Purchase, special contributions and funds given or
bequeathed by friends of the Museum, 1961 (61.198)

In this imaginary portrait of Aristotle, the
Greek philosopher rests his hand reflectively on
a bust of Homer, the epic poet of an earlier age.
A medallion depicting Alexander the Great,
whom Aristotle tutored, hangs from the gold
chain. It is generally supposed that Aristotle
is pondering the worth of worldly success
as opposed to spiritual values. The shadows
playing over Aristotle's brow and eyes suggest
contemplation, while the objects he touches
represent both the material and spiritual
worlds. The picture was painted for the Sicilian
collector Antonio Ruffo and is one of the artist's
greatest works.

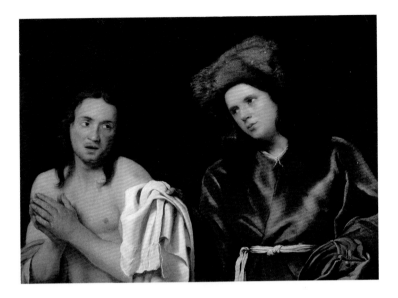

Michiel Sweerts
Flemish, 1618–1664
Clothing the Naked, ca. 1661
Oil on canvas, 32¼ × 45 in. (81.9 × 114.3 cm)
Gift of Mr. and Mrs. Charles Wrightsman, 1984 (1984.459.1)

A native of Brussels, Sweerts worked in Rome between 1646 and about 1653–54. After several years back in Brussels, he went to Amsterdam, where he was recorded in 1661. He probably painted this profoundly personal picture in Holland, where his religious acts of self-denial and charity drew attention. He traveled with French missionaries to Persia in 1662 and then alone to Goa, India, where he died in 1664. Sweerts's personal austerity never impaired his remarkable refinements of color, light, and expression.

Johannes Vermeer
Dutch, 1632–1675
Study of a Young Woman, ca. 1665–67
Oil on canvas, 17½ × 15¾ in. (44.5 × 40 cm)
Gift of Mr. and Mrs. Charles Wrightsman, in memory of Theodore Rousseau Jr., 1979 (1979.396.1)

In the seventeenth century, pictures like this were described as *tronies* (meaning "visages") and were appreciated for their unusual costumes, intriguing physiognomies, suggestion of personality, and demonstration of artistic skill. Although a live model must have been employed, the artist's goal was not portraiture but a study of character and expression. Dutch pictures of this type, like those from elsewhere in Europe, often feature artistic effects, such as the fall of light on fine fabrics, soft skin, or a pearl earring. This may be one of the three

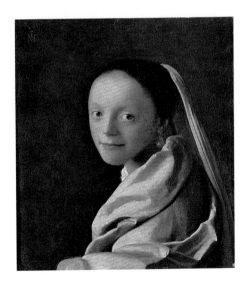

paintings by Vermeer that were described in an Amsterdam auction of 1696 as "A 'face' [*tronie*] in an antique dress, uncommonly artful."

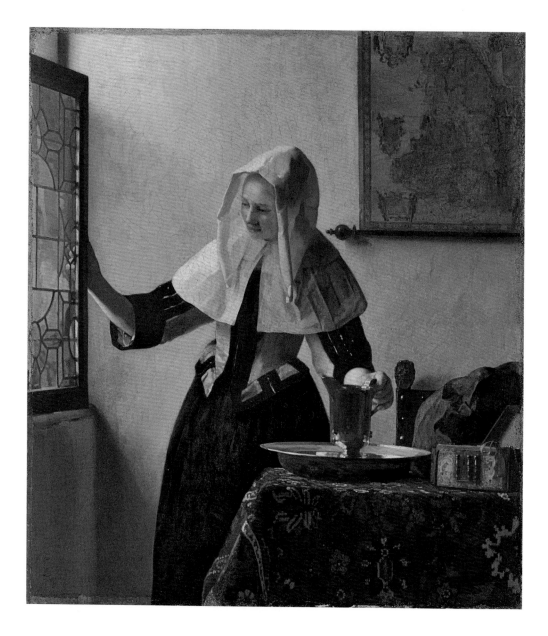

Johannes Vermeer
Dutch, 1632–1675
Young Woman with a Water Pitcher,
ca. 1662
Oil on canvas, 18 × 16 in. (45.7 × 40.6 cm)
Marquand Collection, Gift of Henry G. Marquand,
1889 (89.15.21)

This well-preserved picture of the early 1660s
is characteristic of Vermeer's mature style. Not-
withstanding his remarkable interest in optical

effects, the artist achieved a quiet balance
of primary colors and simple shapes through
subtle calculation and some revision during
the execution of the work. The composi-
tion suits the theme of domestic tranquil-
lity, which is underscored by the basin and
pitcher, traditional symbols of purity. This
canvas was the first of thirteen paintings by
Vermeer to enter the United States between
1887 and 1919.

Jacob van Ruisdael
Dutch, 1628/29–1682
Wheat Fields, ca. 1670
Oil on canvas, 39⅜ × 51¼ in.
(100 × 130.2 cm)
Bequest of Benjamin Altman,
1913 (14.40.623)

This large canvas of about 1670 is Ruisdael's most ambitious view of grain fields, a subject he treated frequently. The monumental design, with its centralized recession into space, might have been intended for a particular setting, perhaps above a mantelpiece. During the seventeenth century, paintings this large were usually hung high.

**Claude Lorrain
(Claude Gellée)**
French, active Italy, 1604/5?–1682
**The Trojan Women Setting
Fire to Their Fleet**, ca. 1643
Oil on canvas, 41⅜ × 59⅞ in.
(105.1 × 152.1 cm)
Fletcher Fund, 1955 (55.119)

The Trojan women set fire to their ships in an effort to end years of wandering after the fall of Troy. The clouds and rain in the distance presage the storm sent by Jupiter, at Aeneas's request, to quench the blaze. Claude noted in his record book, the *Liber Veritatis*, that the picture was painted in Rome for Girolamo Farnese. The learned prelate, who returned to the city in 1643, must have chosen this episode from Virgil's *Aeneid* (5.604–710) to allude to his years of itinerant service as papal nuncio, combating Calvinism in remote Alpine cantons of the Swiss Confederation.

Jan Steen

Dutch, 1626–1679

Merry Company on a Terrace, ca. 1673–75

Oil on canvas, 55½ × 51¾ in. (141 × 131.4 cm)

Fletcher Fund, 1958 (58.89)

In this late painting of about 1673–75, Steen cast himself as the inebriated innkeeper on the left. The artist's second wife, Maria, probably modeled for the provocatively posed hostess in the center. Her glass and the fat man's jug are sexually suggestive, but the woman's familiarity with the young musician and the shape of his stringed cittern suggest that he has more to offer her. The overdressed boy serves as a marginal comment on the adults' behavior; the bridled horse and whip usually stand for temperance.

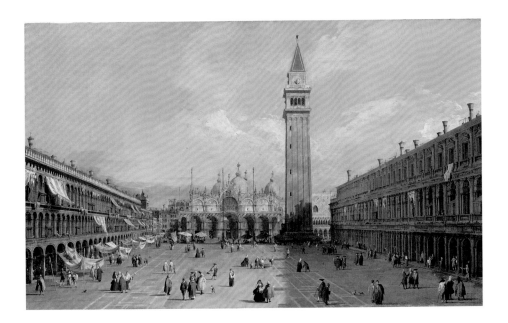

Canaletto (Giovanni Antonio Canal)
Italian, 1697–1768
Piazza San Marco, late 1720s
Oil on canvas, 27 × 44¼ in. (68.6 × 112.4 cm)
Purchase, Mrs. Charles Wrightsman Gift, 1988 (1988.162)

The most famous view painter of eighteenth-century Venice, Canaletto was particularly popular with British visitors to the city. This wonderfully fresh and well-preserved canvas shows the famous Piazza San Marco. The windows of the bell tower here are fewer in number than in actuality, and the flagstaffs are too tall, but otherwise Canaletto took few liberties with the scenery. The loose, ragged handling of paint and high-key palette suggest a date in the late 1720s.

Antoine Watteau
French, 1684–1721
Mezzetin, ca. 1718–20
Oil on canvas, 21¾ × 17 in. (55.2 × 43.2 cm)
Munsey Fund, 1934 (34.138)

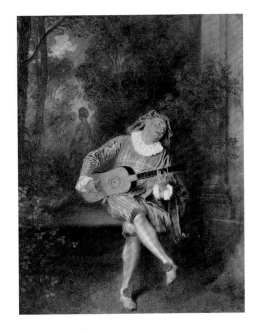

Mezzetin was a stock comic character of the Italian commedia dell'arte and became an established presence on the Paris stage. He was by turns interfering, devious, and lovelorn. This famous painting was owned by Watteau's friend Jean de Jullienne and later by Catherine the Great, empress of Russia. A chalk drawing from the model, also belonging to the Museum, is a study for his tilted head. Both the head and the large, angular hands in this painting are extraordinarily expressive. The statue in the garden is of Venus, who has her back to Mezzetin.

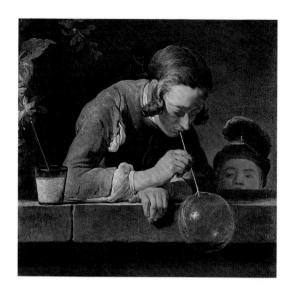

Jean Siméon Chardin
French, 1699–1779
Soap Bubbles, ca. 1734
Oil on canvas, 24 × 24⅞ in.
(61 × 63.2 cm)
Wentworth Fund, 1949 (49.24)

The idle play of children was a favorite theme in the work of Chardin, who was a great naturalist among painters. In this canvas of about 1734, he drew inspiration for both the format and the subject from the seventeenth-century Dutch genre tradition. While it is not certain that he intended the picture to carry a message, soap bubbles were then understood to allude to the transience of life. Later versions of this subject belong to the Los Angeles County Museum of Art and to the National Gallery of Art, Washington.

François Boucher
French, 1703–1770
The Toilet of Venus, 1751
Oil on canvas, 42⅜ × 33½ in. (108.3 × 85.1 cm)
Bequest of William K. Vanderbilt, 1920 (20.155.9)

Madame de Pompadour, the mistress of Louis XV, greatly admired Boucher and was his patron from 1747 until her death in 1764. This famous work is one of a pair that she commissioned for the dressing room at Bellevue, her château near Paris. In 1750 she had performed the title role in a play, staged at Versailles, called "The Toilet of Venus," and while this is not a portrait, a flattering allusion may well have been intended.

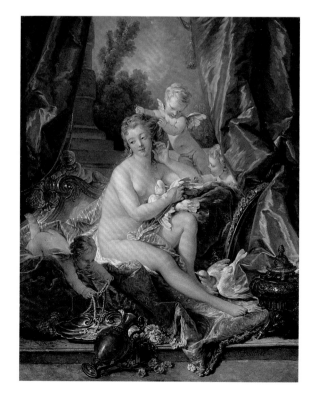

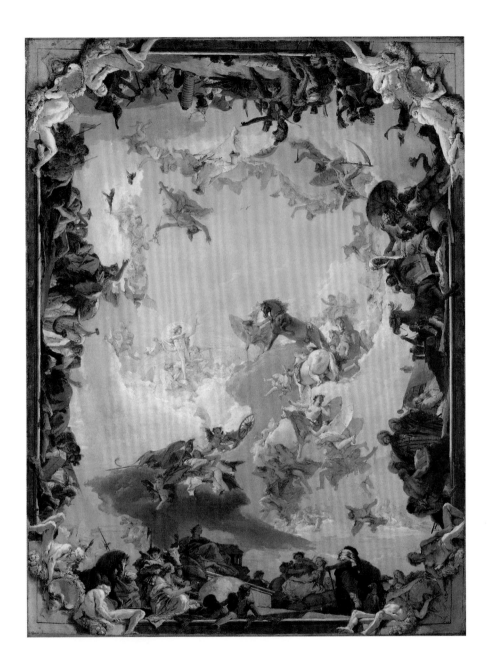

Giovanni Battista Tiepolo

Italian, 1696–1770

Allegory of the Planets and Continents, 1752

Oil on canvas, 73 × 54⅞ in. (185.4 × 139.4 cm)

Gift of Mr. and Mrs. Charles Wrightsman, 1977 (1977.1.3)

This picture, Tiepolo's largest and most dazzling oil sketch, shows Apollo about to embark on his daily course across the sky. Deities around the sun god symbolize the planets, and allegorical figures at the four sides represent the continents. Tiepolo presented this preliminary sketch to Carl Philipp von Greiffenklau, the prince-bishop of Würzburg, on April 20, 1752, as his proposal for the decoration of the vast staircase ceiling of the Residenz, often considered the artist's greatest achievement. The figures in grisaille at the corners were executed on the ceiling in stucco by the decorator-sculptor Antonio Bossi.

Jean Baptiste Greuze
French, 1725–1805
Broken Eggs, 1756
Oil on canvas, 28¾ × 37 in. (73 × 94 cm)
Bequest of William K. Vanderbilt,
1920 (20.155.8)

Although this picture was painted in Rome and features an Italian setting and costumes, the source of its subject is a seventeenth-century Dutch painting by Frans van Mieris the Elder, *The Broken Eggs* (State Hermitage Museum, Saint Petersburg), which Greuze knew through an engraving. The broken eggs symbolize the loss of virginity. The little boy trying to repair one of the eggs represents the uncomprehending innocence of childhood. This picture attracted favorable comment when exhibited in Paris at the Salon of 1757.

Jean-Honoré Fragonard
French, 1732–1806
The Love Letter, ca. 1770
Oil on canvas, 32¾ × 26⅜ in. (83.2 × 67 cm)
The Jules Bache Collection, 1949 (49.7.49)

In the work of Fragonard, finish is a relative term. Here, over a brown tone, Fragonard shaped the composition in darker shades of brown, drawing and modeling with the tip of the brush and with strokes of varying thickness. Color and white are confined to strongly lit passages toward the center of the canvas: the young woman's powdered face; her dress and cap; and the desk, stool, flowers, and dog. It has not been possible to decipher the inscription on the card she holds, to identify the model, or to decide whether this famous canvas should be read as a portrait or a genre scene.

Sir Joshua Reynolds
English, 1723–1792
Captain George K. H. Coussmaker
(1759–1801), 1782
Oil on canvas, 93¾ × 57¼ in. (238.1 × 145.4 cm)
Bequest of William K. Vanderbilt, 1920 (20.155.3)

Coussmaker joined the First Regiment of Foot Guards as ensign and lieutenant, the lowest commissioned rank, in 1776. He was eventually promoted to lieutenant colonel and left the military in 1795 without having seen active service. In 1782 Reynolds recorded twenty-one appointments for sittings with the young man and perhaps as many as eight sessions to paint his horse. The diarist Fanny Burney found Coussmaker to be shy and silent but well mannered. His portrait is painted with extravagant freedom and flexibility in Reynolds's best manner and apparently without the intervention of the artist's studio assistants.

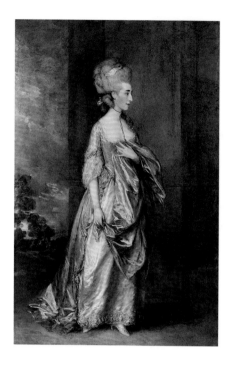

Thomas Gainsborough
English, 1727–1788
**Mrs. Grace Dalrymple Elliott
(1754?–1823),** 1778
Oil on canvas, 92¼ × 60½ in. (234.3 × 153.7 cm)
Bequest of William K. Vanderbilt, 1920 (20.155.1)

Mrs. Elliott was the divorced wife of a Scottish
physician and the constant companion of
Lord Cholmondeley, later first Marquess of
Cholmondeley, who may have commissioned
this portrait. Stylish mounds of padded and
powdered hair contribute to the lady's not
inconsiderable height. She wears modern
eighteenth-century dress of a yellow color that
had been favored more than a century earlier by
Sir Anthony van Dyck. The work was exhibited
at the Royal Academy in 1778.

Sir Thomas Lawrence
English, 1769–1830
**Elizabeth Farren (born about 1759, died
1829), Later Countess of Derby,** 1790
Oil on canvas, 94 × 57½ in. (238.8 × 146.1 cm)
Bequest of Edward S. Harkness, 1940 (50.135.5)

Elizabeth Farren was a comic actress who first
performed on the London stage in 1777. In 1797
she married Edward Smith Stanley, twelfth Earl
of Derby, after a very long courtship. This por-
trait, painted for the earl in 1790, was exhibited
to acclaim at the Royal Academy. Although Lord
Derby thought Miss Farren looked too thin,
Lawrence elected not to make any changes to
his sparkling picture. Along with a full-length
portrait of Queen Charlotte, the canvas brought
early fame to the aspiring and naturally gifted
twenty-one-year-old artist.

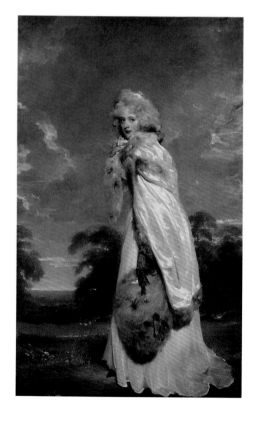

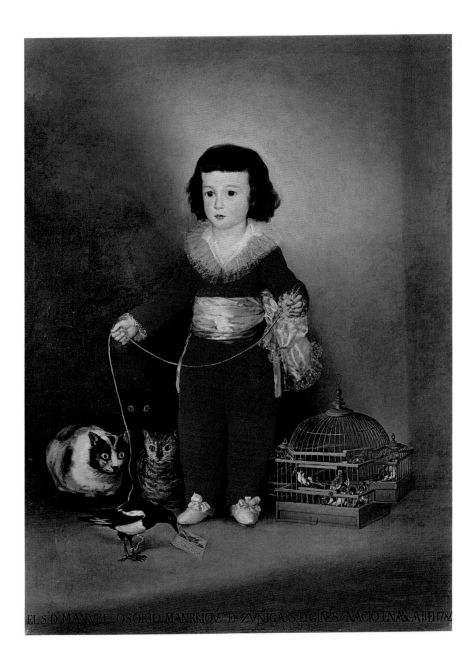

ELS.D.MANVEL OSORIO MANRRIQ^E D. ZVÑIGA S^r DG^{NS} NACIO EN^{A.} A 11D 1784

Goya (Francisco de Goya y Lucientes)
Spanish, 1746–1828
Manuel Osorio Manrique de Zuñiga
(1784–1792), possibly after 1792
Oil on canvas, 50 × 40 in. (127 × 101.6 cm)
The Jules Bache Collection, 1949 (49.7.41)

The sitter in this famous portrait is the son of the Count and Countess of Altamira. Dressed in a splendid red costume, he is shown playing with a pet magpie (which holds the painter's calling card in its beak), a cage full of finches, and three wide-eyed cats. In Christian art, birds frequently symbolize the soul, and in Baroque art caged birds are symbolic of innocence. Goya may have intended this portrait as an illustration of the fragile boundaries that separate the child's world from the forces of evil, or as a commentary on the fleeting nature of innocence and youth. The painting may have been done after the child's death in 1792.

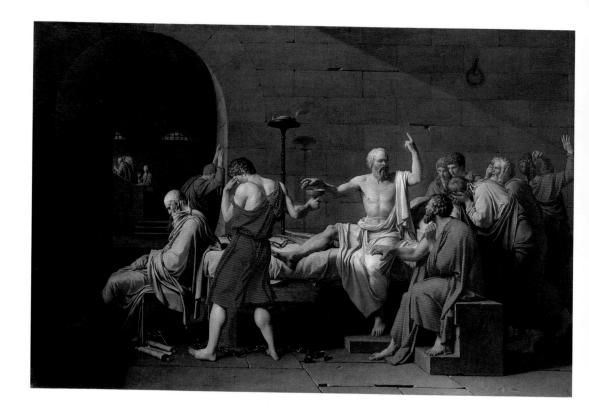

Jacques-Louis David
French, 1748–1825
The Death of Socrates, 1787
Oil on canvas, 51 × 77¼ in. (129.5 × 196.2 cm)
Catharine Lorillard Wolfe Collection, Wolfe Fund,
1931 (31.45)

Accused by the Athenian government of denying
the gods and corrupting the young through
his teachings, Socrates was offered the choice
of renouncing his beliefs or being sentenced
to death by drinking hemlock. David showed
him calmly discoursing on the immortality of
the soul with his grief-stricken disciples. The
picture, with its stoic subject loosely based on
Plato's *Phaedo*, is perhaps David's most perfect
Neoclassical statement. The printmaker and
publisher John Boydell wrote to Sir Joshua
Reynolds that it was "the greatest effort of
art since the Sistine Chapel and the stanze of
Raphael. . . . This work would have done honour
to Athens at the time of Pericles."

Jacques-Louis David
French, 1748–1825
**Antoine-Laurent Lavoisier (1743–1794)
and His Wife (Marie-Anne-Pierrette
Paulze, 1758–1836),** 1788
Oil on canvas, 102¼ × 76⅝ in. (259.7 × 194.6 cm)
Purchase, Mr. and Mrs. Charles Wrightsman Gift,
in honor of Everett Fahy, 1977 (1977.10)

This is one of the greatest portraits of the eigh-
teenth century, painted when David was hailed
as the standard-bearer of French Neoclassicism.
Lavoisier is best known for his pioneering stud-
ies of oxygen, gunpowder, and the chemical
composition of water. In 1789 his theories were
published in the book *Traité élémentaire de chi-
mie*, with illustrations prepared by his wife, who
is believed to have studied with David (a port-
folio of her drawings rests on the armchair to the
left). As Commissioner of Gunpowder, Lavoisier
was involved in a political scandal that led him
to withdraw the painting from the Salon of 1789.
Despite his service to the revolutionary regime,
he was guillotined in 1794.

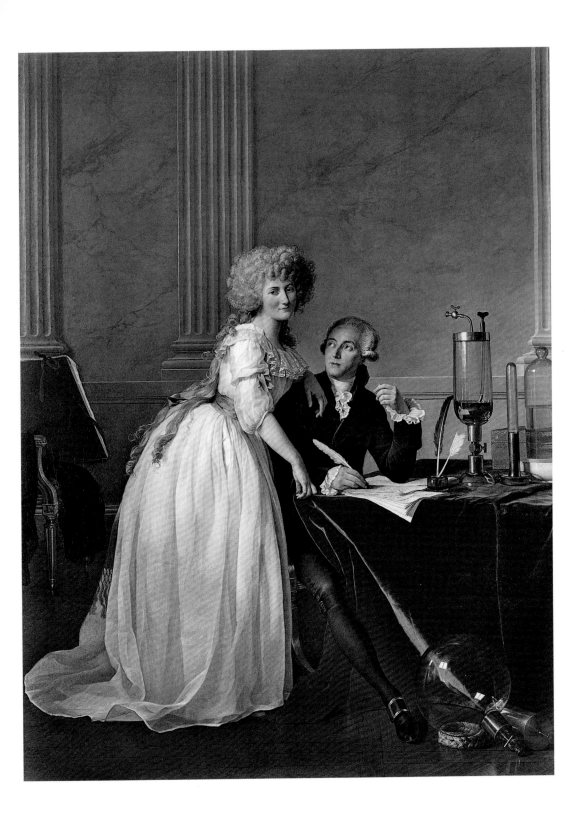

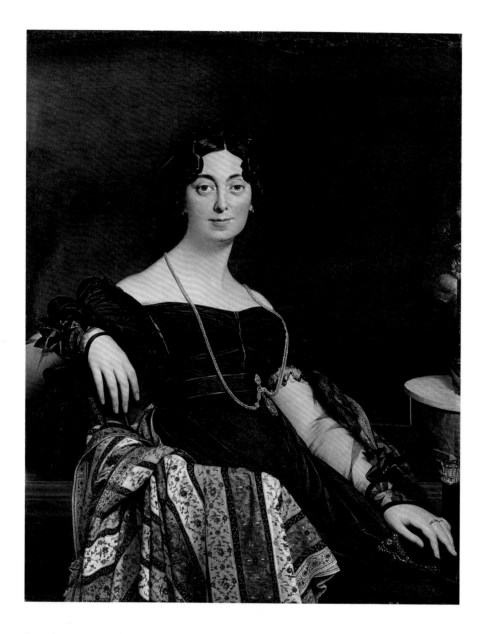

Jean-Auguste-Dominique Ingres
French, 1780–1867
Madame Jacques-Louis Leblanc
(née Françoise Poncelle, 1788–1839), 1823
Oil on canvas, 47 × 36½ in. (119.4 × 92.7 cm)
Catharine Lorillard Wolfe Collection, Wolfe Fund,
1918 (19.77.2)

Jacques-Louis Leblanc and his wife were French
functionaries attached to the court of the
grand duchess of Tuscany, Élisa Baciocchi, née

Bonaparte. After the fall of Napoléon in 1814–15,
the Leblancs remained in Florence. Ingres met
them when he arrived there from Rome in
1820. The portraits, one of each spouse, that
resulted from this association rank among the
largest Ingres ever produced, apart from royal
commissions, and represent the only pair. Edgar
Degas bought them both in 1896 and considered
them to be the finest works by Ingres in his
extensive collection.

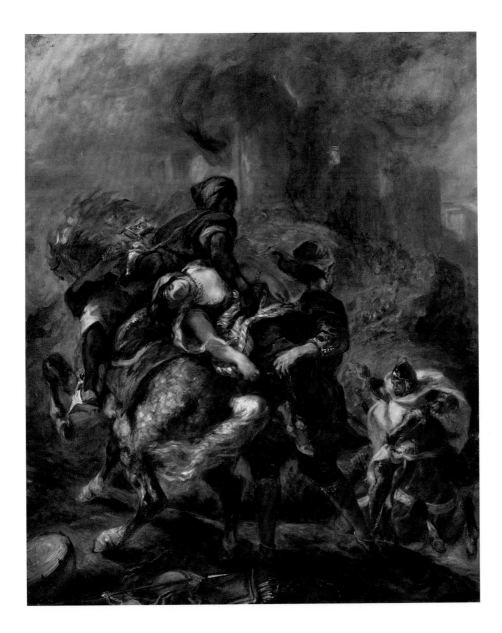

Eugène Delacroix
French, 1798–1863
The Abduction of Rebecca, 1846
Oil on canvas, 39½ × 32¼ in. (100.3 × 81.9 cm)
Catharine Lorillard Wolfe Collection, Wolfe Fund,
1903 (03.30)

Throughout his career, Delacroix was inspired
by the novels of Sir Walter Scott. This painting
depicts a scene from *Ivanhoe*: Rebecca, who had
been confined in a castle, is being carried off by
Saracen slaves at the command of the Christian
knight Bois-Guilbert, who has long coveted her.
The contorted poses and compacted space, which
shifts abruptly from a high foreground across a
deep valley to the fortress behind, create a sense
of intense drama. Critics censured the painting's
Romantic qualities when it was shown in the Paris
Salon of 1846; nevertheless it inspired Baudelaire
to write, "Delacroix's painting is like nature; it has
a horror of emptiness."

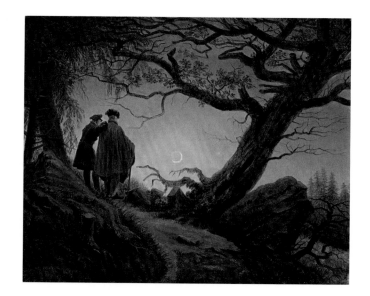

Caspar David Friedrich
German, 1774–1840
**Two Men Contemplating
the Moon,** ca. 1825–30
Oil on canvas, 13¾ × 17¼ in.
(34.9 × 43.8 cm)
Wrightsman Fund, 2000 (2000.51)

This is the third version of one of this artist's most famous compositions, of which the first version (1819) is in Dresden, and the second one (ca. 1824) is in Berlin. The two men pausing on their evening walk through a late autumn forest to contemplate the sinking moon have been identified as Friedrich himself, on the right, and his talented young colleague August Heinrich. The mood of pious contemplation relates to the fascination with the moon as expressed in the poetry, literature, philosophy, and music of the time.

Joseph Mallord
William Turner
British, 1775–1851
The Whale Ship, ca. 1845
Oil on canvas, 36⅛ × 48¼ in.
(91.8 × 122.6 cm)
Catharine Lorillard Wolfe
Collection, Wolfe Fund,
1896 (96.29)

Turner was seventy years old when he first exhibited *The Whale Ship* at the annual Royal Academy exhibition of 1845. Both admirers and detractors of the painting agreed that it required some effort to distinguish the thrashing whale and whale boats in the center foreground of the composition. Turner painted seascapes throughout his career, and many of his late works, such as this one, highlight in an almost abstract way the dramatic power of the sea. This painting and three others, in the Tate in London, are thought to have been inspired in part by Thomas Beale's book *The Natural History of the Sperm Whale* (1839).

Théodore Gericault

French, 1791–1824

Evening: Landscape with an Aqueduct, 1818

Oil on canvas, 98½ × 86½ in. (250.2 × 219.7 cm)

Purchase, Gift of James A. Moffett 2nd, in memory
of George M. Moffett, by exchange, 1989 (1989.183)

This work is one panel in a projected set of four
monumental landscapes representing the times
of day. Painted in Paris during the summer of
1818, the landscapes were conceived as decor in
the manner of the eighteenth-century French
painter Joseph Vernet. The landscapes fuse
souvenirs of ruins in the Italian countryside,
which Gericault had visited in 1817—the aque-
duct at Spoleto is visible here—with the stormy
skies and turbulent moods characteristic of the
emerging aesthetics of Romanticism and the
Anglo-French concept of the Sublime.

Jean-Léon Gérôme
French, 1824–1904
Bashi-Bazouk, 1868–69
Oil on canvas, 31¾ × 26 in. (80.6 × 66 cm)
Gift of Mrs. Charles Wrightsman, 2008 (2008.547.1)

This arresting picture was made after Gérôme
returned to Paris from a twelve-week expedition
in the Near East in early 1868. He was at the
height of his career when he dressed a model
in his studio with textiles he had acquired in
the Levant. The artist's Turkish title for this
picture—which translates as "headless"—evokes
the ferocious, lawless, and unpaid soldiers who
fought for plunder, although it is difficult to
imagine this man charging into battle wearing
such an exquisite silk tunic. Famous for
rendering textures with subtlety, Gérôme spared
no effort in this tour de force, endowing the
model with a dignity not typical of his other
orientalist fantasies.

Camille Corot
French, 1796–1875
Sibylle, ca. 1870
Oil on canvas, 32¼ × 25½ in. (81.9 × 64.8 cm)
H. O. Havemeyer Collection, Bequest of Mrs. H. O.
Havemeyer, 1929 (29.100.565)

This work ranks as one of Corot's most
accomplished attempts to approximate Raphael's
High Renaissance style. The pose closely follows
that of the portrait of Bindo Altoviti in the
National Gallery of Art, Washington, believed in
Corot's day to be Raphael's self-portrait. Yet for
all of the self-conscious *disegno*, Corot arrived
at this composition incrementally. He may have
conceived the work as a depiction of the muse
Polyhymnia playing a cello, which shows in
X-rays of the canvas but which Corot painted
over. The ivy in the figure's hair is perhaps a
reference to the immortality of the arts. The
painting remained unfinished and unsigned
and was not exhibited during Corot's lifetime.

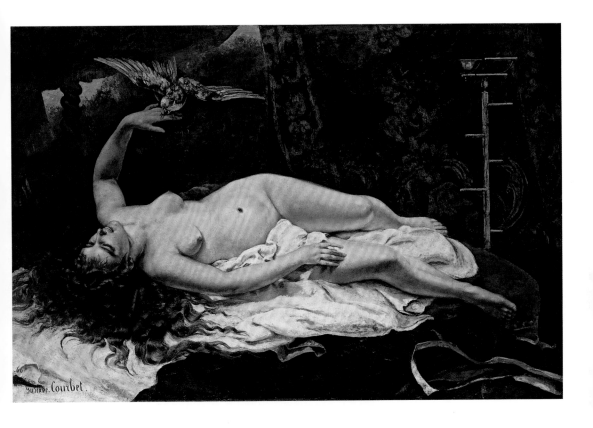

Gustave Courbet

French, 1819–1877

Woman with a Parrot, 1866

Oil on canvas, 51 × 77 in. (129.5 × 195.6 cm)

H. O. Havemeyer Collection, Bequest of Mrs. H. O. Havemeyer, 1929 (29.100.57)

Galvanized by the success of the painted Venuses who reigned over the Paris Salons in the 1860s, Courbet sought to challenge the academy on its own terms by painting a realist nude that the increasingly rigid—and arbitrary—Salon jury would admit. His first attempt, in 1864, was rejected on the grounds of indecency; two years later, when *Woman with a Parrot* was accepted for the 1866 Salon, Courbet boasted, "I told you a long time ago that I would find a way to give them a fist right in the face." Although the figure's pose and subtly modeled flesh aligned it with academic art, the presence of the model's discarded clothing and her disheveled hair clearly differentiated Courbet's work from the mythologized and idealized nudes shown at the Salon. It is thought that Édouard Manet painted *Young Lady in 1866* (in the Museum's collection) in response to Courbet's provocative nude.

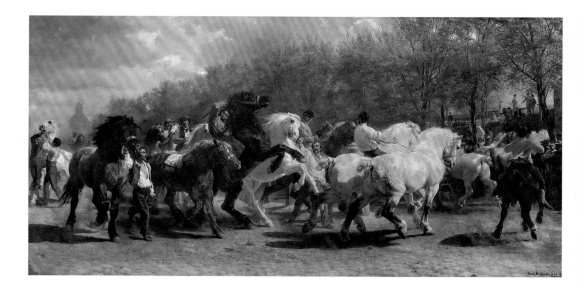

Rosa Bonheur
French, 1822–1899
The Horse Fair, 1852–55
Oil on canvas, 96¼ in. × 16 ft. 7½ in. (2.45 × 5.07 m)
Gift of Cornelius Vanderbilt, 1887 (87.25)

The horse market of Paris was held on the boulevard de l'Hôpital, near the asylum of Salpêtrière, visible in the left background. Twice a week for a year and a half, Bonheur went to the market to sketch, dressing as a man to avoid attention. The painting was begun in 1852 and shown at the Paris Salon of 1853, then later revised. Since its arrival at the Metropolitan in 1887, this impressive and spirited canvas has been one of the Museum's most popular and best-loved paintings.

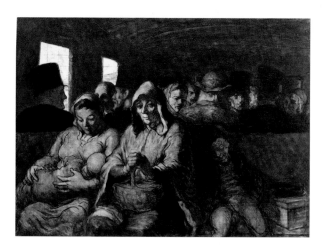

Honoré Daumier
French, 1808–1879
The Third-Class Carriage,
ca. 1862–64
Oil on canvas, 25¾ × 35½ in.
(65.4 × 90.2 cm)
H. O. Havemeyer Collection,
Bequest of Mrs. H. O. Havemeyer,
1929 (29.100.129)

As a chronicler of modern urban life, Daumier captured the effects of industrialization in mid-nineteenth-century Paris. Images of railway travel recur in his art. This unfinished painting is one of three compositions depicting the harsh conditions for travelers in a third-class carriage. Daumier's contemporaries responded to the universality of his subject, one describing it as "a comprehensive survey of human life, with all its miseries and blemishes, thwarted joys and excruciating trials that force one to a fatalistic resignation."

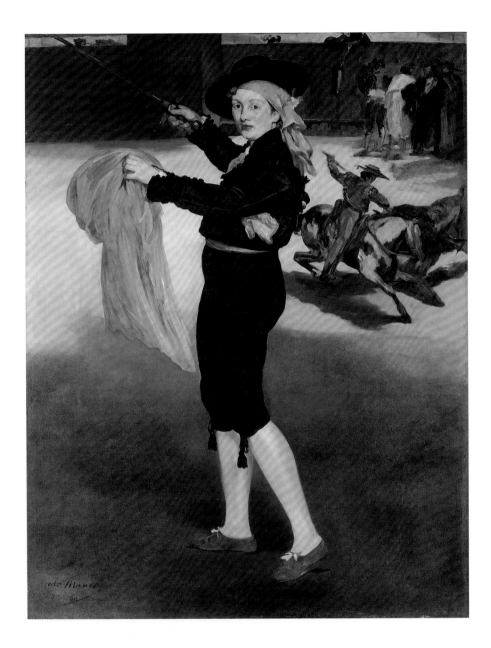

Édouard Manet
French, 1832–1883
**Mademoiselle V. . . in the Costume
of an Espada,** 1862
Oil on canvas, 65 × 50¼ in. (165.1 × 127.6 cm)
H. O. Havemeyer Collection, Bequest of
Mrs. H. O. Havemeyer, 1929 (29.100.53)

At the infamous Salon des Refusés of 1863, Manet
assembled his *Déjeuner sur l'herbe* (Musée d'Orsay,
Paris), *Young Man in the Costume of a Majo* (in the

Museum's collection), and this painting as a
triptych. One writer noted, "Manet loves Spain
and his favorite master seems to be Goya,
whose vivid and contrasting hues, whose
free and fiery touch, he imitates." As many
observed, Manet reproduced a scene from
Goya's *Tauromaquia* as the backdrop for this
picture. The artist depicted his favorite model,
Victorine Meurent, as if she were posing in her
costume for a fancy dress ball.

Arnold Böcklin
Swiss, 1827–1901
Island of the Dead, 1880
Oil on wood, 29 × 48 in.
(73.7 × 121.9 cm)
Reisinger Fund, 1926 (26.90)

Between 1880 and 1886, Böcklin painted five versions of this image, which became one of the most beloved motifs in late nineteenth-century Germany. The Museum owns the second one, commissioned by Marie Berna when she visited Böcklin in his Florence studio in April 1880 and saw on his easel the half-completed first version, now in the Kunstmuseum Basel. At her request, he added a widow, shrouded in white, accompanying a draped coffin in a rowboat to a rocky island whose cliffs are carved with tombs, an allusion to her husband's death years earlier.

Sir Edward Burne-Jones
British, 1833–1898
The Love Song, 1868–77
Oil on canvas, 45 × 61⅜ in. (114.3 × 155.9 cm)
The Alfred N. Punnett Endowment Fund,
1947 (47.26)

This painting, one of the artist's most celebrated, is the definitive version of several works that he based on a refrain from an old Breton song: "Hélas! je sais un chant d'amour, / Triste ou gai, tour à tour" (Alas, I know a love song, / Sad or happy, each in turn). With its figures reminiscent of those by the fifteenth-century Venetian painter Vittore Carpaccio and its "Arthurian" landscape bathed in evening light, *The Love Song* reflects the profound influence of both the Italian Renaissance and the gothicizing Pre-Raphaelite movement.

Jules Bastien-Lepage

French, 1848–1884

Joan of Arc, 1879

Oil on canvas, 8 ft. 4 in. × 9 ft. 2 in. (2.54 × 2.79 m)

Gift of Erwin Davis, 1889 (89.21.1)

Joan of Arc, the national heroine from Lorraine, acquired new symbolic resonance for the French following the Franco-Prussian War (1870–71), which resulted in the loss of her native province to Germany. A succession of sculpted and painted images of the medieval teenage martyr appeared in the Paris Salons of the 1870s and 1880s. Bastien-Lepage, himself a native of Lorraine, exhibited this painting at the 1880 Salon. The artist represented the moment of Joan's divine revelation in her parents' garden. Many Salon critics found the spectral presence of the saints whose voices she heard at odds with the naturalism of the artist's style.

Claude Monet
French, 1840–1926
Garden at Sainte-Adresse, 1867
Oil on canvas, 38⅜ × 51⅛ in. (98.1 × 129.9 cm)
Purchase, special contributions and funds given or
bequeathed by friends of the Museum, 1967 (67.241)

Monet spent the summer of 1867 at the
resort town of Sainte-Adresse on the English
Channel. While there he painted this picture,
which combines smooth, traditionally rendered
aspects with sparkling passages of rapid, broken
brushwork and spots of pure color. The elevated
vantage point and relatively even sizes of the
horizontal areas emphasize the flaglike simplicity
of the composition, which the artist later called
"the Chinese painting in which there are flags."
Sophisticated viewers in the 1860s would have
been reminded of Japanese color wood-block
prints, which were avidly collected by Monet,
Manet, Renoir, Whistler, and others in their circle.
A print by the Japanese artist Hokusai that may
have inspired this composition remains today
at Monet's house at Giverny. The subtle tension
resulting from the combination of illusionism and
the two-dimensionality of the surface continued
to be an important characteristic of Monet's style.

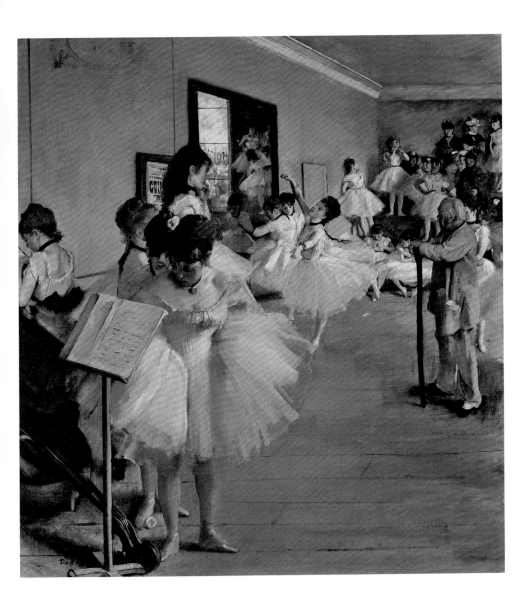

Edgar Degas

French, 1834–1917

The Dance Class, 1874

Oil on canvas, 32⅞ × 30⅜ in. (83.5 × 77.2 cm)

Bequest of Mrs. Harry Payne Bingham, 1986 (1987.47.1)

When this work and its variant in the Musée d'Orsay, Paris, were produced in the mid-1870s, they constituted Degas's most ambitious figural compositions except for history paintings. Some twenty-four women—ballerinas and their mothers—wait while a dancer executes an *attitude* for her examination. Jules Perrot, one of the best-known dancers and ballet masters in Europe, conducts the imaginary class in a rehearsal room in the old Paris Opera, which had recently burned down. The painting was commissioned in 1872 by the opera singer and collector Jean-Baptiste Faure. It was only one of a handful of commissions that Degas ever accepted, and he worked on it intermittently for two years before he finally completed it.

Auguste Renoir
French, 1841–1919
Madame Georges Charpentier
(née Marguérite-Louise Lemonnier,
1848–1904) and Her Children, Georgette-
Berthe (1872–1945) and Paul-Émile-
Charles (1875–1895), 1878
Oil on canvas, 60½ × 74⅞ in. (153.7 × 190.2 cm)
Catharine Lorillard Wolfe Collection, Wolfe Fund,
1907 (07.122)

In 1879 Renoir, who had participated in the first
three Impressionist exhibitions, declined to be in
the fourth and returned to the more traditional
venue of the annual Paris Salon, where he
exhibited *Madame Georges Charpentier and Her
Children* to great acclaim. Commissioned by the
well-known publisher Georges Charpentier, the
painting depicts his wife, Marguérite, wearing
an elegant gown by Charles Frederick Worth.
Following the fashion of the time, the hair of
their three-year-old son, Paul, has not yet been
cut, and he is dressed in clothes that match
those of his sister, Georgette, who is shown at
left, seated on the family pet.

Paul Cézanne
French, 1839–1906
Still Life with Jar, Cup, and Apples,
ca. 1877
Oil on canvas, 23⅞ × 29 in. (60.6 × 73.7 cm)
H. O. Havemeyer Collection, Bequest of Mrs. H. O.
Havemeyer, 1929 (29.100.66)

The still-life genre was central to Cézanne's art in the 1870s. The distinctive patterned wallpaper in this work marks a departure from the artist's typical neutral backgrounds, and the V shapes of the wallpaper's design are mirrored in the white cloth napkin draped over the edge of the chest. The napkin has been interpreted as an inverted reference to Mont Sainte-Victoire, one of Cézanne's favorite landscape motifs, with the mountain's ridges and valleys evoked by the deep folds in the cloth. Such formal analogies reveal the deliberate structure underlying his still-life compositions, which he often used for formal and technical experimentation. Cézanne's application of paint in discrete touches possibly reflects his assimilation of the Impressionist technique.

Henri de Toulouse-Lautrec
French, 1864–1901
The Sofa, ca. 1894–96
Oil on cardboard, 24¾ × 31⅞ in. (62.9 × 81 cm)
Rogers Fund, 1951 (51.33.2)

An inveterate chronicler of the colorful and tawdry nightlife of fin-de-siècle Montmartre, Lautrec set out to document the lives of prostitutes in a series of pictures made between 1892 and 1896. He seems to have found the artistic license in Degas's monotypes of brothel scenes and in erotic Japanese shunga prints to create images of like candor and graphic verve but in large-format, remarkably uninhibited works. Lautrec appreciated the naturalness of prostitutes "who stretch themselves out on the divans . . . entirely without pretensions." *The Sofa* is related to three other paintings of the mid-1890s that focus on the intimacies exchanged between lesbian couples.

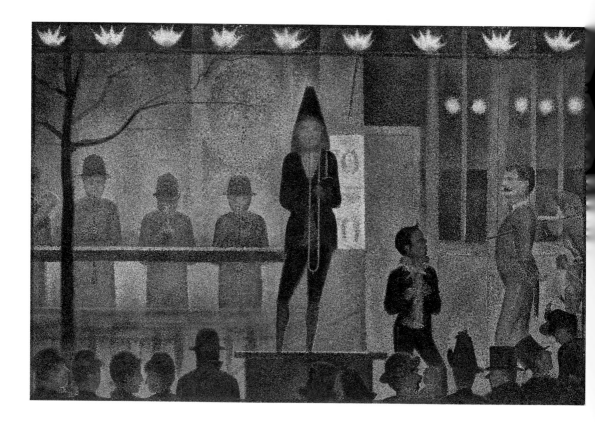

Georges Seurat
French, 1859–1891
Circus Sideshow, 1887–88
Oil on canvas, 39¼ × 59 in. (99.7 × 149.9 cm)
Bequest of Stephen C. Clark, 1960 (61.101.17)

Seurat's finely tuned pointillist approach imparts a sense of timelessness and mystery to this scene of sideshow performers at the entrance to the Cirque Corvi in Paris. On a balustraded stage under the misty glow of nine twinkling gaslights, a ring leader (at right) and musicians (at left) play to a crowd of potential ticket buyers whose assorted hats add a wry and rhythmic note to the foreground. The artist began the work in the spring of 1887 by making sketches of Fernand Corvi's traveling circus, which was set up in a working-class district of Paris; he then developed the composition through several preparatory studies. One of the six major figure compositions from Seurat's brief career, *Circus Sideshow* is distinctive as his first nocturnal painting and the first he devoted to popular entertainment.

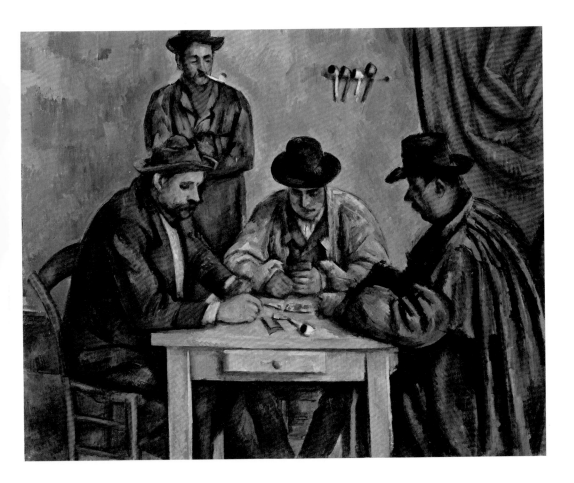

Paul Cézanne
French, 1839–1906
The Card Players, 1890–92
Oil on canvas, 25¾ × 32¼ in. (65.4 × 81.9 cm)
Bequest of Stephen C. Clark, 1960 (61.101.1)

Between 1890 and 1896, Cézanne undertook
an ambitious painting campaign devoted
to the subject of card players. He enlisted
farmhands on his family's estate, near Aix-
en-Provence, as models. On the basis of
numerous preparatory studies, he realized

five compositions that extend and challenge
traditional representations of a theme that had
been popular since the seventeenth century.
The Museum's canvas seems to have initiated
the series. After painting a subsequent version
twice the size of the first and including an
additional figure—a small standing child—
Cézanne pared away extraneous details in
the three successive renditions, which depict
only two card players, starkly confronting one
another across the table.

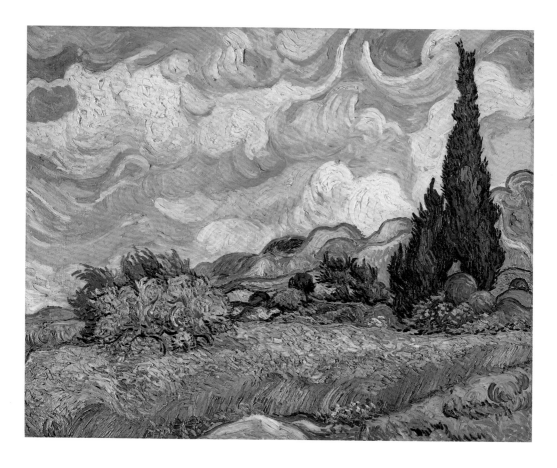

Vincent van Gogh
Dutch, 1853–1890
Wheat Field with Cypresses, 1889
Oil on canvas, 28¾ × 36¾ in. (73 × 93.4 cm)
Purchase, The Annenberg Foundation Gift, 1993 (1993.132)

During his yearlong stay at the asylum in Saint-Rémy, Van Gogh undertook a series of paintings devoted to capturing characteristic aspects of the Provençal countryside, dotted with cypresses and olive trees. Writing to his brother Theo on July 2, 1889, he described his latest addition to the series he had launched that June: "I have a canvas of cypresses with a few ears of wheat, poppies, a blue sky, which is like a multicolored Scotch plaid [and] impasted like Monticellis." Van Gogh regarded this sun-drenched landscape as one of his "best" summer canvases and repeated the composition three times: first in a reed-pen drawing (Van Gogh Museum, Amsterdam) and then in two oil variants he made later that fall (National Gallery, London; private collection).

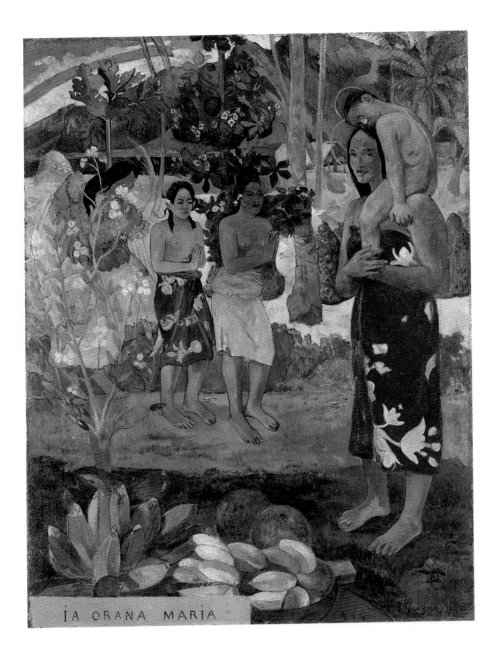

IA ORANA MARIA

Paul Gauguin
French, 1848–1903
Ia Orana Maria (Hail Mary), 1891
Oil on canvas, 44¾ × 34½ in. (113.7 × 87.6 cm)
Bequest of Sam A. Lewisohn, 1951 (51.112.2)

Before embarking on a series of pictures inspired by Polynesian religious beliefs, Gauguin devoted his first major Tahitian canvas to a Christian theme, describing it in a letter of March 1892:

"An angel with yellow wings reveals Mary and Jesus, both Tahitians, to two Tahitian women, nudes dressed in pareus, a sort of cotton cloth printed with flowers that can be draped from the waist. Very somber, mountainous background and flowering trees." The title of this work refers to the angel Gabriel's first words to the Virgin Mary at the Annunciation; "Ia orana" is the standard greeting in Tahiti.

European Sculpture and Decorative Arts

The Department of European Sculpture and Decorative Arts was established in 1907 as part of a reorganization of the Museum under the presidency of J. Pierpont Morgan, the renowned financier and art collector, and coincided with Morgan's gift of more than sixteen hundred French decorative objects. Chief among donors since Morgan, Mr. and Mrs. Charles B. Wrightsman have enhanced many areas of the collection through the sheer multiplicity and quality of their many gifts. Today the department is responsible for about sixty thousand works of art, ranging in scale from monumental marble fountains to diminutive cameo carvings. In scope they stretch from the fifteenth to the early twentieth century and cover sculpture, woodwork and furniture, ceramics, glass, goldsmiths' work (including jewelry), silver, base metals, horology, mathematical instruments, tapestries, and textiles. While the emphasis has historically been on French, English, Italian, German, and Spanish art, in recent years our holdings have broadened to embrace works from the Netherlands and Russia. Among the collection's strengths are distinguished Italian Renaissance sculptures, notably bronze statuettes, French sculpture of the eighteenth and nineteenth centuries, French and English furniture and silver, Italian Renaissance maiolica, and French and German porcelain. The department also maintains entire rooms from great houses: the fifteenth-century *studiolo* from Gubbio, Italy; a sixteenth-century patio from Vélez Blanco, Spain; several salons from eighteenth-century French mansions; and two great English Neoclassical rooms designed by Robert Adam.

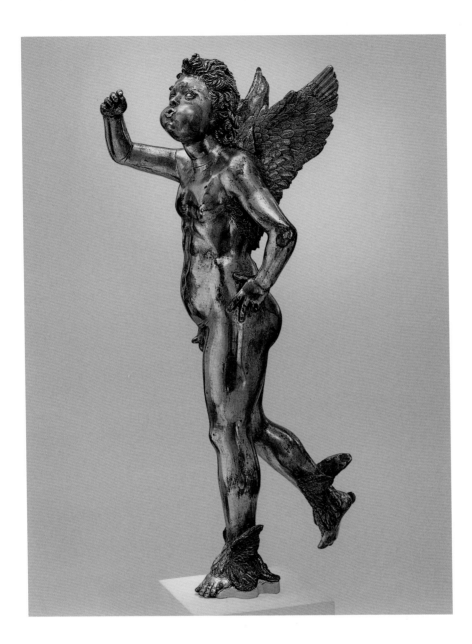

Sculptor close to
Donatello (Donato di Niccolò di Betto Bardi)
Italian, 1386–1466
Sprite, ca. 1436
Gilt bronze, H. 24¼ in. (61.6 cm)
Purchase, Mrs. Samuel Reed Gift, Rogers Fund, by
exchange, and Louis V. Bell Fund, 1983 (1983.356)

In 1436 a fountain was furnished for a courtyard
in the Florentine house of Cosimo de' Medici,
long before it was transformed into the grandiose
Palazzo Medici we know today. Records show

that a stonecutter, Betto d'Antonio, supplied
the fountain and a painter, Antonio, was paid
for gilding a *spiritello* (a sprite, sometimes with
angelic overtones) that surmounted it. That
spiritello was almost certainly this quirky baby.
Its sculptor, closely familiar with Donatello's
bronze angels made for the Baptistery of Siena
in 1429, breezily merged traits of Mercury, the
god of commerce beloved by the banking Medici
family, with those of Zephyr, the west wind that
the Florentines always welcome in May.

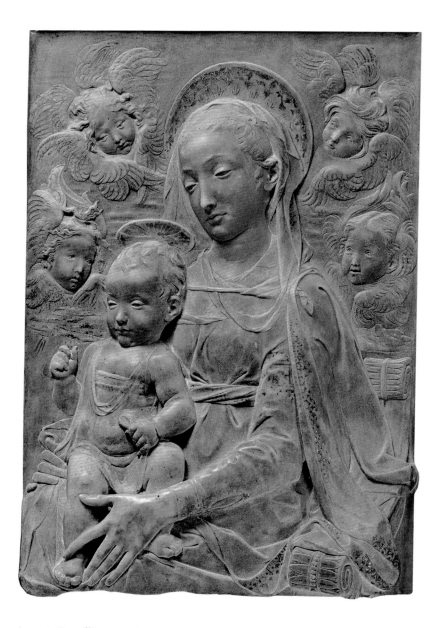

Antonio Rossellino
Italian, 1427–1479
Madonna and Child with Angels, ca. 1455–60
Marble with gilt details, 28⅞ × 21⅛ in. (73.3 × 53.7 cm)
Bequest of Benjamin Altman, 1913 (14.40.675)

The Florentine Antonio Rossellino was one of
the most gifted marble carvers of his generation,
which included Mino da Fiesole and Desiderio
da Settignano. This sensitive relief, made for
private devotion, is an early work of his. The

Virgin sits on an elaborate throne, with scrolled
armrests projecting in high relief. Both she and
the Christ Child in her arms seem strangely
subdued, perhaps contemplating Christ's future
suffering. The protective, caressing gesture of
the Virgin's left hand is especially poignant. The
main figures are set off against a rich variety
of surface details—spiraling flurries of angel
wings, horizontal puffs of clouds, an orna-
mented throne, and gilt passages throughout.

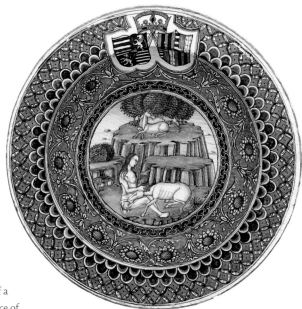

Dish

Italy, probably Pesaro, 1485–90
Maiolica, H. 4 in. (10.2 cm),
DIAM. 18⅞ in. (47.9 cm)
Fletcher Fund, 1946 (46.85.30)

This remarkable large dish was part of a
service ordered as a present for Beatrice of
Aragon, the second wife of King Matthias
Corvinus of Hungary (r. 1458–90); the arms of
Matthias and the House of Aragon decorate
the dish's rim. It is likely that the service was
commissioned by Camilla of Aragon, a cousin
of Beatrice, and that it was produced in Pesaro,
to which Camilla moved when she married
Costanzo Sforza in 1475. The superbly painted
central scene and the finely executed decorative
borders mark it as one of the most significant
pieces of fifteenth-century maiolica.

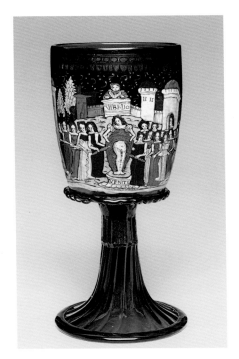

The Virgil Cup

Italy, Murano, ca. 1475–1500
Glass; enameled and gilded, H. 6⅞ in.
(17.5 cm), DIAM. of cup 3⅜ in. (8.7 cm)
Gift of J. Pierpont Morgan, 1917 (17.190.730a, b)

This fine, deep-blue Venetian glass bears exqui-
site enameling, an early surviving example of
this technique and scale of decoration. The
enameling, reminiscent of manuscript illumina-
tion, illustrates an apocryphal story about the
Latin poet Virgil, transformed in the popular
medieval imagination into a magician. Taking
revenge on the maiden Febilla who spurned his
advances, Virgil magically extinguished every
fire in Rome and cruelly demanded that Febilla
be exposed in the marketplace until all of the
city's women rekindled their fires with tapers
lighted from an enchanted live coal he had
placed inside her body.

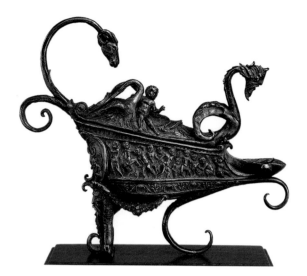

Riccio (Andrea Briosco)
Italian, 1470–1532
Oil Lamp, ca. 1515
Bronze, H. 7⅝ in. (19.4 cm)
European Sculpture and Decorative
Arts Fund, 2009 (2009.58)

Riccio of Padua was the most vital and pioneering bronze artist of the Italian Renaissance, and this is the Museum's finest decorative object from that heroic period. Retaining its lid and legs, it is the only complete oil lamp of the three surviving examples by him. It takes the form of an ancient galleon: its sides are formed by friezes showing putti playing with rams, and its extremities are arranged as eye-catching curlicues, including the neck of a bearded monster poised as if to puff at the wick.

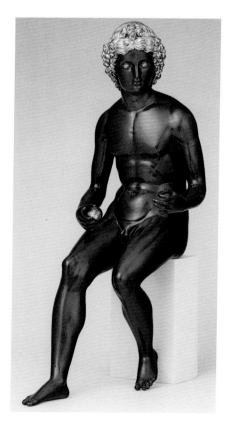

Antico (Pier Jacopo Alari Bonacolsi)
Italian, ca. 1460–1528
Paris, first quarter of the 16th century
Bronze; partly gilt and silvered, H. 14⅝ in. (37.1 cm)
Edith Perry Chapman Fund, 1955 (55.93)

The artist's adopted nickname, Antico, refers to his lifelong work revitalizing and perpetuating the sculpture of antiquity. The Mantuan artist is known above all for bronze statuettes of exquisite detail and refinement that reproduce compositions of famous classical statuary. Though a prototype has not been identified, this robust nude—among his largest statuettes—probably represents the Trojan prince Paris deciding which of three goddesses (Venus, Juno, and Minerva) was the most beautiful. He chose Venus, giving her his golden apple. The smooth flesh, elegantly chased features, and gilt and silvered highlights are good indications of why Antico's best bronzes remain among the most sought-after of all early Renaissance statuettes.

Francesco di Giorgio Martini
Italian, 1439–1501
Executed in the workshop of
Giuliano da Maiano
Italian, 1432–1490, and
Benedetto da Maiano
Italian, 1442–1497
**Studiolo from the Ducal Palace
in Gubbio,** ca. 1478–82
15 ft. 11 in. × 17 ft. × 12 ft. 7¼ in. (4.85 × 5.18 × 3.84 m)
Rogers Fund, 1939 (39.153)

This small room, intended for meditation and study, was commissioned by Duke Federico da Montefeltro for his palace in Gubbio. The panels are dazzling examples of intarsia, an inlay technique, in which thousands of pieces of walnut, beech, rosewood, oak, and fruitwoods were used to create extraordinarily realistic depictions of objects associated with the patron. Armor and insignia allude to his prowess as a warrior and wise ruler, and musical and scientific instruments and books attest to his love of learning. A glorious Renaissance interior, the *studiolo* is rivaled only by a slightly earlier example commissioned by the duke for his palace in Urbino, where it remains.

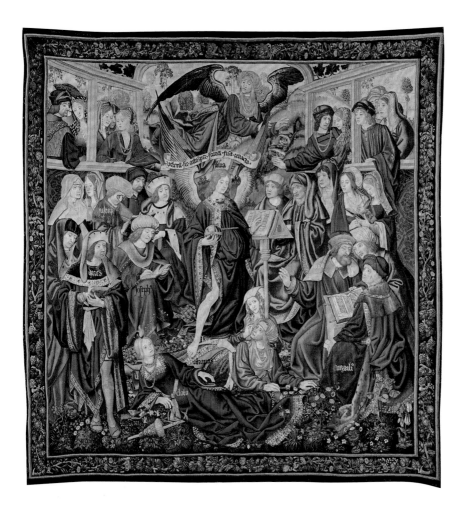

The Triumph of Fame

Flanders, probably Brussels, ca. 1502–4
Wool, silk, 11 ft. 9½ in. × 11 ft. (3.59 × 3.35 m)
Purchase, The Annenberg Foundation Gift,
1998 (1998.205)

This tapestry is extraordinary for its condition, color, and harmonious composition. Based in part on Petrarch's poem *I Trionfi* (The Triumphs), it belonged to a set of six representing the triumphs of Love, Chastity, Death, Fame, Time, and Religion. Here Fame reads at a lectern, surrounded by writers whose works immortalized the deeds of the ancients. Triumphant over Death, she tramples the Fates and holds an orb crowned with a cross, locating the subject in a distinctly Christian context. This tapestry, or one identical to it, was purchased by Isabella, Queen of Castile and Aragon, in 1504.

Patio from the Castle of Vélez Blanco

Spanish, 1506–15
Marble of Macael (Sierra de Filabres),
43 × 44 × 63 ft. (13.1 × 13.4 × 19.2 m)
Bequest of George Blumenthal, 1941 (41.190.482)

The patio from Vélez Blanco, near Almeria, is a composite architectural jewel. Its structure reflects the Spanish origins of its architect in the asymmetrical layout, Gothic gargoyles, flat-timbered ceiling, and low, segmental arches. Carvers from northern Italy executed the decorative Renaissance details. A sumptuous array of fanciful flora and fauna appears on the arches, the piers of the balustrade, and the doors and windows. Though elaborate, the motifs preserve the clarity of form, naturalism, and three-dimensional quality characteristic of the Italian early Renaissance.

Simone Mosca
Italian, 1492–1553
Wall Fountain, 1527–34
Gray sandstone, H. 16 ft. 3 in. (4.95 m)
Harris Brisbane Dick Fund, 1971 (1971.158.1)

Born in the stone-working town Settignano
and trained by the great architect Antonio da
Sangallo the Younger, Simone Mosca worked
with leading artists as a sculptor of architec-
tural ornament. This monumental fountain
was carved of a favored local stone, *pietra
serena*, for the Palazzo Fossombroni in Arezzo.
It vacillates delightfully between architecture
and sculpture, striking a balance among the
bases, columns, and entablature on one hand,
and the masks, scallops, and vegetal motifs
on the other. In these same years, Mosca
executed decoration for Michelangelo in the
Medici Chapel; the subtle push and pull of
surfaces across the fountain show Mosca's
grasp of Michelangelo's intentions.

Valentin Bousch

French, d. 1541

The Deluge, 1531

Glass, painted and stained,

11 ft. 10¼ in. × 5 ft. 7 in. (3.61 × 1.7 m)

Purchase, Joseph Pulitzer Bequest, 1917 (17.40.2a–r)

This window, together with *Moses Presenting the Tablets of the Law* (also in the Museum's collection) and five others, decorated the choir of the Benedictine priory church of Saint-Firmin in Flavigny-sur-Moselle, Lorraine. It was commissioned by the prior, Wary de Lucy. Its maker, Valentin Bousch of Metz, was one of the most significant master glaziers in northeastern France during the Northern Renaissance. Bousch rejected traditional compartmentalization and instead treated each composition like an enormous painted or carved retable within a trompe-l'oeil architectural frame. Brilliant hues of colored glass are combined with painted areas of grisaille and silver stain on clear glass, all cut with daring virtuosity.

Ewer

France, Saint-Porchaire or Paris, ca. 1550
Lead-glazed white pottery, H. 10¼ in. (26.2 cm)
Gift of J. Pierpont Morgan, 1917 (17.190.1740)

This ewer is one of the largest and most impressive examples of low-fire white pottery made in France in the middle years of the sixteenth century. Known as Saint-Porchaire ware, this group of elaborate and often architectural pieces is distinguished by the complex interlace designs of colored clays inlaid into the cream-colored earthenware body. They were believed to have been produced in the town of Saint-Porchaire in western France, but their technical sophistication and the ambition of their designs may indicate a Parisian origin.

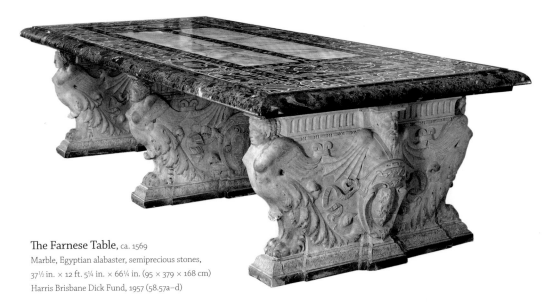

The Farnese Table, ca. 1569

Marble, Egyptian alabaster, semiprecious stones,
37½ in. × 12 ft. 5¼ in. × 66¼ in. (95 × 379 × 168 cm)
Harris Brisbane Dick Fund, 1957 (58.57a–d)

This monumental table embodies the Roman High Renaissance style. Although the relative roles of the makers are not certain, the table's designer is believed to have been Jacopo Barozzi da Vignola (Italian, 1507–1573), who created the superb settings of the state apartments for the Farnese Palace in Rome, for which this sumptuous table was made. Its top, created by Jean Ménard, a Frenchman working in Italy from 1525 to 1582, is a *pietra dura* (hard-stone) inlay of various marbles and semiprecious stones framing two "windows" of Egyptian alabaster in the center. The marble piers were likely carved by Guglielmo della Porta (Italian, ca. 1515–1577) and palace artisans under his supervision. The fleurs-de-lis in the decoration are emblems of the Farnese family, and the arms on the massive piers are those of Cardinal Alessandro Farnese.

Celestial Globe with Clockwork

Austria, Vienna, 1579

Case: silver, partly gilded, and gilt brass; movement:
brass, steel; 10¾ × 8 × 7½ in. (27.3 × 20.3 × 19.1 cm),
DIAM. of sphere 5⅜ in. (13.8 cm)
Gift of J. Pierpont Morgan, 1917 (17.190.636)

Made for Holy Roman Emperor Rudolf II, the
globe houses a movement by the Imperial
clockmaker Gerhard Emmoser, who signed
and dated the meridian ring. The movement,
which has been extensively rebuilt, originally
rotated the celestial sphere and drove an image
of the sun along the path of the ecliptic. A dial
at the top of the globe indicated the hours and
another, the day of the year. The sphere, with its
exquisitely engraved constellations and Pegasus
support, is the work of an anonymous goldsmith
and perhaps an engraver who were probably
employed in the Imperial workshops in Vienna.

Hunters in a Landscape
England, probably London, ca. 1575–95
Wool, silk, 70⅞ in. × 15 ft. 1⅞ in. (1.8 × 4.62 m)
Purchase, Walter and Leonore Annenberg Acquisition
Endowment Fund, Rosetta Larsen Trust Gift, and Friends
of European Sculpture and Decorative Arts Gifts, 2009
(2009.280)

This long and narrow wainscot tapestry has an
exquisitely well-preserved palette. In a manner
referred to by Flemish weavers at the time as
"English style," it would have hung between the
cornice and dado of a wood-paneled room. It is
attributed on stylistic, iconographic, and techni-
cal grounds to immigrant weavers who sought
refuge from war-torn Flanders by relocating to
England, probably London. Representative of
these straitened circumstances, elements of the
tapestry's cartoon have been artfully assembled
around a reused design source: the central man-
or house is based on a woodcut representing
King Solomon's Palace by the Swiss artist Jost
Amman (1539–1591).

Ewer
Italy, Florence, ca. 1575–87
Soft-paste porcelain, 8 × 4¼ × 4⅞ in.
(20.3 × 10.8 × 12.4 cm)
Gift of J. Pierpont Morgan, 1917 (17.190.2045)

The first identifiable efforts to produce
porcelain in Europe occurred in the workshops
of the Medici court in Florence in the late six-
teenth century. Under the patronage of
Francesco I de' Medici, Grand Duke of Tuscany,
artisans began about 1574 to experiment with
porcelain in imitation of Chinese blue-and-
white wares, which were highly prized in
Europe. While Chinese and Ottoman ceramics
influenced the decoration of Medici porce-
lain, many of the forms produced in the ducal
workshop were indebted to contemporary
hard-stone vessels or goldsmiths' work, as is the
case with this ewer. Only about sixty pieces of
Medici porcelain are known to have survived.

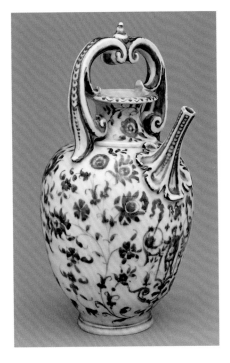

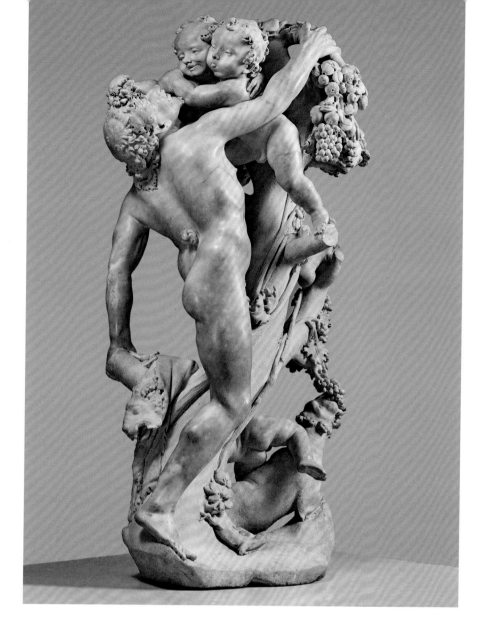

Gian Lorenzo Bernini

Italian, 1598–1680, and

Pietro Bernini

Italian, 1562–1629

Bacchanal: A Faun Teased
by Children, ca. 1616

Marble, H. 52⅛ in. (132.4 cm)

Purchase, The Annenberg Fund Inc. Gift, Fletcher, Rogers, and Louis V. Bell Funds, and Gift of J. Pierpont Morgan, by exchange, 1976 (1976.92)

A prodigy of astonishing facility, Gian Lorenzo Bernini apprenticed with his versatile father, Pietro. During this period they collaborated on a number of marble sculptures in which the son's ambitions and prowess are manifest. The Museum's group is the most ambitious among them, and it exemplifies the young artist's zest for rendering groups of intertwined figures and differentiated textures: witness the faun's muscular tension, his toothless mouth, the chubby children, the tree's bark, and the clusters of juicy fruits. Inspired by ancient sarcophagi, this Bacchic revel shows the fusion of classicism and naturalism typical of art in Rome at the threshold of the Baroque.

below
Attributed to the
Master of the Martyrdom of Saint Sebastian
Austrian
Hercules and Achelous,
probably mid-17th century
Ivory, H. 11 in. (27.9 cm)
The Jack and Belle Linsky Collection, 1982 (1982.60.129)

The feats of Hercules provided sculptors with an opportunity to explore the power of the male figure in intricate action. This large group, carved fully in the round, shows the struggle between the mythological hero and Achelous, a river god who transformed from man to bull to serpent. The work is attributed to an anonymous artist who carved two large relief scenes depicting the early Christian Saint Sebastian assailed by Roman bowmen. This ingenious carver's work is characterized by the expression of violent, exaggerated movements and extreme emotions, and by a fanatical delineation of physical details.

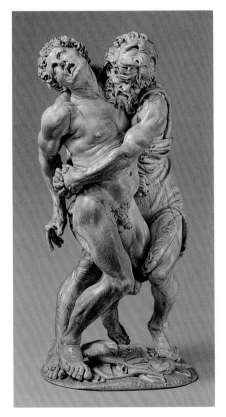

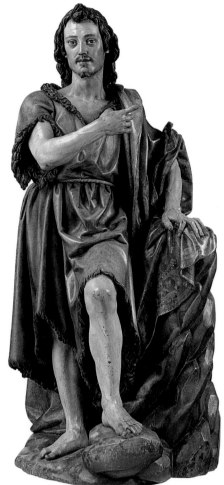

above
Juan Martínez Montañés
Spanish, 1568–1649
Saint John the Baptist, ca. 1625–35
Polychromed wood with gilding, H. 60⅝ in. (154 cm)
Purchase, Joseph Pulitzer Bequest, 1963 (63.40)

Montañés was the foremost Spanish sculptor of his day. He produced many statues and retables, and, for his technical wizardry, was nicknamed *el dios de la madera* (the god of wood). *Saint John the Baptist*, carved in the round, came from the convent of Nuestra Señora de la Concepción in Seville. Montañés followed the standard iconography of the Precursor, vividly portrayed with an intense gaze, a powerful anatomy, and natural skin tones. The richly polychromed and gilded statue combines sculptural and pictorial skills, as Montañés vied with painters to achieve a captivating realism, which elicited and enhanced devotion.

Michel Redlin
German, documented 1688
Casket, ca. 1680
Amber, gold foil, gilt brass, wood, silk satin,
paper, 11¾ × 13 × 8¼ in. (30 × 33 × 21 cm)
Walter and Leonore Annenberg Acquisitions
Endowment Fund, 2006 (2006.452a–c)

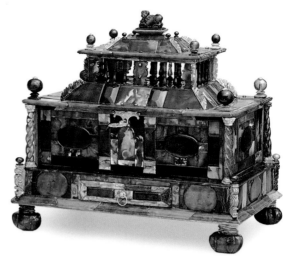

This "parade" casket (made for display only) from Gdansk, Poland, is one of the most important and well-preserved examples of seventeenth-century amber work. It incorporates nearly all types of amber—translucent, opaque, and milky variants—to emphasize the interplay of art and nature, the most desirable characteristic of a treasury, or *Kunstkammer*, object. In post-medieval times, amber, "the gold of the Baltic Sea," was regarded as a substance of mythical origin and magical power. Here the surface is delicately engraved with landscapes and pastoral scenes and enlivened by an ambitious system of rectangular and oval sections consisting of whisper-thin plates of transparent amber. Ingenious carving, turning, and engraving create a palette of sunset colors to delight the eye.

Balthasar Permoser
German, 1651–1732
Bust of Marsyas, ca. 1680–85
Marble, on a black marble socle inlaid with marble
panels, H. with socle 27 in. (68.6 cm)
Purchase, Rogers Fund and Harris Brisbane
Dick Fund, 2002 (2002.468)

Permoser was the preeminent figure in German Baroque sculpture. As a young man he traveled to Italy, and this bust of Marsyas was probably carved in Rome. Drawing on Bernini's *Damned Soul* of 1619 in the Palazzo di Spagna in Rome, Permoser captured the climax of Marsyas's horrific punishment: the satyr, who presumed to challenge Apollo in a music contest, was flayed alive. The squinting eyes and flamelike hair are typical of the sculptor's exaggerated emotionalism. Through the wide-open mouth, one can almost hear Marsyas's stifled scream.

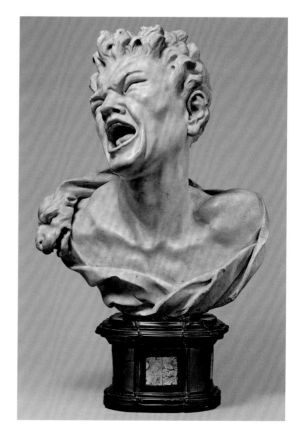

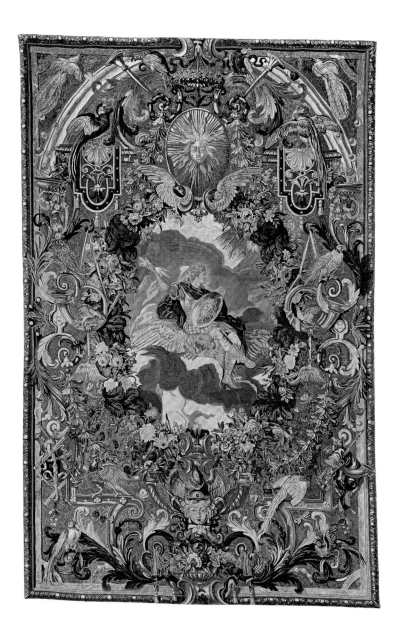

Attributed to
Charles Le Brun
French, 1619–1690
Border design by
Jean Lemoyen le Lorrain
French, 1637/38–1709
Air, ca. 1683
Wool, silk, silver, gilt-silver metal-wrapped
threads on canvas, 14 × 9 ft. (4.27 × 2.74 m)
Rogers Fund, 1946 (46.43.4)

Louis XIV as Jupiter personifies Air, seated on an
eagle, holding a bolt of lightning and a shield, and
surrounded by birds, butterflies, horns, and other
wind instruments. The elaborate design, attrib-
uted to Charles Le Brun, is executed in tent stitch
with an intricate background of silver and gilt-
silver threads couched in herringbone and spiral
patterns. The work comes from a set of eight
hangings (four of which are in the Museum's col-
lection), probably made for the king's mistress the
marquise de Montespan. They depict the Elements
and Seasons with either Louis XIV, the marquise,
or one of their children as the central character.
This hanging was probably embroidered at the
convent of Saint-Joseph-de-la-Providence, Paris.

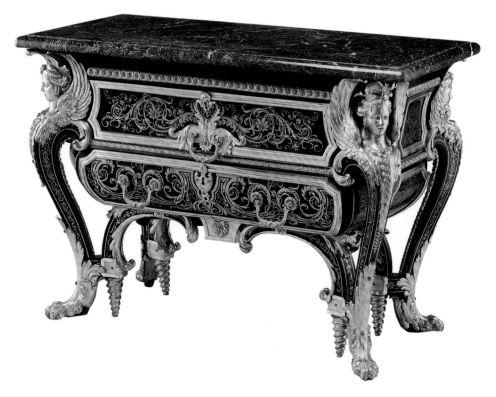

André-Charles Boulle
French, 1642–1732
Commode, ca. 1710–20
Walnut veneered with ebony and marquetry of engraved
brass and tortoiseshell, gilt-bronze mounts, *verd antique*
marble top, 34½ × 50½ × 24¾ in. (87.6 × 128.3 × 62.9 cm)
The Jack and Belle Linsky Collection, 1982 (1982.60.82)

In 1708 Boulle, the most celebrated cabinet-
maker of Louis XIV's reign, executed two
bureaux, or commodes, for the king's bedroom at
the Grand Trianon at Versailles. A new invention
in the history of furniture, these *bureaux* were
a combination of the table and the emerging
commode, characterized by two drawers, in a
shape influenced by Roman sarcophagi and
designs by the court draftsman Jean Bérain. The
model's structure required four extra supports,
which form tapering spirals. The commode
became one of the most frequently repeated
pieces of French eighteenth-century furniture.
This example appears to be an early version
made in Boulle's workshop.

Stuccowork probably by
Abbondio Stazio of Massagno
Italian, 1675–1745, and
Carpoforo Mazzetti
Italian, ca. 1684–1748
Bedroom from the Sagredo Palace
Venice, ca. 1718
25 ft. 2 in. × 18 ft. 2 in. × 13 ft. 2 in. (7.67 × 5.54 × 4.01 m)
Rogers Fund, 1906 (06.1335.1a–d)

This sumptuous bedroom is one of the
finest surviving examples of its period. The
decoration is in stucco and carved wood.
The unornamented portions of the walls are
covered in seventeenth-century brocatelle.
Beautifully modeled *amorini* appear in several
areas of the antechamber: flying out of an
entablature supported by fluted Corinthian
pilasters, holding the gilded frame of a painting
by Gaspare Diziani depicting Dawn triumphant
over Night, and teasingly guarding the entry to
the bed alcove. A paneled wood dado with a red
and white marble base runs around the room,
and the alcove retains its original marquetry
floor—all creating a buoyant ensemble.

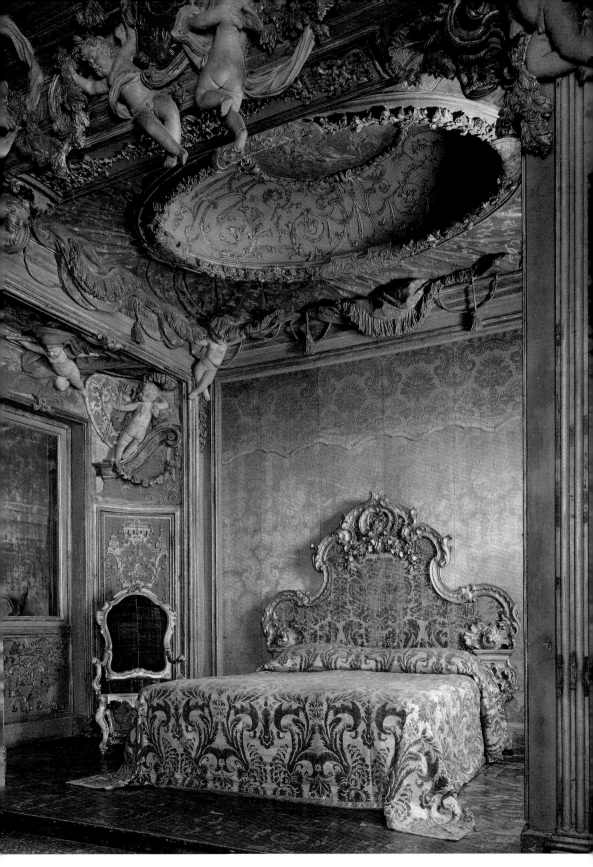

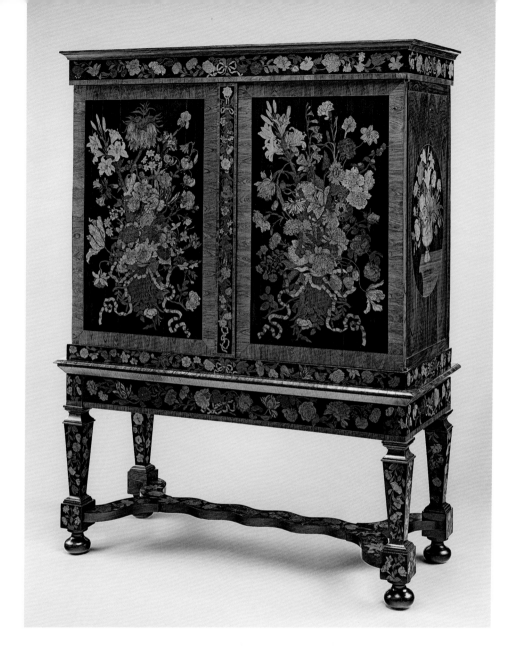

Attributed to
Jan van Mekeren
Dutch, 1658–1733
Cabinet on Stand, ca. 1700–1710
Oak veneered with rosewood, olivewood, ebony, holly,
tulipwood, barberry, other partly stained marquetry woods,
70¼ × 53⅞ × 22½ in. (178.4 × 136.8 × 57 cm)
Ruth and Victoria Blumka Fund, 1995 (1995.371a, b)

This cabinet is the smallest yet most pictorial
of similar known examples attributed to the
cabinetmaker Jan van Mekeren, who specialized

in the production of luxurious marquetry fur-
niture for the Amsterdam elite. Resting on an
open support, the cabinet has a simple, boxlike
superstructure embellished with large bou-
quets of exquisite flowers. By cleverly choos-
ing a bright yellow wood like barberry for the
daffodils, for instance, and by enhancing the
nearly white holly with natural, but not very
durable, dyes, Van Mekeren achieved a rich and
naturalistic palette echoing that of contempo-
rary still-life paintings.

After a model attributed to
Johann Gottlieb Kirchner
German, ca. 1706–1737

Lion
Germany, Meissen, one of a pair, ca. 1732
Hard-paste porcelain, 21 × 32¾ × 13½ in.
(53.3 × 83.2 × 34.3 cm)
Wrightsman Fund, 1988 (1988.294.1)

The menagerie of large-scale porcelain animals ordered for Augustus II's Japanese Palace in Dresden was one of the most ambitious undertakings in eighteenth-century ceramics. There was no precedent for producing animals of this scale in porcelain, and the numerous firing cracks in this lion and its mate reflect the technical difficulty in both modeling and firing such large figures. Despite the minor technical flaws, which also include the bluish cast of the glaze, this lion and the series to which it belongs represent one of the greatest achievements of Germany's Meissen factory, the first in Europe to produce true porcelain.

Simon Pantin
British, ca. 1672–1728
Teakettle, Lamp, and Table, 1724–25
Silver, H. 40¾ in. (103.5 cm)
Gift of Irwin Untermyer, 1968 (68.141.81a–f)

This monumental kettle and stand were very likely made to mark the 1724 wedding of George Bowes of Streatham Castle to the very wealthy heiress Eleanor Verney. It would have been a costly gift, since the bold, undulating supports of the table are cast in solid silver. It is a rare survivor, as most silver furniture of the period was melted down to recover the value of the metal. This piece is distinguished by its elegant Baroque outline, precise casting, and fine engraving. The silversmith, Simon Pantin, was one of many artisans of French Protestant heritage working in London.

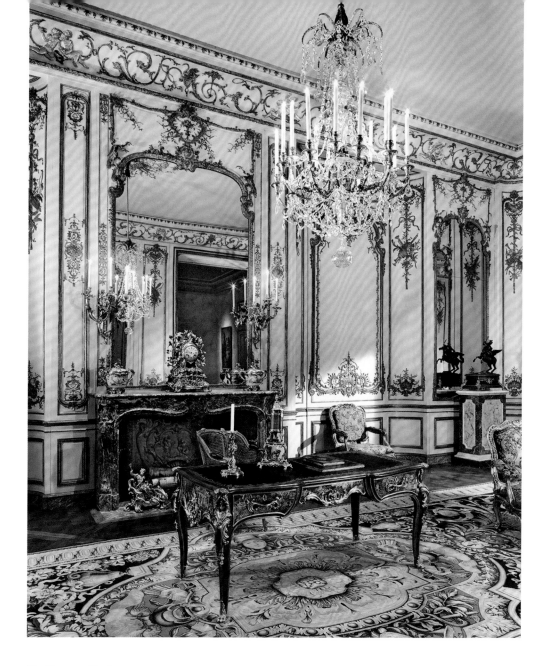

The Varengeville Room

Paris, ca. 1736–52 (with later additions)
18 ft. 3¾ in. × 23 ft. 2½ in. × 40 ft. 6½ in.
(5.58 × 7.07 × 12.36 m)
Purchase, Mr. and Mrs. Charles Wrightsman Gift,
1963 (63.228.1)

Superb carving, partly in high relief, constitutes
the chief glory of this room's boiserie, or wood
paneling, originally from one of the private
residences of eighteenth-century Paris, the
Hôtel de Varengeville, which still stands, albeit

much altered, at 217, boulevard Saint-Germain.
Although the painted and gilded oak paneling is
richly embellished with C-scrolls, S-scrolls, sprigs
of flowers, and rocaille motifs, its decoration
is still largely symmetrical and thus does not
represent the full-blown Rococo style. The
trophies allude to concepts and qualities such
as music, gardening, military fame, and princely
glory, and the long-necked birds perched on the
scrolling frames of the mirrors and wall panels
reflect contemporary interest in the exotic.

Toilet Set in Original Leather Case,
ca. 1743–45
Fourteen identified German (Augsburg) goldsmiths
and other German artisans, Japanese (Imari) porcelain
Gilt silver, hard-paste porcelain, cut glass, walnut, carved
and partially gilt coniferous wood, blind-tooled and
partially gilt leather, partially gilt steel and iron, textiles,
moiré paper, hog's bristle; case H. 17⅜ × 24¾ × 22½ in.
(44 × 63 × 57 cm); mirror 29½ × 23½ in. (74.9 × 59.7 cm)
Purchase, Anna-Maria and Stephen Kellen Foundation Gift,
in memory of Stephen M. Kellen, 2005 (2005.364.1–.48)

This refined ensemble unites an exalted origin
with accomplished artistic design and quality
of craftsmanship. Used as part of the daily levee,
or dressing ritual, of a high-ranking aristocrat,
these accessories were intended to reflect the
owner's status. Customarily, a husband gave
a dazzling set such as this one to his bride as
a "morning gift" following the wedding night.
Made in Augsburg, known for its production
of extensive, intricate silver sets, this ensemble
belonged to the counts Schenk von Stauffenberg
in Swabia. A memorable descendant was Claus
von Stauffenberg, executed in 1944 after an
unsuccessful attempt to assassinate Adolf Hitler.

Potpourri Vase
France, Sèvres, 1756–57
Soft-paste porcelain, 14⅛ × 14¼ × 7¾ in. (35.9 × 36.2 × 19.7 cm)
Gift of Samuel H. Kress Foundation, 1958 (58.75.88a–c)

When this vase was made, the French royal manu-
factory at Sèvres was the most influential and pres-
tigious porcelain factory in Europe. Innovation in
both form and decoration is evident in the complex
pierced design of the vase's cover and shoulder, in
the rich turquoise ground color, and in the detailed
painted and gilded decoration. Its first owner was
Madame de Pompadour, a mistress of Louis XV.

François-Thomas Germain
French, 1726–1791
Coffeepot, 1757
Silver, ebony, H. 11⅝ in. (29.5 cm)
Purchase, Joseph Pulitzer Bequest, 1933 (33.165.1)

This coffeepot, made in Paris and dated 1757, is
one of the most original and successful silver
designs of the period. The dynamic spiral fluting
lends a sense of movement to the form, and
the lushly rendered coffee leaves and berries
on the spout and lid signal the function of the
piece. François-Thomas Germain, son of the
famous silversmith Thomas Germain, was one
of the most fashionable makers in Paris in the
second half of the eighteenth century, and his
large workshop supplied services to the courts of
Russia, France, and Portugal.

Gilles Joubert
French, 1689–1775
Writing Table, 1759
Lacquered oak, gilt-bronze mounts,
leather (not original), 31¾ × 69¼ ×
36 in. (80.7 × 175.9 × 91.4 cm)
Gift of Mr. and Mrs. Charles
Wrightsman, 1973 (1973.315.1)

On December 29, 1759, Gilles Joubert, a success-
ful Parisian cabinetmaker who received numer-
ous royal commissions, supplied this writing
table for the study of Louis XV at Versailles.
The surface decoration imitates red and gold
Chinese lacquer, which in the mid-eighteenth
century was fashionable in France as veneer for
furniture. The partly pierced gilt-bronze mounts
not only emphasize the graceful curving lines of
the writing table but also protect and frame its
lustrous crimson lacquered surface. The writing
table remained at Versailles until the Revolu-
tionary sales of royal property in 1793–94.

Attributed to
William Vile
English, ca. 1700/1705–1767, and
John Cobb
English, ca. 1715–1778
Medal Cabinet, 1760–61
Mahogany, 79 × 27 × 17¼ in.
(200.7 × 68.6 × 43.8 cm)
Fletcher Fund, 1964 (64.79)

This medal cabinet, with 135 shallow drawers that
can accommodate more than six thousand coins
and medals, is one of two cabinets that probably
formed the end sections of a larger piece of
furniture, called His Majesty's Grand Medal Case.
(Its mate is on view today in the British Museum
in London.) The pair appears to have been
commissioned by George, Prince of Wales, who
was crowned King George III in 1760; the door of
the top section is carved with the star of the Order
of the Garter, to which the Prince of Wales had
been elected in 1750. Originally the cabinets rested
on open stands. William Vile made alterations to
both cabinets, the most extensive being the filling
in of the space between the legs.

David Roentgen

German, 1743–1807, master 1780

Commode, ca. 1775–79

Oak, pine, basswood, cherry wood; veneered with tulipwood, boxwood, amaranth, sycamore, pearwood, harewood; drawer linings of mahogany; gilt-bronze mounts; steel and brass operating mechanisms; Catalan red brocatelle marble top not original to commode, 35¼ × 53½ × 27¼ in. (89.5 × 135.9 × 69.2 cm)

The Jack and Belle Linsky Collection, 1982 (1982.60.81)

Branded twice on the back with the mark of the Château de Versailles, this *commode à vantaux* is associated with a 1792 inventory of Louis XVI's private apartments. Roentgen, the principal cabinetmaker of eighteenth-century Europe, supplied an international clientele—including many German princes, Marie-Antoinette, and Catherine the Great—with furnishings of innovative design combined with intriguing mechanical devices. The three marquetry scenes on the front of this example depict theatrical stages; the center scene is occupied by figures from Italian commedia dell'arte.

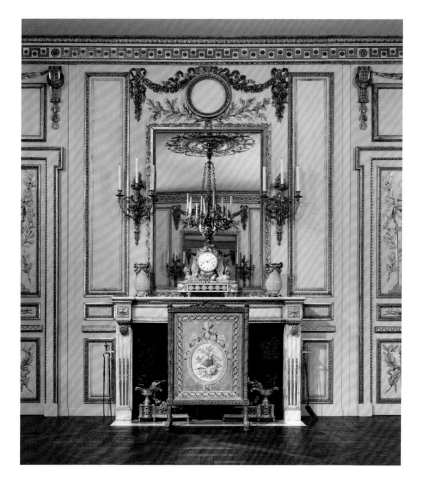

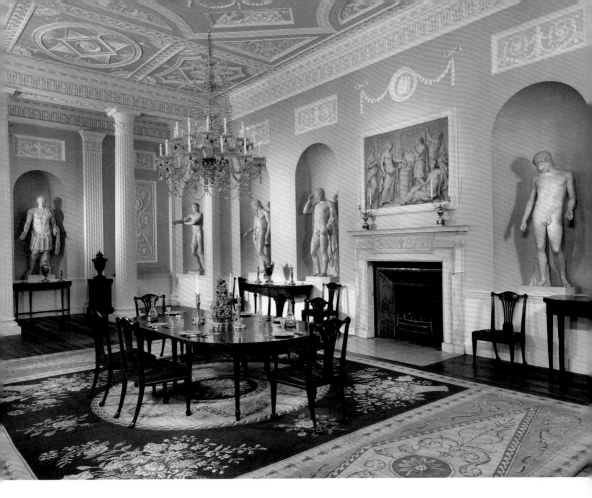

The Cabris Room

Paris, ca. 1774 (with later additions)

11 ft. 8½ in. × 22 ft. 10½ in. × 25 ft. 6 in.

(3.56 × 6.96 × 7.77 m)

Purchase, Mr. and Mrs. Charles Wrightsman Gift, 1972

(1972.276.1)

Commissioned for the new residence of Jean-Paul de Clapiers, marquis de Cabris, in Grasse, this paneling made in Paris is a pure expression of the Neoclassical style. Originally the room had five sets of double doors and an equal number of mirrors, achieving a beautiful harmony by the alternation of the carved and gilded oak with reflective glass surfaces. The rounded corners display trophies of musical instruments suspended from bow-tied ribbons. Smoking incense burners on tripod stands, a motif derived from classical antiquity, embellish the upper door panels. The combination of dulled and burnished gilding creates a particularly lively effect.

After a design by

Robert Adam

English, 1728–1792

Dining Room from Lansdowne House

London, 1766–69

17 ft. 11 in. × 24 ft. 6 in. × 47 ft. (5.46 × 7.47 × 14.33 m)

Rogers Fund, 1931 (32.12)

Located on London's Berkeley Square, Lansdowne House and its interiors were designed by Robert Adam. The Great Eating Room shows the British architect's Neoclassical style at its height. Divided by a columnar screen and featuring carved woodwork, the space incorporates nine niches for antique sculptures. (They now contain copies.) The room's chief glory is the cast-plaster decoration with its rich vocabulary of classical ornament. Although not original to the room, the mahogany side chairs by Thomas Chippendale are of the same model as those supplied to Lansdowne House's owner in 1769.

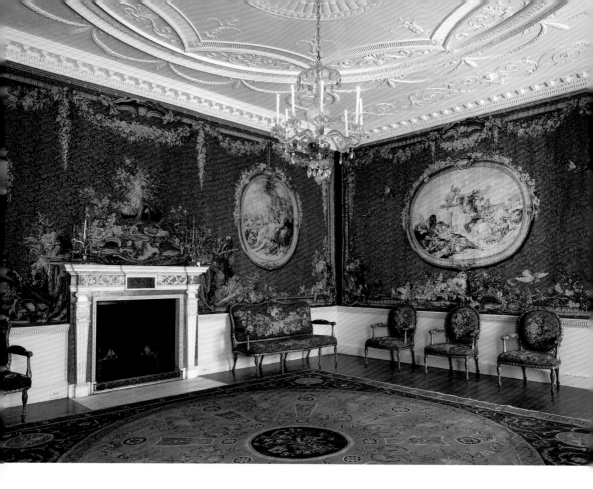

After a design by
Robert Adam
English, 1728–1792
Tapestry Room from Croome Court
Worcestershire, 1763–71
13 ft. 10¾ in. × 22 ft. 8 in. × 27 ft. 1 in. (4.23 × 6.9 × 8.26 m)
Gift of Samuel H. Kress Foundation, 1958 (58.75.1–.22)

Designed in 1763, the plaster ceiling of this room, with its ornamental wheel molding and garlanded trophies, is an example of Robert Adam's vigorous early style. The same year, the sixth Earl of Coventry commissioned the silk and wool tapestry hangings from Jacques Neilson's workshop at the Royal Gobelins Manufactory in Paris. With scenes taken from classical myths to symbolize the elements, the medallions are based on designs by François Boucher. The gilded frames of the chairs and settees were made in London in 1769 by the cabinetmakers John Mayhew and William Ince. The tapestry covers were executed at the Gobelins manufactory.

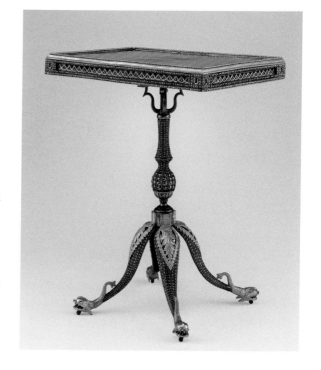

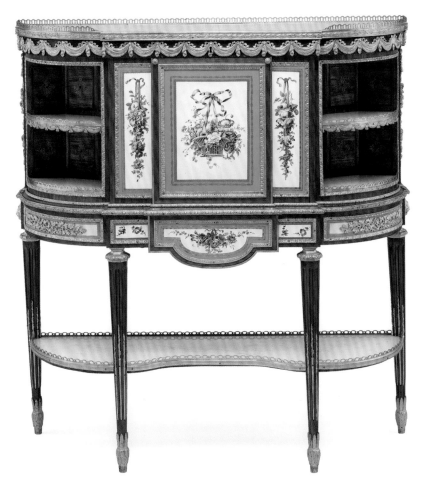

opposite

Imperial Armory

Russia, Tula, south of Moscow

Center Table, ca. 1780–85

Steel, silver, gilt copper, gilt brass, basswood; replaced
mirror glass, 27½ × 22 × 15 in. (69.9 × 55.9 × 38.1 cm)
Purchase, The Annenberg Foundation Gift, 2002 (2002.115)

This table was the first piece of Russian furni-
ture to enter the Museum's collection. Belong-
ing to a small group of pieces embellished with
silver inlay, ornamental etching, and numerous
gilded applications, it is the only example known
outside Russia and is visually the most accom-
plished. These extraordinary objects were usu-
ally diplomatic gifts or part of a dowry. Recent
research reveals that this parade table (meant
for display only) was made for the Russian impe-
rial family; it was recorded in Empress Maria
Feodorovna's bedroom in the palace at Pavlovsk.
In 1801 she gave it to Duke Peter of Oldenburg,
widower of her late sister.

Attributed to

Martin Carlin

French, 1730–1785

Drop-Front Secretary on Stand, ca. 1776

Oak veneered with tulipwood, amaranth, holly, and
sycamore; six Sèvres soft-paste porcelain plaques and
two painted tin plaques; gilt-bronze mounts; marble
shelves; moiré silk, 43½ × 40½ × 12⅞ in. (110.5 ×
102.9 × 32.7 cm)
Gift of Mr. and Mrs. Charles Wrightsman, 1976
(1976.155.110)

Martin Carlin was known for his graceful
furniture mounted with Sèvres porcelain. The
central porcelain plaque of the secretary, painted
by Edmé-François Bouillat, has the letter for
the date 1776 on the back. The secretary's
first owner was the soprano Marie-Joséphine
Laguerre, who enjoyed a luxurious and dissolute
existence made possible by her wealthy lovers.
It was subsequently acquired by Maria Feodo-
rovna while still grand duchess of Russia. She
visited Paris in 1782.

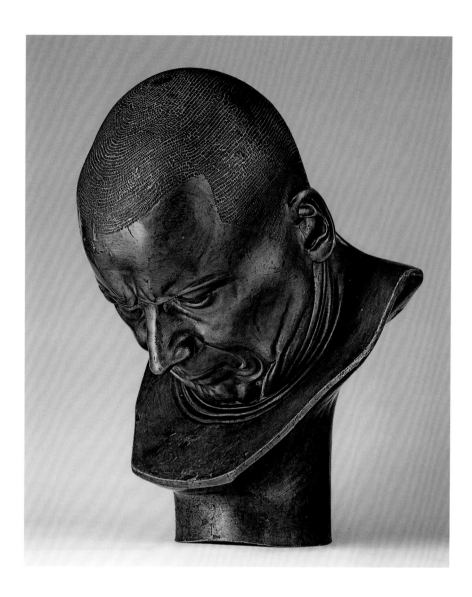

Franz Xaver Messerschmidt
Austrian, born Germany, 1736–1783
A Hypocrite and Slanderer, ca. 1770–83
Tin alloy, 14⅝ × 9⅝ × 11⅝ in. (37 × 24.4 × 29.5 cm)
Purchase, European Sculpture and Decorative Arts Fund;
and Lila Acheson Wallace, Mr. and Mrs. Mark Fisch, and
Mr. and Mrs. Frank E. Richardson Gifts, 2010 (2010.24)

The Austrian sculptor Messerschmidt's series of some sixty character heads, in either metal or alabaster, was a personal obsession that occupied him at the end of his career. The busts acknowledge artistic traditions that relate facial expression to emotions, yet they also reflect contemporary medical theories connecting outward senses to inner feelings. A few of the subjects, like this one, are deeply introspective. In a highly original combination of realism and abstraction, the sculptor portrayed a balding, blocky man, his head sinking to his chest, his concentric wrinkles and symmetrical jowls creating tense patterns.

below

Jean-Antoine Houdon

French, 1741–1828

La Frileuse, 1787

Bronze, H. 56½ in. (143.5 cm)

Bequest of Kate Trubee Davison, 1962 (62.55)

A *frileuse* is a woman sensitive to cold. A
marble version in the Musée Fabre in Mont-
pellier, dated 1783, was originally intended
as an allegory of Winter. For the Museum's
bronze, cast by Houdon himself and coming
from the collection of the duc d'Orléans,
the artist stripped the spiraling columnar
composition to its bare essentials. The
girl's tremulous flesh is offset by her tightly
drawn shawl, elegant but hardly adequate.

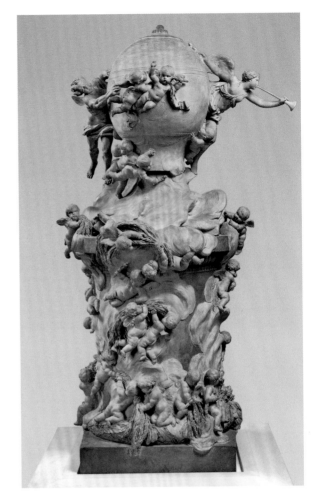

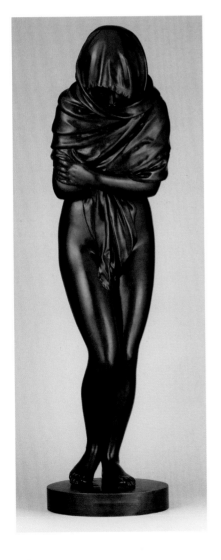

above

Clodion (Claude Michel)

French, 1738–1814

Balloon Monument, 1783

Terracotta, H. 43⅛ in. (109.5 cm)

Purchase, Rogers Fund and Anonymous Gift,

1944 (44.21a, b)

The first successful ascent of a hot-air balloon was
achieved by the Montgolfier brothers in 1783. It
lasted only ten minutes but was widely celebrated.
By the end of the year, the French crown proposed
a monument to the event. Clodion was one of
seven talented sculptors to compete for the com-
mission. His airy Rococo flight of fancy—in which
putti mound bundles of hay to launch the balloon,
guided by Fame and pushed by the wind god Aeo-
lus—is difficult to imagine in marble. After hot-air
ballooning spread to the point of being common-
place, the project was dropped.

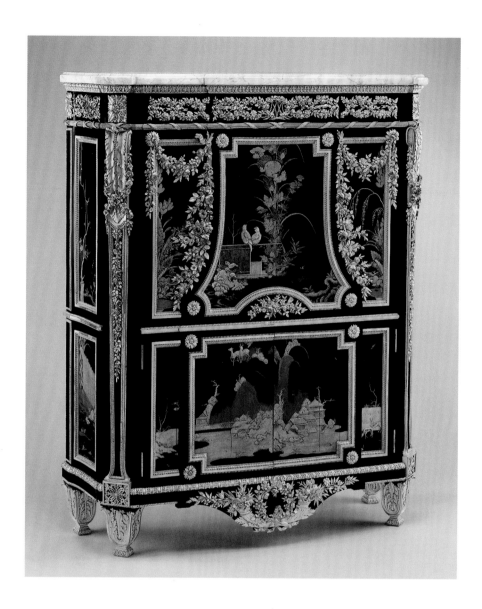

Jean-Henri Riesener
French, 1734–1806
Drop-Front Secretary, 1783
Oak veneered with ebony and 17th-century Japanese
lacquer; interior veneered with tulipwood, amaranth, holly,
and ebonized holly; gilt-bronze mounts; marble; velvet (not
original), 57 × 43 × 16 in. (144.8 × 109.2 × 40.6 cm)
Bequest of William K. Vanderbilt, 1920 (20.155.11)

In 1783 Jean-Henri Riesener created for Marie-
Antoinette this splendid secretary together with
a matching commode, now also in the Museum's
collection. It was commissioned for one of the

queen's private rooms at Versailles, where she
kept the Japanese lacquer boxes she had inher-
ited from her mother, Empress Maria Theresa of
Austria. Choice fragments of seventeenth-
century Japanese lacquer were reused as veneer
for these royal pieces. The shiny black and gold
lacquer and lustrous ebony form a striking back-
ground for the exceptional gilt-bronze mounts,
which consist of swags and interlaced garlands of
naturalistic flowers. The queen's initials are in-
corporated in the center of the frieze at the top.

Designed by
Jean-Démosthène Dugourc
French, 1749–1825
Manufactured by
Camille Pernon
French, 1753–1808
Verdures du Vatican, ca. 1799
Woven silk and metal thread with applied silk
and chenille embroidery, 9 ft. 6¾ in. × 26¼ in.
(291.5 × 66.7 cm)
Acquisitions Fund, 2006 (2006.519b)

This silk wall panel is one of a pair from a
suite of hangings intended to decorate the
billiard room of the Casita del Labrador, the
rural pleasure palace at Aranjuez, Spain, built
between 1791 and 1803 for King Charles IV.
Dugourc, who worked for both the French and
Spanish nobility, was known for his ingenious
integration of motifs from diverse sources.
For these panels, Raphael's decorations in the
Vatican Loggia were the primary inspiration.
Produced by Camille Pernon, premier
producer of luxury silks in Lyon, they are
a tour-de-force combination of woven and
embroidered decoration.

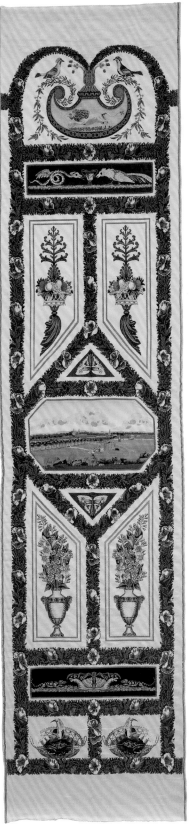

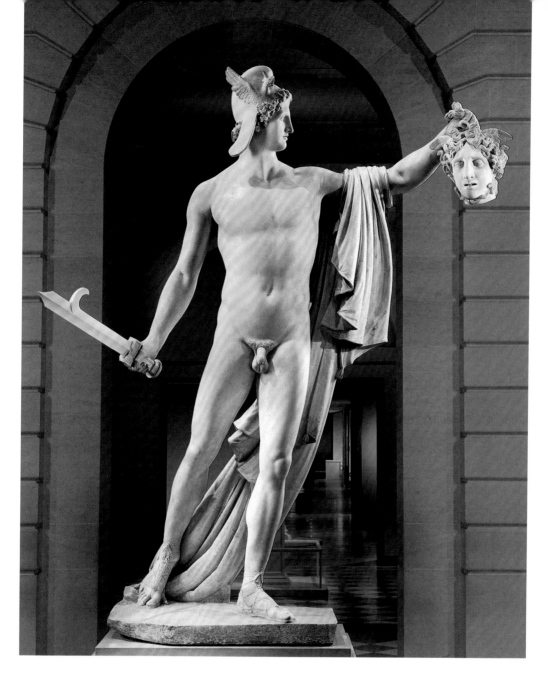

Antonio Canova
Italian, 1757–1822
Perseus with the Head of Medusa, 1804–6
Marble, H. 95½ in. (242.6 cm)
Fletcher Fund, 1967 (67.110.1)

Between 1797 and 1801, Canova carved a statue of *Perseus* based on the second-century A.D. Roman *Apollo Belvedere* in the Vatican Museums. Perseus is shown brandishing the head of Medusa, whom he slew with the help of the goddess Minerva. When the statue was exhibited in Canova's studio, Pope Pius VII purchased it to occupy the place that had been held by the *Apollo Belvedere* before it was temporarily removed to France by Napoléon. The Metropolitan Museum's version, commissioned shortly afterward by a Polish countess, Waleria Tarnowska, was carved with several variants. In his sleek majesty, Canova's *Perseus* became a model of Neoclassical heroic beauty.

right
Designed by
Jean Brandely
French, active 1855–67
Made by
Charles-Guillaume Diehl
French, 1811– ca. 1885
Mounts and large central plaque by
Emmanuel Frémiet
French, 1824–1910
Cabinet, 1867
Oak veneered with cedar, walnut, ebony, and ivory; silvered-bronze mounts, 93¾ × 59½ × 23⅝ in. (238 × 151 × 60 cm)
Purchase, Mr. and Mrs. Frank E. Richardson Gift, 1989
(1989.197)

When the prototype for this cabinet, now in the Musée d'Orsay, Paris, was exhibited at the Paris Exposition Universelle of 1867, the reactions were generally not favorable. Diehl must have been pleased with the results, however, because he made a nearly identical one, the present cabinet, for himself. Unconventional in both shape and decoration, the cabinet features a central plaque that evokes a legendary past and expresses a strong sense of French nationalism. It depicts the triumph of King Merovech after his 451 victory over Attila the Hun. Merovech stands atop a chariot whose driver urges the oxen to step over the body of a fallen enemy.

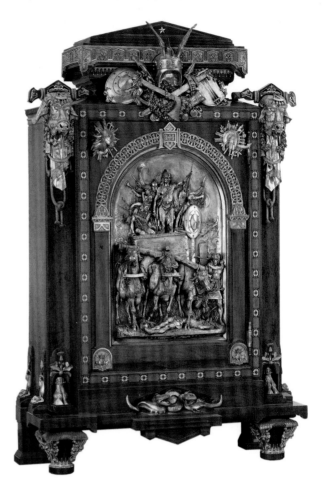

left
Designed by
Georges Hoentschel
French, 1855–1915
Possibly executed by
Émile Grittel
French, 1870–1953
Vase, 1899–1900
Glazed stoneware, 45⅝ × 22 ½ × 24⅛ in.
(115.9 × 57.2 × 61.3 cm)
Purchase, Iris and B. Gerald Cantor Foundation
Gift, 2007 (2007.27)

This vase, a French Art Nouveau masterpiece, is among the most ambitious ceramics designed by Hoentschel, an architect, interior decorator, and art collector as well as a ceramist. Aquatic motifs—fish, crustaceans, shells, and seaweed—are skillfully integrated into the design, and the mottled green glaze reinforces the marine theme. This vase and its mate were displayed prominently at the 1900 Exposition Universelle in Paris.

Jean-Baptiste Carpeaux

French, 1827–1875

Ugolino and His Sons, 1865–67

Marble, H. 77¾ in. (197.5 cm)

Purchase, Josephine Bay Paul and C. Michael Paul
Foundation Inc. and Charles Ulrick and Josephine Bay
Foundation Inc. Gifts and Fletcher Fund, 1967 (67.250)

The subject of this intensely Romantic work
is derived from canto 33 of Dante's *Inferno*,
in which he described how the Pisan traitor

Count Ugolino della Gherardesca, his sons, and
his grandsons were imprisoned in 1288 and ulti-
mately died of starvation. Carpeaux showed the
anguished father resisting his children's offer of
their own bodies for his sustenance. The artist's
visionary, tormented group reflects his passionate
reverence for Michelangelo, specifically for *The
Last Judgment* (1536–41) in the Sistine Chapel of
the Vatican, as well as his own painstaking con-
cern with forceful anatomical realism.

Auguste Rodin
French, 1840–1917
Adam or **The Creation of Man,**
modeled 1880–81, cast 1910
Bronze, 76⅜ × 30⅜ × 32½ in.
(194 × 77.2 × 82.6 cm)
Gift of Thomas F. Ryan, 1910 (11.173.1)

The direct experience of Michelangelo's art, both in Italy and in the Musée du Louvre in Paris, seems to have unlocked for Rodin many of the secrets of the Renaissance master's expressive modeling. Rodin exhibited the original plaster model of this work, titled *The Creation of Man*, in the Paris Salon of 1881. For a time, he intended to incorporate the powerful, larger-than-life figure into his design for *The Gates of Hell*, the portal planned for a new museum of decorative arts that was never constructed. Commissioned by the Metropolitan Museum for a gallery devoted to Rodin's work that opened in 1912, this was the first bronze cast from the model.

Robert Lehman Collection

One of the most distinguished privately assembled art collections in the United States, the Robert Lehman Collection was bequeathed by its namesake to the Metropolitan Museum in 1969. The galleries of the Robert Lehman Wing honor the donor's intention to bring his collection to public view in rooms recalling the courtly interiors of the Lehman family town house. Initiated in the early twentieth century by Robert Lehman's parents, Philip and Carrie, the collection was largely assembled over the next several decades by their son. An aggregate of many collections, the bequest of twenty-six hundred works encompasses more than half a millennium of western European art from the Middle Ages to modernism and includes paintings, drawings, illuminated manuscripts, antique frames, textiles, maiolica, bronzes, enamels, furniture, and glass. Rich in Italian paintings of the fourteenth and fifteenth centuries, Lehman's collection includes distinguished Sienese panels, which, when united with others in the Metropolitan, give the Museum a prominence unparalleled outside of Siena. Sienese artists such as Simone Martini and Giovanni di Paolo feature among equally fine masters of the Florentine school—Bernardo Daddi, Lorenzo Monaco, and Botticelli, for example. Similarly, the maiolica pieces, arguably among the finest of their kind outside of Italy, add untold riches to the Metropolitan's holdings of this precious lusterware. Works on paper by Leonardo, Dürer, Rembrandt, and others augment the Metropolitan's superb selection of old master drawings and are a testament to a collecting heritage of unusual distinction.

Simone Martini

Italian, active 1315–44

Madonna and Child, 1326

Tempera on wood, gold ground,
22½ × 15⅛ in. (57.2 × 38.4 cm)
Robert Lehman Collection, 1975 (1975.1.12)

This beautifully preserved painting, together
with Lehman's *Saint Ansanus* and *Saint Andrew*,
also in the Museum, formed part of a five-
paneled altarpiece commissioned by the civic
government of Siena. The altarpiece was intended
for the Sienese governor's residence, which was
rented for a six-month term of office and was
periodically relocated. The altarpiece's unusual
design, with the center panel—the *Madonna and
Child*—being equal in size to the flanking panels,
allowed it to be folded easily and transported
between residences. All five of Simone's panels
were later incorporated into a larger altarpiece
in a chapel of the Palazzo Pubblico, Siena's town hall.

Bernardo Daddi

Italian, ca. 1290–1348

The Assumption of the Virgin, ca. 1337–39

Tempera on wood, gold ground, 42½ × 53⅞ in.
(108 × 136.8 cm)

Robert Lehman Collection, 1975 (1975.1.58)

Bernardo Daddi was the leading painter in
Florence in the generation after Giotto. This
panel likely formed the upper half of an impor-
tant altarpiece he painted for the chapel of the
Sacro Cingolo in the cathedral of Prato, near
Florence, which houses the venerated relic of the
Virgin's girdle. The Virgin is carried to heaven
by six angels and, as proof of her Assumption,
lowers her girdle to Saint Thomas, whose hands
are visible at the panel's bottom left edge. The
lost lower half of the altarpiece probably depict-
ed Saint Thomas accompanied by other apostles
gathered around the Virgin's deathbed.

Lorenzo Monaco (Piero di Giovanni)
Italian, ca. 1370–1425
The Nativity, ca. 1406–10
Tempera on wood, gold ground,
8¾ × 12¼ in. (22.2 × 31.1 cm)
Robert Lehman Collection, 1975 (1975.1.66)

Lorenzo Monaco, a leading Florentine painter and illuminator of the early fifteenth century, was a Camaldolese monk who was allowed to operate a thriving workshop outside his monastery, that of Santa Maria degli Angeli. The exquisitely rich and subtle tonal harmonies of this painting, one of his most celebrated works, reflect his skill as an illuminator. Compositional elements, such as the shed's pitched roof, are skillfully adapted to the irregular form of the quatrefoil panel, which originally formed part of a predella of an altarpiece.

Aquamanile Depicting Aristotle and Phyllis
South Lowlands, late 14th century
Bronze, H. 13¼ in. (33.7 cm)
Robert Lehman Collection, 1975 (1975.1.1416)

An aquamanile is a vessel for pouring water used in the ritual of hand washing in both secular and religious contexts—by a priest before Mass and in households before a meal. Probably intended to entertain guests at the table in a domestic setting, this example depicts the popular moralizing legend in which Aristotle, the Greek philosopher and tutor of Alexander the Great, allowed himself to be humiliated by the seductive Phyllis as a lesson to the young ruler.

Jean Fouquet
French, ca. 1425–ca. 1478
The Right Hand of God Protecting the Faithful against the Demons, ca. 1452–60
Tempera and gold leaf on parchment,
7⅝ × 5¾ in. (19.4 × 14.6 cm)
Robert Lehman Collection, 1975 (1975.1.2490)

This folio originates from one of the most cele-brated illuminated manuscripts of the fifteenth century: the *Book of Hours* of Étienne Chevalier, treasurer of France from 1452 to 1474. The full-page miniature portrays a congregation of the faithful gazing upward at the hand of God descending from heaven. Fouquet's rendering of medieval Paris is remarkable for its topographical accuracy. The recognizable sites include the cathe-dral of Notre-Dame, the spire of Sainte-Chapelle, the Pont Saint-Michel, and other monuments of the Île de la Cité, such as the Hôtel de Nesle in the foreground. Inscribed at the bottom of the folio are the opening words of the evening prayer for the Hours of the Holy Spirit.

Osservanza Master
Italian, active second quarter
of the 15th century
Saint Anthony the Abbot in the Wilderness, ca. 1435
Tempera and gold on wood,
18½ × 13¼ in. (47 × 33.7 cm)
Robert Lehman Collection, 1975 (1975.1.27)

The Osservanza Master, a pupil of the Sienese artist Sassetta, is best known for a series of eight scenes depicting the life of Saint Anthony the Abbot. In this panel, the artist's penchant for highly descriptive naturalistic details is evident in the barren landscape that evokes the mountainous region near the Red Sea where the hermit saint settled in the final decades of his life. In the foreground, Saint Anthony recoils from a pile of gold (scraped away during the painting's early history), resisting the seduction of worldly goods.

Giovanni di Paolo

Italian, 1398–1482

The Creation of the World and the Expulsion from Paradise, 1445

Tempera and gold on wood, 18¼ × 20½ in. (46.4 × 52.1 cm)
Robert Lehman Collection, 1975 (1975.1.31)

This painting illustrates two episodes from the story of the Creation. Together with the panel *Paradise* in the Museum's collection, it formed part of the predella of an altarpiece for the Guelfi Chapel in the basilica of San Domenico, Siena. Borne by seraphim (a host of angels), God the Father points to the newly created heavens and earth: mountains and rivers encircled by the four elements and the zodiac. Adam and Eve are expelled from Paradise, lush with fruit trees, lilies, roses, and carnations. The accompanying angel's unusual naked human form may symbolize his compassion for the corrupted state of humankind after the fall from grace.

Petrus Christus

Netherlandish, active 1444–75/76

A Goldsmith in His Shop, Possibly Saint Eligius, 1449

Oil on oak panel, 38⅝ × 33½ in. (98 × 85.2 cm)

Robert Lehman Collection, 1975 (1975.1.110)

This celebrated work was signed and dated by Petrus Christus, the preeminent painter in Bruges in the generation after Jan van Eyck. Possibly commissioned by the goldsmiths' guild of Bruges, it may represent a vocational painting (with the finely wrought trade wares advertising the guild's services) or a genre scene. The seated figure, weighing the wedding ring of the sumptuously dressed couple, is more likely a portrait of an eminent contemporary goldsmith than a representation of Saint Eligius, the patron saint of goldsmiths. The convex mirror, an illusionistic device that extends the pictorial space beyond the shop to the street outside, reflects the figures of two male passersby.

Botticelli (Alessandro di Mariano Filipepi)

Italian, 1444/45–1510

The Annunciation, ca. 1485

Tempera and gold on wood,
7½ × 12⅜ in. (19.1 × 31.4 cm)
Robert Lehman Collection, 1975 (1975.1.74)

Botticelli's jewel-like *Annunciation* is set in an architectural interior composed using one-point perspective to give the illusion of deeply recessed space. In the center, a row of square columns divides the monumental space occupied by the messenger Gabriel from the intimate bedchamber of the Virgin. A drapery panel is drawn back, revealing the Virgin in a pose of humility. Although the identity of its patron is unknown, this small painting was almost certainly commissioned as a private devotional image, not as part of a larger work.

Antonio Pollaiuolo

Italian, ca. 1432–1498

Study for an Equestrian Monument,

ca. 1482–83

Pen and brown ink, light and dark brown wash;
outlines of the horse and rider pricked for transfer,
11¹/₁₆ × 10 in. (28.1 × 25.4 cm)
Robert Lehman Collection, 1975 (1975.1.410)

Pollaiuolo, a Florentine sculptor, painter, engraver, and goldsmith, probably prepared this highly finished drawing for Duke Ludovico Sforza of Milan as a model for an unrealized bronze statue of his father, Francesco Sforza. This drawing was owned by the sixteenth-century historian and painter Giorgio Vasari, who described it in his *Lives of the Artists* (1568), and he probably added the dark brown wash around the figures.

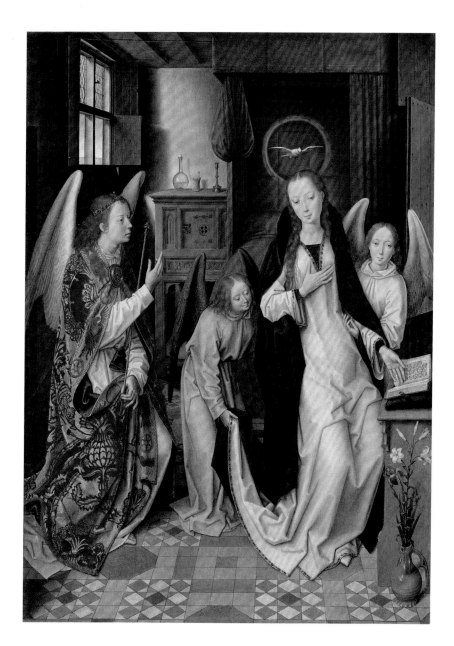

Hans Memling

Netherlandish, active 1465–94

The Annunciation, 1480–89

Oil on wood, transferred to canvas,
30⅛ × 21½ in. (76.5 × 54.6 cm)

Robert Lehman Collection, 1975 (1975.1.113)

Memling modeled this *Annunciation* on the left
wing of Rogier van der Weyden's *Saint Columba
Altarpiece*, now in Munich, but his innovative
rendition replaced the kneeling Virgin with a
swooning Virgin supported by two angels. Like

other fifteenth-century Flemish painters, Mem-
ling cloaked religious imagery in the pictorial
language of everyday life. The lilies symbolize
the Virgin's purity, and the empty candleholder
signifies her imminent role as bearer of Christ,
light of the world. Gabriel's priestly garb alludes
to the ritual of the Mass and, therefore, the
Incarnation of Christ. The Dove of the Holy
Spirit signals that the Incarnation has taken
place in fulfillment of the scriptures, to which
the Virgin gestures with her left hand.

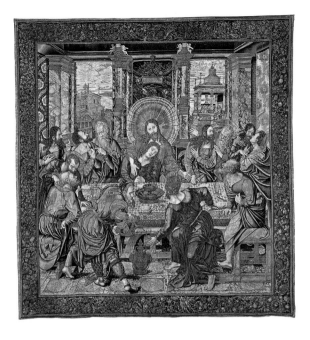

Workshop of
Giovanni Maria Vasaro
Italian, active early 16th century
**Bowl with the Arms of Pope Julius II
and the Manzoli of Bologna,** 1508
Maiolica, H. 4¼ in. (10.9 cm), DIAM. 12¾ in. (32.5 cm)
Robert Lehman Collection, 1975 (1975.1.1015)

Regarded as one of the most beautiful pieces
of maiolica (a refined tin-glazed pottery) ever
made, this bowl is splendidly decorated with
symbols of papal authority, such as keys and
the tiara, and personal references to Pope
Julius II della Rovere and his family, such as
the oak tree. Julius probably commissioned
the bowl for his supporter, the Bolognese
envoy Melchiorre di Giorgio Manzoli—whose
coat of arms appears at the lower edge—to
commemorate the reestablishment of papal
rule in Bologna in 1506. Giovanni Maria Vasaro,
whose name is inscribed on the back, may have
been the painter or the owner of the workshop
in Castel Durante that produced the bowl.

Designed by
Bernaert van Orley
Flemish, ca. 1488–1541
Probably woven by
Pieter de Pannemaker
Flemish, active 1517–35
The Last Supper, ca. 1520–30
Wool, silk, and silver-gilt thread,
10 ft. 11⅞ in. × 11 ft. 5⅞ in. (3.35 × 3.5 m)
Robert Lehman Collection, 1975 (1975.1.1915)

This splendid *Last Supper* is part of a series
of four tapestries illustrating the Passion of
Christ. They were designed by Bernaert van
Orley, a leading artist in sixteenth-century
Brussels. The work exemplifies Van Orley's
integration of Northern traditions and Italian
models to develop a new tapestry style. He
combined the expressive emotion and pen-
chant for detail found in Albrecht Dürer's *Last
Supper* woodcut, which inspired the tapestry's
compositional arrangement, with Raphael's
monumental figures and spatial construction.
Raphael's cartoons for the tapestry series *Acts
of the Apostles*, commissioned for the Sistine
Chapel and sent to Brussels to be woven, were
significant models for Van Orley.

Rembrandt (Rembrandt van Rijn)
Dutch, 1606–1669
The Last Supper, after Leonardo da Vinci, 1634–35
Red chalk, 14¼ × 18¾ in. (36.2 × 47.5 cm)
Robert Lehman Collection, 1975 (1975.1.794)

This unusually large red-chalk drawing, executed by Rembrandt at the age of twenty-eight, is closely based on an early print after Leonardo da Vinci's fresco *The Last Supper* in Santa Maria delle Grazie, Milan. Far from slavishly replicating his model, Rembrandt explored its expressive and dramatic possibilities by recasting all the figures, intensifying their reactions to Christ's words, and condensing the space they occupy. The Lehman sheet is one of three drawings by Rembrandt based on Leonardo's *Last Supper*, a work that profoundly captured his imagination.

El Greco (Domenikos Theotokopoulos)
Greek, active Italy and Spain, 1540/41–1614
Saint Jerome as a Scholar, ca. 1610
Oil on canvas, 42½ × 35 in. (108 × 89 cm)
Robert Lehman Collection, 1975 (1975.1.146)

El Greco executed at least five paintings of Saint Jerome. In this version, from the last years of the painter's life, the saint, clad in the red robes of a cardinal, is seated before an open book, acknowledging his role in translating the Bible from Greek into Latin. His gaunt, sunken features and long white beard refer to his more familiar guise as a penitent. The painting is notable for the novel way in which the artist synthesized the two roles of Saint Jerome—the scholar and the ascetic.

Jean-Auguste-Dominique Ingres
French, 1780–1867
Éléonore-Marie-Pauline de Galard de Brassac de Béarn (1825–1860), Princesse de Broglie, 1851–53
Oil on canvas, 47¾ × 35¾ in. (121.3 × 90.8 cm)
Robert Lehman Collection, 1975 (1975.1.186)

Although Ingres may have been a reluctant portraitist, his ravishing pictures of distinguished aristocrats are among the finest of their kind. The Princesse de Broglie was renowned for her beauty and reserve, attributes captured by the artist. Ingres brilliantly transcribed the material quality of the rich satin and lace of the sitter's gown, her sumptuous jewels, her embroidered scarf, and the silk damask upholstery.

Auguste Renoir
French, 1841–1919
Two Young Girls at the Piano, 1892
Oil on canvas, 44 × 34 in. (111.8 × 86.4 cm)
Robert Lehman Collection, 1975 (1975.1.201)

In late 1891 or early 1892, Renoir was invited by the French government to execute a painting for the Musée du Luxembourg, a new museum in Paris devoted to the work of living artists. Renoir chose this subject of two girls at a piano and, aware of the intense scrutiny to which his submission would be subjected, lavished extraordinary care on the project, developing and refining the composition in a series of five canvases.

André Derain
French, 1880–1954
The Palace of Westminster, 1906–7
Oil on canvas, 31 × 39 in.
(78.7 × 99.1 cm)
Robert Lehman Collection,
1975 (1975.1.168)

In 1905 and 1906, André Derain traveled to London at the suggestion of the art dealer Ambroise Vollard, for whom he executed a number of scenes of the city, including this painting. As Derain later recalled, these canvases were inspired by Claude Monet's views of London painted only a few years earlier, which had "made a very strong impression on Paris." Derain's long, broken brushstrokes and bright, bold colors reflect the influence of the Neo-Impressionists Paul Signac and Henri-Edmond Cross, as well as that of Matisse, with whom Derain spent the summer of 1905 in the south of France.

Henri Matisse
French, 1869–1954
Olive Trees at Collioure, 1906
Oil on canvas, 17½ × 21¾ in. (44.5 × 55.2 cm)
Robert Lehman Collection, 1975 (1975.1.194)

The sun-drenched landscape of Collioure, a scenic town on the Mediterranean coast, was a great source of inspiration for Matisse and other artists of his era. Encouraged by Paul Signac, who also painted in the south of France at this time, Matisse adopted the vibrant, inventive colors preferred by the Fauves. Acquired by Gertrude and Leo Stein shortly after it was completed, this painting is an important work of Matisse's brief Fauve period.

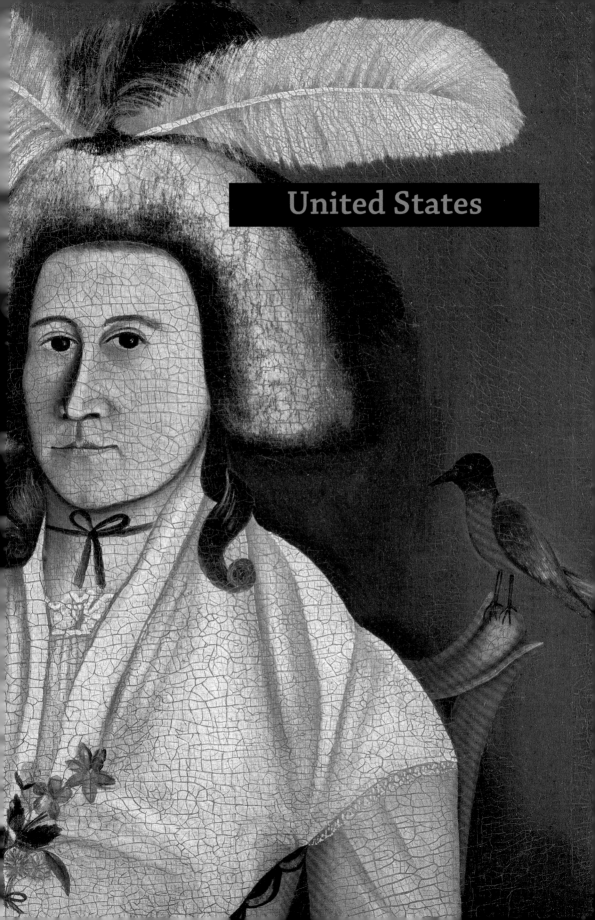

United States

The American Wing

The American Wing is the Museum's principal display of American art made before 1920. Here the emphasis is on artworks and objects from the seventeenth- and eighteenth-century colonial settlements on the East Coast of North America and in the United States as it expanded across the continent, up to the early twentieth century. Among the Museum's early trustees were painters and sculptors who encouraged the acquisition of works by American artists of the time—hence the particularly rich holdings of landscape paintings by the Hudson River School and of marbles and bronzes by sculptors such as Daniel Chester French, Frederic Remington, and Augustus Saint-Gaudens. Later trustees included collectors of the arts of the colonial period, who focused on acquiring historic interiors together with the appropriate decorative furnishings. Beginning in the 1970s, the curatorial staff has expanded its reach into all aspects of the arts of the later nineteenth and early twentieth centuries. In addition, the collection boasts two of the most famous American paintings in the world—Emanuel Leutze's *Washington Crossing the Delaware* and John Singer Sargent's *Madame X (Madame Pierre Gautreau)*—alongside iconic works by John Singleton Copley, Gilbert Stuart, Winslow Homer, Thomas Eakins, James McNeill Whistler, and American Impressionists such as Mary Cassatt and Childe Hassam. The decorative arts holdings, meanwhile, include works by such renowned silversmiths as Myer Myers and Thomas Fletcher, and cabinets like the remarkable nineteenth-century wardrobe by the Herter Brothers of New York.

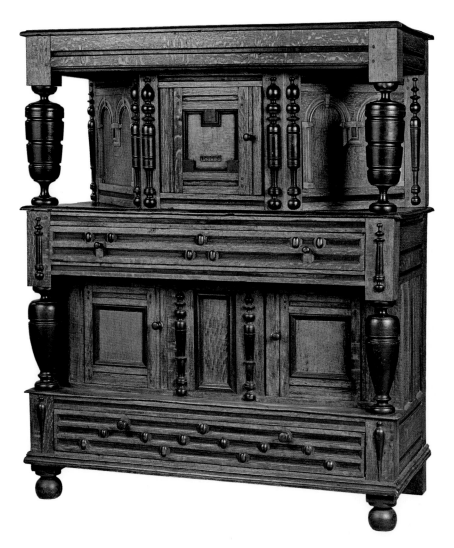

Cupboard

Northern Essex County, Massachusetts, 1680–85
Oak, maple, tulip poplar, with oak and pine,
58¼ × 49½ × 20¾ in. (148 × 125.7 × 52.7 cm)
Purchase, Rogers Fund; Sage Fund, by exchange;
Sansbury-Mills Fund; Anthony W. and Lulu C. Wang
Gift in honor of Morrison H. Heckscher; and Friends
of the American Wing Fund, 2010 (2010.467a–p)

Large oak cupboards used for the storage of
textiles, silver, and other highly valued objects
were the most elaborate pieces of furniture
in seventeenth-century New England homes.
Their scale and ornamental richness made them
showpieces that bespoke the prosperity and
status of their owners. This superlative example
was produced by an unidentified shop noted for
its highly complex and varied joined-oak chests
and cupboards. It features ebonized maple
turnings that freely interpret classical forms
and channel-molded drawer fronts with applied
bosses arranged in rhythmic linear patterns
across their length.

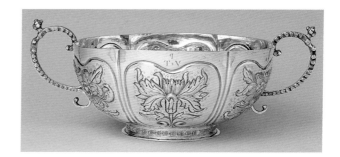

Cornelius Kierstede
American, 1674–ca. 1757
Two-Handled Bowl, 1700–1710
Silver, 5⅜ × 13⅞ in. (13.7 × 35.1 cm)
Samuel D. Lee Fund, 1938 (38.63)

The two-handled bowl chased into six equal panels is a form peculiar to early New York silver. *Brandewijnskom*, or brandywine bowls, were used ceremonially at weddings, funerals, and particularly at the *kindermaal*, where neighborhood women gathered to welcome a newborn child.

Filled with raisins and brandy, the bowl circulated among the guests, who served themselves with a silver spoon. Initials engraved near the rim of this bowl are those of Theunis Jacobsen Quick, a wealthy baker, and his wife, Vroujte, who were married in 1689.

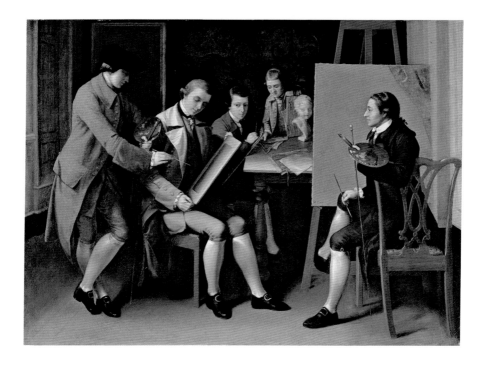

Matthew Pratt
American, 1734–1805
The American School, 1765
Oil on canvas, 36 × 50¼ in. (91.4 × 127.6 cm)
Gift of Samuel P. Avery, 1897 (97.29.3)

When Pratt went to London in 1764, he was welcomed by his slightly younger compatriot Benjamin West, who was already on his way to a highly successful career. Pratt's painting is a

unique portrayal of West teaching his young American students in an informal composition that explores the European academic tradition as carried out among Americans in late eighteenth-century London. The painting was exhibited in 1766 under the title *The American School*. West is the man standing on the far left, giving instruction in drawing. Pratt is the man at the easel, portrayed as an accomplished portrait painter.

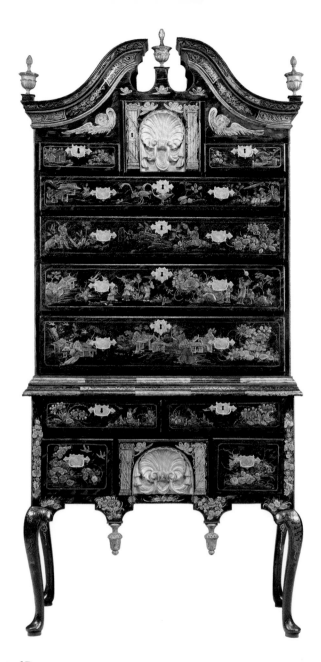

High Chest of Drawers

Boston, Massachusetts, 1730–60
Maple, birch, white pine, paint, gilded gesso
86½ × 40 × 21½ in. (219.7 × 101.6 × 54.6 cm)
Purchase, Joseph Pulitzer Bequest, 1940 (40.37.1)

The scroll-top chest on stand, or high chest of drawers—combining the English flat-top chest on stand with a broken pediment—was the most ambitious, and most distinctively American, form of colonial furniture. In Boston, where the form was introduced about 1730, the most costly of the early examples were japanned, or painted in imitation of Asian lacquer. This example, which is unique for having survived with its matching dressing table and looking glass, is painted with an allover tortoiseshell-like background, upon which chinoiserie motifs—fantastic figures and garden buildings—are picked out in gold. It was made for Benjamin Pickman, a merchant of Salem, Massachusetts, and is the epitome of colonial New England cosmopolitan elegance.

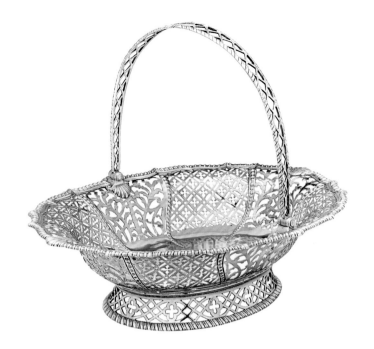

Myer Myers
American, 1723–1795
Basket, 1770–76
Silver, 11⅛ × 14½ × 11⅜ in.
(28.4 × 36.7 × 28.9 cm)
Morris K. Jesup Fund, 1954 (54.167)

This extremely rare American table basket was made for the wealthy West Indies merchant Samuel Cornell and his wife, Susannah, residents of New York City and New Bern, North Carolina. Following his appointment to the North Carolina Provincial Council, Cornell commissioned several outstanding objects from the prominent New York silversmith Myer Myers. According to the inscription on the basket's underside, the Cornells later gave it to their daughter Hannah, who married Herman LeRoy on October 19, 1786. With its lacy pierced panels, gadrooned borders, and hinged openwork handle, this basket emulates high-style London silver.

American Flint Glass Manufactory
American, 1764–74
Founded by
Henry William Stiegel
American, 1729–1785
Pocket Bottle, 1769–74
Blown pattern-molded glass, H. 4¾ in. (12.1 cm)
Gift of Frederick W. Hunter, 1914 (14.74.17)

Henry William Stiegel was an American entrepreneur who challenged the dominance of European imports when he founded his American Flint Glass Manufactory in Manheim, Pennsylvania. His immigrant craftsmen produced the first fine tablewares made in America. In addition to colorless glass, the factory produced glass in the rich jewel-like colors of cobalt blue and amethyst. The daisy within a diamond on this pocket flask was probably a copy of a popular design in cut glass.

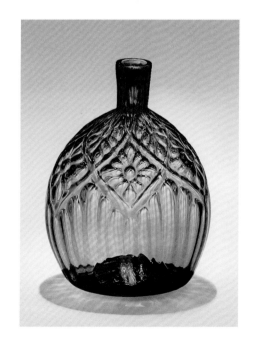

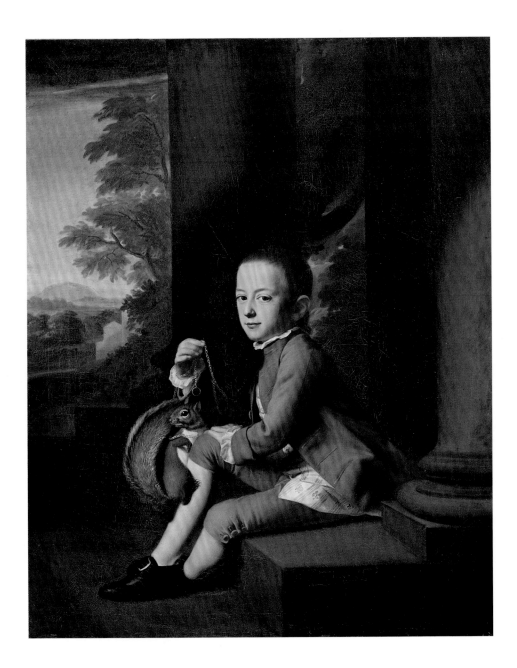

John Singleton Copley

American, 1738–1815

Daniel Crommelin Verplanck, 1771

Oil on canvas, 49½ × 40 in. (125.7 × 101.6 cm)

Gift of Bayard Verplanck, 1949 (49.12)

Daniel Verplanck, scion of a distinguished New York City family, is shown here at the age of nine. In this picture Copley successfully used, as he had previously, the theme of a young aristocratic sitter amusing himself with a pet squirrel on a gold leash. While the squirrel clutches at his leg, the poised sitter keeps the viewer coolly in view. The painting is done in Copley's very best colonial style, remarkable for its keen perception and clarity.

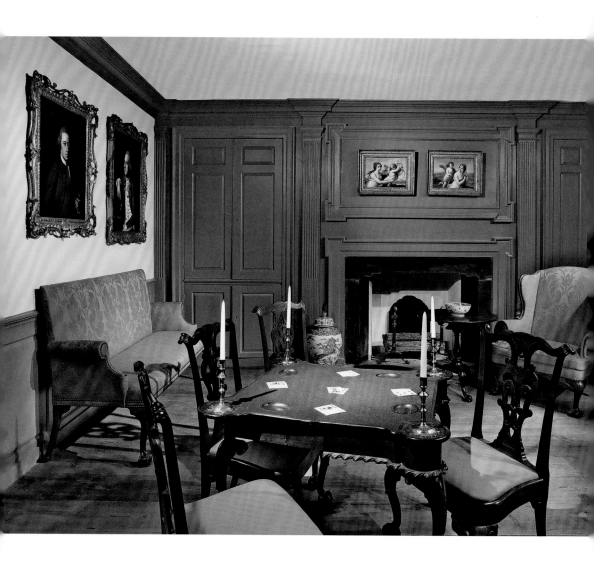

Verplanck Room from the Colden House

Coldenham, New York, ca. 1767
9 ft. 5 in. × 17 ft. 9 in. × 21 ft. (2.87 × 5.41 × 6.4 m)
Purchase, The Sylmaris Collection, Gift of George Coe
Graves, by exchange, 1940 (40.127)

This room, one of twenty historic interiors
in the American Wing, illustrates life in pre-
Revolutionary New York. Its paneled fireplace
wall and other architectural fittings are from a
country house sixty miles north of Manhattan,
built for Cadwallader Colden Jr. (son of the
lieutenant governor of New York) in 1767. It
is furnished with possessions that Samuel
Verplanck and his wife, Judith Crommelin
Verplanck, used, beginning in the 1760s, in their
New York City house on Wall Street. These,
the gifts of their descendants, include family
portraits by John Singleton Copley; a unique
matching set of New York–made chairs, settee,
and card table; and Chinese export porcelains.

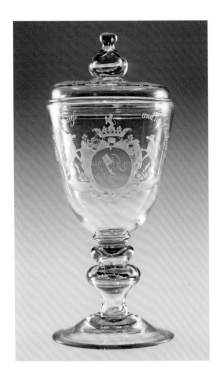

above

New Bremen Glass Manufactory
American, 1784–95
Founded by
John Frederick Amelung
American, active 1784–ca. 1791
Covered Goblet, 1788
Blown and engraved glass, H. 11¼ in. (28.6 cm)
Rogers Fund, 1928 (28.52a, b)

John Frederick Amelung emigrated from Germany to Frederick County, Maryland, where he established his successful glass factory in New Bremen. The form and engraving of this *pokal*, or covered goblet, attest to the German heritage of the factory's craftsmen. Its most dominant feature—the elaborate coat of arms of the city of Bremen, Germany, within a Baroque shield—is characteristic of the most complex engraving on Amelung glass, and indeed on any American glass of the period. That this goblet came to light in Germany illuminates the inscription, "Old Bremen Success and the New Progress." It is likely that Amelung presented it to his German investors as a triumphant toast to his successful American enterprise.

below

Ralph Earl
American, 1751–1801
Elijah Boardman, 1789
Oil on canvas, 83 × 51 in. (210.8 × 129.5 cm)
Bequest of Susan W. Tyler, 1979 (1979.395)

Earl depicted the fashionably dressed dry-goods merchant Elijah Boardman in his store in New Milford, Connecticut. In an unconventional portrayal that captures his entrepreneurial spirit, the rural shopkeeper stands at his felt-covered counting desk in his neatly appointed shop, the storeroom door left open to reveal bolts of expensive imported fabric that invite inspection. Boardman's business sense is informed by a world of knowledge, suggested by the books on the shelves of his desk. Add to that Earl's attention to Boardman's elegant attire and direct and charming gaze, and the portrait becomes an advertisement for both patron and painter.

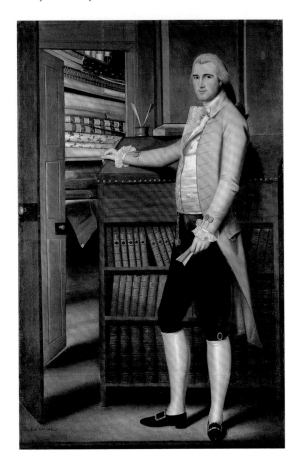

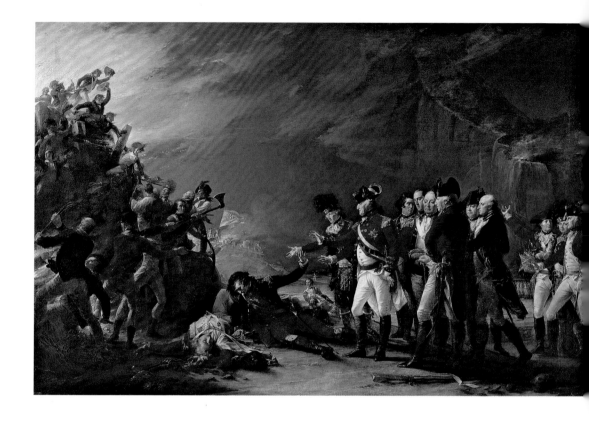

John Trumbull

American, 1756–1843

The Sortie Made by the Garrison of Gibraltar, 1789

Oil on canvas, 71 in. × 8 ft. 11 in. (1.8 × 2.72 m)

Purchase, Pauline V. Fullerton Bequest; Mr. and Mrs. James Walter Carter and Mr. and Mrs. Raymond J. Horowitz Gifts; Erving Wolf Foundation and Vain and Harry Fish Foundation Inc. Gifts; Gift of Hanson K. Corning, by exchange; and Maria DeWitt Jesup and Morris K. Jesup Funds, 1976 (1976.332)

Trumbull, like his fellow countrymen Benjamin West and John Singleton Copley, had an ambition to excel at history painting in the grand manner, to create paintings large in scale and heroic in import. Following West's advice, Trumbull depicted an important episode in the long siege of Gibraltar, when the Spaniards attempted to take the rock from the British. The artist portrayed a specific moment of British victory—when General George Eliott offers compassionate assistance to his dying foe, the young Don José de Barboza. Trumbull's ultimate purpose, however, was to represent the noble conduct of gentlemen, whatever the circumstances.

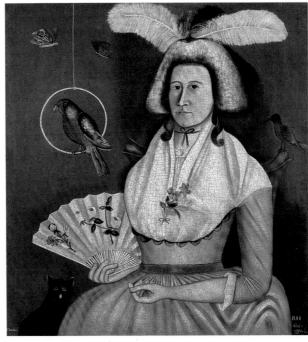

Rufus Hathaway
American, 1770–1822
**Lady with Her Pets
(Molly Wales Fobes),** 1790
Oil on canvas, 34⅛ × 32 in. (86.6 × 81.3 cm)
Gift of Edgar William and Bernice
Chrysler Garbisch, 1963 (63.201.1)

The subject of this portrait is probably
Molly Wales Fobes of Raynham, Mas-
sachusetts. The occasion for the richly
symbolic image was her engagement to
the Reverend Elijah Leonard, minister
of the Second Congregational Church
in nearby Marshfield, whom she married in
1792. Hathaway's earliest known work and one
of the finest examples of American folk art, the
portrait reflects provincial attempts to echo
European styles. The sitter's ostrich feathers and
hérisson-, or hedgehog-, style coiffure, mimic
contemporary French fashion and portraiture,
and the arrangement of her pets is emblematic
in design, all of which Hathaway could have
known through prints.

Possibly
Heinrich Roth
American, active ca. 1790–1810
Plate, 1793
Redware earthenware, with sgraffito
decoration, DIAM. 12¼ in. (31.1 cm)
Gift of Mrs. Robert W. de Forest, 1933 (34.100.124)

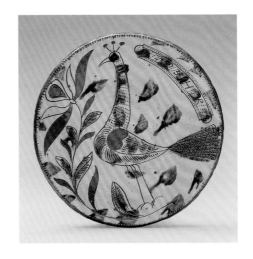

Pennsylvania German potters of the late
eighteenth and early nineteenth centuries,
utilizing the locally available red clay, produced
for a local market utilitarian earthenware
pieces as well as more elaborate wares. These
immigrant craftsmen brought skills and
decorative traditions from their homeland. This
plate from Northampton County exemplifies
the sgraffito technique employed by many
Pennsylvania Germans. The method involves
coating the hardened clay with white slip and
then scratching through the surface with a
sharp tool to reveal the red layer beneath. This
piece, like many of its kind, features a simplified
peacock and floral motif.

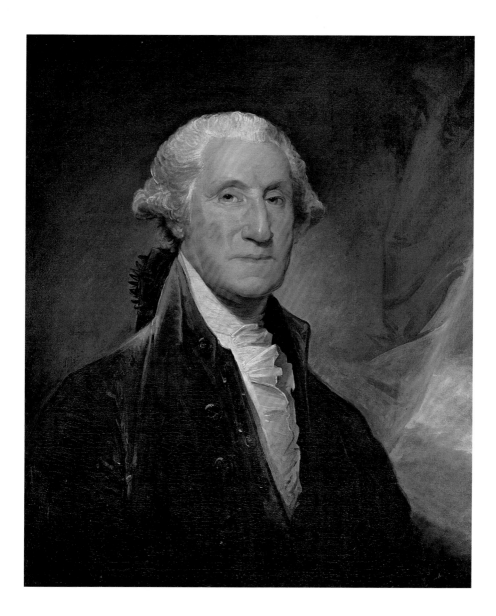

Gilbert Stuart

American, 1755–1828
George Washington, begun 1795
Oil on canvas, 30¼ × 25¼ in. (76.8 × 64.1 cm)
Rogers Fund, 1907 (07.160)

Stuart returned to America from London in March 1793 with the intention of painting a portrait of George Washington. This example is one of eighteen bust-length portraits of Washington facing toward the right, known as the Vaughan group. It contains evidence of Stuart's first life portrait of Washington—beneath the black paint is a reddish-brown coat with yellow buttons—suggesting that Stuart conceived this picture at the same time as he was painting the original Vaughan portrait. Stuart's portraits of Washington are at once lifelike and iconic. Here the artist expertly modeled the skin tones with blue-gray shadows so that Washington's face seems marblelike, producing a monumental image.

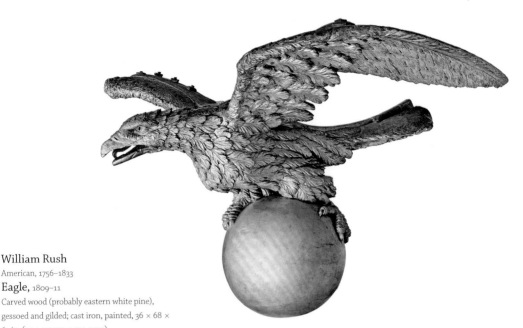

William Rush

American, 1756–1833

Eagle, 1809–11

Carved wood (probably eastern white pine),
gessoed and gilded; cast iron, painted, 36 × 68 ×
61 in. (91.4 × 172.7 × 154.9 cm)

Purchase, Sansbury-Mills Fund, and Anthony W. and Lulu
C. Wang, Mr. and Mrs. Robert G. Goelet, Annette de la
Renta, and Vira Hladun-Goldmann Gifts, 2002 (2002.21.1)

Rush is recognized today as one of America's
first portrait sculptors as well as a leading wood
carver and gilder in the vibrant artisan commu-
nity of early nineteenth-century Philadelphia.
This monumental gilded eagle hung over the
pulpit in Saint John's Evangelical Lutheran
Church in Philadelphia until 1847. It was then
installed in the Assembly Room of Indepen-
dence Hall, where it remained until 1914. In that
location, near the Liberty Bell and above Rush's
wood statue of George Washington, its symbol-
ism changed from attribute of the commission-
ing church's patron saint to icon of American
patriotism and independence.

Julia-ann Fitch

American, 1791–?

Sampler, 1807

Silk on linen, 18 × 15¾ in. (45.7 × 40 cm)

Purchase, William Cullen Bryant Fellows Gifts,
2010 (2010.466)

The central image of this family-record sampler
made by Julia-ann Fitch of Hatfield, Massa-
chusetts, features a seated young lady reading
a book, which surely comments on the much-
debated topic of the day: education for women.
Thirteen circles surround the center oval; most
contain the names and dates of Julia-ann's im-
mediate family members. She also demonstrated
her patriotism: one of the lower circles pays
homage to George Washington's life and recent
death in 1799, and another displays the birth
date of the new nation.

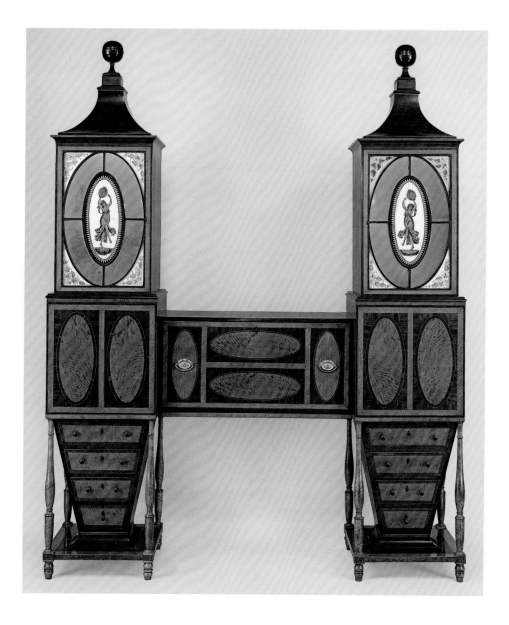

Desk and Bookcase

Baltimore, Maryland, ca. 1811
Mahogany, satinwood, maple, verre églomisé, with cedar,
91 × 72 × 19⅛ in. (231.1 × 182.9 × 48.6 cm)
Gift of Mrs. Russell Sage and various other donors,
by exchange, 1969 (69.203)

Unique among surviving American Federal fur-
niture, this H-shaped secretary desk and book-
case was directly inspired by the Sister's Cylinder
Bookcase, plate 38 in the English cabinetmaker
Thomas Sheraton's *Cabinet Directory* (1803), but

here the maker substituted a rectangular fall-
front desk between the two pedestals for Shera-
ton's retracting cylinder front. The painted and
gilded glass door panels depict dancing Grecian
maidens in antique dress. In combination with
the overall symmetry, geometric abstraction,
and use of contrasting satinwood and mahogany
veneers, they make this secretary among the
most brilliant adaptations of the Neoclassical
style in American furniture.

Thomas Fletcher
American, 1787–1866, and
Sidney Gardiner
American, 1787–1827
Presentation Vase, 1824
Silver, 23⅜ × 20⅛ × 15⅛ in. (59.5 × 51.1 × 38.4 cm)
Purchase, Louis V. Bell and Rogers Funds; Anonymous and
Robert G. Goelet Gifts; and Gifts of Fenton L. B. Brown
and of the grandchildren of Mrs. Ranson Spaford Hooker,
in her memory, by exchange, 1982 (1982.4a, b)

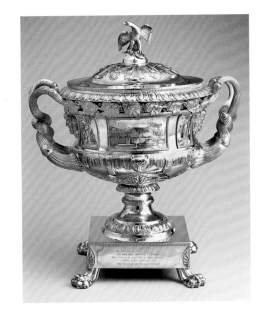

A group of New York merchants commissioned
a pair of monumental vases to be presented in
1825 to Governor DeWitt Clinton, in gratitude
for his promoting construction of the Erie
Canal. Fletcher and Gardiner, of Philadelphia,
modeled the vases' bodies and handles on the
famous Roman urn known as the Warwick Vase,
which was excavated in 1770 near Hadrian's
villa at Tivoli. Allegorical figures and scenes
along the canal route decorate each vase. Here
Mercury (commerce) and Ceres (agriculture)
flank the canal's guard lock and basin in Albany;
on the reverse, Hercules (strength) and Minerva
(wisdom) are depicted with the aqueduct in
Rochester and the falls of the Genesee River.

Charles-Honoré Lannuier
French, 1779–1819
Card Table, 1817
Mahogany veneer, white pine, yellow poplar,
gilt gesso, *vert antique*, gilt brass,
31⅛ × 36 × 17¾ in. (79.1 × 91.4 × 45.1 cm)
Gift of Justine VR. Milliken, 1995 (1995.377.1)

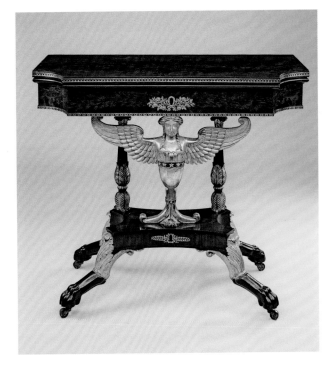

This superlative card table is one of a pair from
a signature series of gilded sculptural pieces
by New York's resident French *ébéniste* of the
Federal period, Charles-Honoré Lannuier,
who worked in the city from 1803 until 1819.
Remarkable not only for their exquisite beauty
but also for their provenance, these signed and
dated masterpieces descended in the family of
the original owner, Stephen Van Rensselaer IV
of Albany. A surviving invoice for tables identi-
cal to these reveals that the pair was priced
at 250 dollars, an astonishing sum when a
journeyman cabinetmaker's wage was roughly
a dollar a day.

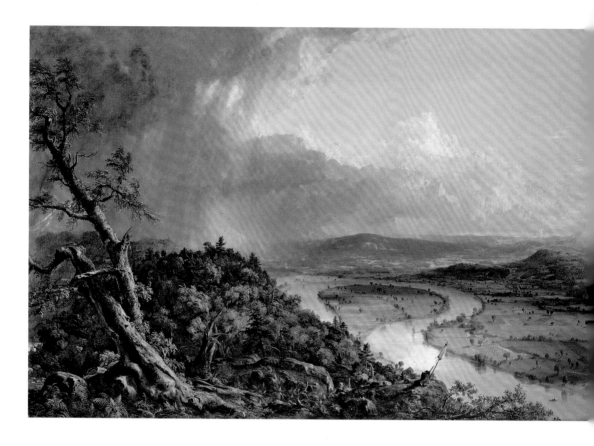

Thomas Cole
American, 1801–1848
View from Mount Holyoke, Northampton, Massachusetts, After a Thunderstorm— The Oxbow, 1836
Oil on canvas, 51½ × 76 in. (130.8 × 193 cm)
Gift of Mrs. Russell Sage, 1908 (08.228)

Cole was fascinated by the curious winding of the Connecticut River below Mount Holyoke and made the so-called Oxbow the subject of this large, dramatic painting. He imbued the scene with the eerie glow that follows a thunderstorm. The mountain wilderness is still shadowed with lingering dark clouds, but the curving river and fields beyond shimmer with brightness. The artist juxtaposed untamed wilderness and pastoral settlement to emphasize the possibilities inherent in the nation's landscape, and he transfigured the actual locale through his artistic vision and imagination. Cole himself, with his easel and umbrella, can be seen in the foreground.

George Caleb Bingham

American, 1811–1879

Fur Traders Descending the Missouri, 1845

Oil on canvas, 29 × 36½ in. (73.7 × 92.7 cm)

Morris K. Jesup Fund, 1933 (33.61)

Bingham grew up in Missouri and knew first-hand about life on the great river that rises near the Canadian border and joins the Mississippi in Saint Louis. The transit from the northern wilderness was made in a gliding dugout, here guided by an old French trader and guarded with a flat rifle by his resting son (a child of Indian and European-American parents) as they head downstream to market their pelts. Mist and silence, impenetrable and bewitched, mark the scene. In fact, Bingham portrayed a form of trading long since outmoded by the mid-nineteenth century, but the painting captivated Easterners who saw it exhibited in New York.

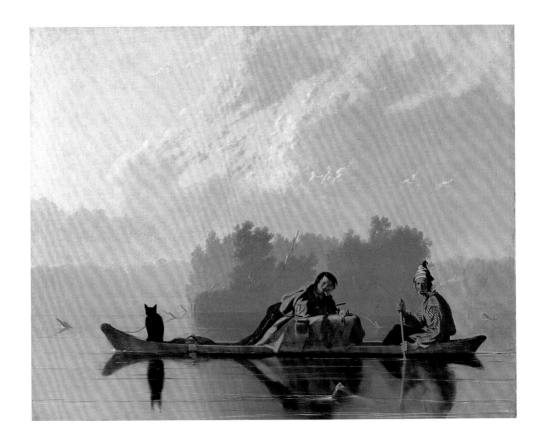

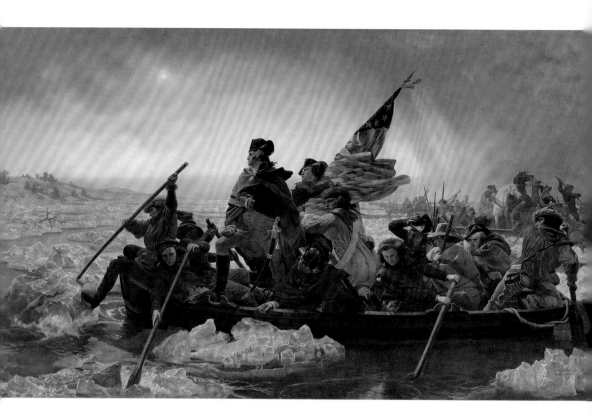

Emanuel Leutze
American, 1816–1868
Washington Crossing the Delaware, 1851
Oil on canvas, 12 ft. 5 in. × 21 ft. 3 in. (3.79 × 6.48 m)
Gift of John Stewart Kennedy, 1897 (97.34)

The attack by Washington and twenty-five
hundred men on the Hessians at Trenton, New
Jersey, on December 25, 1776, was a turning
point in the Revolutionary War. Leutze's
depiction of the event was a great success in
America and in Germany, where he painted
it. The work's popularity lay chiefly in the
artist's choice of subject, which appealed to the
nationalism flourishing at midcentury, and the
monumental scale added to its effectiveness.
Despite some historical inaccuracies, the
painting remains an object of veneration and
is one of the most famous and extensively
published images in American art.

opposite
John H. Belter
American, 1804–1863
Sofa, 1850–60
Rosewood, 53¼ × 66 × 25 in. (135.3 × 167.6 × 63.5 cm)
Purchase, Friends of the American Wing Fund
and Lila Acheson Wallace Gift, 1999 (1999.396)

John Belter has long been recognized as one
of the most important makers of high-style
furnishings in the Rococo Revival style for the
luxury market in nineteenth-century America.
He garnered an international reputation
for the suites of drawing-room furniture he
manufactured, many out of laminated and
richly carved rosewood. He was a prolific
cabinetmaker, and a large body of furniture
is ascribed to his New York shop. Belter's
exuberant drawing-room sofas, which are
embellished with bouquets of naturalistic
blooms, epitomize the very best of his oeuvre.

Hiram Powers
American, 1805–1873
Andrew Jackson, 1834–35, carved 1839
Marble, 34¾ × 23½ × 15½ in.
(88.3 × 59.7 × 39.4 cm)
Gift of Mrs. Frances V. Nash, 1894 (94.14)

Powers first demonstrated his talent as a
sculptor through likenesses of important
American political figures, and this portrait of
President Andrew Jackson launched the artist's
career, most of it spent in Italy. In 1834 Powers
went to Washington, D.C., where Jackson
sat for him at the White House. The portrait
realistically depicts the sixty-seven-year-old
president, with his long, lean face deeply marked
with wrinkles, his mouth and cheeks sunken
from lack of teeth, and his creased forehead set
off by a shock of thick, brushed-back hair. This
bust was carved in marble after Powers settled
in Florence permanently in 1837.

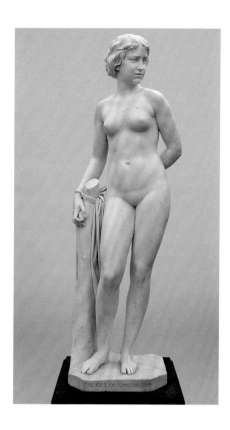

Erastus Dow Palmer
American, 1817–1904
The White Captive, 1857–58, carved 1858–59
Marble, 65 × 20¼ × 17 in. (165.1 × 51.4 × 43.2 cm)
Bequest of Hamilton Fish, 1894 (94.9.3)

The Neoclassical style dominated American sculpture during the mid-nineteenth century, and works in white marble were especially popular because of the medium's strong classical associations. Although the Neoclassical spirit is evident in this graceful lifesize nude, the figure itself was probably inspired by tales of border skirmishes between Indians and white pioneers. Palmer portrayed a young woman abducted from her sleep and held captive, her hands bound and her body stripped of her nightgown, which hangs from a tree trunk. An upstate New Yorker, Palmer was self-taught and, unlike most of his contemporaries, did not go abroad to study.

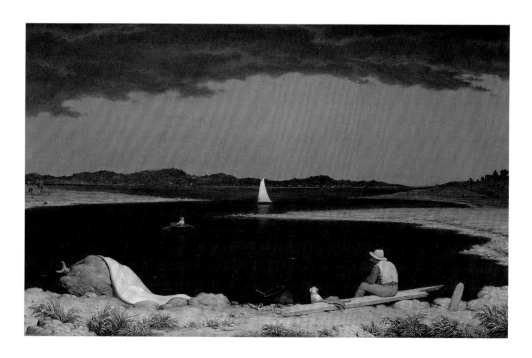

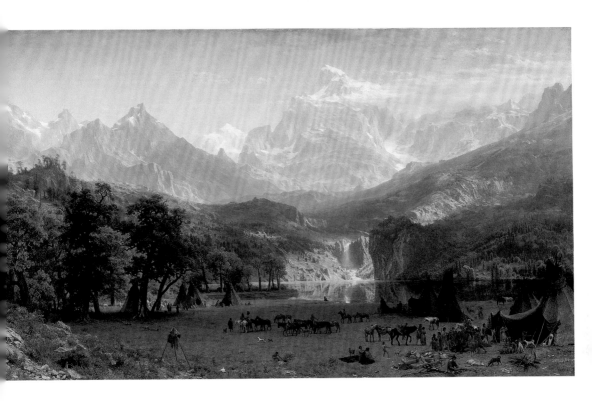

opposite
Martin Johnson Heade
American, 1819–1904
Approaching Thunder Storm, 1859
Oil on canvas, 28 × 44 in. (71.1 × 111.8 cm)
Gift of Erving Wolf Foundation and
Mr. and Mrs. Erving Wolf, in memory
of Diane R. Wolf, 1975 (1975.160)

This painting is one of the earliest of a small
series of coastal-storm subjects that are among
Heade's most ambitious and original works. Of
those, this is the only one known to have been
based on the observation of a meteorological
event in a particular place: Narragansett Bay,
Rhode Island, looking toward Rocky Neck
from Prudence Island. Ignoring conventional,
tempestuous portrayals of storms, Heade vividly
transcribed, in the words of a critic of his day,
the "ominous hush," the storm's tense preamble
of blackening sky and eerily illumined terrain.

Albert Bierstadt
American, 1830–1902
The Rocky Mountains, Lander's Peak, 1863
Oil on canvas, 73½ in. × 10 ft. ¾ in. (1.87 × 3.07 m)
Rogers Fund, 1907 (07.123)

The German-born Bierstadt secured his lasting
identity as the painter of the American West
with images of the Rocky Mountains. Based on
an expedition the artist made to present-day
Wyoming and Utah with Colonel Frederic W.
Lander in 1859, this painting advertised to
Americans a distinctly national frontier and
fueled the idea of Manifest Destiny, the prevalent
belief that Americans were divinely ordained
masters of the continent. The composition is
arranged symmetrically and set out in bold,
simple light contrasts. The foreground depicts a
Shoshone Indian encampment. Exhibited to the
public with great acclaim, Bierstadt's monumental
painting made him a rival of the then-preeminent
American landscape painter Frederic Church.

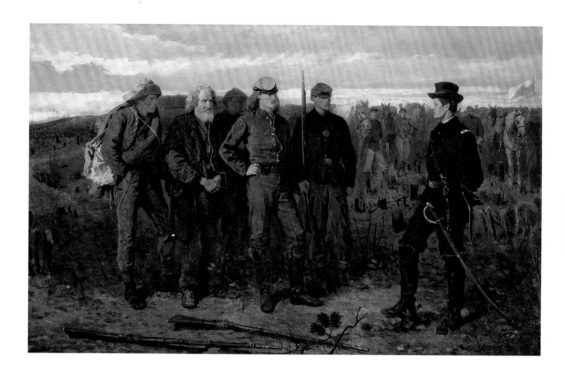

Winslow Homer

American, 1836–1910

Prisoners from the Front, 1866

Oil on canvas, 24 × 38 in. (61 × 96.5 cm)

Gift of Mrs. Frank B. Porter, 1922 (22.207)

As an artist-correspondent for *Harper's Weekly*, Homer had twice visited the Union front during the Civil War. This canvas, painted after the war ended, refers to Brigadier General Francis Channing Barlow's capture of Confederate soldiers and officers in the Battle of Spotsylvania (Virginia) in May 1864. It typifies participants on both sides and symbolizes the ideological rift between the North and South by physical distance and contrasting postures. The painting established Homer's reputation at New York's National Academy of Design and was exhibited to critical acclaim at the 1867 Exposition Universelle in Paris.

Frederic Edwin Church

American, 1826–1900

Heart of the Andes, 1859

Oil on canvas, 66⅛ in. × 9 ft. 11¼ in. (1.68 × 3.03 m)

Bequest of Margaret E. Dows, 1909 (09.95)

Church won early fame with minutely detailed compositions of eastern North American scenery. Inspired by the German naturalist Alexander von Humboldt, the artist made expeditions to South America in 1853 and 1857. *Heart of the Andes* was synthesized from scores of pencil and oil sketches that Church made in Ecuador and represents the climatic range—from tropical to temperate to frigid—that Humboldt had observed in the equatorial Andes. Church originally displayed the painting in a massive frame resembling a window and advised the public that jammed its exhibition hall to view it through opera glasses, the better to appreciate both its wondrous botanical detail and its continental sweep.

John Quincy Adams Ward
American, 1830–1910

The Freedman, 1863, cast 1891

Bronze, 19½ × 14¾ × 9¾ in. (49.5 × 37.5 × 24.8 cm)
Gift of Charles Anthony Lamb and Barea Lamb Seeley,
in memory of their grandfather, Charles Rollinson Lamb,
1979 (1979.394)

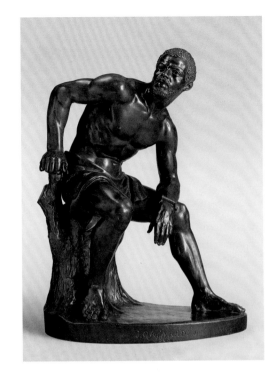

Ward modeled his statuette of a seated African American in the aftermath of Abraham Lincoln's preliminary Emancipation Proclamation, issued on September 22, 1862. Declaring Ward's abolitionist views, this sculpture offers a poignant commentary on the chief political and moral topic of the era. Broken manacles of servitude appear on the former slave's left wrist and in his right hand. Ward, a leading realist sculptor of the nineteenth century, accurately depicted the anatomy and physiognomy of his muscular protagonist. He may have found inspiration for this figure in a resident of his hometown of Urbana, Ohio, or on his travels to the South in 1858.

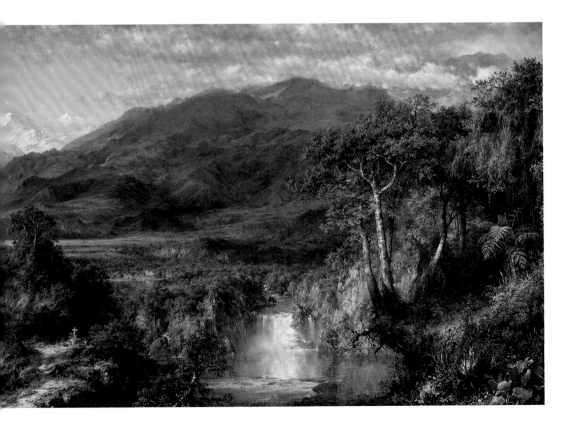

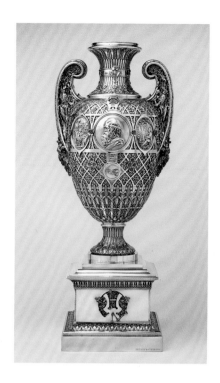

John La Farge
American, 1831–1910
Peonies Blown in the Wind, ca. 1880
Leaded opalescent glass, 75 × 45 in. (190.5 × 114.3 cm)
Gift of Susan Dwight Bliss, 1930 (30.50)

John La Farge, with Louis Comfort Tiffany,
revolutionized the look of American stained
glass. One of his earliest windows, *Peonies Blown
in the Wind* derives from a Chinese handscroll
of peony blossoms. Between 1879 and 1909
La Farge executed at least seven windows
based on the same theme, of which this is the
earliest. The window features innovative and
unusual glass—jewels, cabochons, molded
and pressed glass, and rippled opalescent glass.
The varied textures and bold colors impart a
highly decorative, exotic flavor. Made in New
York, the window was installed in the Newport,
Rhode Island, mansion of Henry G. Marquand.

above
Designed by
James Horton Whitehouse
American, 1833–1902
Made by
Tiffany & Co.
American, 1837–present
The Bryant Vase, 1875–76
Silver, 33½ × 14 × 11¼ in. (85.1 × 35.6 × 28.7 cm)
Gift of William Cullen Bryant, 1877 (77.9a, b)

To honor the poet and newspaper editor
William Cullen Bryant on his eightieth
birthday, several of his friends commissioned
"a commemorative Vase of original design and
choice workmanship" that would "embody . . .
the lessons of [his] literary and civic career."
Its design, which combines Renaissance
Revival sensibilities with those of the Aesthetic
Movement, consists of a Greek vase form
ornamented with symbolic imagery and motifs
that allude to Bryant's life and work. Made by
Tiffany & Co. in New York City and completed
in 1876, the vase was donated the following
year to the Metropolitan, making it the first
piece of American silver to enter the Museum's
collection.

Herter Brothers
American, 1864–1906
Wardrobe, 1880–85
Cherry, 78½ × 49½ × 26 in. (199.4 × 125.7 × 66 cm)
Gift of Kenneth O. Smith, 1969 (69.140)

The New York firm of German émigré brothers Gustave and Christian Herter produced luxury furniture and integrated interior designs for clients of America's Gilded Age. They worked in a variety of modes, including the British design reform and Anglo-Japanese styles seen here, popularized by British architect E. W. Godwin. This wardrobe's ebonized surface and golden marquetry of stylized chrysanthemum blossoms and leaves recall Japanese lacquerwork; the rich black void beneath the falling blossoms further suggests Asian principles of decoration.

Thomas Eakins
American, 1844–1916
The Champion Single Sculls
(Max Schmitt in a Single Scull), 1871
Oil on canvas, 32¼ × 46¼ in. (81.9 × 117.5 cm)
Purchase, The Alfred N. Punnett Endowment Fund
and George D. Pratt Gift, 1934 (34.92)

In 1870, having returned to Philadelphia from
his studies in Europe, Eakins began a series of
sculling pictures. This is the first major work
in the series and his most successful painting
to that date. It probably commemorates the
victory of Max Schmitt, an attorney and skilled
amateur rower, in an important race held on the
Schuylkill River in October 1870. An avid rower,
Eakins showed himself in a scull in the middle
distance. Eakins constructed the painting
according to academic principles espoused by his
principal Parisian teacher, Jean-Léon Gérôme.

John Singer Sargent
American, 1856–1925
Madame X (Madame Pierre Gautreau),
1883–84
Oil on canvas, 82⅛ × 43¼ in. (208.6 × 109.9 cm)
Arthur Hoppock Hearn Fund, 1916 (16.53)

Virginie Amélie Avegno Gautreau, a Louisiana-born
Parisian socialite, was known for her artful appear-
ance. Sargent hoped to enhance his reputation by
painting and exhibiting her portrait. Working with-
out a commission but with his sitter's complicity,
he emphasized her daring personal style, showing
the right strap of her gown slipping from her shoul-
der. After the portrait received more ridicule than
praise at the 1884 Paris Salon, Sargent repainted
the shoulder strap and kept the painting. When he
sold it to the Metropolitan, he commented, "I sup-
pose it is the best thing I have done," but asked that
the Museum disguise the sitter's name.

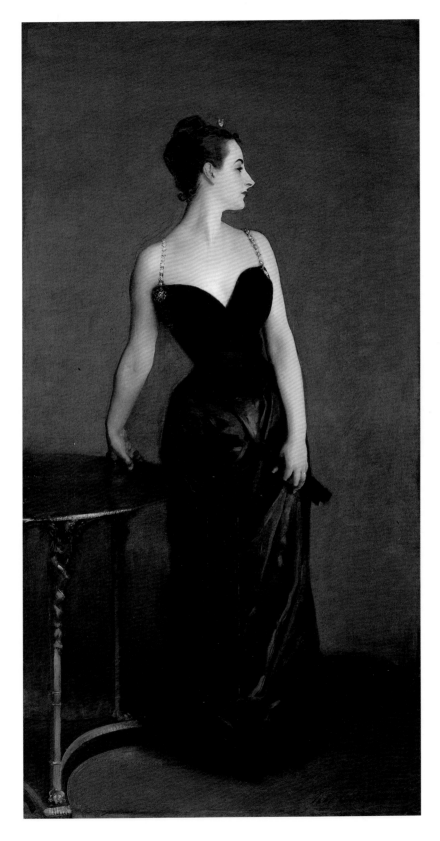

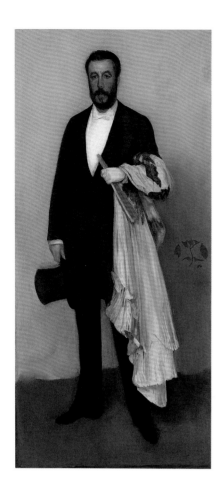

James McNeill Whistler
American, 1834–1903
**Arrangement in Flesh Colour and Black:
Portrait of Theodore Duret**, 1883
Oil on canvas, 76⅛ × 35¾ in. (193.4 × 90.8 cm)
Catharine Lorillard Wolfe Collection, Wolfe Fund,
1913 (13.20)

The Parisian collector and art critic Theodore
Duret, who was an early champion of the work
of Gustave Courbet, Édouard Manet, and
the Impressionists, posed for this portrait in
Whistler's London studio. At Duret's request,
Whistler portrayed him in evening dress,
but the painter suggested that Duret hold a
pink domino—a hooded masquerade robe—
which echoes the flesh tones and relieves the
austere black and gray palette. An exemplary
demonstration of Whistler's mature style, the
portrait combines a skillfully characterized head
with a costume and setting intended to create a
harmonious "arrangement."

Childe Hassam
American, 1859–1935
**Celia Thaxter's Garden, Isles of Shoals,
Maine,** 1890
Oil on canvas, 17¾ × 21½ in. (45.1 × 54.6 cm)
Anonymous Gift, 1994 (1994.567)

This painting is one of the finest of a series of
works Hassam made during summers in the
1890s on Appledore Island, one of the Isles of
Shoals that lie ten miles east of Portsmouth,
New Hampshire. The series portrays the sump-
tuous wildflower garden that Hassam's friend
the poet Celia Thaxter cultivated, a garden that
provided a marvelous contrast to the island's
rugged terrain. In this painting, vibrant red pop-
pies entangled in lush green foliage introduce a

view of bleached Babb's Rock. The work repre-
sents Hassam at the height of his creativity as
an American Impressionist.

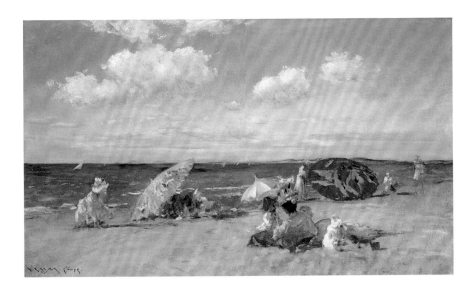

William Merritt Chase
American, 1849–1916
At the Seaside, ca. 1892
Oil on canvas, 20 × 34 in. (50.8 × 86.4 cm)
Bequest of Miss Adelaide Milton de Groot
(1876–1967), 1967 (67.187.123)

From 1891 to 1902, Chase served as director of
the Shinnecock Hills Summer School of Art in
the town of Southampton, New York. He taught
two days each week and spent the rest of his
time painting and enjoying the company of his
family. In this canvas, women and children take
their ease at a beach—probably along Shin-
necock Bay—an ideal site for genteel leisure on
a perfect day. The scene is capped by a broad
expanse of sky that fills the entire upper half of
the canvas, with its scudding clouds echoing the
bright white forms of the children's dresses.

Mary Cassatt
American, 1844–1926
Lady at the Tea Table, 1883–85
Oil on canvas, 29 × 24 in. (73.7 × 61 cm)
Gift of the artist, 1923 (23.101)

Cassatt's portrait shows her mother's first
cousin, Mary Dickinson Riddle, presiding at tea,
a daily ritual among upper-middle-class women.
Mrs. Riddle holds a teapot, part of a gilded
blue-and-white Canton porcelain service that
her daughter had presented to Cassatt's family.
Painted in response to the gift, the portrait dem-
onstrates Cassatt's mastery of Impressionism in
its sketchlike finish, its casual handling of anat-
omy, and the sitter's indifference to the viewer.
Because Mrs. Riddle's daughter disliked the por-
trait, Cassatt kept it until Mrs. H. O. Havemeyer
persuaded her to give it to the Museum.

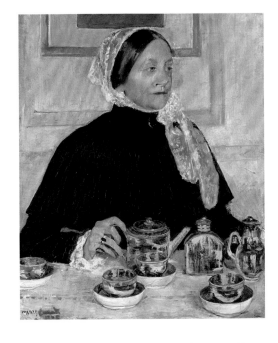

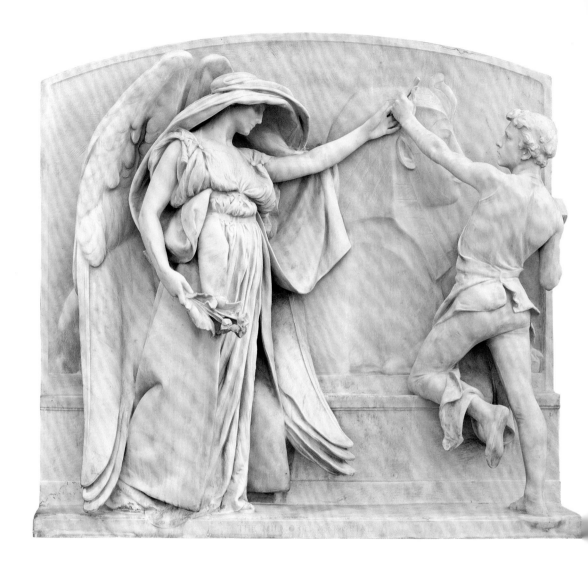

Daniel Chester French

American, 1850–1931

The Angel of Death and the Sculptor from the Milmore Memorial,

1889–93, carved 1921–26

Marble, 93½ in. × 8 ft. 4½ in. × 32½ in.

(2.38 × 2.55 × .83 m)

Gift of a group of Museum trustees, 1926 (26.120)

French's Milmore Memorial was a commission from the family of Boston sculptor Martin Milmore to honor his memory and that of his brother Joseph. The original bronze was erected in 1893 in Forest Hills Cemetery, Jamaica Plain, Massachusetts; this marble replica was later carved for the Metropolitan Museum. An angel of death appears to a young sculptor and reaches out to halt his work. In her right hand she carries poppies, symbolizing eternal sleep. French, a leading monumental sculptor of the early twentieth century, is best known for his *Seated Lincoln* for the Lincoln Monument in Washington, D.C.

below

Frederic Remington
American, 1861–1909
The Mountain Man, 1903, cast by March 1907
Bronze, 27¾ × 12 × 10 in. (70.5 × 30.5 × 25.4 cm)
Rogers Fund, 1907 (07.79)

Through his paintings, illustrations, sculptures, and writings, Remington earned esteem as a chronicler par excellence of the old American West. For *The Mountain Man*, the artist chose a dramatic episode in the daily life of a trapper, who with his mount descends an almost vertical slope. Encumbered with equipment—bear traps, ax, bedroll, and rifle—man and horse work together to navigate the precariously steep path. This bronze cast, like the finest of Remington's statuettes, presents a rich variety of textures, from the fringed buckskin garment and the animal's hairy hide to the rocklike base.

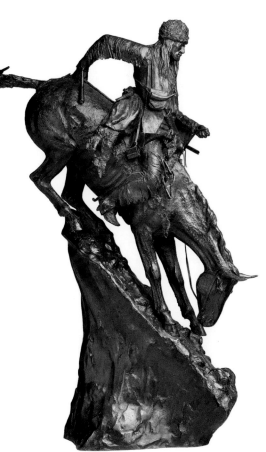

above

Augustus Saint-Gaudens
American, 1848–1907
Victory, 1892–1903, cast 1914–16
Gilt bronze, 38 × 9½ × 18½ in. (96.5 × 24.1 × 47 cm)
Rogers Fund, 1917 (17.90.1)

One of the foremost nineteenth-century sculptors, Saint-Gaudens was among the first generation of American artists to study in Paris and to work in a vital, naturalistic style. This statuette is a reduced version of the full-size figure leading Civil War General William Tecumseh Sherman on horseback in the Sherman Monument placed at the southeast corner of New York's Central Park. With her right arm outstretched, the ethereal winged figure is a guiding force with traditional attributes—a laurel crown on her head and a palm branch in her left hand. An American eagle is emblazoned across her breast.

Frederick William MacMonnies

American, 1863–1937

Bacchante and Infant Faun, 1893–94, cast 1894

Bronze, 84 × 29¾ × 31½ in. (213.4 × 75.6 × 80 cm)

Gift of Charles F. McKim, 1897 (97.19)

This work epitomizes the dramatic French Beaux-Arts style that dominated American sculpture in the late nineteenth century. A bacchante, an intemperate woman devoted to the wine god Bacchus, holds a bunch of grapes over her head and balances a baby on her left arm. The energetic, spiraling form and richly textured surfaces create an exuberant effect. MacMonnies gave this bronze to the architect Charles McKim, who placed it in the courtyard of the Boston Public Library, designed by his firm. After protests against the figure's "drunken indecency," McKim instead presented the sculpture to the Metropolitan Museum.

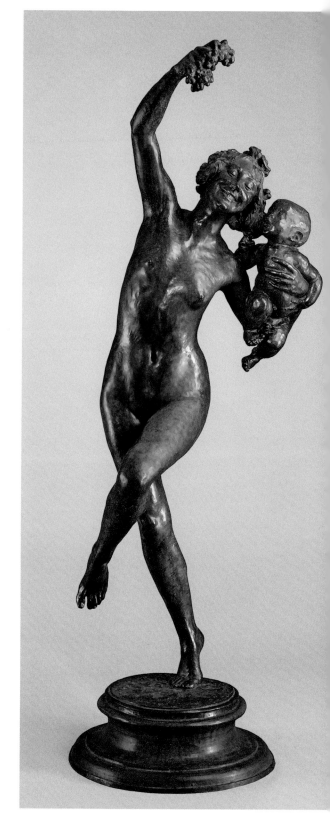

above
George E. Ohr
American, 1857–1918
Teapot, 1897–1900
Earthenware, 7¼ × 7⅛ in. (18.3 × 18.1 cm)
Promised Gift of Robert A. Ellison Jr. (L.2009.22.279a, b)

The self-proclaimed "Mad Potter of Biloxi,"
the Mississippi artist George Ohr, prefigured
Abstract Expressionism in pottery by nearly half
a century. A quintessential art potter, Ohr dug
his own clay, exquisitely formed his own pots
on the wheel, developed his own glazes, and
fired his own kiln. This red earthenware teapot
represents his adventurous and experimental
approach to ceramics. He manipulated the tra-
ditional teapot form by pushing in its sides and
pinching the handle, expressing an inventive-
ness and eccentricity that defied the more con-
trolled ceramics of the period. Ohr's ingenuity
is further demonstrated in the teapot's blistered
red glaze, an unconventional surface treatment.

below
Designed by
Louis Comfort Tiffany
American, 1848–1933
Made by
**Tiffany Glass and
Decorating Company**
American, 1892–1902
Vase, 1893–96
Favrile glass, 14⅛ × 11½ in. (35.9 × 29.2 cm)
Gift of H. O. Havemeyer, 1896 (96.17.10)

In the early 1890s, Louis Comfort Tiffany and
the skilled workers he employed in his Corona,
New York, studio developed the innovative
blown glass he christened Favrile. Ancient glass
and the natural world inspired many of the
shapes, colors, and finishes of Tiffany's vases
and plaques. This iconic vase features Tiffany's
trademark iridescence, which so aptly captures
the oily sheen of peacock feathers. Its fan shape
echoes the peacock's spread plumage. The vase
was part of a large group of objects given to the
Museum in 1896, only three years after Tiffany
started making decorative blown-glass vessels,
by Tiffany's ardent patrons Louisine and Henry
Osborne Havemeyer.

Cecilia Beaux

American, 1855–1942

Ernesta (Child with Nurse), 1894

Oil on canvas, 50½ × 38⅛ in. (128.3 × 96.8 cm)

Maria DeWitt Jesup Fund, 1965 (65.49)

Beaux's two-year-old niece and favorite model, Ernesta Drinker, clutches the hand of her nurse, Mattie, whose figure is boldly cropped. The radical composition and free brushwork reflect Beaux's appreciation of works by Édouard Manet and Edgar Degas. Moving at her baby pace across a polished floor, Ernesta is like Diego Velázquez's royal children, simultaneously dignified and vulnerable. Mattie's hand provides a universal symbol of protection and security, and the large expanse of her apron and uniform sets the scale for the child's tiny figure.

Winslow Homer
American, 1836–1910
Northeaster, 1895, reworked by 1901
Oil on canvas, 34½ × 50 in. (87.6 × 127 cm)
Gift of George A. Hearn, 1910 (10.64.5)

On the Maine coast a northeaster is a storm of exceptional violence and duration. When Homer first showed this canvas in 1895, it included two men in foul-weather gear crouched below the column of spray, which was less massive. Even though the painting was well received and was purchased by George A. Hearn, a leading collector of American art, Homer later reworked it to powerful effect. As one critic observed, *Northeaster* presents "three fundamental facts, the rugged strength of the rocks, the weighty, majestic movement of the sea and the large atmosphere of great natural spaces unmarked by the presence of puny man."

William Glackens
American, 1870–1938
Central Park, Winter, ca. 1905
Oil on canvas, 25 × 30 in. (63.5 × 76.2 cm)
George A. Hearn Fund, 1921 (21.164)

In Glackens's scene, well-behaved children sled down a snowy knoll in New York's Central Park under the watchful eyes of several adults. The children are warmly dressed and the adults are fashionably clothed, signaling that it is a story of middle-class recreation. Glackens was one of a group of artists that came to be called the Ashcan School. Despite their nominal commitment to telling the unvarnished truth about modern life and urban hardship, these artists viewed their world through rose-colored glasses, presenting the city euphemistically.

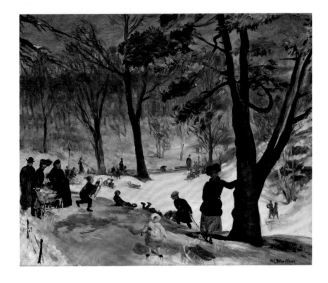

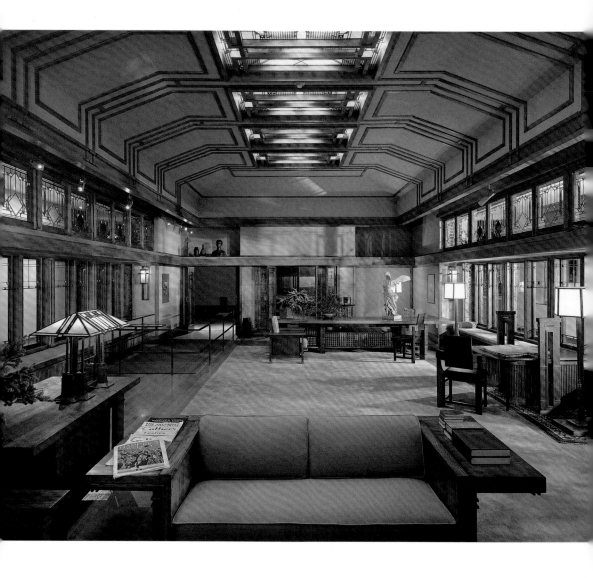

Frank Lloyd Wright

American, 1867–1959

**Room from Francis W. Little House,
Wayzata, Minnesota,** 1912–14

13 ft. 8 in. × 28 ft. × 46 ft. (4.17 × 8.53 × 14 m)
Purchase, Emily Crane Chadbourne Bequest, 1972
(1972.60.1)

This, the latest of the American Wing's period rooms, is the work of America's most famous architect, Frank Lloyd Wright. It was originally built as a grand, freestanding reception room at one end of a house built near Minneapolis, Minnesota, for Mr. and Mrs. Francis W. Little. With its low-pitched roof and broad overhanging eaves, its unpainted white oak trim, and its banks of clear leaded-glass windows, the room is representative of Wright's signature Prairie Style of domestic architecture. The furniture was all designed by Wright and is placed exactly as he intended it. The light-colored pieces were made for this room, the dark-stained ones for an earlier house Wright had designed for the Littles in Peoria, Illinois, in 1903.

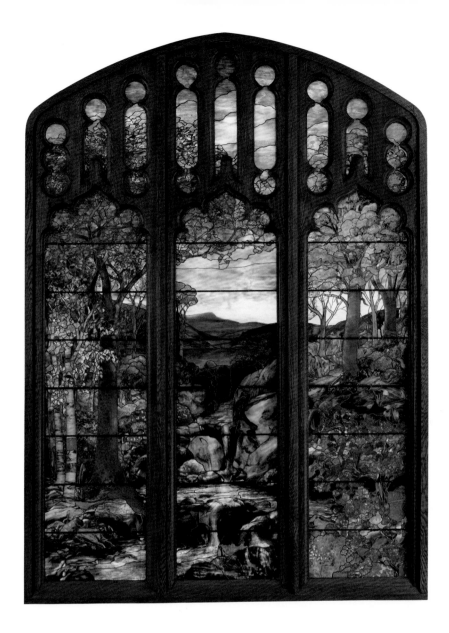

Probably designed by
Agnes F. Northrop
American, 1857–1953
Made by
Tiffany Studios
American, 1902–32
Autumn Landscape, 1923–24
Leaded Favrile glass, 11 ft. × 8 ft. 6 in. (3.35 × 2.59 m)
Gift of Robert W. de Forest, 1925 (25.173a–o)

Louis Comfort Tiffany, the son of the founder of Tiffany & Co., was one of America's preeminent artists, and he mastered many decorative media during his long and successful career. His most innovative work, however, was in glass. This autumnal landscape at sunset, a masterpiece among Tiffany's depictions of the natural world in leaded glass, draws upon all of the abilities and techniques developed in his New York workrooms. The variegated surface was achieved by wrinkling the pot-metal glass; unusual light effects were created by the mottled and confetti glass; and the sense of depth and perspective was suggested by plating more than one layer of glass.

Modern Era

The Costume Institute

The encyclopedic collection of The Costume Institute includes fashionable dress from the late sixteenth century to the present; regional costumes from Asia, Africa, Europe, and the Americas; as well as fashion accessories and photographs. The Institute was created in 1946 when the Museum of Costume Art, formed in 1937 by a group led by Irene Lewisohn, merged with the Metropolitan Museum. The Institute is supported by funds provided by the fashion industry, most notably through the annual Costume Institute Gala Benefit. In 2009 the Brooklyn Museum transferred its renowned costume collection, amassed over more than a century, to the Metropolitan, complementing existing holdings with exceptional examples of European and American fashion from the late nineteenth to the mid-twentieth century and an unrivaled assemblage of designs by the American couturier Charles James. Today The Costume Institute continues to build on those strengths, focusing on iconic examples and masterworks of historic and contemporary dress while also maintaining a comprehensive timeline of Western fashion history, as exemplified by the pieces shown here.

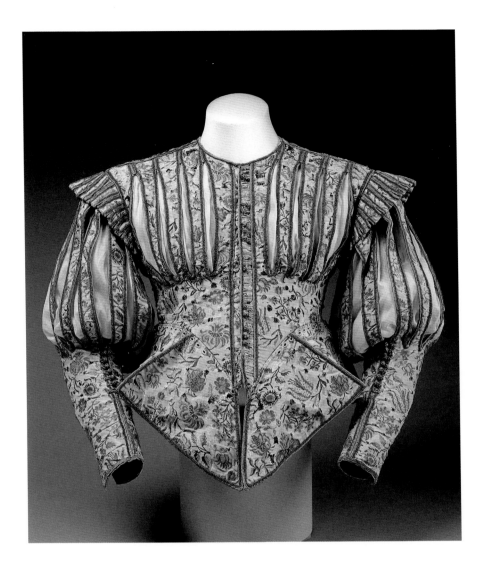

Doublet

French, early 1620s
Ivory silk faille brocaded with floral patterns in pink,
yellow, mauve, green, and purple
The Costume Institute Fund, in memory of Polaire
Weissman, 1989 (1989.196)

This extraordinary doublet is one of just two
surviving examples of its type from the 1620s,
the other being in the collection of the Victoria
and Albert Museum, London. It represents
a fashion that enjoyed only the briefest
vogue. Made of a luxurious silk brocade, it is
embellished with pinking and decorative slits.
Pinking, or the intentional slashing of fabric, was
a popular decorative technique used to reveal the
shirt, chemise, or colorful linings underneath.
It is possible that this particular garment was
constructed from silk previously pinked for
another use, as the pattern created does not
exactly follow the actual cut of the garment.

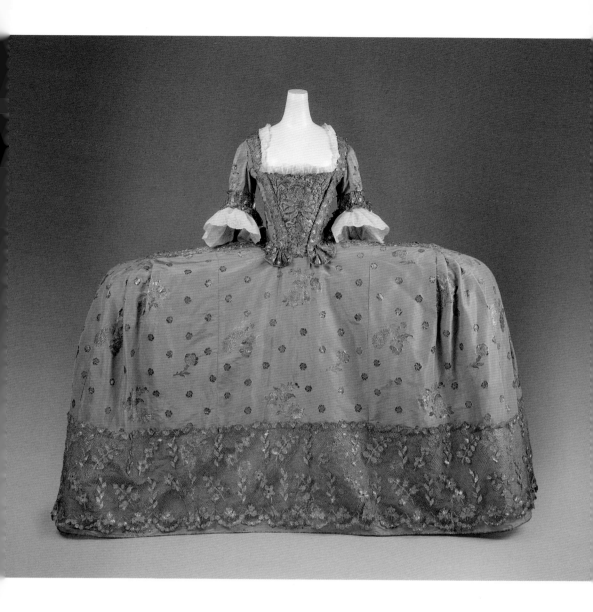

Court Dress

British, ca. 1750
Blue silk taffeta brocaded with floral-patterned hammered
silver and silver filé, with applied silver trim
Purchase, Irene Lewisohn Bequest, 1965 (C.I.65.13.1a–c)

The most remarkable examples of eighteenth-century dress had extreme proportions, appearing barely wider than the body in profile but as broad as possible in a front or rear view. The skirt of this English gown is fifty-five inches wide and was supported by panniers, or side hoops, of bent willow or whalebone covered in linen. A woman in a panniered gown negotiated most doorways by entering sideways in a smooth glide, as prescribed by etiquette. This dress is essentially a planar field of extravagant silk brocade embellished with embroidery of silk threads wrapped in silver and other silver trim. It is the sartorial equivalent of a billboard announcing the wealth and status of the wearer.

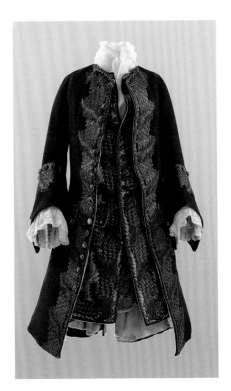

Man's Coat and Waistcoat

Probably French, ca. 1730
Red wool broadcloth with gilt thread
and sequin embroidery
Isabel Shults Fund, 2004 (2004.411a, b)

This elaborate coat is an elegant example
of the luxury and craftsmanship of menswear
in the first half of the eighteenth century. The
full cut of the horsehair-stiffened coat skirt and
the large cuff details are representative of the
exaggerated proportions of the period. These
elements of construction are well documented
in paintings from the Museum's collection, most
notably in Nicolas de Largillierre's 1727 portrait
of André François Alloys de Theys d'Herculais.
The gilt-thread embroidery on the red wool
broadcloth was among the most sumptuous
forms of ornamentation at the time. The embel-
lishment of the coordinating waistcoat is espe-
cially rich, with its scrolling feather pattern in
gilt thread and gilt sequins.

Ensemble

American, ca. 1820
Navy and cream wool broadcloth,
natural polished cotton, white linen
Purchase, Irene Lewisohn Bequest, 1976 (1976.235.3a–e)

The high-waist silhouette seen in women's dress
in the 1820s was faintly echoed in the period's
menswear. A jacket cut away to hug the rib cage
and the raised waist of the trousers emphasized
the length of the legs. Though subtle, the shifted
proportion of this style was the object of carica-
ture. As menswear evolved in the nineteenth
century, it became less susceptible to the caprices
of fashion, with the most expressive elements in
a man's ensemble eventually reduced to his cra-
vat, vest, and, in informal dress, the fabric of his
shirt. Male tailoring became, from the dandy's
perspective, "a uniform livery of affliction that
bears witness to equality."

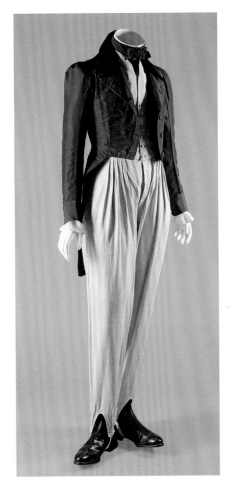

Dress

American or European, ca. 1855
Ivory organza printed with green and black rose pattern
Gift of James R. Creel IV and Mr. and Mrs. Lawrence G.
Creel, 1992 (1992.31.2a–c)

Equipped with two interchangeable bodices,
this ensemble represents a rare pragmatism
in high fashion. Important dresses frequently
survive with two bodices, generally for day
and dinner, or dinner and evening. The swell-
ing bell-shaped skirt, comprising tiers of ruf-
fles over multiple layers of stiff petticoats, was
a style much in vogue in the 1850s. Although
the date of the dress may be ascribed, its
country of origin is much more difficult to
confirm. With the proliferation of fashion
plates conveying the latest designs, the styles
emanating from Paris could be reproduced in a
timely manner anywhere appropriate textiles
were available.

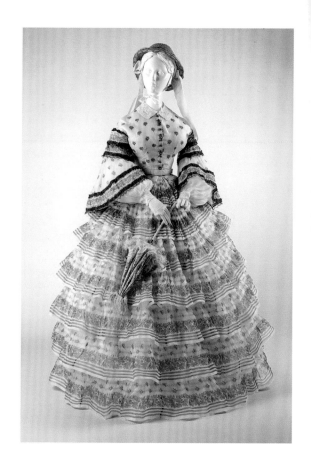

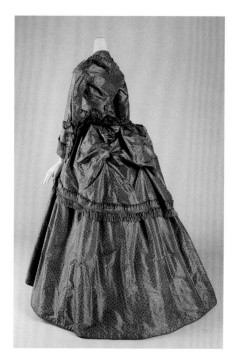

Dress

British, ca. 1868
Green chiné silk taffeta
Catharine Breyer Van Bomel Foundation
Fund, 1980 (1980.409.1a–c)

By 1866 the extreme fullness of the wide
skirt began to be distributed to the center
back and arranged in a variety of decorative
configurations. In some instances a separate
overskirt was added for a similar draped effect.
Over the next few years, the great expanse of
the horsehair or cotton crinoline hoop that
supported the skirt narrowed considerably at
the sides, giving a straighter silhouette when
viewed from the front. This dress retains the
silhouette of the 1860s while introducing a back
detail that anticipates the bustles of the next
two decades.

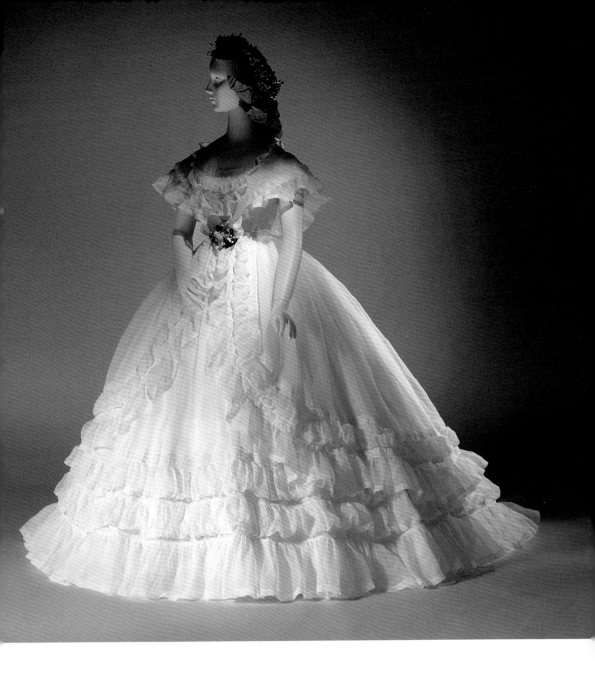

Wedding Ensemble

French, 1864
White cotton organdy
Gift of Mrs. James Sullivan, in memory
of Mrs. Luman Reed, 1926 (26.250.2a–e)

A sloping, triangulated shoulder line that
visually lengthened the neck was prized through
much of the nineteenth century. This ideal of
beauty was reflected in the bodice details of
formal gowns of the 1860s, which were typically
characterized by an off-the-shoulder, bateau
neckline. Because the shoulders were exposed,
corsets were either strapless or designed with
lowered and splayed straps. The wide, bell-
shaped silhouette of the skirt in this period
was made possible by the innovation, a decade
earlier, of the crinoline hoop. By the mid-1860s,
these increasingly wider hoops were able to
support skirts of the most extreme amplitude.

Evening Dress

American or European, 1884–86
Burgundy and peach silk satin, brown silk velvet
Gift of Mrs. J. Randall Creel IV, 1963 (C.I.63.23.3a, b)

The bustle, which took hold in the 1870s, was
at its most exaggerated extension by 1885. At
its extreme, it was almost perpendicular to the
small of the back and appeared as padded and as
heavily embellished as a drawing-room hassock
of the period. It was a popular conceit that the
cantilevers of these bustles could support an
entire tea service. To sustain the weight of the
skirt, bustle pads were often worn under light
and flexible hoops of wire, cane, or whalebone.
Sitting was accomplished by shifting and
collapsing the hoop.

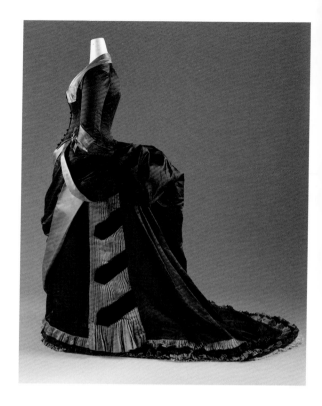

Christian Dior

French, 1905–1957
"Venus" Evening Gown, fall/winter 1949–50
Gray silk net embroidered with opalescent sequins,
rhinestones, simulated pearls, and paillettes
Gift of Mrs. Byron C. Foy, 1953 (C.I.53.40.7a–e)

Christian Dior's "Venus" is realized in the smoky,
eighteenth-century gray that was his signature
color. The bodice and the shell forms of its
skirt are embellished with nacreous paillettes,
sequins, and pearls, suggesting both the
seashell motif and the crescent-wave patterns
of Botticelli's *Birth of Venus* (1485). After World
War II, Dior reintroduced the wasp waist of the
Belle Époque—a silhouette predicated on the
corset—to a public starved for the fantasy of a
more gracious time. In this design, the strapless
bodice is heavily boned. For Dior, beauty resided
in artifice. "I dream," he once wrote, "of rescuing
women from nature."

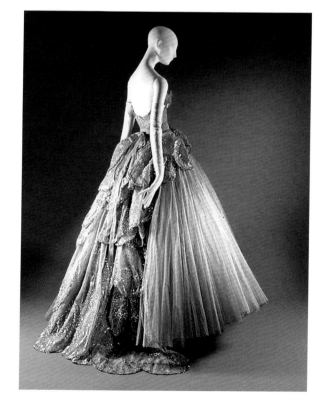

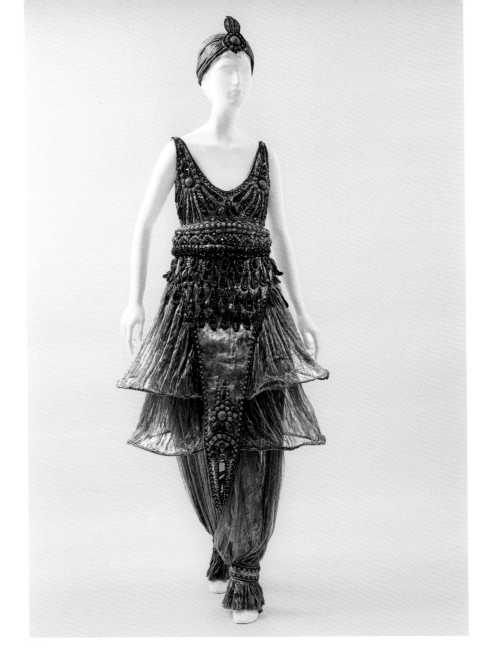

Paul Poiret

French, 1879–1944

Fancy-Dress Costume, 1911

Green silk gauze, silver lamé, blue foil, blue and
silver coiled cellophane cord appliqué; blue, silver,
coral, pink, and turquoise cellulose beading
Purchase, Irene Lewisohn Trust Gift, 1983 (1983.8a, b)

In 1910 Sergei Diaghilev's Russian dance com-
pany, the Ballets Russes, performed *Scheherazade*
in Paris, reigniting the taste for Orientalism in
Europe with its exotic sets and costumes by
Léon Bakst. This fancy-dress ensemble was made
for and worn to Poiret's "Thousand and Second
Night," his legendary 1911 party at which he pro-
moted his new creations through the splendor
and glamour of a pasha's ball. In his memoirs,
Poiret dismissed any relationship between his
work and the artistry of Bakst, but the spectacu-
lar success of *Scheherazade* a year before Poiret's
lavish party makes clear that the designer was
willing to parlay the excitement generated by the
Russians to his own advantage.

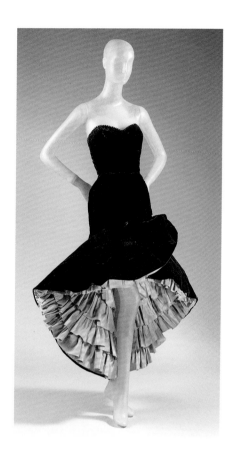

Cristobal Balenciaga
Spanish, 1895–1972
Evening Dress, 1951
Black silk velvet, pink silk taffeta
Gift of Gina Gerardo, 1993 (1993.393.1)

Cristobal Balenciaga is considered one of the twentieth century's greatest masters of haute couture. Equally adept at both tailoring and dressmaking, he was known for the strong sense of structure that informs even his most supple gowns. This dress, like much of his work, is characterized by an assertive silhouette. It also makes explicit reference to Balenciaga's Spanish heritage with the fitted torso and flared short-in-front, long-in-back skirt of a flamenco dress. The designer, however, displaced the tiered ruffles of the typical flamenco dancer's train to the interior of the skirt. There, instead of a lining, the hot pink ruffles provide a flash of coquetry.

Rudi Gernreich
American, born Austria, 1922–1985
Ensembles, 1967
Pink wool jersey, clear vinyl
Ivory wool jersey, clear vinyl
Gift of Léon Bing and Oreste F. Pucciani, 1988
(1988.74.2a–e, 1988.74.1a–f)

Moving away from the formality of Paris-based haute couture, fashions of the 1960s developed along more youth-driven trajectories. Inspired in part by a belief in the utopian possibilities of technology, Gernreich's crisply geometric designs were an American corollary to the architectonic futurism of André Courrèges, Pierre Cardin, and Paco Rabanne in Paris. Gernreich's space-age aesthetic is seen in his use of details such as see-through vinyl, neon colors, and ankle boots.

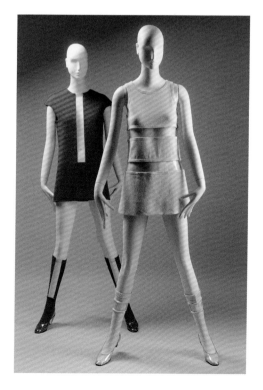

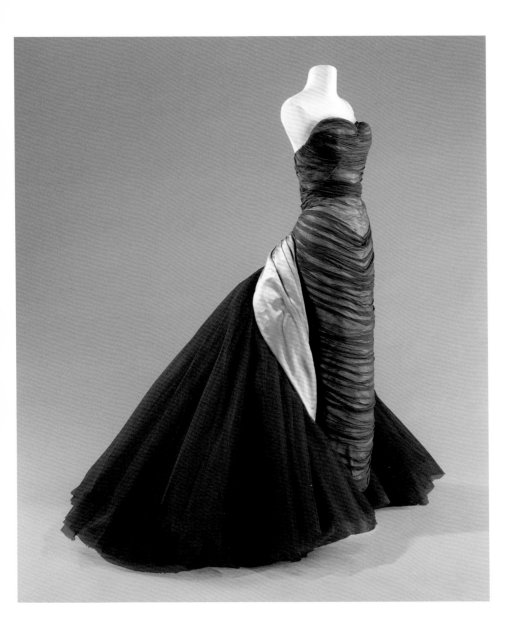

Charles James

American, born Great Britain, 1906–1978

"Butterfly" Evening Gown, 1955

Gray silk chiffon and silk satin; dark purple, lavender, and cream silk tulle

Brooklyn Museum Costume Collection at The Metropolitan Museum of Art, Gift of the Brooklyn Museum, 2009; Gift of Mrs. John de Menil, 1957 (2009.300.816)

Charles James began his design career in the 1930s and had a particularly creative period from the late 1940s to the mid-1950s. Considered to be the only American to work in the true tradition of haute couture, he personally draped and constructed each of the garments that bore his label. This gown is James's version of the tightly fitted bustle dresses of the early 1880s. The body-conscious, sculpted sheath that anchors this design emphasizes the feminine form, and the enormous bustle skirt, an explosion of silk net, was constructed to move and billow seductively. The dress weighs eighteen pounds and incorporates twenty-five yards of tulle.

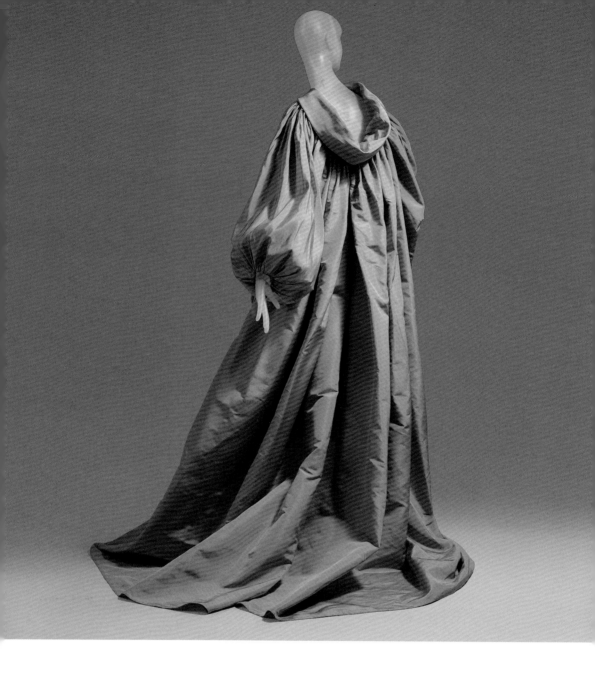

Yves Saint Laurent

French, born Algeria, 1936–2008

Evening Ensemble, fall/winter 1983–84

Yellow silk faille, black silk velvet

Gift of Thomas L. Kempner, 2006 (2006.420.51a, b)

Among the most dramatic pieces from Yves Saint Laurent's fall/winter 1983–84 collection of haute couture is this coat worn over a spare and elegant black gown. In a direct reference to the voluminous evening coats from the golden age of post–World War II haute couture, this Saint Laurent version of heavy silk faille merges the sumptuous romanticism of Christian Dior and the sculptural drama of Cristobal Balenciaga. With its bias collar extending into front ties, the coat may be worn either pulled close to the neck or falling away from the back and shoulders, as was preferred by its owner, Nan Kempner, a perennial presence on the International Best Dressed List.

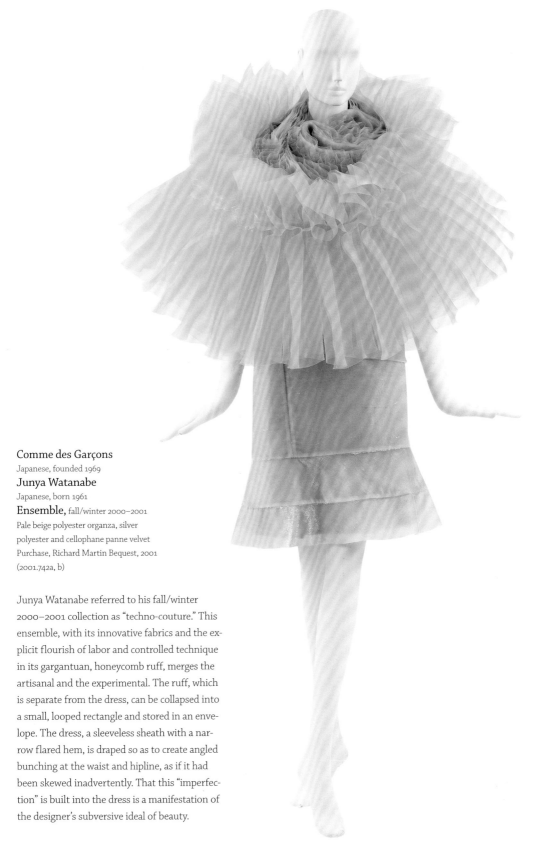

Comme des Garçons
Japanese, founded 1969
Junya Watanabe
Japanese, born 1961
Ensemble, fall/winter 2000–2001
Pale beige polyester organza, silver
polyester and cellophane panne velvet
Purchase, Richard Martin Bequest, 2001
(2001.742a, b)

Junya Watanabe referred to his fall/winter
2000–2001 collection as "techno-couture." This
ensemble, with its innovative fabrics and the ex-
plicit flourish of labor and controlled technique
in its gargantuan, honeycomb ruff, merges the
artisanal and the experimental. The ruff, which
is separate from the dress, can be collapsed into
a small, looped rectangle and stored in an enve-
lope. The dress, a sleeveless sheath with a nar-
row flared hem, is draped so as to create angled
bunching at the waist and hipline, as if it had
been skewed inadvertently. That this "imperfec-
tion" is built into the dress is a manifestation of
the designer's subversive ideal of beauty.

Modern and Contemporary Art

The Metropolitan Museum has collected and exhibited work by living artists since its founding; today its holdings of modern and contemporary art comprise more than twelve thousand works in all media. Among its many renowned highlights are iconic works by early twentieth-century modernists such as Benton, Dove, Hartley, Matisse, Miró, Modigliani, and O'Keeffe, in addition to the promised gift of the Leonard A. Lauder Cubist Collection, widely considered the most important collection of Cubist works by Braque, Gris, Léger, and Picasso in private hands. The Department of Modern and Contemporary Art is also rich in works of modern design by Norman Bel Geddes, Josef Hoffmann, Raymond Loewy, and Émile-Jacques Ruhlmann, and in postwar paintings by de Kooning, Guston, Johns, Pollock, Rothko, and Warhol. In recent years these holdings have been augmented by the acquisition of noteworthy paintings by contemporary artists such as Peter Doig, Anselm Kiefer, and Kerry James Marshall, as well as major collections—the Jacques and Natasha Gelman Collection of twentieth-century art and the Muriel Kallis Steinberg Newman Collection of postwar paintings.

Pablo Picasso
Spanish, 1881–1973
Gertrude Stein, 1905–6
Oil on canvas, 39⅜ × 32 in. (100 × 81.3 cm)
Bequest of Gertrude Stein, 1946 (47.106)

Stein posed for this famous portrait in Picasso's studio in Paris, a warm brown corduroy dress covering her majestic bulk. Impressed by the American writer's sharp mind and free manner, Picasso had offered to paint her portrait. In autumn 1905 began the many sittings, which Stein mythologized as reaching ninety— doubtful in view of Picasso's quick work habits. In spring 1906, dissatisfied with the face, Picasso painted it out. When he returned to Paris that autumn, without seeing Stein, he created this masklike visage, whose archaizing aspect heralds the new style that had fermented during his stay that summer in Gósol, Spain. Picasso was bold in grafting a proto-Cubist head onto Stein's Rose-period body, creating a startlingly unique and iconic image.

Gustav Klimt
Austrian, 1862–1918

Mäda Primavesi (1903–2000), 1912
Oil on canvas, 59 × 43½ in. (149.9 × 110.5 cm)
Gift of André and Clara Mertens, in memory of her
mother, Jenny Pulitzer Steiner, 1964 (64.148)

In 1912 the banker and industrialist Otto
Primavesi, one of the financial backers of the
Wiener Werkstätte, commissioned this portrait
of his daughter Mäda. The sittings took place in
the artist's studio in Vienna, where Klimt also
painted a portrait of Mäda's mother, the actress
Eugenia Primavesi (née Butschek), in 1914. In
a large group of pencil studies, Klimt tried a
variety of poses before adopting this upright,
forward-facing posture that expresses the high
spirits of the nine-year-old girl.

Henri Matisse

French, 1869–1954

Nasturtiums with the Painting "Dance," 1912

Oil on canvas, 75½ × 45⅜ in. (191.8 × 115.3 cm)

Bequest of Scofield Thayer, 1982 (1984.433.16)

This view of Matisse's studio in Issy-les-Moulineaux, southwest of Paris, was painted in 1912, after his return to France from an extended stay in Morocco. A wood armchair is partially cut off on the left; to the right is a tripod table holding a vase of nasturtiums. Occupying the entire background is a section of Matisse's large painting *Dance I* (1909), which is cited in the title and is now in the Museum of Modern Art, New York. Matisse painted two same-size versions of this theme: this sketchlike, luminous first and the intensely hued second (State Pushkin Museum of Fine Arts, Moscow) with a backdrop showing *Dance II* (1909–10, State Hermitage Museum, Saint Petersburg).

Amedeo Modigliani
Italian, 1884–1920
Reclining Nude, 1917
Oil on canvas, 23⅞ × 36½ in. (60.6 × 92.7 cm)
The Mr. and Mrs. Klaus G. Perls Collection, 1997
(1997.149.9)

Modigliani began his great series of nudes in 1917. These women are seen from close-up and usually from above, and their stylized bodies span the entire width of the composition. The dark bed covering on which they recline accentuates the glow of their skin. Their feet and hands always remain outside the picture frame. One or two of the nudes seem to be asleep, but usually, as here, they face the viewer. In these works the artist continued the tradition of depicting the nude Venus, which extended from the Renaissance through the nineteenth century.

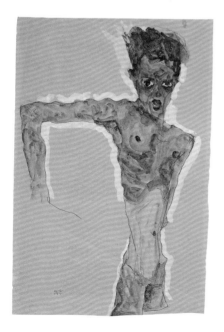

Egon Schiele
Austrian, 1890–1918
Self-Portrait, 1911
Watercolor, gouache, graphite on paper,
20¼ × 13¾ in. (51.4 × 34.9 cm)
Bequest of Scofield Thayer, 1982 (1984.433.298ab)

Schiele was extraordinarily productive during his short, intense career. Before dying from influenza at the age of twenty-eight, he created more than three hundred paintings and several thousand works on paper. The human figure, rendered with powerful energy, was the subject of most of his work. The many self-portraits he created between 1910 and 1918 are searing explorations of his psychic state. Assuming a pose suggestive of the crucified Christ in this self-portrait of 1911, he stares out wildly, his shock of hair standing on end.

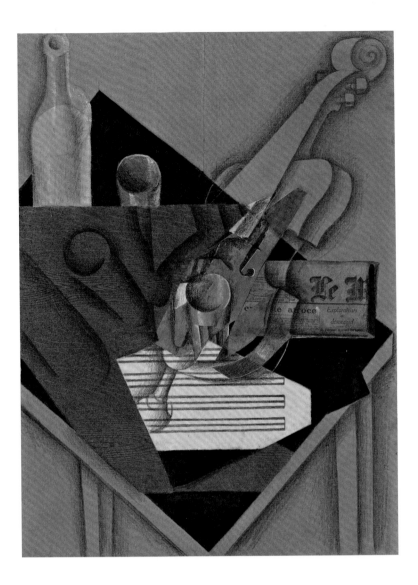

Juan Gris

Spanish, 1887–1927

The Musician's Table, 1914

Conté crayon, wax crayon, gouache, cut-and-pasted printed
wallpaper, blue and white laid papers, transparentized
paper, newspaper, and brown wrapping paper; selectively
varnished on canvas, 31½ × 23¾ in. (80 × 60.3 cm)
Leonard A. Lauder Cubist Collection, Purchase, Leonard
A. Lauder Gift, in celebration of the Museum's 150th
Anniversary, 2018 (2018.216)

In 1912, Georges Braque and Pablo Picasso
invented papier collé, a technique of adhering
paper elements to a composition, as a means
to break further with the tradition of painted
representation; Gris, however, was the first

Cubist artist to exhibit a work in this medium
and was lauded by critics. In the months
of 1914 preceding the outbreak of war, Gris
devoted himself almost exclusively to this
hybrid medium, creating more than forty com-
positions. Gris's invented newspaper headline
acknowledges mounting tensions around the
world but also the rivalry between the Cubists
over technical and formal innovations. With
the inclusion of a violin and staves awaiting
notes, *The Musician's Table* suggests the artist's
hope for harmony with his colleagues.

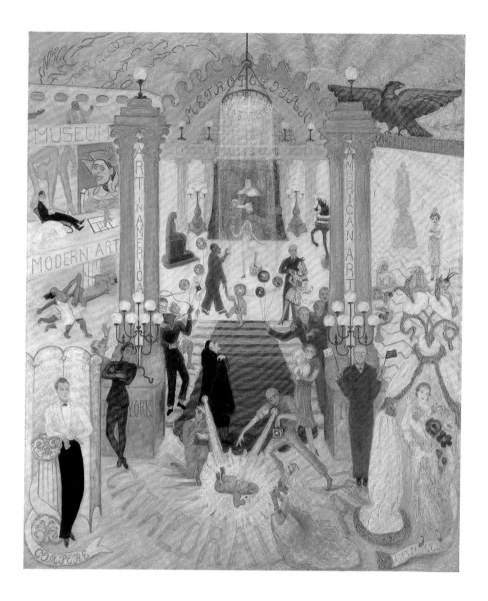

Florine Stettheimer

American, 1871–1944

The Cathedrals of Art, 1942

Oil on canvas, 60¼ × 50¼ in. (153 × 127.6 cm)

Gift of Ettie Stettheimer, 1953 (53.24.1)

In a series of four monumental paintings executed between 1929 and 1942, Stettheimer created extraordinary composite visions of New York's economic, social, and cultural institutions. *The Cathedrals of Art* is a fantastical portrait of the New York art world, featuring microcosms of three of the city's major museums watched over by their directors: the Museum of Modern Art (upper left), The Metropolitan Museum of Art (center), and the Whitney Museum of American Art (upper right). A gathering of art critics, dealers, and photographers of the day, including Stettheimer herself (lower right), appears around The Met's grand staircase.

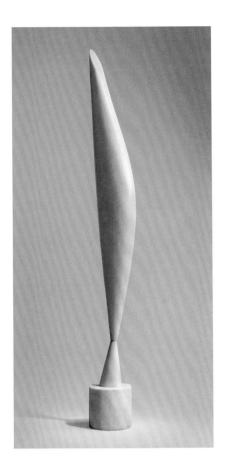

Constantin Brancusi
French, born Romania, 1876–1957
Bird in Space, 1923
Marble, H. 56¾ in. (144.1 cm) (with base)
Bequest of Florene M. Schoenborn, 1995 (1996.403.7ab)

The theme of the bird preoccupied Brancusi throughout his life. In *Bird in Space* the artist concentrated less on the bird itself than on capturing the essence of flight. Wings and features are eliminated, the swell of the body is elongated, and the head and beak are reduced to a slanted oval plane. This work is the first in a series that preoccupied Brancusi for the next two decades, until the 1940s. He created seven additional marble versions and nine in bronze.

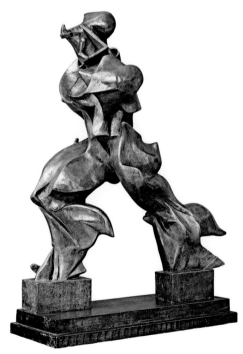

Umberto Boccioni
Italian, 1882–1916
Unique Forms of Continuity in Space,
1913, cast 1949
Bronze, 48 × 15½ × 36 in. (121.9 × 39.4 × 91.4 cm)
Bequest of Lydia Winston Malbin, 1989 (1990.38.3)

Boccioni was one of the major exponents of Italian Futurism, a movement that extolled abstract depictions of speed, movement, and dynamism of form. The versatile artist worked in drawing, painting, and sculpture, and he also authored numerous Futurist manifestos. During the peak years of his career he was preoccupied in sculpture with a muscular, energetic figure rushing through space, emphasizing dynamic force through extreme distortion of the male body. Considered the most successful among Boccioni's sculptural experiments, this work is one of five versions, one of which is in plaster (also 1913). Its casting in 1949 was supervised by the Futurist Filippo Tommaso Marinetti, from whose collection it was acquired by the donor.

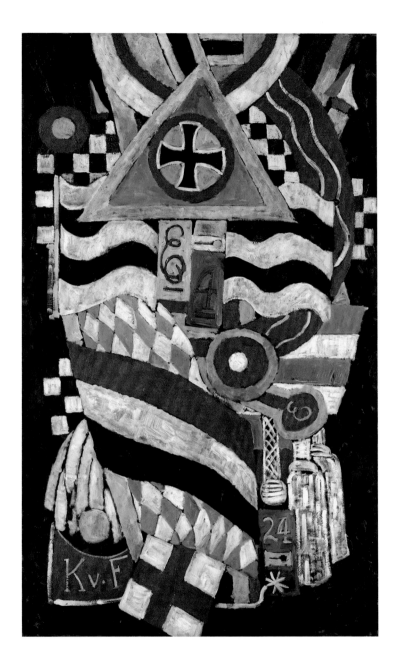

Marsden Hartley

American, 1877–1943

Portrait of a German Officer, 1914

Oil on canvas, 68¼ × 41⅜ in. (173.4 × 105.1 cm)

Alfred Stieglitz Collection, 1949 (49.70.42)

Hartley painted his most advanced abstractions during the first years of World War I, while living in Berlin. This War Motif series conveys his fascination with the pageantry of the German military, as well as his sadness over the death of a close friend, a young cavalry officer named Karl von Freyburg. This abstract portrait, made up of signs, symbols, patterns, and colors, conveys details about his life and service: his initials (KvF), age (24), regiment ("E" for Bavarian Eisenbahn), Iron Cross medal, and Bavarian flag (blue and white).

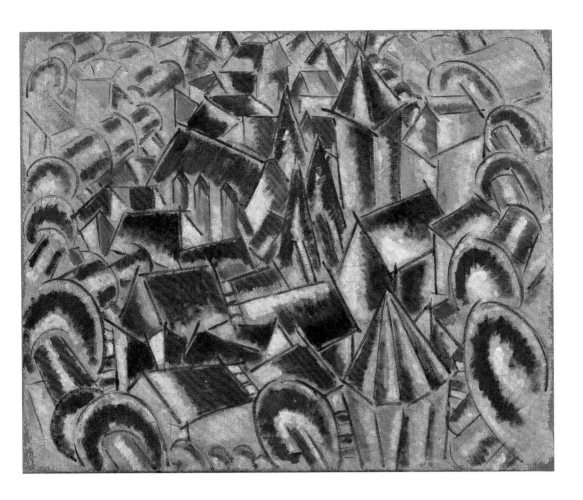

Fernand Léger
French, 1881–1955
The Village, 1914
Oil on canvas, 31½ × 39½ in. (80 × 100.3 cm)
Leonard A. Lauder Cubist Collection, Purchase,
Leonard A. Lauder Gift, 2013 (2013.271)

Expressively painted in primary colors on coarse canvas, this work presents a small village in France. Spherical and cylindrical shapes that suggest trees and possibly a town wall encircle a church, which has buttresses and a bell tower to the right of its facade. This canvas was Léger's final major painting in his Contrasts of Forms series and is thought to be one of the last works he made before World War I. In it, the artist merged the past and the present, depicting historical architecture with the most contemporary means of expression.

Émile-Jacques Ruhlmann
French, 1879–1933
"État" Cabinet, 1926
Macassar ebony, amaranth, ivory,
50¼ × 33¼ × 14 in. (127.6 × 84.5 × 35.6 cm)
Purchase, Edward C. Moore Jr. Gift, 1925 (25.231.1)

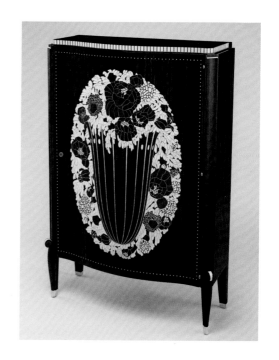

Ruhlmann was the most renowned French designer of the Art Deco period. Aesthetic refinement, sumptuous materials, and impeccable construction techniques place his work on par with the finest eighteenth-century furniture—a formal and ornamental source for his designs. In 1925 the Museum commissioned this cabinet, a variant of one first purchased by the French state, hence the name "État." Ruhlmann sometimes reproduced his furniture models, changing details according to a client's preferences. The wood and ivory veneering is a tour de force recalling a complex jigsaw puzzle.

Lucien Lévy-Dhurmer
French, born Algeria, 1865–1953
"Wisteria" Dining Room,
1910–14
Various media, 12 ft. 2 in. ×
17 ft. 3 in. × 26 ft. 3 in.
(3.71 × 5.26 × 8 m)
Harris Brisbane Dick Fund,
1966 (66.244.1–.25)

This dining room, the only complete French Art Nouveau interior on display in an American museum, comes from the Paris apartment of the engineer Auguste Rateau. The project was overseen by Lévy-Dhurmer, a ceramist who turned to painting and decorating. Each room was conceived according to a unified theme, in this case wisteria, a symbol of welcome. Murals depict birds in wisteria-laden landscapes, and walnut-veneered walls are inlaid with purplish blossoms. Additional blossoms are carved on the walnut furniture and stamped on the leather upholstery. Bronze-and-alabaster lamps evoke wisteria vines, and petals are scattered across the carpet.

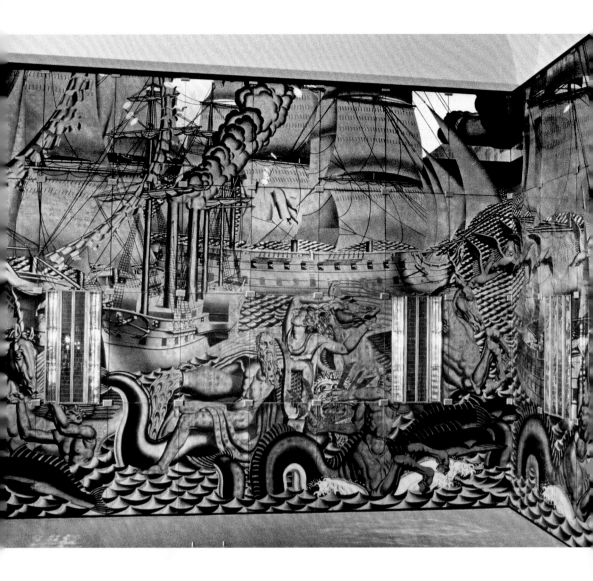

Designed by
Jean Dupas
French, 1882–1964
Manufactured by
Charles Champigneulle
French, 1907–1955
"History of Navigation" Mural, 1934
Glass, paint, gold, silver, palladium leaf,
20 ft. 5 in. × 29 ft. ¾ in. (6.22 × 8.86 m)
Gift of Dr. and Mrs. Irwin R. Berman, 1976
(1976.414.3a–ggg)

The ocean liner *Normandie* was the last great
expression of French Art Deco taste. This
mural was one of four made for the first-class
salon. The history of navigation is its nominal
subject; the profusion of quasi-historical vessels
and mythical creatures was clearly not meant
to tell a story but rather to create a decorative
effect. The *Normandie*'s passengers paid less for
transportation than for atmosphere, and the
salon was a temple of glamour. The mirrorlike
brilliance derives from the *verre églomisé*
technique: the decoration was applied to the
reverse of the plate-glass panels, which were
then mounted with their fronts facing the room.

Paul Klee

German, born Switzerland, 1879–1940

May Picture, 1925

Oil on cardboard,

16⅜ × 19½ in. (41.6 × 49.5 cm)

The Berggruen Klee Collection, 1984 (1984.315.42)

Paul Klee was an active member of the Bauhaus, a school founded in 1919 by German architect Walter Gropius with the goal of combining architecture, sculpture, and painting into a unified creative expression. In December 1924 Gropius closed the Bauhaus in Weimar, to open it again in Dessau in the spring of 1925. It was probably then that Klee signed and dated this painting, which he titled *May Picture*. The work belongs to

a series known as Magic Squares, paintings that have their roots in watercolors Klee created while he was in Tunisia in 1914, in which he fractured landscape into squares. The series is also related to Klee's preoccupation with the laws of color, prompted by his teaching at the Bauhaus. Here the forms evoke odd-shaped stones in all the colors of the rainbow as well as various shades of gray, assembled to form an abstract mosaic. In 1911 in Munich, Klee became a neighbor of Vasily Kandinsky, whose *Improvisation 27* is shown on the facing page. Later, in Dessau, the artists shared one of the two-family houses that Gropius had built for the Bauhaus masters.

Vasily Kandinsky

French, born Russia, 1866–1944

Improvisation 27 (Garden of Love II), 1912

Oil on canvas, 47 3/8 × 55 1/4 in. (120.3 × 140.3 cm)

Alfred Stieglitz Collection, 1949 (49.70.1)

The Russian-born Kandinsky began his artistic career in Munich in 1896, and by 1911 he had developed his innovative artistic language, inspired by spiritual, metaphysical, and theosophical ideas. His nonfigurative abstraction was intended to arouse emotional responses in a viewer through compositions of bright colors and linear elements disembodied from specific form. This painting belongs to a group of thirty-six works, titled *Improvisations*, which frequently use biblical themes as the source of veiled imagery. Here Kandinsky explored the story of the Garden of Eden. Composed around a large yellow sun, the idyllic scene also includes ominous elements such as scattered black forms, as if foretelling the banishment of Adam and Eve from Paradise and the forthcoming disaster of World War I.

Giorgio de Chirico
Italian, born Greece, 1888–1978
The Jewish Angel, 1916
Oil on canvas, 26⅝ × 17¼ in. (67.5 × 44 cm)
Jacques and Natasha Gelman Collection, 1998 (1999.363.15)

This still life is exceptional in the oeuvre of this artist, whose acclaimed magical Italian cityscapes of 1911 to 1917 would influence the Surrealists a decade later. Painted wood elements, among them a pink-dotted French curve, blue-and-white meter stick, and right angles, are stacked pell-mell above what might be kilometer markers. Among these objects, an oversize eye, crudely drawn on a large piece of paper, surprises. De Chirico's father was an engineer with a railroad company, and it has been suggested that this scaffoldlike structure and eye might be an abstract portrait of him.

Joan Miró
Spanish, 1893–1983
Dutch Interior (III), 1928
Oil on canvas, 51⅛ × 38⅛ in. (129.9 × 96.8 cm)
Bequest of Florene M. Schoenborn, 1995 (1996.403.8)

Miró became fascinated with Dutch genre and still-life painting during a stay in the Netherlands in May 1928. After visits to the collections of the Mauritshuis and the Rijksmuseum, he kept postcards of works by Hendrick Sorgh and Jan Steen. In Spain that same summer, he emulated elements of these artists' works in a series of three Dutch interiors, rendered in his characteristic biomorphic style of Surrealism. While the first two in the series can be traced to specific paintings by Sorgh and Steen, respectively, this third one mingles various motifs from both artists.

Leonora Carrington
Mexican, born England, 1917–2011
Self-Portrait, ca. 1937–38
Oil on canvas, 25⅜ × 32 in. (65 × 81.3 cm)
The Pierre and Maria-Gaetana Matisse
Collection, 2002 (2002.456.1)

In this self-portrait, the artist sports white jodh-
purs, Victorian boots, a seaweed-green jacket,
and a wild mane of hair. Marooned in this un-
fathomable room on a blue armchair, Carrington
has as her only companion a prancing hyena with
three pendulous breasts. The large white rocking

horse and its shadow seem painted on the wall.
In the landscape, seen through a window fes-
tooned with yellow curtains, is another, smaller
horse. The strange cast of characters could have
tumbled out of one of Carrington's contempora-
neous, wickedly bizarre short stories.

Max Ernst
French, born Germany, 1891–1976
Gala Éluard, 1924
Oil on canvas, 32 × 25¾ in. (81.3 × 65.4 cm)
The Muriel Kallis Steinberg Newman Collection,
Gift of Muriel Kallis Newman, 2006 (2006.32.15)

Ernst met the poet Paul Éluard and his Russian
wife, Gala, in Cologne in 1921. Their visit began
a lifelong friendship between the men and
initiated a sudden passion between Ernst and
Gala. In 1922 Ernst moved to Paris, where he
lived with the Éluards until 1924. By then he
had become one of the founding members of
Surrealism. At the end of his affair with Gala,
Ernst evoked the eyes of the Russian siren in
this painting, which he based on a photograph
by Man Ray. The top of her head peels away and
scrolls forward like a poster from a wall.

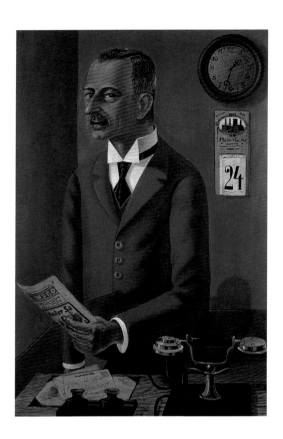

Otto Dix

German, 1891–1969

The Businessman Max Roesberg, Dresden, 1922

Oil on canvas, 37 × 25 in. (94 × 63.5 cm)

Purchase, Lila Acheson Wallace Gift, 1992 (1992.146)

Dix was the best-known painter of the movement toward a deadpan, matter-of-fact realism that became known in Germany in the 1920s as Neue Sachlichkeit (New Objectivity). With clinical, often merciless realism and a few poignant details, he captured the individuality of his sitters, who included lawyers, doctors, and art dealers, as well as poets, prostitutes, and dancers. His diabolical candor is absent in this commissioned portrait of Roesberg, who was a manufacturer of industrial tools and a collector of works by young Dresden artists, Dix among them. Picturesque details anchor the sitter in his small office in town, which is rendered with the sober colors of commerce and money.

Alberto Giacometti
Swiss, 1901–1966
Tall Figure, 1947
Bronze, 79½ × 8⅝ × 16¼ in. (201.9 × 21.9 × 41.3 cm)
The Pierre and Maria-Gaetana Matisse
Collection, 2002 (2002.456.111)

Sometime after 1945, Giacometti stopped
making experimental figures only one or two
centimeters in height and began to focus on
larger ones. By 1947 three main themes had
emerged: the walking man, the standing woman,
and the bust or head. Without volume or mass,
this over-lifesize standing woman appears
remote, her otherworldliness accentuated by
the matte beige paint the artist applied to the
bronze. The figure looks as if it has withstood
centuries of rough weather that has left its sur-
face crusty and eroded. The pose reflects that of
certain ancient Egyptian statues.

Max Beckmann
German, 1884–1950
Beginning, 1949
Oil on canvas; triptych, center panel 71½ × 61½ in. (181.6 ×
156.2 cm); side panels each 67½ × 36 in. (171.5 × 91.4 cm)
Bequest of Miss Adelaide Milton de Groot (1876–1967),
1967 (67.187.53a–c)

Beckmann started *Beginning* in 1946 in
Amsterdam and completed it in 1949 in the
United States, where he immigrated in 1947. It
is the eighth of his ten triptychs, and its theme
is childhood. In the classroom scene on the
right, a stern teacher towers over his students.
In the left panel, a boy wearing a crown watches
through the window a blind organ-grinder whose
music conjures up a choir of angels. The center
image shows an attic playroom where a girl
blows bubbles from a pipe, a little boy in military
costume rides a rocking horse, and Puss in Boots
hangs upside down.

Charles Demuth
American, 1883–1935
I Saw the Figure 5 in Gold, 1928
Oil, graphite, ink, gold leaf on paperboard
(Upson board), 35½ × 30 in. (90.2 × 76.2 cm)
Alfred Stieglitz Collection, 1949 (49.59.1)

In the 1920s Demuth produced a series
of symbolic poster-portraits honoring
contemporary American artists, writers, and
performers. This work was dedicated to William
Carlos Williams, the American poet whose verse
"The Great Figure" inspired the painting's title
and imagery. As in the poem, a No. 5 fire engine
races loudly through the lamplit streets of the
rainy city. The fragmented shapes, words, and
lines connoting movement and sound derive
from French Cubism and Italian Futurism, but
the urban subject matter, sense of scale, and
hard edges are pure American Precisionism.

Georgia O'Keeffe
American, 1887–1986
Cow's Skull: Red, White, and Blue, 1931
Oil on canvas, 39⅞ × 35⅞ in. (101.3 × 91.1 cm)
Alfred Stieglitz Collection, 1952 (52.203)

O'Keeffe made a name for herself in the 1920s
with her large flower paintings, but after 1929
her subjects were mostly inspired by the land-
scape in New Mexico, where she traveled almost
annually (1929–46) and eventually settled (1949).
To her, found animal bones represented the
timeless beauty of the desert and the enduring
strength of the American spirit. Although this
image is seemingly realistic, the artist deleted
and enhanced certain details to emphasize its
harsh beauty. The title and tricolor palette are a
satirical comment on those artists, writers, and
musicians who were obsessed with identifying a
definitive American style.

Thomas Hart Benton

American, 1889–1975

America Today, 1930–31

Ten panels: Egg tempera with oil glazing over Permalba on a gesso ground on linen mounted to wood panels with a honeycomb interior

A. 92 × 160 in. (233.7 × 406.4 cm); B., C. 92 × 134½ in. (233.7 × 341.6 cm); D.–I. 92 × 117 in. (233.7 × 297.2 cm); J: 17⅛ × 97 in. (43.5 × 246.4 cm)

Gift of AXA Equitable, 2012 (2012.478a–j)

Missouri native Benton painted *America Today*, an ambitious mural cycle composed of ten canvas panels, to adorn a boardroom on the third floor of the New School for Social Research, a center of progressive education in Greenwich Village. Depicting an array of figural types—from flappers, farmers, and steelworkers to stock-market tycoons—the murals offer a panorama of rural and urban America. Dynamic scenes evoke the ebullient belief in American industry and progress in the 1920s, while simultaneously alluding to racial tensions, social change, and the economic despair of the Great Depression that would characterize American life in the following decade. In contrast to scenes of labor are vignettes of popular leisure-time activities during Prohibition, particularly dancing to jazz music and (illegal) drinking.

Pierre Bonnard
French, 1867–1947
The Terrace at Vernonnet, 1939
Oil on canvas, 58¼ × 76¾ in. (148 × 194.9 cm)
Gift of Florence J. Gould, 1968 (68.1)

In 1912 Bonnard bought a house in Vernonnet, near Vernon, and used it as a subject for his paintings until 1939. In this large, vividly colored late work, we see a shaded corner of the irregularly shaped, raised terrace that surrounded the house. Oddly enough, the three female figures are given less prominence than the thick tree trunk. A banister indicates the steps that descend to the sprawling garden below. The terrace serves as a stage, with the garden rising like a curtain beyond.

Balthus (Balthazar Klossowski)

French, 1908–2001

The Mountain, 1936–37

Oil on canvas, 8 ft. 2 in. × 12 ft. (2.49 × 3.66 m)
Purchase, Gifts of Mr. and Mrs. Nate B. Spingold and
Nathan Cummings, Rogers Fund and The Alfred N.
Punnett Endowment Fund, by exchange, and Harris
Brisbane Dick Fund, 1982 (1982.530)

This painting presents an imaginary plateau
at the top of a mountain in the Bernese
Oberland of Switzerland, where Balthus had
spent the formative summers of his youth.
In this canvas the artist included a rich brew
of references, both veiled ones with regard to

figures taken from his own life and transparent
ones with regard to those borrowed from
painters he admired, among them Nicolas
Poussin and Gustave Courbet. The focal point
in this composition, which is sharply divided
into light and dark zones, is the blonde Amazon
whose arms reach dramatically above her head.
After an arduous courtship, Balthus married the
figure's real-life model in the year he completed
The Mountain. The picture was exhibited at the
Pierre Matisse Gallery in New York in 1939 with
the subtitle *Summer*—the first of the four panels
depicting the seasons. Balthus never painted the
other three seasons.

Stuart Davis
American, 1892–1964
Report from Rockport, 1940
Oil on canvas, 24 × 30 in. (61 × 76.2 cm)
Edith and Milton Lowenthal Collection,
Bequest of Edith Abrahamson Lowenthal,
1991 (1992.24.1)

The profusion of colors, lines, shapes, and
decorative elements almost obscures the
subject of this painting—the bustling town
square of Rockport, Massachusetts. The canvas
is filled with gas pumps, trees, and storefront
signs, as well as indications of the area's thriving
fishing industry, such as images of water,
nautical flags, ropes, and a Seine-brand fishnet.
Utilizing his new "color-space" theory, Davis
created the illusion of depth by juxtaposing
certain colors while simultaneously negating
it with the absolute flatness of his shapes and
color fields. For the artist, such contradictions
captured the vitality, disjunction, and speed of
modern American life at midcentury.

Isamu Noguchi
American, 1904–1988
Kouros, 1944–45
Marble, H. 9 ft. 9 in. (2.97 m);
base: 34⅛ × 42 in. (86.7 × 106.7 cm)
Fletcher Fund, 1953 (53.87a–i)

Noguchi's interlocking sculptures of the mid-
1940s—produced after his internment during
World War II in a Japanese-American camp—
feature biomorphic forms carved from stone
and assembled without adhesives or pinions.
The extraordinary *Kouros*, with its interlock-
ing sections of pink and gray marble, conveys
graceful yet uncertain balance. Comparing the
work to the ancient Greek sculptural type that
informs it, the sculptor wrote to the Museum:
"The image of man as Kouros goes back to
student memories of . . . the pink Kouros you
acquired [illustrated earlier in this guide]. . . .
The weight of the stone holds it aloft—a bal-
ance of forces as precise and precarious as life."

Carmen Herrera

Cuban American, born 1915

Iberic, 1949

Acrylic on canvas on board

Diam. 40 in. (101.6 cm)

Gift of Tony Bechara, 2019 (2019.13)

Herrera made the tondo-shaped *Iberic*, a lyrical composition of interwoven irregular geometric and organic forms, during her crucial formative period in Paris between 1948 and 1954. Experimenting with various styles of abstraction, she then exhibited at the Salon des Réalités Nouvelles alongside Theo van Doesburg, Max Bill, and Josef Albers, among others. Suprematism and the Bauhaus were influences for the artist, however, the inspiration for *Iberic* came from the work of her close friend, fellow Cuban artist Wifredo Lam. Herrera used acrylic paint as early as 1948, the first artist in Europe to do so; this work is an example of her employment of this new material.

above

Willem de Kooning

American, born The Netherlands, 1904–1997

Attic, 1949

Oil, enamel, and newspaper transfer on canvas,
61⅞ × 81 in. (157.2 × 205.7 cm)
The Muriel Kallis Steinberg Newman Collection,
Gift of Muriel Kallis Newman, in honor of her son,
Glenn David Steinberg, 1982 (1982.16.3)

In this early masterwork, only tiny traces of color remain amid de Kooning's colliding black and white forms. The dynamic composition derives in part from the artist's innovative use of the figure. Here, he erased, repainted, and recombined figural elements, simultaneously suggesting an allover composition reminiscent of Jackson Pollock's work. De Kooning first considered calling this work "Interior." When his wife objected, he decided upon *Attic* "because you put everything in it." While making the painting, de Kooning covered the canvas with newspapers to keep the paint from drying, accepting the transfer of words and imagery left by the newsprint on the surface.

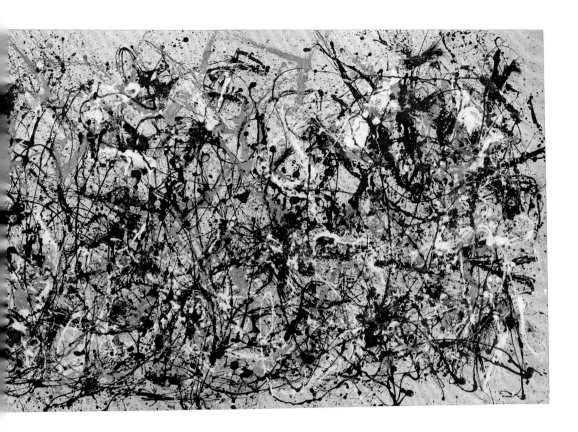

Clyfford Still
American, 1904–1980
1947-48-W No. 1, 1947–48
Oil on canvas, 91¾ × 70¾ in. (233 × 179.7 cm)
Gift of Mrs. Clyfford Still, 1986 (1986.441.3)

Beginning in 1945, Still periodically lived in New York, though his formative years were spent on the West Coast. In 1961 he settled permanently in Maryland. His mature paintings are characterized by amorphous, jagged forms often applied with a palette knife. In this example, large black and white areas are punctuated by flashes of red, yellow, and blue. Although Still disavowed associative meaning in his abstract work, some scholars have suggested allusions to the rugged terrain of the American West in his compositions, while others maintain that the upright nature of his forms invokes the human figure in relation to the environment.

Jackson Pollock
American, 1912–1956
Autumn Rhythm (Number 30), 1950
Enamel on canvas, 8 ft. 9 in. × 17 ft. 3 in. (2.67 × 5.26 m)
George A. Hearn Fund, 1957 (57.92)

In 1945 Pollock and his wife, the painter Lee Krasner, moved to a small house in the Springs section of East Hampton, New York. Over the next few years, working in relative isolation in the barn on the property, Pollock began to develop his distinctive drip technique. Using simple sticks or paint stirrers and enamel house paint—sometimes poured directly from the can—Pollock spun calligraphic lines of color directly onto raw canvas that lay unstretched on the floor. One of the largest of his classic drip paintings, *Autumn Rhythm* was purchased by the Museum from Krasner the year after Pollock's untimely death.

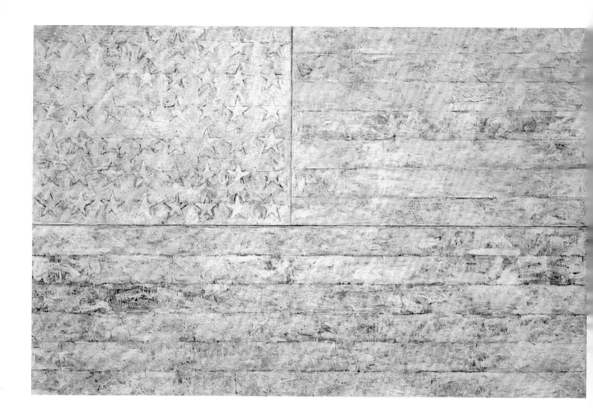

Jasper Johns

American, born 1930

White Flag, 1955

Encaustic, oil, newsprint, charcoal on canvas,
6 ft. 6½ in. × 10 ft. ¾ in. (1.99 × 3.07 m)

Purchase, Lila Acheson Wallace, Reba and Dave Williams, Stephen and Nan Swid, Roy R. and Marie S. Neuberger Foundation Inc., Louis and Bessie Adler Foundation Inc., Paula Cussi, Maria-Gaetana Matisse, The Barnett Newman Foundation, Jane and Robert Carroll, Eliot and Wilson Nolen, Mr. and Mrs. Derald H. Ruttenberg, Ruth and Seymour Klein Foundation Inc., Andrew N. Schiff, The Cowles Charitable Trust, The Merrill G. and Emita E. Hastings Foundation, John J. Roche, Molly and Walter Bareiss, Linda and Morton Janklow, Aaron I. Fleischman, and Linford L. Lougheed Gifts, and gifts from friends of the Museum; Kathryn E. Hurd, Denise and Andrew Saul, George A. Hearn, Arthur Hoppock Hearn, Joseph H. Hazen Foundation Purchase, and Cynthia Hazen Polsky and Leon B. Polsky Funds; Mayer Fund; Florene M. Schoenborn Bequest; Gifts of Professor and Mrs. Zevi Scharfstein and Himan Brown, and other gifts, bequests, and funds from various donors, by exchange, 1998 (1998.329)

White Flag is the largest of Johns's flag paintings and the first in which the flag is presented in monochrome. The fast-setting medium of encaustic enabled Johns to make each brushstroke distinct, while the forty-eight-star flag design provided a structure for the richly varied surface. *White Flag* is painted on three separate panels: the star area, the seven upper stripes to the right of the stars, and the six longer stripes below. Johns built up the stars, the negative areas around them, and the stripes by applying pieces of paper and fabric that had been dipped in molten beeswax. Johns has said that the flag, one of his most frequently depicted images, was prompted by a dream in which he saw himself painting an American flag. As with Johns's other early subjects—the target, numerals, and the alphabet—the image of the flag appealed to him because it already existed. He did not have to invent it. Since 1955 Johns has made dozens of flag compositions in a wide variety of scales, palettes, and media.

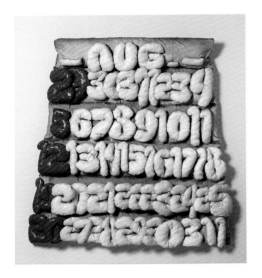

above

Claes Oldenburg
American, born Sweden 1929
Soft Calendar for the Month of August, 1962
Canvas filled with shredded foam rubber,
painted with Liquitex and enamel,
41¾ × 42½ × 4¼ in. (106 × 108 × 10.8 cm)
The Muriel Kallis Steinberg Newman Collection,
Gift of Muriel Kallis Newman, 2006 (2006.32.49)

Oldenburg has consistently embraced contradiction to transform and animate the quotidian objects of his surroundings. In his art, hard becomes soft, minuscule becomes monumental, and, as in *Soft Calendar*, flat becomes three-dimensional. Oldenburg's stuffed fabric sculptures originated in 1962 as props in his happenings and evolved into independent works of art. The giant numbers of *Soft Calendar* are sensuously rounded, pillowlike shapes whose overlapping arrangement asserts their volumetric nature. Once his canvas forms were established, Oldenburg painted the sculpture's surface, calling out each Sunday in brilliant red and covering the remaining days of the week in shiny white enamel.

below

Andy Warhol
American, 1928–1987
Nine Jackies, 1964
Acrylic and silkscreen on canvas; overall 60⅜ ×
48⅛ × ¾ in. (153.4 × 122.2 × 1.9 cm); nine panels,
each approx. 20 × 16 in. (50.8 × 40.6 cm)
Gift of Halston, 1983 (1983.606.14–.22)

In the weeks that followed the assassination of President John F. Kennedy in Dallas on November 22, 1963, Warhol began to collect the photographs of the widowed first lady that flooded the popular press. In 1964, upon moving into a new studio on East 47th Street (the first of his famous New York "Factories"), he began to silkscreen these pictures onto small canvases with blue- and gold-colored grounds. The close-cropped image here reproduces a moment shortly before any shots were fired; the insistent repetition of the picture casts into high relief the ubiquitous coverage and public obsession with the tragic event.

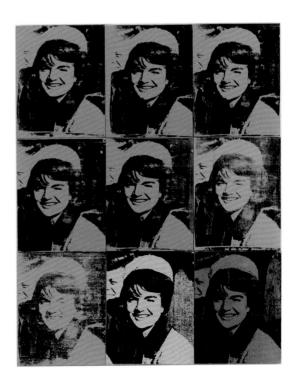

Mark Rothko
American, born Russia, 1903–1970
No. 13 (White, Red on Yellow), 1958
Oil and acrylic with powdered pigments on
canvas, 95⅜ × 81⅜ in. (242.3 × 206.7 cm)
Gift of The Mark Rothko Foundation Inc., 1985 (1985.63.5)

After 1950, Rothko began to limit the number
of horizontal bands of color in his paintings
to three or four, working in this format until
his death. Using several types of wet media
and varying the thickness of his paint layers,
he sometimes changed the orientation of his
pictures in the studio. Indeed, some of the drip
patterns here indicate that the artist worked on
this canvas upside down for a period. Hoping
that his luminous paintings would envelop their
viewers, Rothko commented that he made large
works not to be "grandiose and pompous" but to
be "very intimate and human."

Ellsworth Kelly
American, born 1923
Blue Green Red, 1963
Oil on canvas, 91 × 82 in. (231.1 × 208.3 cm)
Arthur Hoppock Hearn Fund, 1963 (63.73)

Unlike many painters of his generation, Kelly arrived at his abstractions through the observation of his surroundings. "My ideas," he has said, "come from constantly investigating how things look." *Blue Green Red*, the first of a series of eight large-scale pictures in these colors completed between 1963 and 1965, recalls Kelly's 1958 painting *Mask*, composed in the same color scheme and based on shadows cast across an open book. The taut, flat shapes and vibrant, unmodulated colors of *Blue Green Red* create a powerful optical effect and establish a fluctuating relationship between figure and ground.

David Smith

American, 1906–1965

Becca, 1965

Stainless steel, 9 ft. 5¾ in. × 10 ft. 3 in. × 30½ in.
(2.88 × 3.12 × .76 m)

Purchase, Bequest of Miss Adelaide Milton de Groot
(1876–1967), by exchange, 1972 (1972.127)

Between 1961 and 1965, Smith, one of the
twentieth-century's most influential American
sculptors, executed his Cubi series, monumental
works in highly polished steel. These sculptures
incorporate stacked cubic forms and overlap-
ping rectangular plates. *Becca,* named for one of
Smith's two daughters and made the year he died,
exemplifies the bold simplicity of these geometric
forms. Using a disk grinder, Smith burnished
the planar surfaces with calligraphic patterns
that catch the light. These works can be installed
indoors or out, but Smith especially appreciated
the changing atmospheric effects of nature on
their reflective surfaces.

Barbara Hepworth

British, 1903–1975

Oval Form with Strings and Color, 1966

Elm and painted elm with cotton strings,
33½ × 22½ × 21⅝ in. (85 × 57 × 55 cm)
Purchase, Gift of Hon. and Mrs. Peter I. B. Lavan,
by exchange, 2007 (2007.95)

Barbara Hepworth rivals Henry Moore as the greatest British sculptor of the twentieth century and ranks as one of the most celebrated female sculptors of any age. The artist carved *Oval Form* directly from a massive log of English elm when she was at the height of her powers, and it is a key work of her maturity. The egglike shape is a souvenir of her life-changing visit to the Paris atelier of Constantin Brancusi in 1933, whereas the strings derive from the work of her close friends Naum Gabo and László Moholy-Nagy, refugees who became part of the circle of British artists around Hepworth and her husband, Ben Nicholson.

Jean Tinguely

Swiss, 1925–1991

Narva, 1961

Steel bars, metal wheel, tubes, cast iron, wire,
aluminum, string, electric motor 220 v,
86 × 78 × 63 in. (218.4 × 198.1 × 160 cm)
Purchase, Bequest of Gioconda King, by exchange,
and The Louis S. and Mary Myers Foundation Gift, 2006
(2006.277a–fff)

The Dada art movement was born in Zurich in 1916. Characterized by the use of found objects in works that blur the distinction between art and life, Dada celebrated chaos, or at least pointed to the chaos lurking beneath the veneer of civilization. In the 1950s, young artists under the spell of Marcel Duchamp, such as Jean Tinguely, extended Dada to make provocative, raucous, and compelling works of art. *Narva* was made at the moment Tinguely's career blossomed. An assemblage of the stuff of modern life, the work amuses with its impossible complications, like a giant clock gone awry.

James Rosenquist

American, born 1933

House of Fire, 1981

Oil on canvas, 6 ft. 6 in. × 16 ft. 6 in. (1.98 × 5.03 m)
Purchase, Arthur Hoppock Hearn Fund, George A. Hearn
Fund and Lila Acheson Wallace Gift, 1982 (1982.90.1a–c)

Trained as a billboard painter, Rosenquist
began creating large-scale, lavishly composed
works as a Pop artist in the 1960s. *House of Fire*
exudes the dynamism and sensuous polish that
have characterized his work since that period.
In this allegorical triptych, prosaic objects
become strangely treacherous: a grocery bag is
mysteriously suspended in air, a supernaturally
radiant bucket of molten steel descends through
a window, and fiery lipsticks align like a battery
of guns. The allusions to violence, sex, and
consumerism recall earlier works such as the
artist's monumental *F-111* of 1965, which mixes
imagery of a U.S. Air Force fighter-bomber with
that of a child and a mass of spaghetti, producing
a heightened sense of seduction and danger.

Roy Lichtenstein

American, 1923–1997

Stepping Out, 1978

Oil and Magna on canvas, 86 × 70 in. (218.4 × 177.8 cm)
Purchase, Lila Acheson Wallace Gift, Arthur Hoppock
Hearn Fund, Arthur Lejwa Fund in honor of Jean Arp;
and The Bernhill Fund, Joseph H. Hazen Foundation Inc.,
Samuel I. Newhouse Foundation Inc., Walter Bareiss,
Marie Bannon McHenry, Louise Smith, and Stephen C.
Swid Gifts, 1980 (1980.420)

Having imbued his Pop Art works of the 1960s
with the imagery of everyday culture, Lichten-
stein in the 1970s turned his eye toward the
history of modern art. Working in his signature
palette of bright primary colors, he used paint
to suggest the Ben-Day dots that create tone
and shading in commercially printed images like
comics. Here the artist borrowed a dapper figure
from one of Fernand Léger's famous composi-
tions, *The Country Outing* (1954), and added a
female figure whose dramatically reduced and
displaced features resemble the Surrealist
women Picasso painted during the 1930s.

Alice Neel
American, 1900–1984
Henry Geldzahler, 1967
Oil on canvas, 50 × 33⅞ in. (127 × 86 cm)
Anonymous gift, 1981 (1981.407)

Working against the mainstream as a realist
artist, Neel steadily developed her career
with incisive, vivid portraits of those around
her—neighbors in Spanish Harlem, art-
world figures, and members of the women's
movement. Neel painted Henry Geldzahler,
The Met's newly appointed first curator of
twentieth-century art, possibly to ingratiate
herself for inclusion in his upcoming
exhibition. With her quick, active brush,
she shows him with his legs crossed to hide
his stomach and a slightly glum expression.
Neel's depictions of her sitters' hands often
revealed something of their character:
Geldzahler's rubbery left hand appears
cartoonish and unsettled. He did not include
her in his exhibition.

Romare Bearden

American, 1911–1988

The Block, 1971

Cut and pasted printed, colored, and metallic papers, photostats, graphite, ink marker, gouache, watercolor, ink on Masonite; overall 48 in. × 18 ft. (1.22 × 5.49 m); six panels, each 48 × 36 in. (121.9 × 91.4 cm)
Gift of Mr. and Mrs. Samuel Shore, 1978 (1978.61.1–.6)

This mural-size tableau is a tribute to Bearden's Harlem neighborhood in New York City. The row of low-rise buildings (tenement apartments, churches, barber shop, liquor store) was based on his sketches of Lenox Avenue between 132nd and 133rd Streets. Separate vignettes of people at work, rest, and play on the street and inside buildings (seen through windows and cutaways) offer poignant, sometimes humorous observations about human relations and social rituals. Bearden's inventive use of collage and his unexpected shifts in size and scale for expressive emphasis aptly capture the energy and complexity of city life. Although his images and materials were simple, Bearden added layers of meaning with references to other arts and cultures, such as Renaissance painting, Christian iconography, Cubism, and African tribal sculpture.

Anselm Kiefer

German, born 1945

Winter Landscape, 1970

Watercolor, gouache, and graphite
on paper, 16⅞ × 14 in. (42.9 × 35.6 cm)
Denise and Andrew Saul Fund, 1995 (1995.14.5)

Contemplation of wild or so-called Sublime landscapes was a trope of Romanticism, particularly in Germany. Kiefer's *Winter Landscape* evokes that past era, but the roughly plowed, snow-covered earth lends bleakness to the scene. A disembodied female head rises above the field, bleeding from the neck, and spots of blood-red watercolor tinge the pale ground. Kiefer perhaps had in mind mythological personifications of nature—Daphne, for example, whose father transformed her into a laurel tree to escape the attentions of Apollo. Yet this depiction of a ruined terrain, spotted with blood, is difficult to separate from evocations of the scarring wounds of World War II.

Philip Guston

American, 1913–1980

The Street, 1977

Oil on canvas, 69 in. × 9 ft. 2¾ in. (1.75 × 2.81 m)
Purchase, Lila Acheson Wallace and Mr. and Mrs. Andrew
Saul Gifts, Gift of George A. Hearn, by exchange, and
Arthur Hoppock Hearn Fund, 1983 (1983.457)

This monumental painting brings together
many of the themes that characterize Guston's
return to figurative subject matter in the late
1960s, a move that greatly surprised followers
of the former Abstract Expressionist. As
Guston wrote in 1974, his bluntly executed
paintings of this time depict a "sort of Dante
Inferno land." This work is a powerful and
darkly humorous battle scene in which the
street is a locus of disorder, confrontation,
and waste. It features contrasts typical of
Guston's later work, in which cartoonlike
characters populate nightmarish scenes,
rendered in an array of morose grays, bright
reds, and bubble-gum pinks.

Kerry James Marshall
American, born 1955
Untitled (Studio), 2014
Acrylic on PVC panels, 83⁵⁄₁₆ × 119¼ in. (211.6 × 302.9 cm)
Purchase, The Jacques and Natasha Gelman Foundation
Gift, Acquisitions Fund and The Metropolitan Museum of
Art Multicultural Audience Development Initiative Gift,
2015 (2015.366)

Marshall's practice of revering and revising the old masters to depict the lives and history of African Americans—subjects rarely seen in the works of art hanging in the world's great museums—began at an early age. He often recounts an episode from his summer course at the Otis Art Institute after seventh grade, when he visited the studio of his childhood idol Charles White (1918–1979). It was the first time Marshall had seen an artist's atelier in person, and he credits that as the moment when he first imagined himself becoming an artist. In part about that discovery of a black artist's workshop—a distinguished place of labor where an allegorical catalogue of the many modes of art-making are on display—*Untitled (Studio)* is a majestic ode to the occupation of the artist and to the history and ongoing possibilities of painting.

Peter Doig
British, born 1959
Two Trees, 2017
Oil on canvas, 94½ in. × 11 ft. 7¾ in. (240 × 355 cm)
Gift of George Economou, in celebration of the Museum's
150th Anniversary, 2018 (2018.754)

Against a backdrop replete with layers of
reference to old master painting, the two trees
here frame a real view from the artist's hillside
home on Trinidad, the Caribbean island where
he spent his childhood and to which he returned
to live in the early 2000s. Doig has spoken about
how his look east across the sea toward Africa
also reminds him of the journey across the
Atlantic's brutal Middle Passage that so many of
the islanders' forebears were forced to endure.
Trinidad's rich Creole traditions are also deeply
informed by that forced migration. Even as Doig's
three figures carry with them a sense of menace,
they seem to mirror that cultural hybridity as well
as the artist's own condition as an immigrant on
this phantasmal shore.

Photographs

The Metropolitan Museum houses more than forty thousand photographs spanning the history of the medium, from its invention in the 1830s to its most recent manifestations in video and new media. The Museum's collection was begun in 1928 with the American photographer Alfred Stieglitz's initial donation of twenty-two of his own works and greatly enriched by his subsequent donation and bequest of more than six hundred Pictorialist photographs. The Stieglitz Collection forms one of the key building blocks of the Museum's holdings, along with the Ford Motor Company Collection of some five hundred American and European avant-garde photographs from between the two world wars; the Rubel Collection, including masterpieces of early British photography; the Gilman Collection, a rich assemblage of nineteenth-century French, British, and American photography as well as masterpieces from the turn-of-the-century and modernist periods; and the archives of American photographers Walker Evans and Diane Arbus. The Museum's collection is increasingly strong in representing the varied paths of photography since 1960: its role in conceptual art, earth art, and body art; the Düsseldorf School, featuring works by Bernd and Hilla Becher and their students; the Pictures Generation; and other important contemporary artists who use photography. The core collection of photographic art is enriched by select examples of photojournalism as well as fashion, advertising, scientific, ethnographic, and vernacular photography, attesting to the medium's expansive reach and ubiquitous presence in modern society.

Jean-Baptiste-Louis Gros

French, 1793–1870

The Salon of Baron Gros, 1850–57

Daguerreotype, 8⅝ × 6¾ in. (22 × 17.1 cm)
Purchase, Fletcher Fund, Joyce F. Menschel Gift,
Louis V. Bell Fund, Alfred Stieglitz Society and W. Bruce
and Delaney H. Lundberg Gifts, 2010 (2010.23)

Gros's exceptional mastery of the technical
aspects of the daguerreotype was paired with
a refined visual sensibility, seen here in the
richness of the setting and the subtle and
seductive play of light. Every detail is perfectly
calibrated—the ewer carefully silhouetted
in the window, the stylish high-back chair
positioned invitingly in the glancing sunlight,
the daguerreotypes on the easel clearly visible
despite their mirrorlike surfaces, and the closed
curtains providing a theatrical backdrop. It is
an interior and a still life—but most of all it
is a portrait of Baron Gros's social standing,
aesthetic discernment, travels, and talent.

Albert Sands Southworth
American, 1811–1894
Josiah Johnson Hawes
American, 1808–1901
**Lemuel Shaw, Chief Justice of the
Massachusetts Supreme Court,** 1850s
Daguerreotype, 8½ × 6½ in. (21.6 × 16.5 cm)
Gift of Edward S. Hawes, Alice Mary Hawes,
and Marion Augusta Hawes, 1938 (38.34)

The Boston partnership of Southworth and
Hawes produced the finest portrait daguerreo-
types in America for a clientele that included
leading political, intellectual, and artistic figures.
This first photographic process spread rapidly
around the world after its public presentation
in Paris in 1839. Exposed in a camera obscura
and developed in mercury vapors, each highly
polished silvered copperplate is a unique image
that, viewed in proper light, exhibits extraordi-
nary detail and three-dimensionality. Lemuel
Shaw's imposing presence, sculpted by intense
sunlight and gifted artistic vision, is a startling
departure from the conventional posed portrait,
customarily set in a studio and lit indirectly.

Onésipe Aguado
French, 1827–1894
Woman Seen from the Back, ca. 1862
Salted paper print from glass negative,
12⅛ × 10⅛ in. (30.8 × 25.8 cm)
Gilman Collection, Purchase, Joyce F. Menschel Gift,
2005 (2005.100.1)

This picture, by a wealthy amateur photographer
and familiar figure at the French imperial court,
is at once a portrait, a fashion plate, and a jest.
The elaborate chignon, obviously the handiwork
of a skillful maid, the discreet jewelry, and
the luxurious fabrics all indicate a woman of
rank, the epitome of *comme il faut*. Although
we may be curious to know who she is, the
woman's identity may be of less import than
the compelling sense of mystery she projects.
A companion image showing the same woman
in profile reveals a troubled countenance and a
receding chin.

Gustave Le Gray
French, 1820–1884
The Great Wave, Sète, 1857
Albumen silver print from glass negative,
13¼ × 16¼ in. (33.7 × 41.4 cm)
Gift of John Goldsmith Phillips, 1976 (1976.646)

The dramatic effects of sunlight, clouds, and water in Le Gray's seascapes stunned his contemporaries at a time when most photographers found it impossible to achieve proper exposure of both landscape and sky in a single picture. Le Gray solved this problem by printing, on a single sheet of paper, two negatives—one exposed for the sea, the other for the sky—which were sometimes made on separate occasions or in different locations. Le Gray's marine pictures caused a sensation because they not only represented a technical tour de force but also had a poetic effect that was without precedent in photography.

Carleton Watkins
American, 1829–1916
Cape Horn near Celilo, 1867
Albumen silver print from glass negative,
15¾ × 20⅝ in. (40 × 52.4 cm)
Gilman Collection, Purchase, The Horace W. Goldsmith
Foundation Gift, through Joyce and Robert Menschel,
2005 (2005.100.109)

One of the finest landscape artists in any medium, Carleton Watkins made this stunning view of sky, river, rail, and rock on a mammoth plate-glass negative one hundred miles up the Columbia River from Portland, Oregon. Celilo was the farthest reach of a four-month survey commissioned by the Oregon Steam Navigation Company. An artful balance between nature and human incursion into it, the photograph might be interpreted as a visual metaphor for Manifest Destiny, the belief that the United States was destined to span the continent with its sovereignty.

above
Julia Margaret Cameron
English, 1815–1879
Philip Stanhope Worsley, 1866
Albumen silver print from glass negative,
12 × 9⅞ in. (30.4 × 25 cm)
Gilman Collection, Purchase, The Horace W.
Goldsmith Foundation Gift, through Joyce
and Robert Menschel, 2005 (2005.100.27)

Philip Stanhope Worsley was an Oxford-
educated poet who translated the *Odyssey*
and part of the *Iliad* into Spenserian verse.
Tubercular from childhood, he died at the age
of thirty in Freshwater, on the Isle of Wight,
where Julia Margaret Cameron also lived.
The intensity of Worsley's intellectual life and
something of its tragedy are vividly conveyed
in Cameron's portrait, made in the year of the
poet's death. Isolating her subject's face against
an indistinct background, Cameron placed his
raised and baleful gaze at the very center of the
picture. To Worsley's hypnotic gravity she added
intimations of sacrifice, swathing the body and
engulfing the great head, rendered nearly life-
size, in dramatic darkness.

below
Thomas Eakins
American, 1844–1916
Two Pupils in Greek Dress, 1883
Platinum print, 14½ × 10½ in. (36.8 × 26.7 cm)
David Hunter McAlpin Fund, 1943 (43.87.17)

Thomas Eakins employed the camera as a
way to imbue his paintings with increased
naturalism. He used his students at the
Pennsylvania Academy of the Fine Arts in
Philadelphia as models and compiled an
extensive photographic catalogue that directly
aided his studies of the human form. This
photograph, made on an oversize sheet of
platinum-coated paper, is a study of pose and
gesture in which the stance of the models
consciously echoes that of the figures in
Eakins's sculpted relief *Arcadia* (1883), seen
resting on a worktable beneath a pair of the
artist's wooden paint palettes.

Edward Steichen

American, born Luxembourg, 1879–1973

The Flatiron, 1904

Gum bichromate over platinum print,
18⅞ × 15⅛ in. (47.8 × 38.4 cm)
Alfred Stieglitz Collection, 1933 (33.43.43)

While Steichen's palette recalls Whistler's Nocturne paintings and the foreground branch echoes those often found in the Japanese prints that were much in vogue in turn-of-the-century Paris, his subject is distinctly modern and American. The newly completed, twenty-two-story skyscraper soars so high above Madison Square in New York that it could not be contained within the photographer's frame. Crown jewels in the Museum's photography collection, Steichen's three variant printings of *The Flatiron*, each in a different tonality, evoke successive moments of twilight and forcefully assert that photography can rival painting in scale, color, individuality, and expressiveness.

George Seeley
American, 1880–1955
Winter Landscape, 1909
Gum bichromate over platinum print,
17¼ × 21⅛ in. (43.7 × 53.8 cm)
Gilman Collection, Purchase,
The Horace W. Goldsmith Foundation Gift, through
Joyce and Robert Menschel, 2005 (2005.100.116)

Trained as a painter in Boston, Seeley joined the
Photo-Secession, a loose-knit circle of artists
promoted by Alfred Stieglitz, in 1906. On the
occasion of his second exhibition at Stieglitz's
gallery, 291, in 1908, Seeley visited New York
and saw original prints by his colleagues for the
first time. This study of snow on a frozen pond
may be Seeley's response to Edward Steichen's
work, which had especially impressed him.
Boldly simplified in tone, its whip-line contours
in perfect accord with the sinuous forms of Art
Nouveau, this is one of the most insistently
abstract photographic images of its time.

Paul Strand
American, 1890–1976
Blind, 1916
Platinum print, 13⅜ × 10⅛ in. (34 × 25.7 cm)
Alfred Stieglitz Collection, 1933 (33.43.334)

In 1916 Strand made a series of candid street
portraits with a handheld camera fitted with a
false lens attached to its side, allowing him to
point the camera in one direction while actually
taking the photograph in another. This seminal
image of a street peddler was published in 1917
in Alfred Stieglitz's magazine *Camera Work*.
It immediately became an icon of the new
American photography, which integrated the
humanism of social documentation with the
boldly simplified forms of modernism. This
large platinum print is the only known vintage
exhibition print of this image.

Man Ray
American, 1890–1976
Rayograph, 1923–28
Gelatin silver print, 19¼ × 15⅜ in. (49 × 39.8 cm)
Gilman Collection, Purchase, The Horace W. Goldsmith
Foundation Gift, through Joyce and Robert Menschel,
2005 (2005.100.140)

No technique was better suited to Man Ray's
pursuit of Surrealist ambiguity than the
photogram, a cameraless process in which
objects are placed directly upon sensitized paper
and exposed to light. Called "rayographs" by
Man Ray's friend Tristan Tzara, photograms
are unique, unrepeatable, and, to a degree,
uncontrollable. In this, one of Man Ray's largest
rayographs, white incandescent shapes float
against a murky background "painted" by liquid
chemicals, probably representing a creation
metaphor.

Alfred Stieglitz
American, 1864–1946
Georgia O'Keeffe—Neck, 1921
Palladium print, 9¼ × 7½ in. (23.6 × 19.2 cm)
Gift of Georgia O'Keeffe, through the generosity
of The Georgia O'Keeffe Foundation and Jennifer
and Joseph Duke, 1997 (1997.61.19)

This photograph, one of more than three hun-
dred images Stieglitz made of Georgia O'Keeffe
between 1917 and 1937, is part of an extraordi-
nary composite portrait. Stieglitz believed that
portraiture should be a record of a person's
entire experience, a mosaic of expressive move-
ments, emotions, and gestures that function
collectively to evoke a life. "To demand the por-
trait that will be a complete portrait of any per-
son," he claimed, "is as futile as to demand that a
motion picture be condensed into a single still."

Charles Sheeler

American, 1883–1965

Criss-Crossed Conveyors, River Rouge Plant, Ford Motor Company, 1927

Gelatin silver print, 9¼ × 7⅜ in. (23.5 × 18.8 cm)
Ford Motor Company Collection, Gift of Ford Motor
Company and John C. Waddell, 1987 (1987.1100.1)

A highly realistic Precisionist painter as well as
a photographer, Sheeler invariably uncovered
harmonious coherence in the sharply defined
forms of indigenous American architecture.
His series of photographs of the Ford plant
near Detroit was commissioned by the
automobile company through an advertising
agency. Widely reproduced in Europe and
America in the 1920s, this commanding image
of technological utopia became a monument
to the transcendent power of industrial
production in the early modern age.

Walker Evans

American, 1903–1975

Kitchen Corner, Tenant Farmhouse, Hale County, Alabama, 1936

Gelatin silver print, 7⅝ × 6⅜ in. (19.5 × 16.1 cm)
Purchase, The Horace W. Goldsmith Foundation Gift,
through Joyce and Robert Menschel, 1988 (1988.1030)

In the summer of 1936, Walker Evans collaborated
with his friend the writer James Agee on an
unpublished article about tenant cotton farmers
in the American South, which eventually became
the Depression-era masterpiece *Let Us Now Praise
Famous Men* (1941). Agee interviewed three farm
families, and Evans made their portraits as well
as detailed studies of their homes, furniture,
clothing, and land. This intimate, respectful
photograph of a simple broom, a piece of worn
cheesecloth, and a ladderback chair recalls Agee's
musing that everything in one of the families'
cabins "might be licked with the tongue and made
scarcely cleaner."

Diane Arbus
American, 1923–1971
Child with a toy hand grenade
in Central Park, N.Y.C. 1962, 1962
Gelatin silver print, 15½ × 15⅛ in. (39.5 × 38.3 cm)
Purchase, Jennifer and Joseph Duke Gift,
2001 (2001.474)

One of the most influential artists of the last
half century, Diane Arbus forever altered our
expectations of portraiture with her lacerating,
matter-of-fact photographs of the normal and
the marginal in American society. In 1962, on a
bucolic day in Central Park, the photographer
and a young boy engage face-to-face. Armed
with searing gazes but relatively benign weapons
(a plastic toy hand grenade and a camera), they
attain a momentary, if unbearably intense,
draw. With exquisite prescience, Arbus was
able to grasp that explosive potential and
translate it into an indelible picture about
childhood tomfoolery, war, and the role of the
photographer in society.

Andy Warhol
American, 1928–1987
Self-Portrait, 1979
Instant color print, 24 × 20 in. (61 × 50.8 cm)
Purchase, The Andy Warhol Foundation for
the Visual Arts Gift, Joyce and Robert Menschel
Gift and Rogers Fund, 1995 (1995.251)

Much of Warhol's work can be read as a
meditation on the transience of life, from
his iconic portrayals of a stoically suffering
Jacqueline Kennedy to his paintings of skulls
from the mid-1970s. With eyes closed and
an unearthly pallor, the artist appears here
as a martyred saint, suspended between the
agonies of the flesh and the blinding white
light of the afterlife. Stripped of the guile of
many of his self-portraits, this riveting picture
seems both to refer back to the attempt made
on his life in 1968 and to chillingly prefigure his
untimely death.

Jeff Wall
Canadian, born 1946
The Storyteller, 1986
Silver-dye bleach transparency in light box,
7 ft. 6¼ in. × 14 ft. 4⅛ in. (2.29 × 4.37 m)
Purchase, Charlene and David Howe, Henry Nias
Foundation Inc., Jennifer Saul, Robert Yaffa,
Harriet Ames Charitable Trust, and Gary and
Sarah Wolkowitz Gifts, 2006 (2006.91)

For this work, Wall restaged an everyday
scene that he had witnessed firsthand. Using
nonprofessional actors and a real location,
Wall presented the final image as a backlit
transparency of the kind seen at bus stops and
in airports. Yet the alert viewer may notice that
some of the figures' poses echo those seen in
famous French canvases by Édouard Manet
and Georges Seurat, who in their time had also
referenced past masters.

Richard Prince
American, born 1949
Untitled (cowboy), 1989
Chromogenic print, 50 × 70 in. (127 × 177.8 cm)
Purchase, The Horace W. Goldsmith Foundation Gift
through Joyce and Robert Menschel, and Jennifer
and Joseph Duke Gift, 2000 (2000.272)

Untitled (cowboy) is a high point of this artist's
ongoing deconstruction of an American arche-
type as old as the first trailblazers and as timely
as then-outgoing president, Ronald Reagan.
Prince's picture is a copy (the photograph) of a
copy (the advertisement) of a myth (the cow-
boy), and a trenchant statement on our culture's
continuing attraction to images as opposed to
lived experience—what the artist has described
as "the closest thing to the real thing."

opposite below
Thomas Struth
German, born 1954
Restorers at San Lorenzo
Maggiore, Naples, 1988
Chromogenic print, 46⅞ × 62⅞ in. (119.1 × 159.7 cm)
Purchase, Vital Projects Fund Inc. Gift, through Joyce and
Robert Menschel; Alfred Stieglitz Society Gifts; Jennifer
Saul Gift; Gift of Dr. Mortimer D. Sackler, Theresa Sackler
and Family; and Gary and Sarah Wolkowitz Gift, 2010
(2010.121)

Made at a moment in the late 1980s when
Struth felt art had lost its way in a culture of
commodities and media hype, *Restorers* is the
artist's signature image and a curtain-raiser
to his most celebrated series, large-scale color
photographs that show people looking at art
in museums, churches, and other "cathedrals
of culture." It is also a family portrait of sorts,
describing a group of individuals united not
by blood but by a communality of purpose—
rescuers of the past for the needs of the present,
much like the artist himself.

David Hammons
American, born 1943
Phat Free, 1995
Single-channel video;
color; sound; 5 min. 14 sec.,
dimensions variable
Purchase, Alfred Stieglitz
Society Gifts, 2003
(2003.269)

Part shaman, part huckster, Hammons has sold snowballs on an uptown New York sidewalk; created elegant, slightly less ephemeral sculpture from chicken bones and human hair gathered from a Harlem barbershop; and exhibited a giant billboard portrait of Jesse Jackson in whiteface on a Washington, D.C., street in 1989. The artist's first and only video, *Phat Free*, begins with the very loud and prolonged sound of what seems like furious drumming on trash cans; when revealed, the mysterious figure "kicking the bucket" along the Bowery at night becomes an alternately menacing and exhilarating wake-up call.

Index of Works

Photograph Credits

Published by
The Metropolitan Museum of Art, New York

Mark Polizzotti, Publisher and Editor in Chief
Gwen Roginsky, Associate Publisher and General
 Manager of Publications
Peter Antony, Chief Production Manager
Michael Sittenfeld, Senior Managing Editor
Bonnie Laessig and Chris Zichello, Production
 Managers
Jane S. Tai, Image Acquisition and Permissions
 Specialist

Edited by Harriet Whelchel, Margaret Aspinwall,
 and Elisa Urbanelli
Project management by Elizabeth Zechella

Designed by Steven Schoenfelder
Typeset in Centaur and Chaparral
Printed on 130 gsm Cartiere Burgo R4
Separations by Professional Graphics, Inc.,
 Rockford, Illinois
Printed and bound by Conti Tipocolor, S.p.A.,
 Florence, Italy

Cover illustrations: (front) Juan Gris,
The Musician's Table (detail), 1914 (p. 403);
Buddha, Probably Amitabha (detail). China,
Tang Dynasty, early 7th century (p. 88)

p. 1: Balthasar Permoser, *Bust of Marsyas* (detail),
ca. 1680–85 (p. 310)
p. 2: Onésipe Aguado, *Woman Seen from the Back*
(detail), ca. 1862 (p. 438)
p. 3: *Wall Painting with Seated Woman Playing a
Kithara* (detail). Roman, Late Republican period,
ca. 50–40 B.C. (p. 78)
p. 4: *Plate with a Hunting Scene.* Iran, Sasanian period,
ca. A.D. 400–500 (p. 37)
p. 5: *Length of Fabric* (detail). Turkey, probably
Istanbul, ca. 1565–80 (p. 138)
p. 6: *Queen Mother Pendant Mask.* Nigeria, Kingdom
of Benin, Edo peoples, 16th century (p. 145)
p. 7: John Singer Sargent, *Madame X* (detail), 1883–
84 (p. 373)
p. 8: The Great Hall of The Metropolitan Museum
of Art
p. 10: Ellsworth Kelly, *Blue, Green, Red* (detail),
1963 (p. 427)
p. 12: *Pichwai Depicting the Celebration of the Festival
of Cows* (detail). India, Deccan, late 18th–early 19th
century (p. 120)

Copyright © 2012, 2019 by The Metropolitan
Museum of Art, New York

Revised edition

Photographs of works of art in The Metropolitan
Museum of Art's collection are by the Imaging
Department, The Metropolitan Museum of Art,
unless otherwise noted. Additional photograph
credits appear on p. 455.

The Metropolitan Museum of Art
1000 Fifth Avenue
New York, New York 10028
metmuseum.org

Distributed by
Yale University Press, New Haven and London
yalebooks.com/art
yalebooks.co.uk

Cataloguing-in-Publication Data is available from
the Library of Congress.
ISBN 978-1-58839-700-3